EXTRA ART: A SURVEY OF ARTISTS' EPHEMERA, 1960–1999

Extra Art: A Survey of Artists' Ephemera, 1960–1999
October 12–December 8, 2001
California College of Arts and Crafts
1111 8th Street, San Francisco, CA 94107

This catalogue is published in conjunction with the exhibition
"Extra Art: A Survey of Artists' Ephemera 1960-1999," organized
by guest curator Steven Leiber for the CCAC Institute for
Exhibitions and Public Programs.

Editor: Pilar Perez
Design: Michele Perez
Production: Leigh Smith
Copy Editor: Sherri Schottlaender

Vol. VIII, no. 76
ISBN 1-889195-48-0
© 2001 Smart Art Press
Published by Smart Art Press
2525 Michigan Avenue, Building C1
Santa Monica, CA 90404
(310) 264–4678 tel
(310) 264–4682 fax
www.track16.com

Distributed by RAM Publications
2525 Michigan Avenue, Building A2
Santa Monica, CA 90404
(310) 453–0043 tel
(310) 264–4888 fax
e-mail: rampub@gte.net

Printed and bound by
JOMAGAR, S.A., Spain.

Cover image: Dave Muller

EXTRA ART: A SURVEY OF ARTISTS' EPHEMERA, 1960–1999

ccac · smart art press

TABLE OF CONTENTS

NO FREE READING

**Coracle Press/
Workfortheeyetodo**
NO FREE READING.
Workfortheeyetodo,
London, England. 1996.
Postcard.
REF NO. 114

It is a rare historical exhibition that breaks new ground and offers us a novel way to consider the history of art. In organizing "Extra Art: A Survey of Artists' Ephemera, 1960–1999" for the CCAC Institute, guest curator Steven Leiber has done precisely that. Taking on a neglected, inadequately documented, and utterly crucial terrain of recent art history, Leiber has assembled ephemera works by approximately 190 artists from around the globe, and in the process he makes a persuasive case for the uniquely innovative potentials of this type of art.

The remarkable diversity of the works included in this exhibition, both in terms of their graphic strategies as well as their conceptual concerns, is truly revealing. It suggests the extent to which experiments within this particular area of art-making have preoccupied artists over the past four decades. At the same time, much of the work in the show also directly relates to core concerns of contemporary art practices, especially those that seek to reject confinement in that private garden of self-cultivation which comprises the conventional world of "fine" art.

Indeed, a democratic impulse underlies a great deal of artists' ephemera works. This impulse is perhaps most conspicuously evident in the desire of artists to reach a larger public than that constituted by gallery visitors, and to do so by creating works that can be widely and inexpensively distributed. It is also evident in the artists' embrace of mass reproduction, inexpensive materials, and an aesthetic that is modest and unpretentious. Unafflicted by melancholy over the supposed loss of the art object's aura (as described by Walter Benjamin in his prescient 1935 essay, "The Work of Art in the Age of Mechanical Reproduction"), the artists in "Extra Art: A Survey of Artists' Ephemera, 1960–1999" exuberantly explore the possibilities offered by commercial printing techniques for taking art into different cultural and social spaces.

The need for such exploration was demanded, in part, by the explosion of new forms of art-making in the late 1950s and early 1960s which sought to exist outside the traditional framework of museums and galleries. As Steven Leiber and Todd Alden argue in their catalogue essay, the pioneering developments in artists' ephemera works reflect the seminal changes of that era which forever altered the practice and understanding of contemporary art. Leiber and Alden cogently demonstrate that while predecessors such as Marcel Duchamp and the Russian Constructivists made use of commercially printed matter, widespread interest in ephemera grew out of movements as disparate as Pop, Fluxus, and Conceptual art. Although it reflected different motives, a similar interest was revived in the activist and socially critical art of the 1980s, and it appears today in art engaged with blurring the boundary between art and graphic design, as well as in the work of many artists influenced by Conceptualism.

In her essay Anne Mœglin-Delcroix examines the different roles and functions that artists' ephemera works have served, with a focus on the way they emphasize the significance of time—documenting short-lived events or announcing future exhibitions—over that of space. Indeed, precisely because they tend towards the timely rather than the timeless, Mœglin-Delcroix declares ephemera to be "the most 'contemporary' of the arts we call contemporary."

Viewing this rich vein of art history from another angle, Ted Purves's essay reflects on the ways in which artists' ephemera works altered, enhanced, and enriched traditional relationships between artist, artwork, and audience. Exploring the notion of travel, he discusses ephemera works that aim to link disparate places and which ask audiences to make imaginative and intellectual connections between different environments and what they represent.

All of these essayists have earned our respect and gratitude for their thoughtful and incisive contributions on a subject about which very little has been written. Taken together, the catalogue and exhibition comprise an educational and aesthetic experience that perfectly matches the goals of the CCAC Institute. For this, we are deeply indebted to guest curator Steven Leiber, not only for organizing both endeavors, but also for the example of his exacting standards as a researcher, his intelligence as a curator, and his passion for a form of art that all too frequently has been relegated to the dustbins of history.

On behalf of the CCAC Institute, I must also offer profound thanks to Tom Patchett, whose great generosity and critical acumen made this publication possible. In addition, Pilar Perez and Cindy Ojeda of Smart Art Press brought their considerable expertise to bear on this project, helping to ensure its success. Book designer Michele Perez and copy editor Sherri Schottlaender also deserve our enduring thanks for their substantial contributions.

Finally, this exhibition could not have been realized without the help of the CCAC Institute's incomparable staff. In particular, I would like to thank Kirstin Bach, Hilary Chartrand, Valerie Imus, and Marina McDougall—and above all, Ted Purves, who has contributed to this project in many, many ways.

Ralph Rugoff
Director, CCAC Institute
California College of Arts and Crafts

INTRODUCTION

Ralph Rugoff

Yves Klein
Dimanche. 27 NOVEMBRE
1960. NUMÉRO UNIQUE.
[Self-published].
November 27, 1960.
Artist's publication.
REF NO. 253

YVES KLEIN PRÉSENTE :
LE DIMANCHE 27 NOVEMBRE
1960

NUMÉRO UNIQUE

FESTIVAL D'ART
D'AVANT-GARDE
NOVEMBRE - DÉCEMBRE 1960

La Révolution
bleue
continue

SEANCE DE 0 HEURE A 24 HEURES

Dimanche
27 NOVEMBRE

Le journal
d'un
seul jour

0,35 NF (35 fr.)

THEATRE DU VIDE

UN HOMME DANS L'ESPACE !

(Photo Shunk-Kender)

ACTUALITÉ

Le peintre de l'espace se jette dans le vide !

L'ESPACE, LUI-MÊME.

Sensibilité pure

● SUITE EN PAGE 2

ART FOR THE OCCASION ART DE CIRCONSTANCE

Dance cards scattered among petals dropped from wilted flowers, a concert program, a list of dinner guests, all make up a special literature having in itself the immortality of a week or two. The existence of nothing can be forgotten in an era: everything belongs to everyone.
—Stéphane Mallarmé, *La Dernière Mode*

Listes de danseurs perdues avec les fleurs effeuillées, programme du concert ou carte des dîneurs composent, certes, une littérature particulière, ayant en soi l'immortalité d'une semaine ou de deux. Rien n'est à négliger de l'existence d'une époque : tout y appartient à tous.
S. Mallarmé, *La Dernière Mode*

Anne Mœglin-Delcroix

Could it be that the genealogy of contemporary art goes back farther than Marcel Duchamp? In fact, he was the first to recognize in the work of Stéphane Mallarmé the model, *par excellence*, of what he termed a "dry art":[1] "Mallarmé was a great figure. It is in this direction that art should go—towards an intellectual expression rather than an animal expression . . ."[2] The importance of this late-nineteenth-century French poet could thus be wider than the specific influence that *Un coup de dés* had on concrete poetry or on the work of Marcel Broodthaers. It affects the very spirit of contemporary art.

Mallarmé, then, can help us understand what is involved in artists' ephemera works, at least up to a certain point. If we rely on the Greek etymology, ephemera works should be works that last no more than a day. But if we rely on common usage, they are works made for a specific day or announce what will take place on a given date. Their short life is simply the result of their immediate obsolescence. Over a period of nearly twenty years, from 1881 to 1898, besides writing his major works, Mallarmé dedicated many very short poems to his friends for different occasions. He turned postal addresses on envelopes into verse; he wrote poetic lines on stones that he picked up on the beach at Honfleur, on bottles of Calvados, and on fans; he created invitations for the launch of a periodical; and he sent little verses to celebrate all manner of occasions. These verses share two characteristics with artists' ephemera works.

Se pourrait-il que la généalogie de l'art contemporain remonte au-delà de Marcel Duchamp ? Celui-ci fut le premier à reconnaître dans Mallarmé le modèle par excellence d'un "art sec"[1] : "Mallarmé était une grande figure. C'est dans cette direction que l'art devrait se tourner : vers une expression intellectuelle, plutôt qu'une expression animale [...][2]." L'importance du poète français de la fin du XIXe siècle pourrait donc être plus générale que l'influence spécifique exercée par *Un coup de dés* sur la poésie concrète ou sur une œuvre comme celle de Marcel Broodthaers. Elle concerne l'esprit même de l'art contemporain.

Ainsi Mallarmé peut-il, par exemple, aider à comprendre ce qui est en jeu dans les *artists' ephemera works*. Jusqu'à un certain point, du moins. Si l'on se fie à l'étymologie grecque, les *ephemera works* devraient être des œuvres qui ne durent qu'un jour. Mais si l'on se fie à l'usage, ce sont des œuvres faites pour un jour donné ou qui annoncent ce qui aura lieu à une date précise. La brièveté de leur existence n'est que la conséquence de leur rapide obsolescence. Pendant près de vingt ans, de 1881 à 1898, à côté de ses œuvres majeures, Mallarmé écrivit quantités de très courts poèmes, adressés à des amis, en relation à telle ou telle occasion : adresses postales versifiées sur les enveloppes de ses lettres ; messages manuscrits sur des galets ramassés sur la plage d'Honfleur, sur des cruches de Calvados et sur des éventails ; invitations à l'inauguration d'une revue ; célébration d'une fête et commémoration

1. Marcel Duchamp, "Interview: Marcel Duchamp—James Johnson Sweeney," in *Duchamp du Signe: Écrits*, ed. Michel Sanouillet (Paris: Flammarion, 1976), p. 179.
2. Cited by Octavio Paz in *Marcel Duchamp: L'Apparence Mise à Nu . . .*, trans. Monique Fong (Paris: Gallimard, 1977), p. 81.

1. Marcel Duchamp, "Entretien Marcel Duchamp - James Johnson Sweeney", in *Duchamp du signe. Écrits*. Ed. Michel Sanouillet. Paris : Flammarion, 1976, p. 179.
2. Cité par Octavio Paz, *Marcel Duchamp : L'Apparence mise à nu...* Trad. Monique Fong. Paris : Gallimard, 1977, p. 81.

Ian Hamilton Finlay
potatocut robin. linocut garden
fork. wood-engraved tree.
Christmas 1990, Little Sparta.
[Wild Hawthorn Press, Lanark,
Scotland]. 1990.
Christmas card.
REF NO. 149

On the one hand, they are made for special occasions, and the content is specific to a given day; for this reason, they are often modest and unpretentious. On the other hand, they are nevertheless works that make an original artistic contribution to the information they communicate.

In this respect, artists' greeting cards are obviously closest to Mallarmé's personal messages: these greetings for Christmas or the New Year are, at the same time, little printed works sent as gifts to friends. The tradition of sending this type of message is an old one, even if over the last forty years it has taken forms very different from the traditional little print slipped into an envelope and sent by mail, such as a postcard, a flyer, or a little book made for the occasion, like those that Ian Hamilton Finlay sends to his friends every year at Christmas with the words "Christmas 19_" either printed or handwritten.

Since the 1960s, the number of artists' ephemera works has grown considerably, and their nature, as well as their function, has become increasingly diversified. This phenomenon can be explained by new directions in artistic creation, generated by a general mistrust of the object. The consequence of what was called "dematerialization," or more correctly, "de-objectification,"[3] resulted in artists emphasizing the importance of time over that of space in the visual arts. The dimension of time then takes on one of two aspects: either the duration of a process, or the appointed moment. In both cases, whether the purpose is to record short-lived actions or announce a coming event, it is necessary to develop strategies of documentation and information that become integral parts of the artistic activity. Printed material in all its forms is one means among others, but as an invitation to an artistic event, it is obviously more suitable than video or photography.

This is why, no matter how great their diversity, artists' ephemera works have something in common which distinguishes them from Mallarmé's occasional verses. His poems are a kind of aside, an addition to his work, and they are not intrinsically related to it. The only relation is one of contrast: they are doggerel, poetic games, frivolous and unimportant, and they demonstrate the poet's virtuosity in writing little nothings that have no other purpose than to entertain those who receive them. Artists' ephemera works are also part of the realm of the "little" and of detail, of the secondary and the minor. But, unlike Mallarmé's occasional verses, they rarely stand on their

d'un anniversaire, etc. Ces vers partagent avec les *artists' ephemera works* deux traits : d'une part, ce sont des pièces de circonstance, dont le contenu concerne un jour donné, et qui, pour cette raison, sont souvent modestes et sans prétention ; d'autre part, ce sont malgré cela des œuvres qui ajoutent une contribution artistique originale à l'information qu'ils communiquent.

A cet égard, ce sont les cartes de vœux d'artistes qui sont évidemment les plus proches des envois de Mallarmé : messages pour Noël ou Nouvel An, qui sont en même temps une petite œuvre imprimée, envoyée en cadeau à des destinataires définis. La tradition de ce genre d'envois est ancienne, même si, depuis quarante ans, elle a pris bien d'autres formes que la traditionnelle petite gravure mise sous enveloppe et envoyée par la poste : par exemple, une carte postale, un dépliant, voire un petit livre faits pour l'occasion, comme ceux que Ian Hamilton Finlay a coutume d'envoyer à ses correspondants à l'occasion de Noël, avec la mention "Christmas 19..", imprimée ou manuscrite.

Depuis les années 60, le nombre des *artists' ephemera works* s'est considérablement accru et leur nature comme leur fonction se sont grandement diversifiées. Ce phénomène s'explique par les orientations nouvelles de la création artistique qui engendrent la méfiance des artistes envers l'objet. Elle se traduit, entre autres choses, par l'importance prise par le temps au détriment de l'espace dans les arts visuels. La dimension du temps peut y prendre deux aspects : la durée d'un processus ou le rendez-vous ponctuel. Dans les deux cas, qu'il s'agisse de garder trace d'une suite de faits ou d'annoncer un événement, il devient nécessaire de développer des stratégies de documentation et d'information qui deviennent parties intégrantes de l'activité artistique. Le papier imprimé sous toutes ses formes en est un moyen parmi d'autres. Mais, pour inviter à un événement artistique, il convient évidemment mieux que la vidéo ou la photographie.

C'est pourquoi, quelle que soit par ailleurs leur diversité, les *artists' ephemera works* ont un point commun décisif qui les distingue des vers de circonstance de Mallarmé. Ceux-ci représentent un à-côté de son œuvre et n'ont pas de relation intrinsèque avec elle. La seule relation est de contraste : ce sont des vers de mirliton, jeux poétiques frivoles et sans importance qui témoignent de la virtuosité du poète à écrire sur de petits riens et ils n'ont d'autre but que de divertir leurs destinataires. Certes, les *artists'*

3. Lucy Lippard and John Chandler, "The Dematerialization of Art," Art *International* (February 1968). Ursula Meyer, "De-objectification of the Object," *Arts* Magazine (Summer 1969).

own and most of them belong to and complement a larger work. In some cases this complement is accessory, in others it is necessary. Even though ephemera works are marginal to the work as a whole, their function is not always marginal, as can be demonstrated by a few particularly significant examples.

In the following discussion, the main outline of a typology will be briefly sketched out. It is not intended to be exhaustive, for the production takes on so many different forms that it would be impossible to discuss them all. This attempt at a typology merely aims at isolating several major trends. It is based not on material criteria (categorization of documents by types: cards, posters, flyers, etc.), but on criteria of function in relation to the different ways in which ephemera works take hold of the factor of time.

THE ANNOUNCEMENT AND/OR THE WORK

As for the accessory complement, the most common type is that of announcement cards that are for the most part invitations to an exhibition and on which is found all the relevant information about the exhibition. Since the 1960s the artist has often been the author, for during a period when there was an increasingly widespread claim to freedom in all areas, the artist also sought to control the manner in which his or her work was presented, and in particular, the information circulated about it, from announcement cards and posters to the catalogue. Thus, each card, in addition to being a means of information, becomes a work printed for the exhibition. Usually they are simply cards with an image printed on one side and practical information on the reverse. But it is the artist who has conceived the content and the design.

Nonetheless, some of these announcement cards are exceptional within the genre. Because of his own often barely readable typography and the unusual presentation

ephemera works appartiennent aussi au domaine du "petit", du détail, du secondaire. Mais, à la différence des poèmes de circonstance de Mallarmé, il est rare qu'ils soient autonomes. Ils sont, pour la plupart, au service d'une œuvre dont ils sont un complément. Dans certains cas ce complément est accessoire, dans d'autres il est indispensable. Bien que les *ephemera works* soient en marge de l'œuvre, leur fonction n'est donc pas toujours marginale. On va essayer de le montrer sur quelques exemples particulièrement significatifs.

Les lignes qui suivent se proposent d'esquisser les grandes lignes d'une typologie. Elles ne visent pas l'exhaustivité. Le voudraient-elles qu'elles ne le pourraient pas, tant la production est multiforme. Leur ambition se borne à essayer de dégager quelques lignes de force majeures. Cet essai de typologie se fonde non pas sur des critères matériels (classement des documents par genres : cartes, affiches, *flyers,* etc.), mais sur des critères pour ainsi dire fonctionnels, concernant les différents manières dont les *ephemera works* prennent en charge le facteur du temps.

L'INVITATION [ANNOUNCEMENT] ET L'ŒUVRE

Du côté du complément accessoire, l'exemple le plus courant est fourni par les announcement cards, destinées d'ordinaire à inviter à une exposition en donnant tous les renseignements nécessaires. À partir des années 60, l'artiste en est souvent l'auteur : dans le contexte ambiant d'une revendication accrue de liberté dans tous les domaines, il cherche lui aussi à pouvoir contrôler la réception de son travail et notamment l'information diffusée sur son œuvre, depuis les cartons d'invitations et les affiches jusqu'aux catalogues. Ainsi, chaque carte devient, en plus d'un moyen d'information, une œuvre imprimée à l'occasion de l'exposition. La plupart du temps, il s'agit d'une simple carte, avec image au recto et informations pratiques au verso, mais c'est l'artiste lui-même qui en conçoit le contenu et le design.

James Lee Byars
THE EPITAPH OF CON.ART IS WHICH QUESTIONS HAVE DISAPPEARED? JAMES LEE BYARS. Wide White Space, Antwerp, Belgium. [Summer 1969]. Announcement in envelope.
REF NO. 92

James Lee Byars
WWS HAS BEEN RENAMED THE INSTITUTE FOR ADVANCED STUDY OF JAMES LEE BYARS. Wide White Space, Antwerp, Belgium. [April 18–May 7, 1969]. Star-shaped announcement card in envelope.
REF NO. 91

(a card cut in the shape of a star or a strip of wrinkled paper, for example), the announcement cards of James Lee Byars are probably the most easily identifiable examples of a document that is first of all a work. This is all the more so because these cards generally have no information on them about the exhibition, this being printed on the envelope, which is also conceived by the artist. Visually and conceptually, these announcement cards are thus an introduction to the work exhibited, and depending on the work itself, provide a little fragment of it or an enigmatic introduction to it.

Nearly all of the "bulletins" published by Art & Project in Amsterdam between 1968 and 1989 are in the format of a large sheet of paper folded in half along the vertical axis so that there are four pages; these are then folded in three horizontal sections so that the bulletin can be sent as a letter. On the first page, in addition to the number of the bulletin—thus presenting it as a kind of periodical—the name of the artist appears, and where appropriate, the dates of the exhibition. The three other pages are put at the artist's disposal so that he or she can create a work for the occasion and for the format. Several of the issues are particularly remarkable, such as No. 43, for which Sol LeWitt simply folded the white paper into squares; or No. 24, a nonproject by Daniel Buren, who decided that this issue would not have a material existence but would nevertheless be numbered in the series. The role of these bulletins thus goes beyond the straightforward announcement of an exhibition. They immediately suggest little movable works that travel by post or are taken away from the gallery by the visitor. In this way, art and information about art become one. They also make it possible for the artist to reach a much wider public than that of the gallery. But above all, the traditional relationship between publication and exhibition is reversed: following a strategy similar to that of the catalogs published by Seth Siegelaub (also as of 1968), the publication becomes more important than the exhibition and sometimes takes its place.

The distinction, then, between the occasional invitation and the occasional work is not always easy to make, particularly in the realm of conceptual art. A series of eight announcement cards (in fact, seven cards and one flyer) conceived by Robert Barry in 1972–1973 is a good example. Together they make up *Invitation Piece*, a circular path that took place over the course of one year, month to month and gallery to gallery, with each gallery announcing

Toutefois, un certain nombre de ces *announcement cards* présentent un intérêt exceptionnel. En raison de leur typographie particulière, à peine lisible, et de leur aspect souvent inhabituel (carton découpé en forme d'étoile ou bande de papier froissé par exemple), les *announcements* de James Lee Byars sont vraisemblablement l'exemple le plus immédiatement identifiable d'une information qui est d'abord une œuvre. Cela est d'autant plus manifeste que, généralement, ces cartons ne comportent aucune indication concernant l'exposition. Celles-ci sont imprimées sur l'enveloppe d'expédition, elle-même conçue par l'artiste. Ces *announcements* introduisent donc visuellement et conceptuellement au travail exposé dont ils semblent donner, selon les cas, un fragment détaché ou une introduction énigmatique.

Presque tous les "bulletins" édités par la galerie Art & Project à Amsterdam entre 1968 et 1989 se composent d'une grande feuille pliée en deux dans le sens de la hauteur pour former quatre pages, elles-mêmes pliables en trois dans l'autre sens pour pouvoir être expédiées comme une lettre. Sur la première page, en plus du numéro du bulletin qui le rapproche d'un périodique, figure le nom de l'artiste concerné, avec, s'il y a lieu, les dates de son exposition. Les trois autres pages sont mises à sa disposition pour qu'il réalise une œuvre conçue pour l'occasion et pour le format. Certains numéros sont particulièrement remarquables, tels le n° 43 où Sol LeWitt a simplement plié le papier blanc en carrés ou le n° 24, non-projet de Buren, qui a décidé que ce numéro n'aurait pas d'existence matérielle, mais qu'il compterait néanmoins dans la numérotation des bulletins. Leur rôle dépasse donc la simple annonce d'une exposition. Ils proposent directement des petites œuvres mobiles, qui voyagent par la poste ou sont emportées par le visiteur de la galerie. Par ce moyen, l'art et l'information sur l'art se confondent. Ils permettent à l'artiste d'atteindre un public bien plus large que celui de la galerie. Mais surtout, le lien traditionnel entre publication et exposition s'inverse : suivant une logique proche de celle des catalogues édités par Seth Siegelaub à partir de 1968 également, la publication devient plus importante que l'exposition et parfois elle en tient lieu.

La distinction entre l'invitation circonstancielle et l'œuvre circonstancielle n'est donc pas toujours facile à faire, en particulier dans le domaine de l'art conceptuel. Une série de huit cartons d'invitation (exactement 7 cartons et un *flyer*) conçus par Robert Barry en 1972-1973 en offre un

Art & Project/Sol LeWitt
bulletin 32. Sol LeWitt / Ten
thousand lines.
Six thousand two hundred and
fifty-five lines.
Art & Project, Amsterdam,
The Netherlands. [1971].
Artist's publication.
REF NO. 27

LEFT (from top)
Robert Barry
PAUL MAENZ, COLOGNE
INVITES YOU TO AN
EXHIBITION BY ROBERT BARRY
AT ART & PROJECT,
AMSTERDAM DURING THE
MONTH OF NOVEMBER 1972.
Paul Maenz, Cologne, Germany.
November 1972.
Announcement card.
REF NO. 43

Robert Barry
art & project invites you to an
exhibition by robert barry at jack
wendler gallery, london, during
the month of december 1972.
Art & Project, Amsterdam, The
Netherlands. December 1972.
Flyer.
REF NO. 44

Robert Barry
jack wendler gallery invites you to
an exhibition by robert barry at
leo castelli gallery, new york
during the month of january, 1973.
Jack Wendler Gallery, London,
England. January 1973.
Announcement card.
REF NO. 45

RIGHT (from top)
Robert Barry
LEO CASTELLI INVITES YOU
TO AN EXHIBITION BY
ROBERT BARRY AT YVON
LAMBERT/PARIS DURING THE
MONTH OF FEBRUARY 1973.
Leo Castelli, New York, N.Y.
February 1973.
Announcement card.
REF NO. 46

Robert Barry
Yvon Lambert invites you to an
exhibition by Robert Barry at
Galerie MTL Brussels during the
month of March 1973.
Yvon Lambert, [Paris, France].
March 1973.
Announcement card.
REF NO. 47

Robert Barry
galerie MTL invites you to an
exhibition by Robert Barry at
galleria Toselli, Milan during the
month of April 1973.
Galerie MTL, Brussels, Belgium.
April 1973.
Announcement card.
REF NO. 48

Robert Barry
Galerie Toselli invites you to an
exhibition by Robert Barry at
galleria Sperone, Turin during
the month of may 1973.
Galleria Toselli, Milan, Italy.
May 1973.
Announcement card.
REF NO. 49

Robert Barry
GIAN ENZO SPERONE INVITES
YOU TO AN EXHIBITION BY
ROBERT BARRY AT PAUL
MAENZ, COLOGNE, DURING
THE MONTH OF JUNE 1973.
Gian Enzo Sperone, Turin, Italy.
June 1973.
Announcement card.
REF NO. 50

PAUL MAENZ, COLOGNE INVITES YOU TO AN EXHIBITION BY ROBERT BARRY AT ART & PROJECT, AMSTERDAM DURING THE MONTH OF NOVEMBER 1972

art & project

adriaan van ravesteijn
geert van beijeren bergen en henegouwen

amsterdam 7
van breestraat 18
(020) 792835

drukwerk aan/
printed matter to

michael compton

london sw1 england
c/o tate gallery
millbank

art & project invites you to an exhibition
by robert barry at jack wendler gallery, london, during the month of december 1972

jack wendler gallery
invites you to an
exhibition by robert barry
at leo castelli gallery, new york
during the month of
january, 1973

A HAPPY CHRISTMAS
THE POST OF
LONDON
19 DEC
1972

AVALANCHE
93 GRAND ST
NY NY 10013
USA

jack wendler gallery,
164 north gower st.
london, nw1
tel. 01-387 7163

LEO CASTELLI INVITES YOU TO AN EXHIBITION BY
ROBERT BARRY AT **YVON LAMBERT/PARIS**
DURING THE MONTH OF FEBRUARY 1973.

Yvon Lambert invites you to an exhibition by Robert Barry
at Galerie MTL Brussels during the month of March 1973.

galerie MTL invites you to an
exhibition by Robert Barry
at galleria Toselli, Milan during
the month of April 1973

Galerie Toselli invites you to
an exhibition by Robert Barry
at galleria Sperone, Turin du-
ring the month of may 1973.

GIAN ENZO SPERONE
TORINO
C. S. MAURIZIO 27
TEL. 830220

GIAN ENZO SPERONE INVITES YOU
TO AN EXHIBITION BY ROBERT BARRY
AT PAUL MAENZ, COLOGNE, DURING
THE MONTH OF JUNE 1973

GIAN ENZO SPERONE ANNUNCIA
LA MOSTRA DI ROBERT BARRY
PRESSO PAUL MAENZ, COLONIA
DURANTE IL MESE DI GIUGNO 1973

"an exhibition by Robert Barry" to be held not in its own space but in the next one. According to the artist, "The piece describes a large geographical circuit (the itinerary that I normally take each year to make my exhibitions) and an artistic season, from October to June."[4] Artist's ephemera work? Autonomous conceptual work? Both. This piece is in the same vein as Barry's works on the invisible, which in 1969 led him to send announcement cards where it was stated that the gallery would be closed during the exhibition. One might think that such a series of cards was inviting one to a series of exhibitions which, in the logic of conceptual art, uses printed space as an alternative to the physical space of the gallery. The paradox is that, in order to do this, these invitations utilize the invisible network of contemporary art galleries, and by so doing, make it visible. The sequence of mailings made it clear that the participating galleries in Europe and the United States were not only offering gallery space, but that each gallery also became a link in the solidarity of the international organization that is the contemporary art market. In other words, the eight announcement cards together make up a fully fledged work that is both analytical and critical. In this context, the calendar of exhibitions announced—which in fact is vague because only the months are given—proposes no specific occasion but a formal structure: any series of sequential dates could be used to demonstrate this.

THE ANNOUNCEMENT, BEFORE AND AFTER

Thus we have touched on those necessary complements that are often ephemera works. It is no longer simply a question of announcing an exhibition: by using this announcement, a work is made to exist. Also belonging in this category are all the small printed materials such as flyers, posters, cards, and advertisements in newspapers and magazines which are all part of the preparation of a project. Among them we find invitations to Happenings, such as those of Allan Kaprow, to performances and other actions that could not succeed without the participation of the public invited by the artist and to whom a program, a score, or instructions are sometimes given. These invitations function like announcement cards for an exhibition, except that without them, the event could not take place: the announcement is not separate from the project and is an essential condition for its realization.

In recent art there have been real citywide publicity campaigns that have taken the place of mailings, common in

bon exemple. Ensemble, ils composent *Invitation Piece*, circuit en boucle d'une année, de mois en mois et de galerie en galerie, chacune invitant tour à tour à "an exhibition by Robert Barry", mais dans la galerie suivante. "La pièce décrit un large circuit géographique (l'itinéraire que j'emprunte habituellement chaque année pour faire mes expositions) et une saison artistique, d'octobre à juin."[3] *Artists' ephemera work* ? Oeuvre conceptuelle autonome ? Les deux. Cette pièce s'inscrit dans la suite des travaux de l'artiste sur l'invisible qui l'amenèrent, en 1969, à envoyer des cartons d'invitation sur lesquels on pouvait lire que la galerie serait fermée le temps de l'exposition. On peut donc penser que la série de cartes invite réellement à une suite d'expositions qui, suivant la logique de l'art conceptuel, proposent chaque fois un espace imprimé comme alternative à l'espace physique de la galerie. Le paradoxe est que, pour ce faire, ces invitations utilisent le réseau invisible des galeries d'art contemporain et que, par là-même, elles le rendent visible. Ainsi, l'envoi en chaîne, parfaitement réglé, des invitations matérialise-t-il le fait que les galeries ne proposent pas seulement à l'artiste des espaces d'exposition ici ou là en Europe et aux États-Unis, mais que chacune est le maillon d'une organisation internationale solidaire qui constitue le marché de l'art contemporain. Autrement dit, les huit cartons d'invitation forment aussi une œuvre à part entière, à la fois analytique et critique. Dans ce contexte, le calendrier des expositions annoncées, d'ailleurs imprécis puisque seuls les mois sont indiqués, n'est pas une circonstance déterminante, mais une structure formelle : n'importe quelle série de dates successives pourrait convenir pour la démonstration.

L'INVITATION ET LA TRACE [AU SENS DES DOCUMENTS QUI RESTENT D'UN ÉVÉNEMENT PASSÉ ET EN TÉMOIGNENT]

Ainsi est-on déjà passé du côté des compléments indispensables que sont souvent les *ephemera works*. Il ne s'agit plus alors seulement d'annoncer un événement ou une manifestation, mais, par cette annonce, de faire exister une œuvre. De cette catégorie relèvent aussi les documents, souvent moins exceptionnels que les précédents, que sont tous les petits imprimés tels que *flyers,* affiches, cartes, *advertisements* dans des revues et journaux, qui accompagnent la préparation d'un projet et sans lesquels le projet ne serait pas réalisable. Il en va ainsi des invitations à des *happenings,* ceux de Kaprow par exemple, et de toutes les petites publications qui

4. Robert Barry, *L'Art conceptuel, une perspective* (Paris: Musée d'Art Moderne de la Ville de Paris, 1989), p. 122.

3. Robert Barry, en *L'Art conceptuel, une perspective*. Catalogue d'exposition. Paris: Musée d'Art Moderne de la Ville de Paris, 1989, p. 122.

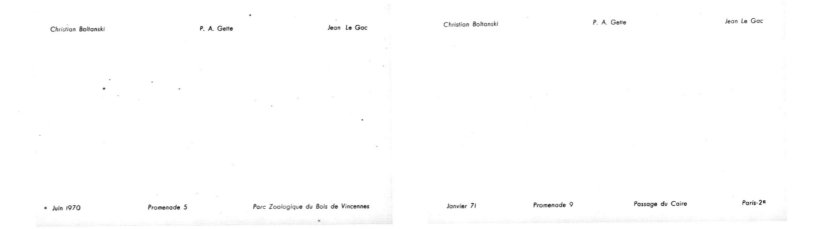

Christian Boltanski P. A. Gette Jean Le Gac Christian Boltanski P. A. Gette Jean Le Gac

Juin 1970 Promenade 5 Parc Zoologique du Bois de Vincennes Janvier 71 Promenade 9 Passage du Caire Paris-2ᴱ

LEFT
Christian Boltanski/Paul-Armand Gette/Jean Le Gac
Christian Boltanski. P. A. Gette. Jean Le Gac. Promenade 5. Parc Zoologique du Bois de Vincennes.
[Self-published]. June 1970. Announcement card.
REF NO. 67

RIGHT
Christian Boltanski/Paul-Armand Gette/Jean Le Gac
Christian Boltanski. P. A. Gette. Jean Le Gac. Promenade 9. Passage du Caire Paris-2ᴱ.
[Self-published]. January 1971. Announcement card.
REF NO. 69

the sixties and seventies, to a selected audience that was often limited to the art world. There have been posters stuck up on city billboards, or announcements published in major local daily newspapers which invite a public outside the art world to participate, for example, in lecture-demonstrations by Matthieu Laurette: we read that on such and such a date and in such and such a place the artist will explain "how to make refunded purchases" in department stores. In this case, posters and advertisements in newspapers or flyers are not only the means necessary for the realization of the work, but they are also the only documentation that records it. The announcement is at the same time the archive of the event.

When the action is private, it does not require any announcement or advertising in order to be realized. Only documents that record it are necessary. The artist no longer needs to invite anyone to an appointed place at an appointed time, but only to certify that the action took place, for without a publication it would remain known only to those who participated and would have no artistic existence. When actions are being documented, photographs or video recordings are invaluable. However, the objection to them is that they transform into images what was an experience, and into a permanent object what was of the moment. In contrast, the little cards announcing the walks taken by Christian Boltanski, Paul-Armand Gette, and Jean Le Gac in 1970 and 1971, which were sent after each walk to approximately one hundred addresses, say simply and vaguely that a "promenade" had taken place in such and such a

accompagnent des projets qui ne pourraient être menés à bien sans la participation d'un public à qui l'artiste fixe un rendez-vous et auquel il donne parfois un programme ou une partition [score]. Ces publications fonctionnent comme des cartons d'invitations à une exposition, sauf que, sans eux, l'événement ne pourrait pas du tout avoir lieu : l'annonce n'est pas séparable du projet dont elle constitue une condition essentielle.

Dans l'art récent, il arrive que de vraies campagnes de publicité à l'échelle d'une ville prennent la place des envois postaux ou de la diffusion restreinte des années 60-70, souvent limitée aux réseaux spécialisés. Il s'agit alors d'affiches collées sur les panneaux publicitaires urbains ou d'annonces publiées dans la grande presse quotidienne locale, qui font appel à un public extérieur au milieu de l'art pour participer, par exemple, aux conférences-démonstrations de Matthieu Laurette : ainsi apprend-on qu'à telle date et dans telle salle, l'artiste expliquera "comment faire ses achats remboursés" dans les grandes surfaces. Dans son cas, affiches, publicités *[advertisements]* dans les journaux ou *flyers* sont non seulement des moyens nécessaires à la réalisation de l'œuvre, mais aussi la seule documentation qui en témoignera. L'invitation est donc en même temps l'archive de l'événement.

Quand l'action est privée, elle n'exige pas de publicité pour être réalisée et l'annoncer est inutile. Seuls sont nécessaires des documents pour que l'action soit reconnue après coup. L'artiste n'est plus alors dans la situation d'inviter à un rendez-

month and to such and such a place, and that it carries a number in the series. By announcing the action, these little cards make it public after the fact, the recipients having not been invited to it. The cards play the role of a certificate or a registration.

Similar to Laurette's publicity flyers, these cards/certificates reveal the conceptual significance of an art that cannot be separated from information, whether the latter is prior to or follows the action. In both, the documents are the only visible form of the event or the action, and as a result, the only possible form of the exhibition of the work. We could then properly call them primary documents.

THE ANNOUNCEMENT AND THE RELIC

Different from the document of a past action which proves after the fact that it once took place and which retains, abstractly but absolutely, its memory, the relic is a material vestige that remains from what once existed but has now disappeared. It is a real part of what was. That is why it is a concrete but fragile memory. In this category belong the remains of actions, such as, for example, bits of paper used by Byars during certain performances, or stickers reading "Caution Art Corrupts," which Jochen Gerz stuck in public places in 1968, especially in Florence and in Basel, at the time of his first street actions. In this same category also belong the remains of environments as, for example, all the small printed material added by Martine Aballéa to her sets to enliven the atmosphere, which visitors could take away: publicity cards, beverage coasters, notepads, coupons, stationery, and so on.

It is worth discussing in a bit more detail a case that is more complex—that of an ephemera work that brings

CAUTION ART CORRUPTS

vous, mais de certifier la réalité d'une action qui, sans la publication, resterait connue de ses seuls participants et n'aurait aucune existence artistique. Quand il s'agit de documenter des actions, photo ou vidéo sont irremplaçables. Mais ils ont l'inconvénient de transformer en images ce qui fut une expérience et de donner la permanence d'un objet à ce qui fut ponctuel. Au contraire, les petites cartes signalant les promenades faites à trois par Boltanski, Le Gac et Gette en 1970-1971, et qui furent envoyées après chaque promenade à une centaine de destinataires, disent simplement qu'une promenade a eu lieu, tel mois et à tel endroit et qu'elle porte tel numéro dans la série. En faisant part de l'action, elles en rendent publique l'existence, mais sans l'illustrer. Elles jouent le rôle d'un certificat ou d'une déclaration [registration ?].

Comme pour les tracts publicitaires de Laurette, ces cartes-certificats mettent en évidence la signification conceptuelle d'un art inséparable de l'information, que celle-ci soit antérieure (annonce) ou postérieure (registration) à l'action. Dans les deux cas, les documents constituent de toutes façons la seule forme visible de l'événement ou de l'action et, par conséquent, la seule forme possible de l'exposition de l'œuvre. On pourra alors à bon droit les nommer documents premiers [primary documents].

L'INVITATION ET LE VESTIGE [VESTIGE ? AU SENS DE RELIC]

A la différence du document d'une action passée qui atteste a posteriori son existence et en garde abstraitement mais durablement la mémoire, le vestige est un reste [relic] matériel laissé derrière lui par ce qui a disparu. Il est une partie réelle de ce qui a existé. C'est pourquoi il en est un souvenir concret [par opposition à abstrait] mais fragile. À cette catégorie appartiennent les reliques d'actions, par exemple les morceaux de papier variés utilisés par Byars lors de certaines performances ou les étiquettes "Caution Art Corrupts", collées par Gerz en 1968 dans des lieux publics, notamment à Florence et à Bâle, pour ce qui fut sa première action dans la rue. À la même catégorie appartiennent aussi les restes d'environnements, comme par exemple les éléments imprimés ajoutés par Martine Aballéa à ses décors pour en renforcer l'atmosphère et que les visiteurs peuvent emporter : carte publicitaire, *beverage coaster, notepad, coupon* [sic en anglais], *stationery,* etc.

On voudrait évoquer plus longuement un cas moins simple, celui d'un *ephemera work* qui réunit à la fois l'invi-

Jochen Gerz
CAUTION ART CORRUPTS.
[Self-published]. [1968].
Label.
REF NO. 179

TOP
Daniel Buren
BUREN.
Wide White Space Gallery,
Antwerp, Belgium.
January 17–February 6, 1969.
Poster.
REF NO. 85

MIDDLE LEFT
Daniel Buren
BUREN.
Wide White Space
Gallery, Antwerp, Belgium.
May 12–June 5, 1971.
Poster.
REF NO. 86

MIDDLE RIGHT
Daniel Buren
BUREN.
Wide White Space Gallery,
Antwerp, Belgium.
June 2–15, 1972.
Poster.
REF NO. 87

BOTTOM LEFT
Daniel Buren
BUREN.
Wide White Space Gallery,
Antwerp, Belgium.
Opening June 22, 1973.
Poster.
REF NO. 88

BOTTOM RIGHT
Daniel Buren
BUREN.
Wide White Space Gallery,
Antwerp, Belgium.
[April 23–June, 1974].
Poster.
REF NO. 89

together both the announcement and the relic: the series of announcement posters by Daniel Buren for his five exhibitions at the gallery Wide Wide Space in Antwerp from 1969 onwards. The posters were printed on both sides—one side with striped bands of color and the other with the practical information about the exhibition. They were folded into the format of a large envelope. From one exhibition to another, the only changes were, other than the obvious correction of dates, the color of the stripes, the choice of which the artist left to the gallery owner, Anny De Decker. But the most interesting point is that Buren used the announcement poster as the element of construction of his work *in situ*: he glued the posters edge to edge inside and outside the gallery, each time in the same place, in a row at the bottom of the walls. The information on the work as announced became the primary material of the work itself. The announcement poster is thus the key element of the exhibition from three points of view: that of the material, that of the form, and that of the significance of the work exhibited. As a result, the sequence of five exhibitions appears in retrospect as so many variations generated by the original announcement poster. Each one can be considered not only as a fragment of the work or of the exhibition, but also as its basic module. Reversing the normal functions of the invitation as secondary to the exhibition and of the exhibition as secondary to the work, here the invitation is primary: it makes possible both the work and the exhibition. But once the work *in situ* is taken down, the invitation then becomes its last relic.

Whether it is an accessory or a necessary complement, whether it is a secondary or primary document, whether it comes before or after or is part of something that occurs on a given date, the ephemera work takes up a challenge: to archive the ephemeral, and in so doing to inscribe the moment in duration. It doesn't prevent what is temporary from disappearing, but it does prevent it from disappearing from memory. Just as the meaning of the word "monument" was understood in the Renaissance to be a written document, so the ephemera work can be said to be a fragile monument that retains and transmits what takes place only once.

WORKS FOR OCCASIONS

As we have seen, ephemera works depend on works made for an occasion which they announce or record or of which they are a relic. However, they may also be sufficient unto they are a relic. However, they may also be sufficient unto

tation et le vestige. Il s'agit de la série des *announcement posters* de Buren pour ses cinq expositions à la galerie Wide Wide Space, à Anvers, à partir de 1969 : imprimé sur les deux faces, le poster montrait d'un côté des bandes rayées et de l'autre il comportait les indications pratiques concernant l'exposition. Le tout était plié au format d'une grande enveloppe. D'une exposition à l'autre, les seuls changements furent, en dehors de la correction visible des dates, la couleur des bandes, dont le choix fut abandonné par l'artiste à la galeriste, Anny De Decker. Mais le point le plus intéressant est que Buren utilisa l'affiche d'invitation comme élément de construction d'une œuvre *in situ* : il colla bord à bord les affiches dans l'espace de la galerie et chaque fois différemment. L'information sur le travail annoncé devenait la matière première du travail lui-même. L'invitation se révélait être l'élément clef de l'exposition, du triple point de vue du matériau, de la forme et de la signification de l'œuvre exposée. Par conséquent, les expositions successives peuvent apparaître rétrospectivement comme autant de variations engendrées par l'*announcement poster* initial. Chaque invitation envoyée peut en effet être interprétée non pas seulement comme un fragment de l'œuvre ou de l'exposition, mais comme son module de base. L'invitation devient ainsi la condition de l'exposition. Renversant les rapports usuels de subordination de l'invitation à l'exposition, et de l'exposition à l'œuvre, l'invitation est première, condition de possibilité de l'œuvre et de l'exposition à la fois. Mais une fois l'œuvre *in situ* détruite, l'invitation se transforme aussi en vestige ultime.

Qu'il soit un complément accessoire ou indispensable, qu'il soit un document secondaire ou primaire, qu'il précède, qu'il suive [au sens de venir après] ou qu'il participe [dans le sens d'être une partie de qch] de ce qui a lieu à telle date, l'*ephemera work* relève le défi de pérenniser l'éphémère, de l'inscrire dans la durée. Il n'empêche pas ce qui est passager de passer, mais il l'empêche de disparaître de la mémoire. Dans la mesure où, selon le sens premier du mot, celui qui prévalut à la Renaissance, un monument est un document écrit, l'*ephemera work* est un monument fragile qui, même quand il l'annonce comme à venir, conserve et transmet ce qui a lieu une seule fois.

L'ŒUVRE DE CIRCONSTANCE

Comme on vient de le voir, les *ephemera works* dépendent d'une œuvre circonstancielle qu'ils annoncent, qu'ils enregistrent ou dont ils sont un vestige. Toutefois, il arrive qu'ils

themselves. Then they are independent works, but their existence, that is, their publication, either depends on a precise day or is rooted in the present. This present is, by definition, imposed. Yet it happens that the present can be invented. It also happens that it can be denounced.

In this category of works for occasions belong greeting cards, discussed at the beginning of this essay, as well as works that celebrate a particular event. For example, the commemorative stamp designed in 1972 by Joyce Wieland for World Health Day does not distinguish itself from the many commemorative stamps published regularly by the post office, except for the fact that it was commissioned from an artist.

There are, however, examples that are more exceptional, such as the publication by Yves Klein dated Sunday, 27 November 1960, or the advertisements by Stephen Kaltenbach published in the advertising section of twelve issues of *Artforum* in 1968 and 1969. In Klein's publication the layout of the four pages was based on a tabloid newspaper. All of the articles were written by the artist and related to his works, which made it a kind of manifesto. On the first page was reproduced the famous photograph of Klein jumping into the void. This single issue was actually sold at newstands on the 27th of November, and it was the artist's work for the Avant-Garde Festival of Paris (November to December 1960).

On the contrary, the Kaltenbach ads are statements that stand on their own: "Art Works," "Tell a Lie," "Teach Art," and so on. The ads had a short life and were soon out of date because they changed each month with each new issue of the art journal. Unlike Yves Klein's publication, they are not related to any external event, but only make sense within the precise context in which they are published: the advertising pages of an art journal. Placed at the crossroads of art and advertising, Kaltenbach's ads force us to question the possible relationship between an art journal and advertising methods: are not both of them intrinsically part of today's world and similarly involved in the promotion of selected objects?

Although they are rare, there are works for occasions where the occasion itself is invented. We can cite the amazing case of seven posters conceived by Henri Chopin and Gianni Bertini in 1967 announcing various evening events at a fictive Festival de Fort-Boyard to be devoted to avant-

se suffisent à eux-mêmes. Ils sont alors une œuvre autonome, mais dont l'existence, c'est-à-dire la publication, soit dépend d'un jour précis, soit s'inscrit dans l'actualité. L'actualité est, par définition, imposée. Pourtant il arrive qu'elle soit inventée. Il arrive aussi qu'elle soit dénoncée.

À la catégorie des œuvres de circonstance appartiennent les cartes de vœux déjà évoquées en commençant, mais aussi les œuvres qui célèbrent un événement particulier : par exemple, un timbre commémoratif comme celui réalisé par Joyce Wieland pour the World Health Day et qui ne se distingue pas des nombreux timbres commémoratifs régulièrement édités par la poste, si ce n'est qu'il a été commandé à une artiste.

Il est cependant des exemples moins banals, comme le journal d'Yves Klein daté du dimanche 27 novembre 1960 ou les advertisements de Stephen Kaltenbach, publiés dans les pages publicitaires de douze numéros d'*Artforum* en 1968-1969. Dans le journal de Klein, mis en page sur le modèle d'un quotidien illustré de quatre pages, tous les articles sont de l'artiste et portent sur ses œuvres, ce qui en fait une sorte de manifeste. Sur la première page figure notamment la photographie légendaire de son saut dans le vide. Le numéro unique de ce journal fut réellement vendu dans les kiosques le 27 novembre en tant que participation de l'artiste au Festival d'avant-garde de Paris (novembre-décembre 1960).

Les Kaltenbach's *ads* sont des statements autonomes ("Art Works", "Tell a lie", "Teach Art", etc.). Leur validité est brève puisqu'ils changent chaque mois avec chaque nouveau numéro de la revue. À la différence du journal d'Yves Klein, ils ne prennent pas sens par rapport à quelque circonstance extérieure, mais à l'intérieur du contexte précis où ils sont publiés : les pages publicitaires d'une revue d'art. Situés eux-mêmes au croisement de l'art et de la publicité, les Kaltenbach's *ads* amènent à s'interroger sur une possible parenté entre la revue d'art et la publicité : l'une et l'autre ne sont-elles pas étroitement liées à l'actualité et engagées, de la même manière, dans la promotion de certains objets contemporains ?

Mais il est des œuvres de circonstance, rares il est vrai, dont l'actualité est inventée. On peut citer le cas étonnant de sept affiches conçues par Henri Chopin et Gianni Bertini en 1967 pour annoncer les différentes soirées d'un prétendu Festival de Fort-Boyard, consacré aux avant-gardes poétiques. Ces

Joyce Wieland
WORLD HEALTH DAY. Canada 8.
Canada Post Office, Canada.
1972.
Artist's stamp on envelope.
REF NO. 485

which, once reached, will somehow mark it as a success or justify its struggle. But art doesn't work that way; it knows only where it has been and, in its most conscious moments, where it is in its present. Hence, art history can describe how an artist has evolved *from* one situation into another. To suggest that he is evolving *toward* the future, however, is to deny the human limits of both art and art history.

The assumption that art evolves toward the future is, I think, the most serious methodological flaw in Arnason's book. The others are more annoying than misleading or distortive. For instance, the study depends heavily on the concept of one artist influencing another: "Pollock departed from the tradition of Renaissance and modern painting before him and, although he had no direct stylistic followers, he affected the course of experimental painting after him." And so forth. This kind of statement occurs throughout the text, but it never comes to mean anything. Certain paintings are said to "recall" other paintings or to be "reminiscent" of them, but the encounter that takes place when one artist looks at the work of another is never investigated with any precision, nor with any thought about how this encounter has changed in modern as opposed to pre-modern art. Likewise, Arnason fails to investigate how the concept of "style" as a methodological tool has changed in the case of modern art.

Nor is there any effort in Arnason's book to make sense out of artistic quality. Like so many art history texts, this one implies that quality somehow results: that is, when an artist does enough things in one picture—like bringing together Cubism and Surrealism, abstraction and primitivism, or creating a new kind of space, a new awareness of his medium, and so on. In other words, quality emerges as an effect of art historical description rather than its stimulus. After all, the union of Cubism and Surrealism does not make a picture good; it matters for art history only because it is contained in good pictures. But Arnason never examines this aspect of the discipline; thus, his book can only help to prolong the confusion regarding how art history is "objective."

AN INDEPENDENT PROFESSIONAL ART SCHOOL IN HIGHER EDUCATION.

Fine Arts
Advertising
Arts
Photography
Film
Humanities

SVA

209 EAST 23RD STREET, NEW YORK, N.Y. 10010.

winn galleries
austin, texas

talmage MINTER

robert ECKER

OCTOBER 3 — 23

Smoke

Talmage Minter, "Quarry Sills" Acrylic Lacquer, 1968.

Indeed, this is perhaps the crux of the matter, for this is not Pop art, but an extremely sophisticated, self-consciously cultivated pseudo-Primitivism contrived by a very gifted amateur possessed of broad art-historical and theoretical awarenesses and acute, sometimes brilliant, technical comprehensions, who has much to say about both Primitivism and Pop art, and who has, as well, a genuine involvement with his pictorial subject matter. [Mr. Fiscus, who began painting in 1967, is an admitted self-taught novice and avocational amateur in art, with the difference that he is professionally a Humanities teacher, who has been for some years on the faculty of a major art school —the San Francisco Art Institute.]

Fiscus is a native Californian with strong feelings for the grandeur and variety of Western landscape and Pacific Coast seascape, both of which he explores with intimate familiarity in a number of series, each devoted to the terrain traversed by some well-known scenic highway, the road map designation of which captions the series. Hence, while Fiscus may whimsically indulge in an occasional syntactical hyperbole, as an aside in the contemporary tongue-in-cheek vein of art-that-comments-on-art, his total concept is far from merely the extravagant put-on it might appear to be at a casual glance. For he clearly regards seriously the challenge of making the devices unique to his pseudo-Primitive schematization communicate some of his responses to these panoramas. Thus, his considerable self-developed insights and resources

Gallery Reese Palley.

THOMAS STOKES
Sept 15 — Oct 4
THEORA HAMBLETT
Sept 15 — Oct 4
POUSETTE-DART
Oct 7 — Nov 1

BETTY PARSONS GALLERY

Teach Art

ADDRESS CHANGES

Subscribers can assure the speedy and accurate recording of new addresses by following these directions:
1. Report your address change to:
Circulation Department
ARTFORUM
P.O. Box 664
Des Moines, Iowa 50303
2. Include both your old address and zip-code number and your new address and zip-code number.
3. Be sure zip-code numbers are correct.
Address changes received before the 15th of the month can usually be recorded in time for the next issue to be delivered to the new address.

Aaronel Gruber
september 16–october 8

BERTHA SCHAEFER 41 EAST 57 STREET

Mel Ramos, *Leta and the White Pelican*, o/c, 60x52", 1969. David Stuart Galleries.

ings, cutely conceals the pubic regions), and bits of print shop embellishment—metallic surfaces, embossing, etc. I found the lithographs unsatisfactory, looking on first glance like record album covers and on second glance like superbly designed institutional advertisements (e.g., Union Carbide making a point about air pollution). But the lithographs suffer not from concept, but merely from being commercial on a pedestrian level; Ramos, however, believes in the paintings, and it is with them we must decide why, in spite of all those compartments of desirability, they seem so soul-less, even ingested tongue-in-cheek. I think it is because, indicating the borders on either side, they are not as bravely crummy as Warhol's silk-screen paintings and not as really whimsical as Ed Ruscha's gunpowder drawings.

TOM HOLLAND's eight new paintings (plus one in the office) called the "Malibu Series" are made from sheets of translucent plastic, liberally and loosely painted with predominantly white, black, or an overall mix like

earlier work but, if there is an intended connection in "funk" between the airplanes and telescopes and waterfalls of yesterday, and the loosely carpentered, riveted, bolted and punctured sheets of plastic, it fails—all to the better. The incantations of Cubist formalism are too strong, the drip is too elegant, and the color compromise too knowledgeable (too little chroma and we'd have patinated sculpture, too much and it would destroy the multi-surface readings) for Holland to pretend to any kind of primitivism. He's best in the basket-weave pictures when he stays closest to painting, and forces the reading on those terms, although the moebius-band pictures do usefully contain an old-fashioned figure-ground ambiguity. Perhaps one last thing ought to be noted: there is a slight feeling of stylish eclecticism, i.e., a programmed emulsion of the "right" non-art materials and a timely revival of Abstract Expressionism. There are vague reports aplenty in Los Angeles of other name artists "using" Abstract Expressionism in new work in progress, similar to Lichtenstein's *faux naif* employment of Thirties Moderne.

—PETER PLAGENS

HAIGH SHOWS OUTRAGEOUS PAINTINGS AT THE BERKELEY GALLERY SAN FRANCISCO DECEMBER 2 - 20

Paintings Drawings Graphics
GALLERY ARTISTS
M SACHS 29 W 57

You are me.

BRUCE TIPPETT
Sculpture
GREGORY MASUROVSKY
Drawings
December 2 — 20
CLEVE GRAY
Paintings & Painted Forms
January 6 — 24

BETTY PARSONS GALLERY

garde poetry. These posters were stuck up at night near places committed to contemporary art, in particular the Museum of Modern Art of the City of Paris (Musée d'Art Moderne de la Ville de Paris). They announced the program for each evening of the festival, to be held during the month of June, and people were invited to come to the fortress of Fort-Boyard, an old prison situated on an island off the French Atlantic coast, to listen to or watch works by Ian Hamilton Finlay, Julien Blaine, Brion Gysin, Gil Wolman, François Dufrêne, Mimmo Rotella, among others. For the two artists, this festival would take place only on posters, but there were some who made the trip! This work was not only a joke, but a homage to the power of the imagination and to the independence of art in relation to reality. Some time later, in a collective booklet in which the posters were reproduced and the story recounted, Chopin concluded with the claim that a year before May 1968, the organizers had already put imagination into power: "We were not post- or pre-revolutionaries, not even revolutionaries, but living beings who placed creation in non-creation above all else. . . ."[5] The event was thus not a festival but a series of posters with an imagined program apparently written into the calendar, but in fact totally independent of its constraints and even beyond the possibility of failure. These announcement posters give the lie to common sense, which expects works for occasions to be regulated by the principle of reality even more than other works.

At the extreme opposite, that of an actual engagement in real situations, we must make room for a last category, one that is rich in examples of works that react to the burning issues of the day in the form of protest and indignation. These are committed publications in the tradition of lampooning pamphlets from the eighteenth century or of agitprop in the twentieth century. These ephemera works are weapons in a war against certain aspects of the contemporary art world, or simply of the modern world itself. The tone is often that of irony or of anger. There is no shortage of examples: derisive open letters by Marcel Broodthaers; anonymous postcards by Le Gac, poking fun in recent years at several bizarre tactics in the functioning of contemporary art in France; *cartes de circonstance* ("occasional cards") sent by Ernest T., of which a large part of the printed production is openly polemical, in particular the periodical *Cloaca maxima*, named after the sewers of ancient Rome, which is printed on yellow onionskin as flyers and self-published irregularly between 1985 and 1988; the militant posters of the Guerrilla Girls against

affiches furent collées de nuit, aux abords des lieux dévolus à l'art contemporain, notamment le Musée d'art moderne de la ville de Paris. Elles comportaient le programme de chacune des soirées du festival, au cours du mois de juin, et invitaient à se rendre à la forteresse de Fort-Boyard, ancien bagne situé sur un île des côtes françaises de l'Atlantique, pour écouter ou regarder les œuvres de Finlay, Blaine, Gysin, Wolman, Dufrêne, Rotella, entre autres. Mais les deux artistes avaient prévu que ce festival n'aurait d'existence que sur l'affiche. Il y en eut pourtant qui firent le voyage ! Ce n'était pas seulement un canular, mais un hommage au pouvoir de l'imagination et à l'indépendance de l'art à l'égard de la réalité. Un peu plus tard, dans un fascicule collectif qui reproduisait les affiches et en racontait l'histoire, Chopin conclut qu'un an avant mai 68, les organisateurs avaient déjà mis l'imagination au pouvoir : "Nous n'étions pas des post- ou pré-révolutionnaires, ni des révolutionnaires, mais des vivants qui plaçaient au-dessus de tout la création dans la non-création [...]".[4] L'événement ne fut donc pas le festival, mais la série des affiches et leur programme idéal, apparemment inscrit dans le calendrier, mais en réalité totalement indépendant de ses contraintes et à l'abri de ses risques, dont celui de l'échec. Ces *announcement posters* apportaient un gai démenti au bon sens qui voudrait que les œuvres de circonstance soient plus que les autres régies par le principe de réalité.

A l'extrême opposé, celui d'un engagement effectif dans la réalité, il faut faire une place à une dernière catégorie, abondante, qui concerne des œuvres qui réagissent à chaud à l'actualité, sur le mode de la protestation et de l'indignation. Ce sont des publications engagées, dans la tradition des libelles de la littérature pamphlétaire [au sens français !] du XVIIIe siècle ou de l'agit-prop du XXe siècle. Les *ephemera works* y sont des armes dans un combat contre certaines réalités du monde de l'art contemporain ou du monde contemporain tout court. Le ton y est souvent celui de l'ironie ou de la colère. Les exemples ne manquent pas : lettres ouvertes persifleuses de Marcel Broodthaers ; cartes postales anonymes de Le Gac raillant certaines bizarreries récentes dans le fonctionnement de l'art contemporain en France ; "cartes de circonstance" envoyées par Ernest T., dont une bonne partie de la production imprimée est ouvertement polémique, notamment les feuilles de papier pelure jaune de la publication à parution irrégulière (1985-1988) *Cloaca maxima*, ainsi nommée du nom des égouts de la Rome antique ; posters militants des Guerrilla Girls contre le sexisme dans l'art ; papier à lettres de Finlay, avec

5. *Festival de Fort-Boyard 1967* (Turin, Italy: Punto, 1970), unpaginated.

4. Festival de *Fort-Boyard 1967*. Turin: Punto, 1970, non paginé.

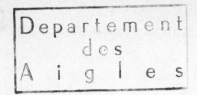

Paris, le 29 novembre 1968.

Chers Amis,

Mes caisses sont vides. Nous sommes au bord du gouffre.
Preuve: Quand je n'y suis pas, il n'y a personne. Alors?
Assumer plus longtemps mes fonctions? Le système des musées
serait-il aussi compromis que celui des galeries? Cependant,
notez que le Département des Aigles est encore indemne bien
que l'on s'efforce à le détruire.

Chers amis, mes caisses sont superbes; ici un peintre
célèbre, là un sculpteur connu, plus loin une inscription qui
fait prévoir l'avenir de l'Art. Vive l'histoire d'Ingres!
Ce cri résonne au fond de ma conscience. Cri de guerre. Je suis
en péril. Je renonce à vous donner des explications qui
m'exposent à un péril supplémentaire

P o è m e

Je suis le directeur. Je m'en fous. Question ?
Pourquoi le faites-vous ?

P o l i t i q u e

Le département des aigles du musée d'art moderne, section XIXe
siècle, a été effectivement inauguré le 27 septembre 1968 en
présence de personnalités du monde civil et militaire. Les
discours ont eu pour objet le destin de l'Art.(Grandville). Les
discours ont eu pour objet le destin de l'Art.(Ingres). Les
discours ont eu pour objet le rapport entre la violence institu-
tionalisée et la violence poétique.

Je ne veux, ni ne peux vous exposer les détails, les soupirs,
les étoiles, les calculs de cette discussion inaugurale. Je le
regrette.

I n f o r m a t i o n

Grâce au concours d'une firme de transport et de quelques amis,
nous avons pu composer ce département qui comprend en ordre
principal: 1/ des caisses
 2/ des cartes postales "surévaluées"
 3/ une projection continue d'images (à suivre)
 4/ un personnel dévoué.

Chers amis, je suis désolé du trop long silence dans lequel je
vous ai laissés depuis mes lettres datées de
Je dois, pour l'instant, vous quitter.Vite, un mot d'affection,

 votre Marcel Broodthaers.

P.S.Mon ordre, ici, dans l'une des villes de Duchamp est peuplé
de poires; on en revient à Grandville.
Correspondance: Musée d'Art Moderne, Département des Aigles,
 30 rue de la Pépinière,Bruxelles 1. Tél.02/12.09.54

BONNE NUITS PETITS

MANET ET PICASSO !

LES ATHLÈTES DE LA PENSÉE :

plus forts que le penseur de Rodin sur son chiotte, on annonce toutes veines temporales dilatées, les "dix ans* de réflexion" d'Alfred et Bernard au Centre G. Pompidou.

* on ne sait pas si leurs nuits sont décomptées.

sexism in art; Finlay's letterhead on which he had printed various scathing quotations taken from eighteenth-century French revolutionaries in support of his battle against the regional Strathclyde officialdom and police assault on his garden in Scotland, which he called Little Sparta for the occasion; also by Finlay, the countless cards and booklets inspired by the French Revolution and directed against those in the Paris art world who intrigued against him at the time he had received an official commission for a garden to celebrate the bicentenary of the Revolution of 1789; the first tract by Roberto Martinez and Antonio Gallego published in reaction to the war in Yugoslavia in 1993 (*Tombola Paris-Sarajevo*); and so on.

The pressure of events is sometimes such that it can temporarily transform an artist's magazine into an ephemera work. This is the case with *Eter*, edited by Paul-Armand Gette, which contained contributions from various artists and appeared irregularly two or three times a year, but that changed radically in May 1968 in order to intervene rapidly and effectively during a tumultuous time of political and social upheaval. The publication took the title *Eter contestation*, and it was printed on heavy card stock as a single sheet folded in half. Created collectively by Gette, Jean Degottex, Claude Bellegarde, and Iannis Xenakis, the three issues appeared in quick succession on May 30, June 3, and June 18. "No" is the *mot d'ordre* branded across the inside double-page spread of the first issue, which carried a list of everything that should be rejected in contemporary society, to which the second issue supplies this slogan as

citations virulentes en réponse aux divers épisodes de la bataille dite de Little Sparta qui l'opposa administrativement mais aussi physiquement à la Strathclyde Region ; ou bien encore, de Finlay toujours, d'innombrables cartes et brochures inspirées par la Révolution française et dirigées contre ceux du milieu de l'art parisien qui montèrent une cabale contre lui à l'occasion d'une commande officielle qui lui avait été faite d'un jardin pour le bicentenaire de la Révolution de 1789 ; premier tract de Roberto Martinez et Antonio Gallego en réaction à la guerre de Yougoslavie en 1993 (*Tombola Paris-Sarajevo*), etc.

Sous la pression de l'actualité, un magazine d'artiste peut se métamorphoser provisoirement en *ephemera work* afin d'intervenir plus vite et plus fort. C'est ainsi que la revue éditée par Paul-Armand Gette, *Eter*, qui rassemblait des contributions d'artistes variés et paraissait à intervalles très espacés, changea complètement en mai 1968. Elle prit le titre de *Eter contestation*, passa de l'assembling à une simple planche pliée en deux, réalisée collectivement par Gette, Degottex, Bellegarde et Xenakis, et parut trois fois de suite les 30 mai, 3 et 18 juin. "Non" est le mot d'ordre qui barre en grand la double page intérieure du premier numéro qui comporte la liste de tout ce qu'il faut refuser dans la société contemporaine ; à quoi répond, dans le deuxième, le slogan : "Oui créez la révolution continue". Le troisième contient une affiche pliée, imprimée en rouge et dont le texte fait précisément référence aux grèves, manifestations, affrontements avec la police, etc. Chacun des numéros fut déposé en plusieurs endroits, à la dispo-

a response: "*Oui créez la révolution continue*" ("Yes create the continuous revolution"). The third issue contained a folded poster with text printed in big red block letters about strikes, demonstrations, confrontations with the police, etc. Although printed in runs of only one hundred copies, each of the issues was left in several places for anyone to take. For a few days the magazine became a kind of political tract.

These weapons are of course paper weapons, but for this very reason they can be printed and circulated quickly. Most of them are self-published, inexpensive in terms of time and money, intentionally unassuming, and unintentionally clandestine. Because they are meant to respond to the urgency of a situation, they last only for the time it takes to hand them out or send them.

Generally, we can say in conclusion that ephemera works have something that is intrinsically provocative as regards the common practices of art insofar as they claim to be in the here and now. Thus, their lack of pretense to timelessness. In their essence they are the most "contemporary" of the art we call contemporary, for they are absolutely *in time* and *of their time*. That is why they retain, perhaps more than other works, the most radical of what contemporary art has brought to the history of the visual arts: a relation to work that is no longer contemplation but reading.

Translated from the French by Patricia Railing.

sition de qui voulait. La revue était devenue pour quelques jours une sorte de tract politique.

Certes, ces armes sont des armes de papier mais, pour cette raison même, elles peuvent être réalisées et mises en circulation sans retard. La plupart sont des productions légères, autoéditées, volontairement discrètes, souvent clandestines malgré elles. Faites pour répondre à l'urgence d'une situation, elles existent le temps d'une distribution ou d'un envoi.

Plus généralement, l'on peut dire pour conclure que les *ephemera works* ont ceci d'intrinsèquement provocant au regard des usages de l'art qu'ils revendiquent leur enracinement dans l'ici et le maintenant. D'où leur absence de prétention à la pérennité. Ils sont par essence ce qu'il y a de plus "contemporain" dans l'art dit contemporain : ils sont absolument dans le temps et dans leur temps. Ce faisant, peut-être préservent-ils, plus que d'autres productions, ce que l'art contemporain a introduit de plus radical dans l'histoire des arts visuels : un rapport aux œuvres qui n'est pas de contemplation mais de lecture.

SPECIMEN

No 0

ETER 1992

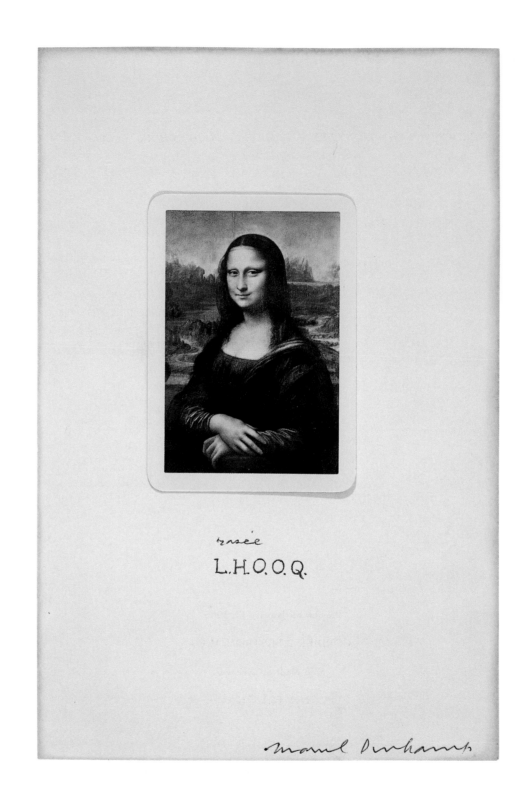

Marcel Duchamp
[L.H.O.O.Q Shaved].
Cordier and Ekstrom
Gallery, New York, N.Y.
January 13, 1965.
Announcement card.
REF NO. 128

E•phem•er•a *n., pl.* **–as** or **–erae**. **1**. Something short-lived or transitory. **2**. *Plural.* Printed matter of current and passing interest, such as periodicals, handbills, and topical pamphlets. (From the plural of EPHEMERON.)[1]

Steven Leiber
& Todd Alden

EXTRA ART: SURVEYING *ARTISTS' EPHEMERA*, 1960–1999

Extra Art: A Survey of Artists' Ephemera, 1960–1999 introduces a previously unexamined history of *artists' ephemera*, which is to say, ephemera conceived and/or created by artists which is generally intended to be useful for a short period of time; this category includes exhibition invitation cards, performance invitation cards, posters, postcards, magazine and newspaper advertisements, flyers, brochures, stickers, labels, buttons, business cards, printed performance materials, and other miscellany, all of which are freely or inexpensively distributed.[2]

This exhibition isolates artists' ephemera as a distinctive, specific class of art ephemera. Of all art ephemera created during the last forty years, fewer than one percent is within the purview of our inquiry; the vast majority is otherwise conceived and/or designed by someone other than the specific artist.

Like other ephemera, most artists' ephemera functions in a supplementary relationship to art-related events or to art itself; in certain instances, however, this shifting supplementary character situates ephemera not simply in an external relationship to art, but also ambivalently as an integral component of art itself. By announcing exhibitions, registering performances, etc., and typically, but not always, distributed through the mail, artists' ephemera generally occupies the margins of art rather than art's primary spaces (e.g., galleries and museums). When created and/or conceived purposively by artists, however, ephemera not only exhibits surprising invention and artfulness, but the material can also be understood to operate, in a worklike manner, as art.

With the aim of shedding light on this almost completely neglected class of printed matter and encouraging further inquiry, we have tried to represent a broad overview of these materials by drawing on diverse fields of artistic inquiry from 1960 until the present.

WHAT IS ARTISTS' EPHEMERA?

Our introduction of the term "artists' ephemera" evolves out of dissatisfaction with the existing language used to discuss these items. Frequently used descriptions include "ephemera," "graphic design," "documentation," "nonart media," and "printed stuff." All of these terms, however, inadequately distinguish this class of printed material.[3]

One explanation as to why there seems to be little agreement about what to call these materials stems from institutional and critical neglect. This has to do with the *purposiveness* of artists' ephemera, but it can also be attributed to the fact that, unlike unique works, artists' ephemera is mass produced and freely or inexpensively distributed. More modest than prints, multiples, or artists' books—which are also widely ignored by museums in favor of unique works—artists' ephemera typically lacks such obvious trappings of "authorship" as edition limitations and, most notably, the artist's signature. Although museums such as the Museum of Modern Art and the San Francisco Museum of Modern Art do save mailed exhibition announcements, flyers, and posters—some of which includes artists' ephemera—they generally end up in the museum's research library in the "artists' files" together with general information and/or other kinds of ephemera

1. *The American Heritage Dictionary of the English Language*, s.v. "ephemera."
2. Although this exhibition includes advertisements placed by artists in periodicals—particularly in the 1960s and 1970s—we have chosen, with certain exceptions, not to include commissioned projects by artists which appear in magazines and newspapers. This is partly because of the overwhelming quantity of this material, but mostly due to our opinion that these commissioned inserts, of which *Parkett* is representative, became institutionalized and therefore centralized locations for artworks during the 1980s. Although magazines technically fall under the definition of "ephemera," commissioned inserts have increasingly come to function more as spaces incorporating unambivalent expressions of art; as such, they frequently do not operate in the fugitive spirit of either ephemera or artists' ephemera.
3. The term "ephemera" is inadequate because it doesn't distinguish ordinary printed matter created by usually anonymous designers from ephemera generated by artists themselves. (It is important to acknowledge, of course, that artists' ephemera is often created in collaboration with others, including professional graphic designers. As is also the case with most reproducible artworks, designers, printers, and fabricators frequently participate in the creative process.) The terms "graphic design" and "documentation" are too pejorative, and they inadequately express the "worklike" aspect of certain printed materials—printed matter that functions, to greater or lesser degrees, in the manner of artworks. The term "nonart media," however attractive in its lack of pretension, lacks nuance and is incapable of accounting for the wide range of artists' ephemera, which function, in varying degrees, as integral components of art (or of an art practice), or as art itself. Finally, the term "printed stuff" is simply too general.

concerning the artist. Freely distributed, plentiful in quantity (at least initially), and consisting of degradable printed materials, artists' ephemera has historically had little or no market value, a factor that has also undoubtedly contributed to the critical and institutional disregard for these items.

Only seldom do these materials enter the main spaces of museum exhibitions. If they are included they are typically sidelined and marginalized in "art documentation" or "reading rooms." On the rare occasions when artists' ephemera is actually included in spaces containing works of art, curators typically do not distinguish the material from the general printed materials concerning the artist.[4]

A few attempts have been made to survey more general aspects of art ephemera, such as Jean-Noel Herlin's well-received "The Design Show" at Exit Art in New York in 1993, but like other efforts, the exhibition surveyed the more general field of art ephemera and focused more on "the visual language of design."[5]

ROUGH CRITERIA

Extra Art: A Survey of Artists' Ephemera, 1960–1999 is the first museum survey of exclusively artist-generated ephemera. As such, we were compelled to come up with our own parameters for classifying materials for inclusion in this exhibition. This has been particularly challenging partly due to the fact that ephemera, whose essential character is fugitive and transitory, resists classification almost by definition. Other challenges arose in identifying "authorship" of certain materials; for this purpose, many of the artists included in this exhibition have been contacted. Although the artists' intentions were important considerations, it was also necessary to develop our own criteria for ascertaining what constitutes artists' ephemera. Those criteria are as follows:

1) All materials are conceived and/or created by artists specifically for the purpose of being reproduced.
2) All materials are distributed for free or very inexpensively.
3) All materials have a *supplemental* relationship to art and perform a double function: a) they are secondary expressions *of* or *about* art, finding distribution in contexts in which these expressions are useful or instrumental for a short, limited time, and b) although these secondary expressions sometimes function in an

external relationship to art, they also function, to varying degrees, as integral components of art or as art itself.

Although we generally think of ephemera as being defined by cheap or degradable materials, artists' ephemera is also distinguished by function, determined in part by the means by which it is distributed and the contexts in which it appears.

ARTISTS' EPHEMERA IN THE TWENTIETH CENTURY

Examples of artists' ephemera certainly pre-date 1960. The modernist avant-garde, particularly attracted to the possibilities of wider distribution, created ephemeral, reproducible works, including manifestos, posters, revues, letterheads, book jackets, and so forth. Particularly notable is the work of Russian Constructivists El Lissitsky, Alexandr Rodchenko, and Kasimir Malevich, as well as German-born John Heartfield. Each of these artists abandoned easel painting and the notion of creating unique works to instead engineer often politically engaged messages in reproducible, inexpensively distributed media, including newspapers and magazines.

Precedents can also be found in Dada and Surrealism, nowhere more notably than in the legacy of Marcel Duchamp. Duchamp made few unique artworks after 1917, preferring thereafter to make reproducible things that, more often than not, played with various forms of ephemerality; these included exhibition announcements, posters, book jackets, etc. The artist authorized many of these materials to be included in both his first *catalogue raisonné* (1959) and the catalogue of his 1963 retrospective at the Pasadena Art Museum, a modest reminder of the importance he placed on this kind of material.[6]

Included in this exhibition is Duchamp's 1965 dinner invitation, *L.H.O.O.Q. Shaved*, a playing-card reproduction of the *Mona Lisa* mounted onto an invitation to a dinner held in honor of the artist's 1965 exhibition at Cordier & Ekstrom Gallery, New York. The *Mona Lisa,* however, lacks Duchamp's familiar additions of a mustache and goatee; the artist's only addition is the phrase "L.H.O.O.Q. rasé" (translated as "L.H.O.O.Q. shaved"). Because Duchamp's signature makes this invitation approximate an artwork more than most announcements, we doubt if many of the lucky recipients threw this invitation away with the others they typically received.

4. One recent example of this institutional carelessness is the recent retrospective exhibition of Marcel Broodthaers (March 10–June 10, 2001) at the Palais des Beaux-Art de Bruxelles. While the exhibition included artists' ephemera, it did not acknowledge or distinguish between materials conceived and/or created *by* Broodthaers from those produced *about* the artist.
5. Other notable examples of general exhibitions surveying aspects of art ephemera include "RSVP," a show of exhibition announcements at the High Museum of Art (organized by Carrie Przybilla at the High Museum of Art, Atlanta, 1991) and "Public Notice Art and Activist Posters: 1951–1997" (organized by Jeanette Ingberman, Papo Colo, and Cesar Trasobares at Exit Art, New York, 1991).
6. Duchamp executed the design and layout for his 1959 *catalogue raisonné*, and he designed both the cover for the 1963 Pasadena Museum of Art catalogue and the accompanying "poster within a poster." Graphic activities such as these—typically considered outside the purview of artistic procedures—were clearly integral components of Duchamp's artistic practice. See Robert Lebel, *Marcel Duchamp*, trans. George Heard Hamilton (New York: Grove Press, 1959), and *By or of Marcel Duchamp or Rrose Sélavy* (Alhambra, Calif.: Cunningham Press, 1963).

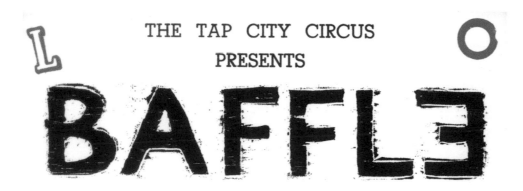

THE TAP CITY CIRCUS

PRESENTS

L O

BAFFL3

3 to 5 p.m. SUNDAY April 28th, 1968
at 2215 N. Topanga Blvd.
Topanga

V 3

THE SHIFT FROM NATURE TO CULTURE

During the late 1950s and early 1960s, a reevaluation of Duchamp's legacy was under way, and while the rediscovery of Duchamp by younger artists clearly influenced artistic attitudes and artistic forms, this alone does not account for the explosion of artists' ephemera in both America and Europe during this period.

The widespread proliferation of artists' ephemera, beginning around 1960, coincided with the demise of the dominant model of painting—Abstract Expressionism in America and Informel in Europe—in favor of art that is concerned with new kinds of processes, new kinds of picture surfaces, and new kinds of reproductive spaces. Among the first art historians to identify this transformation from modernism to postmodernism was Leo Steinberg. First writing in 1968, Steinberg discussed this shift in the context of Robert Rauschenberg's own transformation of conventional picture surfaces into a "flatbed picture plane," a term that refers, significantly, to a printing press. What Steinberg saw in Rauschenberg's art was nothing short of seismic, "the most radical shift in the subject matter of art, the shift from

nature to culture."[7] This shift would also impact the way artists began to think about exhibition announcements, posters, and other printed matter. As artists incorporated commercial printing techniques—and printed culture—into the space of their work, it seems logical that this new cultural direction would spill over into new printed forms. This exhibition is, in part, a testimony to the increasing interest of artists in not only achieving a wider distribution of less commodified messages, but also in exploring the reproductive and fugitive spaces of ephemera.

BEAT

Beat artists such as Wallace Berman, George Herms, and Bruce Conner, all of whom are represented in this show, exhibited a lyrical vision reflecting the improvisational counterculture of the 1950s and early 1960s. These artists gen-erated an impressive array of printed materials, including gallery invitations and posters, buttons, and greeting cards. Particularly notable are George Herms's mid-sixties self-published letterpress and woodblock invitations to the artist's raffles—referred to by him as "Roofles" or "Baffles"—where works were offered for sale when the artist was broke or "tapped out." The cheap materiality of

7. Leo Steinberg, "Other Criteria," in *Other Criteria* (New York: Oxford University Press, 1972), pp. 55–91.

LEFT
Claes Oldenburg
CLAES PAT OLDENBURG.
Green Gallery, New York, N.Y.
September 24–October 20,
[1962].
Poster.
REF NO. 359

RIGHT
Robert Rauschenberg
[Jewish Museum Poster].
The Jewish Museum, New York,
N.Y. March 31–May 8, 1963.
Poster.
REF NO. 399

ephemera provided a particularly suitable support for the Beats' experimental images.

POP

In contrast to the unique gestures of Abstract Expressionism, Pop artists aimed to reach a new and larger audience for art. Whereas it is uncommon to find posters or exhibition announcements created and/or conceived by Abstract Expressionists, the opposite is true for Pop artists.

Pop artists challenged modernist conventions of originality by borrowing images from the mass media and commercial and popular culture; they often reproduced serial imagery using the techniques of commercial art. Drawing on the legacy of Duchamp, Pop artists made use of ephemera as a natural extension of their gallery art. Leo Castelli Gallery (New York), Sidney Janis Gallery (New York), Dwan Gallery (New York and Los Angeles), Green Gallery (New York), Bianchini Gallery (New York),

as well as the Jewish Museum (New York), the Institute of Contemporary Art (Philadelphia), and others provided institutional support by publishing early artists' ephemera in conjunction with exhibitions and art events. Claes Oldenburg's announcement/poster for the Green Gallery, which features an image of a biplane (1962); Robert Rauschenberg's poster for the Jewish Museum, created from leftover stones used to make the print *Rival* (1963) and subsequently altered by the artist (1963); and Andy Warhol's announcement/poster for the Institute of Contemporary Art, which depicted S & H Green Stamps (1965)—all are early representative examples of the Pop art ephemera explosion. Pop artists also expanded the reproductive terrain of ephemera, creating such diverse expressions as Roy Lichtenstein's paper plates, which were published by the New York store On First Inc. (1969). Although the paper plates are typically discussed as "multiples," this latter-day elevation to the unambivalent status of art appears to be the consequence of market interests. Commercially printed and wrapped in clear

cellophane in packages of ten, the plates were originally intended to be used and then thrown away.

NOUVEAU RÉALISME

The appellation Nouveau Réalisme, coined by the French critic Pierre Restany, refers to a geographically broad association of European artists who called for "new approaches to the perception of the real." The Nouveau Réalistes—Arman, César, Christo, Yves Klein, Niki de Saint Phalle, Daniel Spoerri, and others—eschewed Informel's tasteful, introspective painted abstractions in favor of an art that responded to everyday life and everyday materials. For his 1960 exhibition at Iris Clert in Paris, Arman filled and sealed five hundred sardine cans with trash, using them as the exhibition announcements for the exhibition "Full Up." For the exhibition itself, Arman filled the gallery with trash; this was his response to Yves Klein's earlier exhibition at Iris Clert, "L'exposition du Vide" (1958), which consisted of the gallery completely emptied of its contents. The sardine cans were each labeled "open before 25 October, 1960," so Arman's trash-filled announcement functions as a metonym for the gallery installation and makes an amusing analogy between the fugitive time frame of the exhibition and the expiration-dated sardines.

Daniel Spoerri's invitation/menu for his 1963 *Restaurant de la Galerie J* performance and exhibition is another representative example of how the Nouveau Réalistes put ephemera to work. For the duration of his exhibition at Galerie J. (Paris), Spoerri prepared a variety of meals; he was assisted by notable critics and poets who provided table service. The menu, laced with double entendre and art-world innuendo, set out the meals for the eleven-day event, including the daily prices and the names of the servers, who included Pierre Restany and John Ashberry. This invitation/menu functions as the primary registration of the restaurant performance.

HAPPENINGS

A number of artists associated with Pop also participated in a new theater and art form called Happenings. Under the influence of John Cage, Allan Kaprow coined the term in 1959 for his event *18 Happenings in 6 Parts*. This Happening took place at the Reuben Gallery, a gallery also associated with other Happenings artists, including Jim Dine, Red Grooms, Claes Oldenburg, and Robert Whitman. The word "Happenings" was used, as Kaprow

recalls, to "suggest something spontaneous that just happens to happen."[8] Transcending visual forms, Happenings were themselves ephemeral events. A Happening was an all-encompassing art form "in which all manner of materials, colors, sounds, odors, and common objects and events were orchestrated in ways that approximated the specta-cle of modern everyday life."[9] Posters for Allan Kaprow's Happenings such as

8. Michael Kirby, *Happenings* (New York: E. P. Dutton, 1966), p. 47.
9. Jeff Kelly, *The Blurring of Art and Life: Allan Kaprow* (Berkeley: University of California Press, 1993), p. xii.

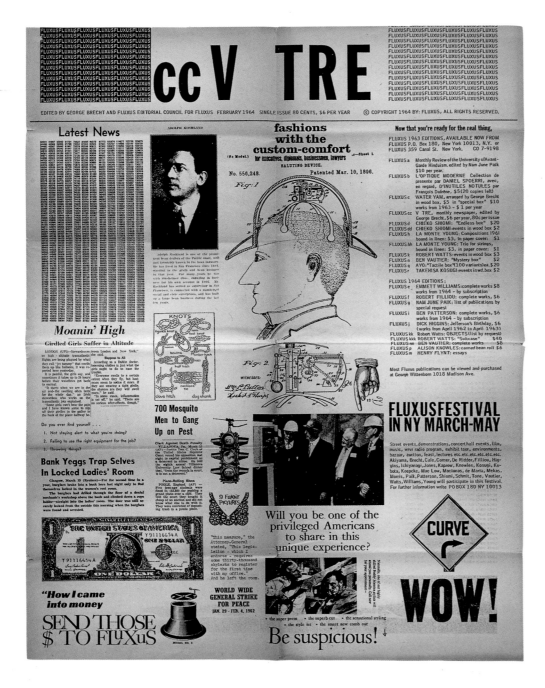

Fluids (Pasadena Art Museum, 1967), Moving (Museum of Contemporary Art, Chicago, 1967), and Runner (Washington University, St. Louis, 1968) functioned as both invitations and scores for Kaprow's Happenings. They were also the primary means of registration for these short-lived works, which were referred to as "days off" by the artist.

FLUXUS

Fluxus, a parallel movement to Happenings, is the international network of artists orchestrated by Lithuanian-born George Maciunas. Fluxus artists, whose work often included performance-related activities, were engaged with games and chance, and they were indebted to the legacy of John Cage. Many of the primary Fluxus players were students in Cage's class at the New School for Social Research in New York City.

Unlike Pop, Fluxus did not ally itself with commercial culture; rather, it sought to create new, less commodified forms and attitudes. In addition to creating numerous inexpensive multiples, Fluxus activities included concerts and other live events. Examples of Fluxus ephemera include manifestos, newsletters, event scores, and postcards. Perhaps the most characteristic form of Fluxus ephemera is the Fluxus newspaper V TRE (1964–79, of which eleven issues were produced). Initially edited by George Brecht and the Fluxus Editorial Council (George Maciunas), the newspapers presented events, scores for events, documentation of Fluxus festivals and performances, advertisements for Fluxus editions, and more. No Fluxus multiples are included in this exhibition: even though they were distributed inexpensively and often assume ephemeral forms, they function more or less simply as inexpensive art.

Artists' writings have commonly found expression in ephemeral forms. Dick Higgins, director of The Something Else Press, wrote and published The Something Else Newsletters (1966–73) and Newscards (1965–?), drawing on the avant-garde example of disseminating socially and politically directed manifestos. Functioning in the space between artist and publisher, Higgins's activist newsletters—such as "Intermedia" (vol. 1, no. 1 [February 1966]) are a kind of manifesto, defining the collapse of categories of discrete media and their social implications. Both The Something Else Newsletters and Newscards were distributed via the mail to the purchasers of books published by the Something Else Press.

LEFT
Dan Flavin
FOUR "MONUMENTS" FOR
V. TATLIN 1964-1969. FROM
DAN FLAVIN.
Leo Castelli, New York, N.Y.
February 7–28, 1970.
Poster.
REF NO. 158

RIGHT
Robert Morris
FLOOR PLAN WITH DATES
OF CHANGES DURING THE
EXHIBITION. ROBERT MORRIS.
Leo Castelli, New York, N.Y.
Opening March 4, 1967.
Poster.
REF NO. 330

VISUAL POETRY

International in scope, visual poetry is the term used
to broadly identify a number of related artistic forms:
Concrete Poetry, Typewriter Poems, Kinetic Poetry,
Spatialism, Sound Poetry, and other hybrids. Summarizing
the field, artist and art historian Richard Kostelanetz
describes Visual Poetry as "the art of incorporating word
within image . . . artifacts that are neither word nor image
alone but somewhere or something in between."[10]
Representative is Ian Hamilton Finlay, the artist/publisher
behind the Wild Hawthorn Press (located in Stonypath,
Dunsyre, Lanark, Scotland), which produced artists'
books and booklets, cards and folding cards, poster
poems, and multiples. Included in this exhibition are
Finlay's printed cards and folding cards, among them,
"THE DESMOULINS CONNECTION" (1988), a series of
approximately fifty small, folded propaganda cards con-
taining texts pertaining to the artist's disputes or personal
wars. Other often overlooked artists associated with visual

poetry whose materials are included in this exhibition are
J. F. Bory, Zaj, B. P. Nichol, Jiri Valoch, and Timm Ulrichs.

MINIMALISM

Leo Castelli Gallery frequently published artist-generated
exhibition announcements, often in the form of posters to
be mailed on the occasion of an artist's gallery show. One
example of the poster/exhibition announcement combina-
tion is Dan Flavin's "FOUR 'MONUMENTS' FOR V. TATLIN
1964–1969 FROM DAN FLAVIN" (1970), consisting of a
photographic image of Constructivist Vladamir Tatlin juxta-
posed with a reproduction of one of Flavin's commemora-
tive neon sculptures.[11] Castelli also published the poster
"FLOOR PLAN WITH DATES OF CHANGES DURING THE
EXHIBITION. ROBERT MORRIS" (1967), consisting of text
and diagrams of Morris's installation, altered by the artist
throughout the duration of the exhibition. Unlike most
posters, which reproduce iconic images of existing works
of art, Morris's poster functions both independently and

10. Richard Kostelanetz, ed., *Imaged Words and Worded
Images* (New York: Outerbridge and Dienstfrey,
1970), n.p.
11. In an unusual example of a poster *preceding* a print,
Flavin later reworked the poster "Four 'Monuments' For
V. Tatlin 1964–1969 from Dan Flavin" as an editioned
print published two years later, omitting the gallery
information printed on the verso of the poster. The print
version was included in *Works by Artists in the New
York Collection for Stockholm* (New York: Experiments
in Art & Technology, Inc., 1973).

nonmimetically, providing visual and textual clues for the viewer to apprehend the artist's fugitive system. Similar to the kinds of nontraditional materials the artist ultimately used in his gallery work (i.e., felt, sound installations, etc.), the ephemeral form of this poster/announcement functions as a suitable correlative for Morris's artistic message.

Of the Minimalists who created artists' ephemera, Carl Andre probably took the greatest interest. Andre, who once considered himself primarily a poet, created and or conceived numerous exhibition announcements and posters, including "CARL ANDRE" (John Weber Gallery, New York, 1976), which employs structural and syntactical elements similar to those used in the artists' poems.[12] Also worth mentioning are Donald Judd's little-known, self-published street posters. One example from 1970, "De Tocqueville: All those who seek to destroy the liberties of a democratic nation [. . .]," incorporates black text

mimeographed onto yellow poster paper; it reproduces quotations about war and democracy borrowed from De Tocqueville, Jefferson, Whitman, Thoreau, Roosevelt, and Dean Rusk. Produced in an unlimited edition, these posters were created for and distributed at a benefit for the War Resisters League.[13] Judd also created other self-published, politically directed street posters.

CONCEPTUAL ART

One of the characteristics of Conceptual art is that it situates both language and information in the context of art. Previously, language and information had been histori-cally understood as *supplemental* (and therefore external) to art: while each could be used to describe art in a *secondary* manner, they were rarely used in the central space of art itself. Conceptual artists not only employed language in the "primary" sites of art, but they also

12. Carl Andre's poems were presented by the artist as artworks. See Carl Andre, *Carl Andre: Eleven Poems* (Turin, Italy: Sperone Editore, 1974).

13. Kasper Koenig, ed., *Donald Judd: Complete Writings, 1959–1975* (Halifax: The Press of the Nova Scotia College of Art and Design), p. 205.

exploited other supplementary structures as a means of presenting works. To this end, Conceptual artists frequently presented works and exhibitions in the context of exhibition catalogues, posters, and exhibition announcements, locations previously understood to contain secondary expressions of art rather than art itself.

Conceptual artists, not surprisingly, were among the most fertile producers of artists' ephemera. These ephemeral materials and spaces were particularly suitable vehicles for presenting information concerning this fugitive and immaterial art. Robert Barry, for example, created a 1969 poster in conjunction with his *Inert Gas Series*, which consisted only of one line of small black text printed on a white ground. The poster itself constituted the registration of invisible works for which there was no *primary* audience; even if there had been a "first-hand" audience, "nothing" would have been visible. As art historian Anne Rorimer explains,

> A poster for Barry's April 1969 exhibition in Los Angeles, organized by [Seth] Siegelaub, records the release of five inert gases: helium, neon, argon, krypton, and zenon. To realize this exhibition, Barry purchased vials of gas from a scientific supply store and broke them open at different locations in and around Los Angeles. He smashed one at the edge of an outdoor swimming pool, another in the desert, and another on the beach. Each work represented the passage of a substance "from a measured volume to indefinite expansion" as is printed on the exhibition poster.[14]

By reproducing linguistic descriptions in the context of a mailed poster—secondary expressions conveying information concerning the release of inert gas—Barry extended his exploration of dematerialized artworks in an alternative, nongallery context.

Continually seeking alternative contexts for their work in the late 1960s, Conceptual artists—including Dan Graham, Stephen Kaltenbach, Joseph Kosuth, Edward Ruscha, and others—placed artist-generated advertisements in newspapers and magazines.[15] Most of these advertisements operate as independent works for which there is no other expression. Kaltenbach placed twelve artist's advertisements in the ad sections of *Artforum* magazine. These differed from conventional advertisements because they

Dan Graham
FIGURATIVE. BY DAN GRAHAM.
Hearst Corporation, New York, N.Y. March 1968.
Proposal for artist's advertisement in the periodical *Harper's Bazaar* (no. 3076 [March 1968], p. 90).
Offset lithograph.
REF NO. 193

14. Anne Rorimer, *New Art in the 60s and 70s: Redefining Reality* (New York: Thames and Hudson, 2001), pp. 85–86.
15. Dan Graham's proposal for a magazine advertisement, "FIGURATIVE. BY DAN GRAHAM," in *Harper's Bazaar* (March 1966, p. 90). Edward Ruscha's advertisement for *Artforum*, "ED RUSCHA SAYS GOODBYE TO COLLEGE JOYS," *Artforum* (vol. 5, no. 5 [January 1967], p. 7). Stephen Kaltenbach's advertisements for *Artforum* (November 1968–December 1969 [vol. 7, no. 3–10; vol. 8, no. 1–4]). Joseph Kosuth's three-part advertisement, *II. Relation (Art as Idea as Idea)* (1968), which appeared in the following publications: *Lawrence Eagle-Tribune* (Lawrence, Mass., 11 March 1969, p. 6), *The Quill* (Bradford, Mass., 14 March 1969, p. 1), and *The Haverhill Gazette* (Haverhill, Mass., 31 March 1969, p. 12). Although Kosuth does not consider these to be advertisements, the locations they occupy are within the advertising space of the newspapers.

neither announced an exhibition nor reproduced works available for sale. Instead, Kaltenbach used the location as a site to present art: "The ads are passing on possibilities," he suggested at the time.[16]

Certain Conceptual artists created exhibition announcements and exhibition posters as a means of critically examining these kinds of spaces. Particularly notable are Marcel Broodthaers and Daniel Buren, both of whom sustained rigorous inquiries into these information locations as an extension of their work involving the critique of institutions, and with particular relevance here, the discourse of institutions.

Marcel Broodthaers created a wide range of ephemera during his entire brief career. More often than not, he designed his own announcements, many of which evince the same critical elegance and opaque sensibility that one finds in everything that he made. In conjunction with his fictional *Musée d'Art Moderne* (1968–72), Broodthaers created exhibition announcements, institutional letterhead, publicity, and mimeographed "open letters," some of which bear the officious marks of his fictional museum's rubber stampings and which the artist mailed to approximately five hundred to a thousand primarily artworld recipients.[17] Through these and other numerous examples, Broodthaers's artists' ephemera frequently adopted and interrogated the rhetorical forms, fonts, and flourishes of the museum's discourse and the ideology of its publicity apparatus.

For five exhibitions at Wide White Space (Antwerp) between 1969 and 1974, Daniel Buren created five variations of a poster/announcement reproducing his signature stripes, in a different color—green, red, yellow, blue, and brown—each time. The front side of the sequential poster/announcements was identical for each of the different presentations but for the variation in the color of the stripes. On the verso of each poster, information was printed concerning the dates of the exhibition, along with information concerning the previous related exhibitions; the earlier information was crossed out as the sequence progressed.[18] It is interesting to note that the installations themselves consisted of what appeared to be posters identical to the poster/announcement, which covered both the interior and exterior walls of the gallery, stripe side showing.[19] Additionally, copies of the poster were available for viewers to take away from each gallery installation—thus the stripes, quite literally, extended beyond

the confines of the gallery space, so the entire exhibition could never be seen all at once. Buren's gestures function as a critique of artistic tendencies that conceive of artworks as unique objects. The artist favors instead a serial approach to art which examines art's relationship to its institutional frame, in this case in relation to a series of gallery presentations.

In addition to Wide White Space, Amsterdam-based Art & Project was among the more ambitious, programmatic publishers of artists' ephemera. Between 1968 and 1989 Art & Project, run by Geert van Beijeren and Adriaan van Ravensteijn, regularly and freely mailed to people on their gallery mailing list a series of 156 bulletins; many of these were conceived and/or created by the artists and architects who, in every case, were associated with the gallery's exhibition program.[20] Participating artists included Bas Jan Ader, John Baldessari, Hanne Darboven, Gilbert & George, Douglas Huebler, Allen Ruppersberg, David Tremlett, and Lawrence Weiner. Each sequential bulletin typically consisted of offset printing on a single folded sheet; occasionally, the bulletins did double duty as gallery invitations.[21] Although a number of bulletins (particularly the later ones) were neither created nor conceived by artists and did simply reproduce images of artworks exhibited at the gallery—art ephemera as opposed to artists' ephemera— the majority consist of contributions created and/or conceived for the bulletins. Lawrence Weiner and Sol LeWitt each contributed several bulletins. LeWitt's "bulletin 43" (September 7–October 2, 1971), which consisted only of the bulletin folded into forty-eight squares in the manner of the artist's series *Folded Paper Pieces* (begun in 1966), was another way of making grids with no drawn lines.

Lawrence Weiner's five contributions to the Art & Project bulletin series occasionally strayed from the familiar bulletin format. One such example was "bulletin 113" (January 12, 1980). In addition to being one of the only artists to use color (green) on a bulletin cover, Weiner doubled the scale to poster-sized dimensions; "bulletin 113" was also one of the only examples of a bulletin used by an artist as an actual component of a gallery installation. Weiner classifies his contributions to the Art & Project bulletins as "catalogues," but he also designates most as vehicles that "contain work."[22] Weiner's Art & Project "bulletin 140" (February 17–March 16, 1985)—which the artist indicates does *not* contain work—also differs formally from all the other bulletins, taking the form of an invitation postcard.

16. Patricia Norvell, *Recording Conceptual Art: Early Interviews with Barry, Huebler, Kaltenbach, LeWitt, Morris, Oppenheim, Siegelaub, Smithson, and Weiner* (Berkeley: University of California Press, 2001), p. 83.

17. Catherine David, ed., *Marcel Broodthaers* (Paris: Éditions du Jeu de Paume, 1991), p. 199.

18. Presumably because of space limitations, the last poster (brown version) for this series of presentations includes all of the earlier exhibitions crossed out, but it does not include details for the final 1974 exhibition.

19. To be technically precise, Anny De Decker and Bernd Lohaus, directors of Wide White Space, recall that the posters used in the installations omitted the information printed on the verso; this slight alteration was likely made either for financial reasons (to save money on printing) or for the more practical purpose of preventing the black text from bleeding through when pasted to the walls. Conversation with Anny De Decker and Bernd Lohaus, 25 March 2001.

20. Loose examples of the Art & Project bulletins were also available for the taking at the Art & Project gallery.

21. Because the bulletins frequently, but not always, functioned as exhibition announcements, they were not always distributed sequentially; "bulletin 24" was never produced at all.

22. Dieter Schwarz, *Lawrence Weiner: Books 1968–1989* (Cologne: Verlag der Buchandlung Walther König, 1989).

It is not surprising that Weiner, whose artistic achievement consists, in part, of displacing iconic images with language in the primary spaces of art, is among the most prolific creators of artists' ephemera.

LAND AND EARTH ART

The impetus behind much Land and Earth art lies in its rejection of such conventional locations for art as galleries and museums. Frequently siting their work in remote areas, Earth and Land artists needed a means with which to make their art accessible to distant audiences. Robert Smithson, Michael Heizer, Dennis Oppenheim, Newton Harrison and Helen Mayer, Richard Long, Hamish Fulton, and Lothar Baumgarten all make good use of artists' ephemera to map, chronicle, and register their works.

Dwan Gallery sponsored many of the early earthworks and accompanying artists' ephemera. Representative examples include Robert Smithson's ¾-by-34½-inch folding invitation for the Dwan Gallery show "Mono Lake Site Mono Lake Nonsite/Robert Smithson. Nonsites" (New York, February 1–27, 1969). This gallery invitation consists of a folded piece of paper upon which is reproduced a thin slice of a map of the United States, spanning from Mono Lake (in California) to New York City. By mimicking a cartographic device, Smithson concisely conveys the dual structure of his artistic conceit: he locates his work at both the gallery nonsite and the Mono Lake site.

POSTMINIMALISM AND ARTE POVERA

The innovative nature of many Postminimal and Arte Povera works did not simply depend on the use of such new or traditionally nonart materials as latex, fiberglass, neon, Plexiglas, felt, and so on: paramount was the conception and placement of these works, which took precedence over the objects themselves.[23] Lynda Benglis, Alighiero Boetti, Raphael Ferrer, Joel Fisher, Robert Morris, Bruce Nauman, Richard Nonas, Keith Sonnier, and Richard Tuttle, among others, have often used the gallery/museum information system to produce ephemera works. Particularly noteworthy is Bruce Nauman's 1968 Sacramento State Art Gallery poster/invitation, which functions very much like the artist's instruction drawings from the same period. Like the instruction drawings, in which the instructions became the work, the instructions for creating this poster became the poster itself.

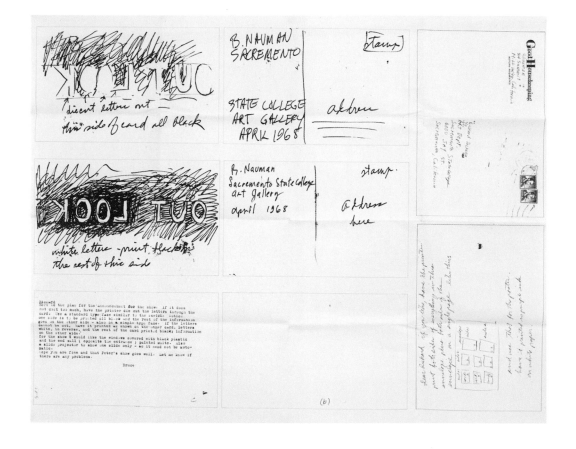

For at least thirteen separate exhibitions in the mid–seventies, Joel Fisher created witty invitation announcements that consisted of two photographs: one of his own eyes, the other of his art dealer's eyes. Fisher photographed the eyes of such dealers as Nigel Greenwood and Folker Skulima, for example, and they in turn photographed the artist's eyes. These invitations were unrelated to Fisher's usual gallery work, which at that time consisted of pieces of handmade paper. The artist confides that he seized this opportunity primarily because he felt that his paper works were too difficult to reproduce. The two images—which played with the phrase "the dealer has a good eye"—were sent together; the exhibition details were typically printed on the mailing envelope because Fisher "preferred the separation of content from information, making the information external."[24]

Bruce Nauman
B. NAUMAN.
Sacramento State College
Art Gallery, Sacramento, Calif.
April 1968.
Poster.
REF NO. 347

23. James Monte and Marcia Tucker, *Anti-Illusion: Procedures/Materials* (New York: Whitney Museum of American Art, 1969), p. 4.
24. Letter from Joel Fisher to Steven Leiber, undated.

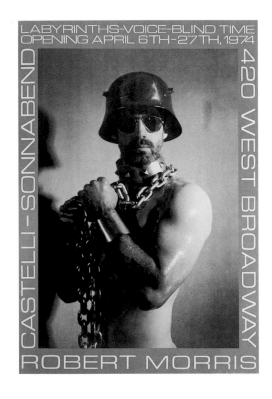

LEFT
Robert Morris
LABYRINTHS-VOICE-BLIND
TIME. ROBERT MORRIS.
Castelli-Sonnabend, New York,
N.Y. April 6–27, 1974.
Poster.
REF NO. 332

RIGHT
Lynda Benglis
[Artforum Piece].
Artforum, New York, N.Y.
November 1974.
Artist's advertisement in the peri-
odical *Artforum* (vol. 13, no. 3
[November 1974], pp. 3–4).
REF NO. 62

25. Rosalind Krauss and Thomas Krens, eds., *Robert Morris* (New York: Guggenheim Museum Publications, 1994), p. 256.
26. Ibid.
27. Amy Newman, *Challenging Art: Artforum 1962–1974* (New York: Soho Press, Inc., 2000), p. 415.
28. Letter from Lynda Benglis to Steven Leiber, 10 April 2001.

Together with Sonnabend Gallery, Leo Castelli Gallery published the 1974 poster/exhibition announcement "LABYRINTHS—VOICE—BLIND TIME. ROBERT MORRIS." (April 6–27, 1974) on the occasion of exhibitions held at both galleries. The poster image is a waist-up photograph of the artist "in a strange hybrid of S & M and battle gear: dark sunglasses, a smooth curving helmet, a silver spiked collar, and manacles. Muscular, seductive, and threatening, this representation—this persona—is imbued with a violent eroticism."[25] Interestingly, Morris's visual poster supplements his sound installation at Castelli: *Voice*, like the poster, "was intended to refer to one of several levels of masculinity and authority subverted, dissected, or parodied, rather than elevated, in [its] complex layers."[26] The uncredited photographer of this poster image is Rosalind Krauss, Morris's companion, who was an *Artforum* editor at that time.[27]

Perhaps mistakenly, critics have discussed Lynda Benglis's November 1974 parodic advertisement in *Artforum* as a response to Morris's Castelli–Sonnabend poster. Originally conceived as a "pinup," Benglis's infamous advertisement

was a two-page spread: the right-hand page consists of a three-quarter-length nude photograph of the artist in a provocative pose; she wears white-rimmed glasses and holds a large dildo. The information on the blacked-out page at left reads, simply, "Lynda Benglis, courtesy of Paula Cooper Gallery." Benglis wanted the work to suggest "a centerfold," and she intended that the ad literally appear as the middle spread of the magazine.[28] It did not, however, ultimately appear as the centerfold—the space was apparently not available. The same issue also carried a full-length article on Benglis written by Robert Pincus-Witten.

Benglis contends that her "pinup" was *not* conceived in reaction to Morris's representation of exaggerated masculinity; in fact, it belonged to what the artist considers a broader series of advertisements and announcements exploring role-playing, women, sex, art, and the media. Among these was an advertisement she placed in the April 1974 issue of *Artforum* for her Paula Cooper show entitled "Metallized Knots." This ad featured the artist wearing sunglasses and with slicked-back hair, standing in front of a Porsche in a macho posture. The invitation for this same

exhibition, also conceived by Benglis, featured a 1940s Betty Grable–type pinup photo (snapped by Annie Leibovitz) of a vertical and virtually nude Benglis, with her jeans pulled down to her high heels. The images for all of these ads and invitation cards were created expressly for these specific contexts, and they did not—as most art advertisements often do—simply reproduce or advertise already existing works.[29]

Benglis explains that she and Morris were collaborating on a video work in early 1974 and were carrying on a discussion and correspondence involving pornography. She suggests that Morris was aware of her idea for the *Artforum* ad before he made *his* poster. She also indicates that Morris was invited to participate in the production of her November *Artforum* advertisement: she asked him to accompany her to 42nd Street in order to purchase the dildo used in the photograph, an invitation Morris apparently accepted.[30]

PERFORMANCE AND BODY ART

Like the history of theater, the history of Performance and Body art is primarily recovered from scripts, scores, relics, event materials, primary documents, film, video, and photographic material. Unlike theater, however, some Performance and Body art was never intended to be presented to live audiences. Rather, it was often conceived to exist as *documentation*: it was created exclusively to be photographed, filmed, or videotaped. Many of these artists also used ephemera as a primary means of both registering and disseminating their art.

James Lee Byars, who referred to his performances as "actions," frequently handed out sheets of typically small-sized papers upon which were printed questions for the audience. One unusually large handout consisted of a piece of paper twenty-seven inches in diameter which was released into the air by the artist during the action "A White Paper Will Blow Through the Streets" (Kyoto Museum of Art, Japan, 1967). Byars also conceived and/or created a large quantity of printed ephemera to be distributed through the mail to artists, dealers, critics, curators, and the artist's patrons. One example distributed by Wide White Space in the summer of 1969 consists of a crumpled piece of paper stuffed into an oversize envelope; it asks the printed question, "THE EPITAPH OF CON.ART IS WHICH QUESTIONS HAVE DISAPPEARED? JAMES LEE BYARS."

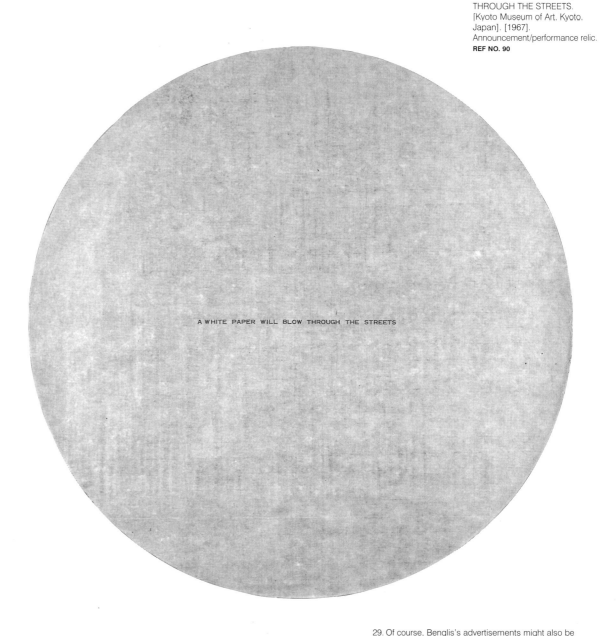

James Lee Byars
A WHITE PAPER WILL BLOW THROUGH THE STREETS. [Kyoto Museum of Art. Kyoto. Japan]. [1967]. Announcement/performance relic.
REF NO. 90

A WHITE PAPER WILL BLOW THROUGH THE STREETS

29. Of course, Benglis's advertisements might also be understood to function like conventional advertisements in the sense that they do serve to brand Benglis's artistic identity: they market her persona through the familiar Madison Avenue strategy of using sex appeal, however parodic or critical the artist's intentions may be.
30. Newman, *Challenging Art*, p. 416.

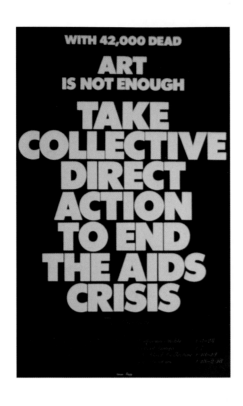

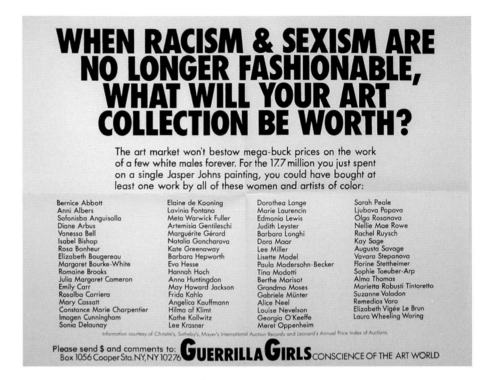

31. *Event for Lateral Suspension*, Tamura Gallery, Tokyo
(12 March 1978).
32. Michael Crane and Mary Stofflet, eds., *Correspondence
Art* (San Francisco: Contemporary Arts Press, 1984),
p. 208.
33. Eleanor Antin, *100 Boots* (Philadelphia: Running Press,
1999), n.p.

Characteristically, Byars used artists' ephemera to raise questions that were themselves the subject and substance of his actions.

The Australian endurance artist Stelarc has performed his actions since the late 1970s. These actions have included such activities as hanging his body vertically via the insertion of eighteen hooks in his skin for a static suspension lasting one minute.[31] Appearing in Sydney, Tokyo, Los Angeles, Melbourne, Mexico City, Canberra, and Munich, Stelarc registered his performances by reproducing photographic documentation of them on postcards, which were then mailed as a means of disseminating his work to audiences not otherwise present at his actions.

CORRESPONDENCE AND MAIL ART

Although a great deal of Correspondence and Mail art consists of unique works—which often incorporate collage elements—a number of these artists also made good use of printed ephemera. Rejecting the institutional constraints of the gallery system, these artists distributed their work through a traditional nonart network: the postal system. Ray Johnson, often referred to as "the father of Correspondence and Mail art," founded the New York Correspondence School, which has been described by critic Thomas Albright as "a continuous happening by mail, a sophisticated communications feedback system in which correspondence is always being received, replied to, or ignored."[32] Correspondence and Mail artists also participated in their own exhibitions, festivals, and performances. Typically consisting of offset printed materials, a small sampling of Correspondence and Mail art ephemera is included in this exhibition; the artists include Guglielmo Achille Cavellini, Ray Johnson, Endre Tót, and The New York Graphic Workshop.

Artists who made use of the postal system were certainly not limited to members of the New York Correspondence School. Eleanor Antin's witty *100 Boots* (1971–73), for example, featured a self-published series of fifty-one black-and-white postcards containing an evolving epic narrative: a travelogue consisting of one hundred black rubber boots—army/navy surplus—photographed in various locations throughout the United States.[33] Antin, an artist loosely associated with Conceptual art, was an early practitioner of

set-up photography, and she used the method to create the photographic tableaux featured on the front of each card; on the verso was a description of the precise geographical location of the boots, as well as the date and time each photograph was taken. Over a period of about two years Antin created and mailed postcards individually to approximately one thousand recipients—as Antin recalls, to "artists, dancers, writers, critics, museums, galleries, universities, libraries, and assorted innocent bystanders."[34] At the end of the journey, the boots themselves put in an appearance at the Museum of Modern Art. The only means of distribution for *100 Boots*, however, was through the postal system, and this was always free to the lucky recipients. The original photographs of the tableaux, taken by Philip Steinmetz, were never presented as artworks—only the mailed postcards constituted the work.

ART IN THE 1980S

Cultural producers during the 1980s—including Jenny Holzer, Barbara Kruger, Louise Lawler, Group Material, Guerrilla Girls, and Gran Fury—created a variety of messages interrogating the relationship between mass culture and the politics of representation. In order to disseminate these messages, these artists and artist-based groups employed such traditional nonart, mass-cultural formats as street posters, billboards, advertisements in magazines and newspapers, stickers, and matchbooks. In fact, a fairly large number of street posters by artists/activists were plastered in large metropolitan areas during the early 1980s. Influenced in part by the music posters she remembers seeing downtown in New York, in the early 1980s Jenny Holzer wheat-pasted her "Inflammatory Essays" all over the streets of Manhattan; these were a series of printed texts conveying a wide range of polemical messages. In the mid-1980s the activist group Gran Fury disseminated social messages about homophobia and AIDS via a variety of street posters. And the Guerrilla Girls postered the streets with their often comical criticisms that highlighted the underrepresentation of women in museums, galleries, and art publications.

Louise Lawler has produced a variety of ephemera, including exhibition announcements, brochures, press releases, and matchbooks—all of which are integral to her artistic practice and a logical extension of her fine art activity involving framing the institutional and discursive contexts of art. One example of Lawler's ephemera is the artist-generated brochure produced on the occasion of her 1987 "Projects" exhibition at the Museum of Modern Art; Lawler's brochure, "DID YOU TAKE THIS AIRPLANE HOME? Enough," mimics the form and size of the didactic brochure commonly accompanying museum exhibitions. The artist slyly distributed it together with the museum-produced brochure, which of course, reflected the institutional perspective on her art. Lawler's stealth brochure—a cagey infiltration of museum-generated information—included directions on how to fold the piece into a paper airplane, a comment on U.S. support of the Nicaraguan Contras for which a Congressional vote was upcoming.

Also worth mentioning here are Raymond Pettibon's gig flyers/posters for his brother's California punk band, the legendary Black Flag, which he began producing beginning around 1978. (Pettibon continues to create flyers for his own musical events, including appearances by his band, Sur Drone, formed during the 1990s). These exemplify a certain do-it-yourself attitude particularly evocative of the Punk and No Wave ethic whereby cultural producers frequently sought distribution channels for their messages beyond the confines of art galleries.

ART IN THE 1990S

Artists continued to conceive and create their own ephemera in the 1990s. Although such early supporters as Leo Castelli Gallery and Art & Project lost their vitality or disappeared altogether during the 1990s, new institutions emerged to publish and provide support and distribution for artist's ephemera. Reflecting the art world's continuing complicity and collaboration with the fashion industry, Paris fashion houses agnès b. and Colette have emerged as significant supporters of artists' ephemera during the 1990s. Particularly notable is agnès b.'s *point d'ironie*, a so-called "hybrid periodical, half newspaper, half poster." This typically eight-page tabloid-sized publication is freely distributed in "agnès b. boutiques, museums, galleries, schools, cafes" in an edition of 100,000. Since 1997 artists have been invited by agnès b. and curator Hans-Ulrich Obrist to fill the entire publication with their contributions, for which the artists are said to be given "carte blanche." Artists invited to participate include established names such as Christian Boltanski, Hans-Peter Feldmann, Gilbert & George, Annette Messager, and Lawrence Weiner, as well as younger artists such as Douglas Gordon, Joseph Grigely, and Gabriel Orozco. One of the more widely

Louise Lawler
DID YOU TAKE THIS AIRPLANE HOME? Enough. Louise Lawler.
Project: Moma, 1987.
Self-published. 1987.
Artist's publication.
REF NO. 277

34. Ibid.

distributed examples of ephemera created by artists, *point d'ironie* is reportedly available in forty-three countries.

Generosity has been an underlying aspect of the tradition of artists' ephemera. Felix Gonzalez-Torres's "Untitled" (Death by Gun) (1990), one example of such generosity, consists of stacks of freely distributed printed sheets designed to be constantly replenished from an endless edition. As the printed sheets note, "*Untitled* [*Death by Gun*] display the names, ages, and most of the faces of 460 people who died in one week in America by gunshot." Curator Deborah Wye explains:

> [Gonzalez-Torres] has said that his idea of having viewers take part of the piece away with them . . . derives from several impulses, among them the desire "to give information and meaning back to the people," an interest in the "re-contextualization of information" as it leaves one place and occupies another, a preoccupation with the "intersection of public and private," and the hope for a better understanding of "disappearance, loss, and regeneration."[35]

Gonzalez-Torres's sheets present an interesting contradiction with regard to the typically free or inexpensive distribution of ephemera: although the artist stipulates that they should be gratis to gallery or museum visitors, the work itself—the initial stack of sheets, the concept of the work—is neither free nor inexpensive to the acquiring institutions or collectors.

PASSING THOUGHTS ON PASSING THINGS

Contemporary artists have created a wide range of printed materials, and they have used them in a variety of ways for a variety of purposes. While not all artists who conceive and/or create artists' ephemera consider these materials to function in the same manner as artworks, some do—particularly Conceptual, idea-based, and politically motivated artists. In fact, many of these artists do not distinguish their ephemera from gallery-based work, preferring to produce both as parallel expressions of their artistic practice. Many of these artists choose to create ephemera to self-consciously challenge or invert historical divisions—between art and nonart, between high and low—to expand the cultural field and its audience. Some create artists'

ephemera to disrupt the legacy of unique artworks and their structures of authenticity. They seek to reinvent not only the limits of art, but also our fundamental conception of exactly what constitutes art.

Until now, artists' ephemera has been relegated to the dustbin of neglect primarily because of its nonart characteristics: its use value, lack of legible author function, and short-lived, transitory character (along with its typically cheap and degradable materiality) all stand in opposition to the history of Western aesthetics—expressed perhaps most emphatically in the writings of Emmanuel Kant—which historically understands art as the timeless, universal, and disinterested expression of artistic genius.

These by-products of mechanical reproduction are, on the one hand, quintessentially *modern*, partially because of their characteristic tendency to speak *about* or *as* art in the language of the here and now. Unlike universal and eternal things, ephemera are passing signs of passing things. "Modernity," Baudelaire wrote, "is the transient, the fleeting, the contingent; it is one half of art, the other being the eternal and immovable."[36] At the same time, artists' ephemera remains a class of printed matter that is distinctive to the last forty years: it is a testimony to artistic interest not only in printed things, but also in reproductive and traditionally nonart spaces. These fugitive materials not only teach us so much about art and artists, but they also reveal the transitory character of the material world.

35. Deborah Wye, "Untitled (Death by Gun) by Felix Gonzalez-Torres" *The Print Collector's Newsletter* 22, no. 4 (September–October 1991): 118.
36. Charles Baudelaire, "The Painter of Modern Life," reprinted in Baudelaire, *Selected Writings on Art and Artists*, trans. P. E. Charvet (Cambridge: Cambridge University Press, 1972), p. 403.

TOP LEFT
Point D'Ironie/
Christian Boltanski
[point d'ironie] 7. Christian
Boltanski, L'Ecole de
Hamburgerstrasse.
agnès b. and Hans-Ulrich
Obrist, Paris, France. July 1998.
Artist's periodical.
REF NO. 390

TOP RIGHT
Point D'Ironie/Joseph Grigely
[point d'ironie] 1. Joseph
Grigely.
agnès b. and Hans-Ulrich
Obrist, Paris, France. June 1997.
Artist's periodical.
REF NO. 383

BOTTOM LEFT
Point D'Ironie/Gabriel Orozco
[point d'ironie] 9.
Gabriel Orozco.
agnès b. and Hans-Ulrich
Obrist, Paris, France.
December 1998.
Artist's periodical.
REF NO. 392

BOTTOM RIGHT
Point D'Ironie/
Annette Messager
[point d'ironie] 5. Annette
Messager.
agnès b. and Hans-Ulrich
Obrist, Paris, France. April 1998.
Artist's periodical.
REF NO. 388

TICKETS, TRIPS, AND PASSPORTS

Thoughts about Travel, Souvenirs, and Contemporary Art

Ted Purves

SETTING OUT

How to begin to tell the story of the trips we have taken? How to tell those who were not there what it was like? How do we tell them where we went and what the world looked like when we were at that place and they were not?

When I was young, my father traveled extensively for his work. He went to far-off corners of the world and to small towns within the United States, all of which, to my young mind, seemed equally remote. We who stayed behind wanted to know what each trip was like and what Dad did there. He was good about bringing us back "mementos": a bar of soap from a hotel, a plastic swizzle stick, or a coin in some new currency, and (most interesting of all) he would always send a postcard. There would be a message, of course, on the back; short, descriptive, familiar, sometimes referring to the scene depicted on the front, sometimes not. Because of this, decades later, though I have yet to see many of the places he visited (Budapest, Sydney, even Houston), I still have a vision of what they were like, a vision crafted through the ephemera of those journeys.

Similarly, it seems to me that artists' ephemera—whether a postcard, invitation, poster, piece of stationary, sticker, or small object—serves as a souvenir and relic of another kind of journey, the journey of an artist through a life of art-making and exhibitions. Once that similarity is noted, however, artists' ephemera moves beyond nostalgia, and other stories emerge. Certain pieces of this ephemera begin to tell the story of how art moved out into new territo-ries, into time, into the world and away from the object. With these sorts of "movements" afoot, it is perhaps only appropriate to tell this particular story in terms of travel and to use the idea of maps and the vocabulary of location to speak of the journeys that were made. In order to experi-ence these artists' works, we must learn to read the frag-ments that they have sent to us from these new locations. The ephemera they have generated become our signposts, our passports, and our guidebooks into the areas where art now resides.

WISH YOU WERE HERE

Soon after art moved out into the world and began occu-pying spaces outside of galleries—the corners of cities and the woods and hills beyond—postcards from those new frontiers began to drift back and arrive in the mailbox. These cards no longer just informed the recipient of gallery hours or when the opening reception would take place. Rather, they revealed that art was being generated in distant places or already had been exhibited, perhaps days or even weeks before.

Whether communicating about a specific place or a part of a journey, or whether by picture or comment, one of the principal uses of postcards is as locator. It is a way to say to the recipient: "As I write to you, I am here." In this way postcards become markers that allow the receivers a place from which to survey the senders' movements and/or activ-ities. Contained in this act of location and reception/sending and receiving, there is also a tacit hope that the card will

bridge some of the distance that separates sender and receiver, and that in doing so it will communicate the sender's experience of being "me, here" to the receiver, who becomes "you, there."

Two postcards by Eleanor Antin serve to illustrate how a postcard becomes an agent of location. The images on the face of these cards show a baked dry California hillside. One of the images shows a trail of black riding boots progressing up the hillside trail in pairs and coming to rest at a wooden emplacement. On the back of the postcard, the description of the image reads: "Eleanor Antin, 100 Boots on Reconnaissance, Sorrento Valley, California, June 24, 1972, 9:30 A.M. (Photo: Philip Steinmetz)." The other image shows the same hillside from a different view, but in this instance there are no boots visible at all. Its description reads: "Eleanor Antin, 100 Boots Over the Hill, Sorrento Valley, California, June 24, 1972, 9:40 A.M. (Photo: Philip Steinmetz)." Beyond the description there is little other information on the back of the card. On each of them there is a typed address label and a postmark ("5 Mar. 1973" and "5 Feb. 1973," respectively).

From just this small amount of information, it is possible to determine two important facets of the work. The first is that the work—i.e., the work that is authored by Antin—lies in the act of arranging the boots in the landscape. By noting that the photographs were taken by someone other than the artist, the receiver might well rule out the idea that Antin's work could be simply the photograph, which the postcard is reproducing. The second detail that registers is that because the postcard was mailed more than a year after the boots were arranged and photographed, there is no real possibility that we can make a trip to Sorrento Valley to see the boots. The postcard is documenting an ephemeral and temporary artwork that can only be witnessed through the agency of the card.

These two postcards are a small segment of a larger work called *100 Boots*. *100 Boots* was a multiyear project in which Antin arranged and documented a group of one hundred black boots in a successive sequence of circumstances and a variety of indoor, urban, and rural settings. Photographs documented this set of temporary arrangements, and the resulting work is an amalgam of performance, installation, and photographic documentation. Rather than simply show the work by hanging the documents on the wall of a gallery, Antin chose instead to publish postcards of each of the

arrangements and mail them individually and sequentially to one thousand people, each of whom received the entire set of postcards between 1971 and 1973.

Because Antin's work was both temporary and specific to a remote location, it occupies a different "position" than a painting or a sculpture. The traditional model of the relationship between artist, work, and audience could be diagrammed as follows:

Artist ———> Work ———> Audience

One important facet of this set of relationships is that the audience is in the presence of the artwork. It is encountered as both "here" and "now." Antin's work reconfigures this relationship by moving the location of the work away from the audience: the audience does not see the work, only the postcard that documented it. They encounter the work "there" and "then," with the postcard serving to connect the viewer with the removed work. A diagram of the new relationship would look like this:

Artist ———> Work ———> Document ———> Audience

Antin, of course, was not alone in repositioning the work and the audience in this way. This relocation of art was a major feature of much of the contemporary work created in the late 1960s and early 1970s, and it continues into the present. British Earth artists such as Richard Long and Hamish Fulton made landscape interventions far from even the possibility of a viewer encountering them, and they also frequently used photographs to create a document that served to navigate the distance between the viewer and the work. Artists working with performance and the body as a site for action-based art, such as Marina Abramovic, relied on the creation of documents to register their ephemeral gestures.

What is singular about *100 Boots* is Antin's decision to complete the work through the distribution of postcards directly to an audience. In many ways, the postcard is ideally suited for the task: while going to a gallery to view the "there and then" is—or was—an atypical experience, "there and then" is precisely how we are accustomed to regarding postcards. To receive a postcard is to receive an opportunity for mental travel: we are taken from our location, and through the medium of the card we are taken to its point of origination.

SPINNING YARNS

Moving forward twenty-six years, a postcard by the artist
Francis Alÿs continues this tradition of mental travel. The
postcard shows the lower half of a man seen from the
back. The man, who is clad in a light-blue sweater, walks
away from the camera. From his left sleeve a single strand
of yarn trails off onto the sidewalk, leading back to where
he has come from. Superimposed on the image is a type-
written text that reads:

> Here is a fairy tale for you
> Which is just as good as true
> What unfolds will give you passion
> Castles on the hill & also treason
> .How, from his cape a fatal thread
> To her window the villains led

The card is titled *the loser/the winner*, and it is a fragment
of a larger work of the same name which was created by
Alÿs in Stockholm in 1998. In this piece Alÿs linked two
different museums in Stockholm—the Museum of Science
and Technology and the Nordic Museum—creating a single
work displayed in two parts, one located at each museum.
As a unifying action to connect the two locations, Alÿs
walked from one to the other while wearing a blue sweater
from which a single loose strand was moored at the
starting point. As he made his way forward, the sweater
became "un-made." It slowly transformed itself back into
a single thread that connected both the two locations and
the beginning and end of the walk. At each museum Alÿs
displayed one painting of a man walking through a dark
wood; each work was similar to but not exactly like the
other. Near each painting stood a rack that contained
unlimited copies of the postcard described above. These
postcards were free for museum visitors to take with them.

What is interesting is how the postcard operated in this
work. While Alÿs's postcard functions, like Antin's *100
Boots*, to document the ephemeral "there and then," it also
demands something different from the audience: namely,
the audience, if they are to "see" the entire work, must walk
the same or a similar path as the artist in order to make
their own link between the two spaces. As they traverse the
distance, it is possible that they are also carrying the
postcard, which they picked up at the first museum, with
them. Their own walk is then superimposed onto Alÿs's,
and the postcard becomes something like a guide or an

Francis Alÿs
FRANCIS ALÿS. "the loser/
the winner", 1998.
Stockholm, Sweden.
@ insertions @ Archipelago.
1998.
Postcard.
REF NO. 8

MONO LAKE SITE ROBERT SMITHSON DWAN GALLERY 29 W 57 NEW YO

echo of the original gesture. Likewise, there is also an echo of the "fairy tale" mentioned in the postcards' text as the "story" of the walk is carried by the receiver into the present. The postcard, in this case, links the "there and then" with the "here and now"; like any good fairy tale or fable, the possibility exists with each new telling that it will come true again, unfolding for each of us.

In addition to *the loser/the winner*, Alÿs has explored the use of the postcard in many other works. Over the last ten years he has made many "*paseos*," or walks, like the one undertaken in Stockholm. He punctured a paint can to create a small hole, and he then walked through the streets of São Paulo leaving a thin trail of paint (*The Leak*, 1995). He traveled from Tijuana to San Diego without crossing the U.S/Mexican border, a circuitous journey that took him around the entire Pacific Rim to eventually arrive at his destination (*The Loop*, 1997). He arranged a walk for two people, each of whom carried half of a tuba as they strolled through Venice until they met, whereupon they joined the separate halves and played a song (*Duet*, 1999). No other artist currently explores so thoroughly the use of

the postcard as an integral component of his or her works. For every walk that Alÿs has made, he has produced a post-card. The postcards are always available when the walk is displayed, and they are always free.

A LEGEND AND A DISLOCATION

It is difficult to say for certain where some maps will lead. In 1969, upon opening an envelope from the Dwan Gallery one was presented with a map designed by artist Robert Smithson. The map acted as an invitation to an exhibition, and it did contain information about a gallery. However, after reading this map carefully one finds that even as it points to the gallery, it also leads the recipient into areas of uncertainty and suspect terrain.

The map is itself an interesting and singular object. Even when folded it is clearly not an ordinary map, and it is certainly not an ordinary invitation to an art exhibition. Folded, it measures just three-quarters of an inch in height and four-and-a-half inches in length; unfolded it extends to approximately thirty-two inches long. On one side of the

Robert Smithson
MONO LAKE SITE MONO
LAKE NONSITE. ROBERT
SMITHSON. NONSITES.
Dwan Gallery, New York, N.Y.
February 1–27, 1969.
Announcement.
(front and back view).
REF NO. 427

OPENS SATURDAY FEBRUARY 1-27 1969 NONSITES MONO LAKE NONSITE

invitation is a section of a map whose right edge shows the tip of Manhattan and left edge shows Mono Lake (in California), with the remainder of the United States in between. On the reverse side there is a long line of text. From left to right the text reads "Mono Lake Site" on the left margin and ends with the words "Mono Lake Nonsite" at the far right. Between these poles, the address of the Dwan Gallery and the date and title of Smithson's show are printed in a single line.

A map's legend is the body of text on the margins which describes how its symbols and content are to be read and interpreted. It is helpful in the case of Smithson's map to consider the words "site" and "nonsite" in a similar light, because they serve as the legend for understanding its interpretation. The map clearly indicates that the site is located in California and the nonsite is in New York. This serves to realign the map reader to a new set of cardinal points: after all, the card invites one to a New York gallery to look at Smithson's artwork, yet it implies a different relationship between periphery and center. On another level the map serves as a guide to understanding the set of

relations contained in the works of art in the exhibition. Smithson's *Nonsites* are a series of open-topped geometric bins that contain stones, dirt, or some combination of the two. On the wall above the bins are hung framed maps and photographs. The information in the frames leads the viewer to understand that the material in the bins (the nonsite) has been collected from an area shown in the maps (the site).

During his short career Robert Smithson's work included critical writing, large-scale earthworks, and minimalist sculpture. Many feel that one of his most important and original contributions to the developing trajectory of contemporary art was the creation of the *Nonsites*. Through these works Smithson configured new relationships that would come to be central to the emerging mediums of "Conceptual," "Post-Object," and "Performance" art (and indeed, it is these sets of relations that Antin worked with in *100 Boots*). The *Nonsites* insisted that what was seen in the gallery—the collection of stones or earth—was a page short of the whole story. The presence of the map on the wall insists that the remote place of origin, not the sculp-

ture physically before you, is the location of the site. It is the "original" location of the work, thus placing the resulting sculpture—the nonsite—in a contingent position.

Smithson saw *Nonsites* as inherently dialectical and unstable objects. Their contingent status continually led the viewer away, both from the work before them and from the gallery that contained them. Once outside of the exhi-

bition space's white walls, however, the site itself was difficult to find with any degree of certainty. If someone were to follow the map, they would arrive at a place that was uncontainably large, a place that merged into adjacent sites and could be understood only as an approximate space. This endpoint, this "dead end," then leads the viewer back to the gallery, where the *Nonsite*, bordered and finite, sits—the only part of the site which can be circumscribed by our view.

Of course, the invitation/map does not explain all of these relationships explicitly, nor does it describe to viewers exactly what they will find at the *Nonsites* or what meanings they might uncover there. But the map functions as any map should because it opens a path for the viewer to enter the territory, while its legend gives them some idea of what the territory will contain. In this case, the map and its legend lead the viewer to both see the exhibition of nonsites and to discover that the actual region—the site, the larger picture itself—will be elsewhere, permanently inaccessible.

AT THE CROSSROADS

Imagine that you are walking alone in the city in which you live. You come around a corner, almost home. A stranger approaches, smiling. As you smile back, he hands you a piece of paper and waits for you to read it, and he explains briefly that he is an artist who is interested in making a sculpture in collaboration with you. You are confused, perhaps nervous, and certainly not ready to make a sculpture with a complete stranger, but you cannot simply walk away. As you read the text given to you and listen to the man, you realize that he is telling you that the making of the sculpture has already begun.

Welcome to right here. Ben Kinmont's work moves the location of art one step farther away from the gallery and two steps forward from the past. Over the last decade Kinmont's art has manifested itself primarily through the instigation of specific encounters between himself and other individuals who are at once the audience and co-creators of the work. Ben Kinmont left in a gallery a stack of paper plates that were printed with an invitation to the recipient of the plate to come to his house for breakfast (*Waffles for an Opening*, 1991). He approached people on the street to ask them to allow him to help with their dishes or housework (*Forse*, 1995). He persuaded the owner of an expensive fashion boutique to allow anyone from the street

Ben Kinmont
WE ARE THE SOCIAL
SCULPTURE! THIS IS THE
THIRD SCULPTURE! YOU ARE
THE THINKING SCULPTURE!
[Self-published]. 1991.
Flyer/"catalytic text."
REF NO. 1126

WE ARE THE SOCIAL SCULPTURE!

THIS IS THE THIRD SCULTPURE!

YOU ARE THE THINKING SCULPTURE!

I wish to share an understanding of life. But first I want you to slow down and listen. Notice the fear, the love and energy that is our sculpture, our community. We are of that sculpture, we together, you and I, and those around us; and because we are all joint creators, co-creators in a piece that includes the poor, the rich, the patriotic, and the sick, we must realize that the act of the individual is the act of the community. We must learn to accept ourselves as sculptors and the sculpted.

Remember to have compassion for yourself, the other, and our space that lies in between. Because we are a culture based on the individual, one of private goals and loneliness, we need to start with the personal, the moments where we feel fear and joy and create understanding. We must leave behind the American poet's declaration that "I am a multitude" and realize that we are a multitude. WE ARE A MULTITUDE.

Ben Kinmont, 1991.

to come in and exchange the shirt "off their back" for one of the shirts for sale in the store (*Exchange*, 1995). His work is generous, relational, and wholly concerned with art manifested in the present and as the product of an exchange, or contract, between him and the recipient.

Kinmont disperses and delivers his work through what he terms "catalytic texts." These are small photocopied fliers, which he hands out on the street; they describe to the recipient who Kinmont is and what he is interested in creating with them. The work of art in this case is not located in an object and not located at a site made remote through time or place. The work of art is located precisely at the moment of interaction between the artist and the audience, at the crossroads of two intersecting paths, and it occupies a space created by that interaction for as long as it continues. The catalytic text becomes a passport to allow travel into this newly created space.

Looking at several of these catalytic texts today, removed from the artist and the streets where they were passed out, they seem somehow mute—they no longer permit the artist to enter my home, nor do they provide me with breakfast or a shirt. The simple sheets that once instigated and outlined an artwork in the present are now relics, yet there still remains an evocation in these texts. The actions they invite can still be undertaken in a new context, between a new set of participants. In this way, the texts never fully become relics: they are still passports that contain all that is required for a trip through the portals between art and life. They serve as invitations to all to become part of the social sculpture.

THRESHOLD

Once upon a time, before Francis Alÿs told the story of the loser and the winner and before Robert Smithson's trip to Mono Lake, a small advertisement appeared in the back pages of *Art and Artists* magazine. It was tucked in a column between small announcements of exhibitions and openings. The ad was a terse instruction: "Go to Eros fountain and throw in all your jewelleries." The work was called *Fountain Piece*, an instruction piece created by Yoko Ono in 1966, one of many such works created by the artist during the 1960s. She envisioned these installation pieces as scores, or directions for works that could be made by anyone: you, her, or anyone else. These works continually exist, now and in the future, always ready to be made

Forse. Rallenta. Dal momento che teniamo l'uno all'altro tu sei la mia visione e io lo sono per te. Siamo giunti qui mentre andavamo da qualche altra parte, andavamo a fare spese, a vedere ancora un po' d'arte, o andavamo a trovare un amico. Questi percorsi ogni tanto si incrociano, come i nostri oggi, e creano l'opportunitá di colmare un vuoto che separa l'uno dall'altro. Da un pensiero o un momento ad un altro. Ti chiedo di aiutarmi a colmare il vuoto che separa il mondo dell'arte dal mondo della non-arte. Se faremo cosí potremo creare un clima di fiducia e di generosità fra me e te. Forse potrei aiutarti nei lavori domestici per dividere le tue responsabilitá quotidiane. Forse in cambio potremo parlare delle mie preoccupazioni sulla dinamica arte-vita e tu potresti aiutarmi a fare una scultura.

Perhaps. Slow down. In so far as we care for one another, you are my vision and I am for you. We have come to this place on our way to something else, on our way to buy groceries, to see more art, or to visit a friend for a cup of coffee. These pathways sometimes cross, as ours have today, and create the opportunity for bridging a gap that separates the self from the other. From one idea or moment to another. I am asking you to help me bridge the gap which separates the art world from the non-art world. In so doing, perhaps we can create a situation of trust and generosity between myself and you. Perhaps I can help you with a household chore to share in your daily responsibilities. Perhaps, in exchange, we could discuss my concerns about the art-life dynamic and you could help me to make a sculpture.

anew. By placing the piece in a small corner of the art magazine's ad section, away from the articles and reviews, Ono created the possibility that the *Fountain Piece* could be simply happened upon—it could be found by someone reading that page for some specific purpose with no relation to the instruction that she planted there. The work thus becomes a disconnect between what one expects to find in a place and what is actually there. In this way *Fountain Piece* prefixes later disconnects created by artists like Eleanor Antin, who also created works that moved away from where they were supposed to reside by instead placing them out in the world. *Fountain Piece* is also an invitation, and in this way the work on the page functions as a kind of ticket. It lets you pass through a door: on one side you are reading a magazine; on the other you are finishing an artwork by performing a score created by the artist. And in the end, of course, *Fountain Piece* is not really there at all. It is not "in" the pages of that 1966 magazine any more than it is "in" the pages of this catalogue. The advertisement simply serves as a signpost, similar to the social sculptures of Ben Kinmont, which will lead one to complete the artwork yourself. And it can be started—and finished—over and over again.

One final detail about *Fountain Piece*: along the margin Yoko Ono added the words "cut out and save." This slightly perplexing request seems to go against the intent of the rest of the work. If she wanted people to save the work, why did she hide it in a magazine? And if the work is to be completed in the mind of the receiver, then why bother asking people to save the signpost? Why keep the ticket stub once the show is over?

There are two possible answers. The first is that your trip to the Eros fountain might turn out to be neither simple nor short, and you might need to carry the directions for a long time, tucked in your wallet or front pocket, with all "your jewelleries" in hand. And the other answer? Well, when you return from the journey, from the cities and the seas, you might want to have that slip of paper in hand to give to your children.

MILAN
CADARIO Via Dell Spiga 7
 Gianni Secomandi Oct 13-25
DELL'ARIETE Via S. Andrea 5
 Franco Angeli from Oct 5
PATER Via Borgonuovo 10
 Mario Alinovi – Oct
SCHWARZ Via Gesu 17
 Modern Italians

ROME
ARCO D'ALIBERT vicolo Orto di
 Napoli
 Young Contemporary Italian Painters
LA MEDUSA 124 Via del Babuino
 Burri, Appel, Morandi, etc.
LA SALITA Via Gregoriana 5
 Festa, Lorenzetti, Mauri, etc.
LA TARTARUGA Piazza del Popolo 3
 Young Contemporary Italian Painters
L'OBELISCO 146 Via Sistina
 ' The Light ' – Oct
MARLBOROUGH Via Gregoriana 5
 Graphic Works by Contemporary artists
 – Oct
ODYSSIA Via Ludovisi 16
 Gallery Group Show – Oct
SCHNEIDER Rampa Mignanelli 10
 Thieler Oct 4-24
 Manlio from Oct 26
VIA MARGUTTA
 Art Fair – Oct

VENICE
L'ELEFANTE Campo S. Provolo 4707
 Van Amen Oct 7-21

COPENHAGEN
COURT Ostergade 24
 Tajiri: sculptures – Oct
GAMMEL STRAND Gl Stand 44
 Dirke Dietz Oct 14-30
KUNSTFORENINGEN
 Asgrimur Jonsson Oct 15-Nov 11
KUNSTKRED IOKALER
 Ane Brugger Oct 18-31
MARYA Bredgade 37
 Hans Meyer Petersen Oct 13-Nov 1

HUMLEBAEK
LOUISIANA MUSEUM Humlebaek
 Oluf Host Nov 8-20

MALMO
MUSEUM OF MODERN ART
 Vincent Van Gogh to Oct 23

STOCKHOLM
KONSTNARSHUSET Smalandsgatan 7
 Gallery Group to Nov 2
LATINA Engelbrektsgatan 12
 Jean-Pierre Vielfaure Oct 15-Nov 3
MODERNA MUSEET
 Unga Fotografer (Young Photographers)
 1966 Oct 8-Nov 6
NATIONALMUSEUM
 Christina, Queen of Sweden Exhibition
 to Oct 16

SUNDSVALL
SUNDSVALL MUSEUM
 Kumi Sugai to Oct 17
 Johansson, Hagberg, Hoglund to Nov 1

AMSTERDAM
STEDELIJK MUSEUM
 Bill Copley Oct 14-Nov 20

ROTTERDAM
DELTA Witte de Withstraat 35a
 The Zekveld Follies Oct 21-Nov 31

BREMEN
KUNSTHALLE
 Max Beckmann to Oct 30
EMMY WIDMANN Schleifmuhle 40
 Alexander Camaro Oct-Nov

COLOGNE
WALLRAF-RICHARZ MUSEUM
 Graham Sutherland to Nov 6

DUSSELDORF
ALEX VOMEL Konigsallee 42 I
 Rolf Nesch to Oct 15
 Horst Skodlerrak from Oct 20
KUNSTVEREIN FUR DIE RHEIN-
 LANDE UND WESTFALEN
 Kunsthalle Heinrich-Heine-Allee 11a
 Mark Tobey to Oct 3

NIEPEL Grabenstrasse 11
 Eleven Pop Artists (Philip Morris
 Ed. New York) to Oct 28

HANOVER
DIETER BRUSBERG
 Fernando Botero to Oct 20
 Woldemar Winkler from Oct 25

MUNICH
FREIDRICH-DAHLEM Maximilianstr
 Young British Sculpture I to Nov 3

STUTTGART
MULLER Hohenheimerstrasse 7
 Stella Oct 15-Nov 25

BASLE
BEYELER Baumleingasse 9
 Pierre Bonnard to Nov 15

BERNE
MARBACH Neuengasse 28
 Auguste Luig

ST. GALLEN
IM ERKER Gallusstr. 32
 Hans Arp – Oct

ZURICH
GIMPEL & HANOVER Clariden-
 strasse 25 *Jean Tinguely* to Nov 5
SEMIHA HUBER Talstrasse 18
 Seven Italian Sculptors – Oct
SUZANNE BOLLAG Limmatquai 116
 Elsa Burckhardt-Blum from Oct 21
KUNSTHAUS
 18th-19th c British Paintings

MADRID
JUANO MORDO Villanueva 7
 Erwin Bechtold Oct 10-31

SKOPJE
MUSEUM OF CONTEMPORARY
 ART
 10 *American Pop Artists* – Oct

FOUNTAIN PIECE

*Go to Eros
fountain and
throw in all
your jewelleries*

cut out and save

YOKO ONO LONDON, SEPT, 1966

44

Jan Dibbets
On May 9 (friday), May 12
(monday) and May 30 (friday)
1969 at 3:00 Greenwich Mean
Time (9:00 EST) Jan Dibbets will
make the gesture indicated on
the overside at the place marked
"X" in Amsterdam, Holland.
Seth Siegelaub, New York,
N.Y. 1969.
Announcement card.
(front and back view).
REF NO. 120

On May 9 (friday), May 12 (monday) and May 30 (friday) 1969 at 3:00 Greenwich Mean Time (9:00 EST) Jan Dibbets will make the gesture indicated on the overside at the place marked "X" in Amsterdam, Holland.

Le 9 May (vendredi), le 12 May (lundi), le 30 May (vendredi) 1969 à 3:00 heures di l'après-midi GMT, Jan Dibbets fera le geste comme indiqué à ce verso à l'endroit marqué "X" à Amsterdam, Pays Bas.

Am 9 Mai (Freitag), 12 Mai (Montag) und 30 Mai (Freitag) 1969 um 3:00 Nachmittags (GMT), Jan Dibbets wird das Gebärde wie am anderen Seite machen auf der mit einem "X" bezeichneten Stelle in Amsterdam, Holland.

Op 9 mei (vrijdag), 12 mei (maandag) en 30 mei (vrijdag) 1969 om 3:00 uur 's middags (GMT), zal Jan Dibbets het gebaar, zoals op de andere kant van deze kaart, maken op de met een "X" gemarkeerde plek in Amsterdam, Nederland.

SETH SIEGELAUB NEW YORK

Mr. Douglas Huebler
6 So. Park
Bradford, Mass. 01830

Over the past three years since this project was initiated, many people have provided invaluable assistance in assuring its realization. My appreciation is largely beyond description and cannot be appropriately set out here in the usual space and time given over to acknowledgments. Nevertheless, a number of individuals should be singled out, because their contributions were essential to this endeavor.

For inititating this project on behalf of the CCAC Institute, I want to thank former Director Larry Rinder for giving me the opportunity to curate this exhibition. Because of the unexplored subject matter of the exhibition, Rinder has once again demonstrated his developmental and visionary powers in bringing new art information to the public. For keeping this project alive during the period when the Institute was without a director—as well as seeing it through to the end—I would like to profusely thank Assistant Director Kirstin Bach. For his insight and support I must also offer profound thanks to CCAC Institute Director Ralph Rugoff. The exhibition has required the support of numerous staff members of the College, all of whom I applaud; however, in particular I would like to extend special thanks to Hilary Chartrand, Courtney Fink, and Kim Lessard.

For producing a succinct essay concerning a number of complicated aspects of artists' ephemera, I am very pleased to thank Anne Mœglin-Delcroix. Equally, I express my appreciation to Ted Purves, whose unique perspective on the subject matter made for an engaging essay. Ted has been involved in many other aspects of this project, and I am deeply moved by his constancy and generosity. Finally, without the insight and rigor of collaborator Todd Alden, this project could have become a trackless waste. I cannot thank him enough for his patience and motivation throughout this often very trying process.

This publication has been supported by Tom Patchett and Smart Art Press long before the CCAC Institute initiated the project. Tom's interest in my curatorial projects has always gone well beyond appreciation, and he has previously produced several of my exhibitions and publications for Track 16 Gallery. Taking chances is never boring—so he has said on more than one occasion—and with this publication he has given us all a great opportunity. I thank him for his friendly criticism and considerable generosity, which, simply stated, made this publication possible. Also from the Smart Art Press family I would like to thank Pilar Perez, Cindy Ojeda, and Ransom Mayfield, who made every effort to make the publication process both enjoyable and rewarding. Copy editor Sherri Schottlaender and book designer Michele Perez also deserve many thanks for their essential contributions.

Without the assistance of colleague Yoon Ki Chai I would not have contracted to produce this project. It is impossible for me to acknowledge the full extent of her importance in keeping this overwhelming project going in the right direction—Yoon Ki has participated in every facet of the enterprise along the way. It has been a great privilege to work with her on this and the many other projects we have collaborated on over the last six years.

For assembling the materials for the exhibition, I would like to thank Todd Alden, Robert Barry, Alexandra Bowes, A. A. Bronson, Ernst Caramelle, Morey Chaplick, Jay Dandy, Constance Glenn, Rhona Hoffman Gallery, John Lindell, Michael Lowe, The Museum of Modern Art Library and Archives, Tom Marioni, Tom Patchett, the Louise Sloss Ackerman Library San Francisco Museum of Modern Art, Printed Matter, Ted Purves, Kay Rosen, and other private collectors.

Numerous artists spent many hours with me discussing their art and artists' ephemera in general. I would especially like to thank those artists I interviewed and those who helped in other ways, such as by loaning materials and allowing access to their personal archives: Martine Aballéa, Kim Abeles, Marina Abramovic, Eleanor Antin, Stephen Antonakos, Arakawa, David Askevold, Ay-O, Lutz Bacher, John Baldessari, Robert Barry, Bill Beirne, Barton Lidicé Benes, Lynda Benglis, Jonathan Borofsky, A. A. Bronson, Chris Burden, Daniel Buren, Richmond Burton, Luis Camnitzer, Ernst Caramelle, Claude Closky, Bruce Conner, Simon Cutts, Lowell Darling, Jan Dibbets, Peter Downsbrough, Sam Durant, Ger van Elk, Ernest T., John Fekner, Hans-Peter Feldmann, Gerald Ferguson, Sabato Fiorello, Joel Fisher, Sylvie Fleury, Terry Fox, Jochen Gerz, Paul-Armand Gette, Joe Goode, Hans Haacke, George Herms, Robert Huot, Jim Isermann, Stephen Kaltenbach, Allan Kaprow, Garry Neill Kennedy, Ben Kinmont, Komar & Melamid, Barbara Kruger, Louise Lawler, Jean Le Gac, William Leavitt, Cary Leibowitz, Les Levine, John Lindell, Richard Long, Chip Lord, Tom Marioni, Daniel Joseph Martinez, Bruce McLean, Pieter Laurens Mol, Dave Muller, Richard Nonas, Lucio Pozzi, Kay Rosen, Allen Ruppersberg, Edward Ruscha, Karen Shaw, Peter Schuyff, Mieko Shiomi, Alexis Smith, David Tremlett, Richard Tuttle, Ulay, Ben Vautier, Lawrence Weiner, Pae White, and Ian Wilson.

Finally, it is my pleasure to extend my sincere gratitude to the many other individuals and institutions who, in numerous ways, have made invaluable contributions to this project: Philip Aarons, Bill Allen, Paul Andriesse, Richard Axsom, David Basham, Robert Berman, Jean-Phillipe and Françoise Billarant, Kirsten Biller, Blum & Poe, Stephen Bury, Brian Butler, Roger Bywater, Shaun Caley, Eugenie Candau, Jean-Dominique Carré, the Chelsea School of Art Library, Christophe Cherix, Liz Cohen, Kaatje Cuuse, Anny De Decker, Sean Downey, Mike Dyar, Janis Ekdahl, Steven Fama, Thom Faulders, Alec Finlay, Adrienne Fish, Rosemary Furtak, John Goodwin, Bruce Hainley, Katherine Sidnam Heath, Jon Hendricks, Jean-Noël Herlin, Judith Hoffberg, Rose Holtz, Milan Hughston, Joan Hugo, Peter Huttinger, Catriona Jeffries, Carole Ann Klonarides, Walther König, Anne Kovach, Shmulik Krampf, Françoise Lambert, Wouter van Leeuwen, David Leiber, Lynn Letart, Bernd Lohaus, Sue Maberry, Mary Manning, Bernard Marcelis, Lawrence Markey, Matthew Marks, Jill Martinez, Egidio Marzona, Charlyne Mattox, Robin Moll, Ian Murray, the Otis College of Art and Design Library, Patrick Painter, Stephen Perkins, Andrew Pierce, Carrie Pilto, David Platzker, Robert Rainwater, David Raskin, Vivian Rehberg, Louisa Riley-Smith, Bennett Roberts, Will Rogin, Anne Rorimer, Joan Rothfuss, Harry Ruhe, Marvin Sackner, M.D., Rita Sartorius, Max Schumann, Cindy Smith, Gian Enzo Sperone, Laurie Steelink, Morgan Thomas, Michael Toy, Robert Violette, Angela Westwater, Pam Wihidden, Andrew Wilson, Beth Wilson, and William Wilson.

ACKNOWLEDGMENTS

Steven Leiber

Mieko (Chieko) Shiomi
SPATIAL POEM NO. 4.
shadow event.
[Self-published]. 1971.
Event score and printed sheet.
REF NO. 419

SHADOW

SPATIAL POEM NO. 4

shadow event

Make a shadow or shadows of the enclosed letter SHADOW on somewhere.
Please describe to me in details how you performed it········ ····about the place,
light source, duration, movement, deformation etc.
Your reports will be recorded on the world map.

٭ Performance period Dec. 11—31, 1971

٭ Reports should preferably be written in English and within about three
 hundreds words

٭ Please add to your report the date and time of your performance

SELECTED BIBLIOGRAPHY

MARTINE ABALLÉA
Aballéa
Martine Aballéa: Essai de Rétrospective. Limousin, France: Fonds Regional d'Art Contemporain, 1990. Texts by Martine Aballéa, Michel Nuridsany, and Jérôme Sans.

KIM ABELES
Abeles
Kim Abeles: Encyclopedia Persona A–Z. Los Angeles: Fellows of Contemporary Art, 1993. Texts by Kim Abeles, Karen Moss, and Lucinda Barnes.

ANT FARM
Ant Farm
Ant Farm 20/20 Vision. Houston, Tex.: Contemporary Arts Museum, 1973.

BAS JAN ADER
Ader (Andriesse)
Andriesse, Paul. *Bas Jan Ader: Kunstenaar/Artist*. Trans. Beth O'Brien and Ruth Koenig. Amsterdam: Openbaar Kunstbezit, 1988.
Ader (Irvine)
Bas Jan Ader. Irvine: Art Gallery, University of California, Irvine, 1999. Texts by Brad Spence, Thomas Crow, and Jan Tumlir.
Ader (Braunschweig)
Bas Jan Ader: Filme, Fotografien, Projektionen, Videos und Zeichnungen aus den Jahren 1967–1975. Braunschweig: Kunstverein Braunschweig; Bonn: Bonner Kunstverein; Munich: Kunstverein München, 2000. Texts by Christopher Müller and Frances Stark.

CARL ANDRE
Andre (Whitechapel)
Carl Andre: Sculpture 1959–1978. London: Whitechapel Art Gallery, 1978. Texts by Nicholas Serota.
Andre (Musée d'Art Moderne)
Carl Andre. Sculptures en Bois. Paris: Musée d'Art Moderne de la Ville de Paris, 1979.

ELEANOR ANTIN
Antin
Fox, Howard N. *Eleanor Antin*. Los Angeles: Los Angeles County Museum of Art; Los Angeles: Fellows of Contemporary Art, 1999.
Antin (100 Boots)
Antin, Eleanor. *100 Boots*. Philadelphia: Running Press, 1999.

DAVID ASKEVOLD
Askevold
David Askevold: Cultural Geographies. Charlottetown, Prince Edward Island, Canada: Confederation Centre Art Gallery and Museum, 1998. Texts by Terry Graff, Petra Rigby Watson, Mike Kelley, Cliff Eyland, and David Askevold.

JOHN BALDESSARI
Baldessari
van Bruggen, Coosje. *John Baldessari*. Los Angeles: The Museum of Contemporary Art; New York: Rizzoli, 1990.

ROBERT BARRY
Denizot/Barry
Denizot, René. *Word for Word: It's About Time/Mot Pour Mot: Il Est Temps*. Paris: Yvon Lambert, 1980.

WALLACE BERMAN
Berman
Wallace Berman: Support the Revolution. Amsterdam: Institute of Contemporary Art, 1992. Texts by Tosh Berman, Colin Gardner, Walter Hopps, Christopher Knight, Eduardo Lipschutz-Villa, Michael McClure, and David Meltzer.

JOSEPH BEUYS
Beuys
Joseph Beuys Plakate: Werbung für die Kunst. Munich: Schneider-Henn, 1991.

ALIGHIERO BOETTI
Boetti
Alighiero Boetti. London: Whitechapel Art Gallery, 1999. Texts by Antonella Soldaini, Giovan Battista Salerno, Shirazeh Houshiary and Mario Codognato, Sol LeWitt, and Diletta Borromeo.

CHRISTIAN BOLTANSKI
Boltanski
Flay, Jennifer, ed. *Christian Boltanski—Catalogue: Books, Printed Matter, Ephemera, 1966–1991*. Cologne: Walther König; Frankfurt am Main: Portikus, 1992.

MARCEL BROODTHAERS
Broodthaers (October)
Buchloh, Benjamin H. D., ed. *Broodthaers: Writings, Interviews, Photographs (October*, no. 42). Cambridge: MIT Press, 1987. Journal.
Broodthaers (Walker)
Marcel Broodthaers. Minneapolis: Walker Art Center; New York: Rizzoli, 1989. Texts by Michael Compton, Douglas Crimp, Bruce Jenkins, and Martin Mosebach.
Broodthaers (Jeu de Paume)
Marcel Broodthaers. Paris: Galerie Nationale du Jeu de Paume, 1991. Texts by Johannes Cladders, Jurgen Harten, Catherine David, and Birgit Pelzer.

CHRIS BURDEN
Burden 71–73
Burden, Chris. *Chris Burden, 71–73*. Los Angeles: [Chris Burden], 1974.
Burden 74–77
Burden, Chris. *Chris Burden, 74–77*. Los Angeles: C. Burden, 1978.

JAMES LEE BYARS
Byars (Valencia)
James Lee Byars: The Perfect Moment. Valencia: IVAM/Instituto Valenciano de Arte Moderno; Valencia: Generalitat Valenciana, Consellería de Cultura, 1995. Texts by Heinrich Heil, Rudi Fuchs, Ángel González García, Thomas McEvilley, and Kevin Power.
Byars (Weserburg)
James Lee Byars: Bücher—Editionen—Ephemera. Bremen: Neues Museum Weserburg Bremen, 1995. Texts by Thomas Deecke and Guy Schraenen.

ANDRE CADERE
Cadere
Andre Cadere: All Walks of Life. New York: The Institute for Contemporary Art, P.S. 1 Museum; Paris, Musée d'Art Moderne de la Ville de Paris, 1992. Texts by Cornelia Lauf, Bernard Marcelis, and Jean-Pierre Criqui.

ERNST CARAMELLE
Caramelle
Jahresmuseum 1997: Kunsthaus Mürzzuschlag. Mürzzuschlag, Austria: Kunsthaus Mürzzuschlag, 1999.

GUGLIELMO ACHILLE CAVELLINI
Cavellini
Cavellini, Guglielmo Achille. *Cavellini in California and in Budapest: The Living Room Show*. Brescia, Italy: Guglielmo Achille Cavellini, 1980.

JUDY CHICAGO
Chicago (Through the Flower)
Chicago, Judy. *Through the Flower: My Struggle as a Woman Artist*. New York: Penguin Books, 1993.
Chicago (Beyond the Flower)
Chicago, Judy. *Beyond the Flower: The Autobiography of a Feminist Artist*. New York: Penguin Books, 1997.

CLAUDE CLOSKY
Closky
Paul, Frédéric. *Claude Closky*. Paris: Éditions Hazan, 1999.

BRUCE CONNER
Conner
2000 BC: The Bruce Conner Story Part II. Minneapolis: Walker Art Center, 1999. Texts by Peter Boswell, Joan Rothfuss, and Bruce Jenkins.

COUM TRANSMISSIONS
Coum
Ford, Simon. *Wreckers of Civilisation: The Story of Coum Transmissions and Throbbing Gristle*. London: Black Dog Publishing, 1999.

MARCEL DUCHAMP
Duchamp
Schwarz, Arturo. *The Complete Works of Marcel Duchamp*. New York: Harry N. Abrams, 1968.

DONALD EVANS
Evans
Eisenhart, Willy. *The World of Donald Evans*. New York: Harlin Quist Books, 1980.

HANS-PETER FELDMANN
Feldmann
Lippert, Werner. *Hans-Peter Feldmann: Das Museum im Kopf*. Cologne: Walther König, 1989.

ROBERT FILLIOU
Filliou
Robert Fillliou [sic]. Paris: Éditions du Centre Georges Pompidou, 1991. Texts by Paul-Hervé Parsy, Roland Recht, Frédérique Mirotchnikoff, and Catia Riccaboni.

IAN HAMILTON FINLAY
Finlay (Abrioux)
Abrioux, Yves. *Ian Hamilton Finlay: A Visual Primer*. Edinburgh: Reaktion Books, 1985.
Finlay
Ian Hamilton Finlay and the Wild Hawthorn Press: A Catalogue Raisonné, 1958–1990. Edinburgh: Graeme Murray, 1990.

DAN FLAVIN
Flavin
Dan Flavin: Drawings, Diagrams and Prints, 1972–1975. Fort Worth, Tex.: Fort Worth Art Museum, 1976. Texts by Jay Belloli and Emily S. Rauh.

SYLVIE FLEURY
Fleury
Sylvie Fleury: The Art of Survival. Graz, Austria: Neue Galerie am Landesmuseum Joanneum, 1993. Texts by Peter Weibel, Eric Troncy, Christa Steinle, Alexandra Foitl, Adrian Dannatt, Elizabeth Hess, Valerie Filipovna, Elein & Co., and Peter Fend.

FLUXUS
Fluxus Etc.
Hendricks, Jon, ed. *Fluxus Etc.* Bloomfield Hills, Mich.: Cranbrook Academy of Art Museum, 1981.
Fluxus Codex
Hendricks, Jon. *Fluxus Codex*. Detroit: The Gilbert and Lila Silverman Fluxus Collection; New York: Harry N. Abrams, 1988.
Fluxus Etc. Addenda I
Hendricks, Jon, ed. *Fluxus Etc./Addenda I*. New York: Ink &, 1983.
Fluxus Etc. Addenda II
Hendricks, Jon, ed. *Fluxus Etc./Addenda II*. Pasadena, Calif.: Baxter Art Gallery, California Institute of Technology, 1983.

GENERAL IDEA
General Idea
General Idea: Multiples—Catalogue Raisonné, Multiples and Prints, 1967–1993. Toronto: S. L. Simpson Gallery, 1993.

JOCHEN GERZ
Gerz
Dufour, Gary. *Jochen Gerz: People Speak*. Vancouver: Vancouver Art Gallery, 1994.

PAUL-ARMAND GETTE
Gette
Paul-Armand Gette: Printed Matters, 1945–1993. Neckargemünd, Germany: Paul-Léon Bisson-Millet, 1993.

GILBERT & GEORGE
Gilbert & George
Gilbert & George: The Complete Pictures, 1971–1985. New York: Rizzoli, 1986. Text by Carter Ratcliff.
Gilbert & George (Jahn)
Jahn, Wolf. *The Art of Gilbert & George: Or, an Aesthetic of Experience*. London: Thames and Hudson, 1989.
Gilbert & George (Violette)
Violette, Robert, and Hans-Ulrich Obrist, eds. *The Words of Gilbert & George: With Portraits of the Artists from 1968 to 1997*. New York: Violette Editions; New York: D.A.P./Distributed Art Publishers, 1997.

FELIX GONZALEZ-TORRES
Gonzalez-Torres
Spector, Nancy. *Felix Gonzalez-Torres*. New York: Solomon R. Guggenheim Museum, 1995.

DAN GRAHAM
Graham
For Publication: Dan Graham. Los Angeles: Otis Art Institute, 1975.

HANS HAACKE
Haacke
Hans Haacke: Framing and Being Framed—7 Works 1970–75. Halifax: Press of the Nova Scotia College of Art and Design; New York: New York University Press, 1975. Texts by Jack Burnham, and Howard S. Becker and John Walton. Work by Hans Haacke.
Haacke (Unfinished Business)
Wallis, Brian, ed. *Hans Haacke: Unfinished Business*. New York: The New Museum of Contemporary Art; Cambridge: MIT Press, 1986. Texts by Leo Steinberg, Rosalyn Deutsche, Fredric Jameson, Brian Wallis, and Hans Haacke.

LYNN HERSHMAN
Hershman
Chimaera Monographie: Lynn Hershman. Montbéliard, France; Belfort, France: Édition du Centre International de Création Vidéo, 1992. Texts by Moira Roth, David James, Pierre Restany, Stephen Sarrazin, Diane Tani, and Lynn Hershman.

ROBERT INDIANA
Indiana
Sheehan, Susan. *Robert Indiana Prints: A Catalogue Raisonné, 1951–1991*.
New York: Susan Sheehan Gallery, 1991.

JIM ISERMANN
Isermann
Jim Isermann: Fifteen. Milwaukee: Institute of Visual Arts, University of
Wisconsin-Milwaukee, 1998. Texts by David Pagel and Michael Darling.

RAY JOHNSON
Johnson
Ray Johnson: Correspondences. Columbus, Ohio: Wexner Center for the
Arts; Paris: Flammarion, 1999. Texts by Donna De Salvo, Mason Klein,
Wendy Steiner, Jonathan Weinberg, Sharla Sava, Lucy R. Lippard,
William S. Wilson, and Henry Martin.
Johnson/Willenbecher
Wilson, William, ed. *Ray Johnson, John Willenbecher*. New York: Between
Books, 1977.

DONALD JUDD
Judd
Judd, Donald. *Donald Judd: Complete Writings, 1959–1975*. Halifax: Press
of the Nova Scotia College of Art and Design; New York: New York
University Press, 1975.

YVES KLEIN
Klein
Yves Klein. Paris: Musée National d'Art Moderne, Centre Georges
Pompidou, 1983. Texts by Pierre Restany, Thomas McEvilley, Nan
Rosenthal, Carol Mancusi-Ungaro, Michel Conil-Lacoste, Claude Parent,
et al.

JOSEPH KOSUTH
Kosuth/Morris
Joseph Kosuth, Robert Morris. Bradford, Mass.: Laura Knott Gallery,
Bradford Junior College, 1969.

BARBARA KRUGER
Kruger
Barbara Kruger. Los Angeles: The Museum of Contemporary Art;
Cambridge: MIT Press, 1999. Texts by Rosalyn Deutsche, Katherine
Dieckmann, Ann Goldstein, Steven Heller, Gary Indiana, Carol Squiers,
and Lynne Tillman.

LES LEVINE
Levine
Les Levine Copies Everyone. Toronto: The Isaacs Gallery, 1970.

SOL LEWITT
LeWitt
Legg, Alicia, ed. *Sol LeWitt*. New York: The Museum of Modern Art, 1978.
LeWitt Retrospective
Garrels, Gary, ed. *Sol LeWitt: A Retrospective*. San Francisco: San
Francisco Museum of Modern Art; New Haven, Conn.: Yale University
Press, 2000.

RICHARD LONG
Long
Richard Long: Postcards, 1968–1982. Bordeaux: CAPC Musée d'Art
Contemporain, 1984.

BRICE MARDEN
Marden
Brice Marden: Paintings, Drawings and Prints 1975–80. London:
Whitechapel Art Gallery, 1981. Texts by Nicholas Serota, Stephen Bann,
and Roberta Smith.

TOM MARIONI
Marioni
The Sound of Flight: Tom Marioni. San Francisco: M. H. de Young Memorial
Museum; San Francisco: Gallery Paule Anglim, 1977.

DANIEL MARTINEZ
Martinez
Daniel J. Martinez: The Things You See When You Don't Have a Grenade!
Santa Monica, Calif.: Smart Art Press, 1996. Texts by David Levi Strauss,
Coco Fusco, Mary Jane Jacob, Susan Otto, Victor Zamudio-Taylor, and
Roberta Bedoya.

GUSTAV METZGER
Metzger
Gustav Metzger: "Damaged Nature, Auto-Destructive Art." London:
Coracle@Workfortheeyetodo, 1996. Texts by Gustav Metzger, Andrew
Wilson, and Clive Phillpot.

ROBERT MORRIS
Morris
Cherix, Christophe. *Robert Morris: Estampes et Multiples, 1952–1998*.
Geneva: Cabinet des Estampes du Musée d'Art et d'Histoire; Chatou,
France: Maison Levanneur, Centre National de l'Estampe et de l'Art
Imprimé, 1999.
Morris (Labyrinths)
Berger, Maurice. *Labyrinths: Robert Morris, Minimalism, and the 1960s*.
New York: Harper and Row, 1989.

N. E. THING CO. LTD. (IAIN & INGRID BAXTER)
N. E. Thing Co. Ltd.
Baxter, Iain. *Media Works*. Toronto: Art Metropole, 1992.

BRUCE NAUMAN
Nauman
van Bruggen, Coosje. *Bruce Nauman*. New York: Rizzoli, 1988.
Nauman (Walker)
Bruce Nauman. Minneapolis: Walker Art Center; Washington, D.C.:
Hirshhorn Museum and Sculpture Garden; New York: D.A.P./Distributed Art
Publishers, 1994.

CLAES OLDENBURG
Oldenburg
Axsom, Richard H., and David Platzker. *Printed Stuff: Prints, Posters, and
Ephemera by Claes Oldenburg—A Catalogue Raisonné, 1958–1996*.
New York: Hudson Hills Press; Madison, Wisc.: Madison Art Center, 1997.

YOKO ONO
Ono (Arias and Objects)
Haskell, Barbara, and John G. Hanhardt. *Yoko Ono: Arias and Objects*.
Salt Lake City, Utah: Gibbs Smith, 1991.
Ono
Munroe, Alexandra, with Jon Hendricks. *Yes Yoko Ono*. New York: Japan
Society; New York: Harry N. Abrams, 2000.

ROBERT RAUSCHENBERG
Rauschenberg
Robert Rauschenberg: Prints 1948/1970. Minneapolis: Minneapolis Institute
of Arts, 1970. Text by Edward A. Foster.

MARTHA ROSLER
Rosler
De Zegher, Catherine, ed. *Martha Rosler: Positions in the Life World*.
Birmingham, England: Ikon Gallery; Vienna: Generali Foundation;
Cambridge: MIT Press, 1998.

ALLEN RUPPERSBERG
Ruppersberg
Allen Ruppersberg: Where's Al? Grenoble, France: Magasin—Centre National d'Art Contemporain, 1996. Texts by Catherine Quéloz, Dan Cameron, and Allen Ruppersberg.

EDWARD RUSCHA
Ruscha
Edward Ruscha: Editions 1959–1999. Minneapolis: Walker Art Center; New York: D.A.P./Distributed Art Publishers, 1999. Texts by Siri Engberg and Clive Phillpot. 2 volumes.

MIEKO (CHIEKO) SHIOMI
Shiomi
Shiomi, Mieko. *Spatial Poem: Mieko Shiomi.* Osaka: Mieko Shiomi, 1976.

ROBERT SMITHSON
Smithson (Writings)
Holt, Nancy, ed. *The Writings of Robert Smithson.* New York: New York University Press, 1979.
Smithson
Hobbs, Robert Carleton. *Robert Smithson: Sculpture.* Ithaca, N.Y.: Cornell University Press, 1981.

DANIEL SPOERRI
Spoerri
Wenn alle Kunst untergehn die edele Kochkunst bleibt bestehn: Daniel Spoerri. Amsterdam: Stedelijk Museum, 1971.
Spoerri (CNAC)
CNAC Archives: Daniel Spoerri. Paris: CNAC/Centre National d'Art Contemporain, 1972.

ERNEST T.
Ernest T.
Ernest T. : Art Department, Catalogue 1990. Paris: Galerie Gabrielle Maubrie; Geneva: Galerie Éric Franck, 1990.

DAVID TREMLETT
Tremlett
David Tremlett. London: Serpentine Gallery, 1989. Texts by Liliana Albertazzi and Lieven van den Abeele.

RICHARD TUTTLE
Tuttle
Richard Tuttle. Amsterdam: Institute of Contemporary Art; The Hague: SDU Publishers, 1991. Texts by Richard Tuttle, Susan Harris, Richard Marshall, and Dieter Schwarz.

ULAY
Ulay
McEvilley, Thomas. *Ulay: Der erste Akt.* Ostfildern, Germany: Cantz, 1994.

ULAY/MARINA ABRAMOVIC
Ulay/Abramovic
Abramovic, Marina, and Ulay. *Relation Work and Detour.* Amsterdam: Ulay and Marina Abramovic, 1980.

ANDY WARHOL
Warhol
Feldman, Frayda, and Jörg Schellmann. *Andy Warhol Prints: A Catalogue Raisonné 1962–1987.* 3d ed. New York: D.A.P./Distributed Art Publishers; New York: Ronald Feldman Fine Arts, 1997.

LAWRENCE WEINER
Weiner (Buchloh)
Buchloh, Benjamin H. D., ed. *Lawrence Weiner: Posters, November 1965–April 1986.* Halifax: Press of the Nova Scotia College of Art and Design; Toronto: Art Metropole, 1986.
Weiner (Schwarz)
Schwarz, Dieter. *Lawrence Weiner: Books, 1968–1989.* Cologne: Buchhandlung Walther König; Villeurbanne, France: Le Nouveau Musée, 1989.
Weiner
Some Things Brought to Hand: The Multiples of Lawrence Weiner. New York: Marian Goodman Gallery, 1995.

GENERAL BIBLIOGRAPHICAL REFERENCES

Artforum
Newman, Amy. *Challenging Art: Artforum, 1962–1974.* New York: Soho Press, 2000.

Art in Los Angeles
Art in Los Angeles: Seventeen Artists in the Sixties. Los Angeles: Los Angeles County Museum of Art, 1981.Texts by Maurice Tuchman, Anne Bartlett Ayres, Susan C. Larsen, Christopher Knight, and Michael D. De Angelus.

Beyond the Picture
Beyond the Picture: Works by Robert Barry, Sol LeWitt, Robert Mangold, Richard Tuttle, from the Collection of Dorothy and Herbert Vogel, New York. Bielefeld, Germany: Kunsthalle Bielefeld, 1987. Texts by Erich Franz, Vivian E. Barnett, Barbara L. Myers, and Dorothy Vogel.

Bonnefantenmuseum
Over Wandelingen en Reizen (On walks and travels*).* Maastricht, The Netherlands: Bonnefantenmuseum, 1979. Text by Alexander van Grevenstein.

Buchstäblich Wörtlich
Glasmeier, Michael. *Buchstäblich Wörtlich, Wörtlich Buchstäblich.* Berlin: Staatliche Museen Preussischer Kulturbesitz, 1987.

Correspondence Art
Crane, Michael, and Mary Stofflet, eds. *Correspondence Art: Source Book for the Network of International Postal Art Activity.* San Francisco: Contemporary Arts Press, 1984.

Crow
Crow, Thomas. *Modern Art in the Common Culture.* New Haven, Conn., and London: Yale University Press, 1998.

Dwan
Virginia Dwan: Art Minimal—Art Conceptuel—Earthworks: New York, Les Années 60–70. Paris: Galerie Montaigne, 1991. Texts by Charles Stuckey, Virginia Dwan, and Jan van der Marck.

Fischer
Ausstellungen bei Konrad Fischer: Düsseldorf, Oktober 1967–Oktober 1992. Bielefeld, Germany: Edition Marzona, 1993.

Fröliche Wissenschaft
Kellein, Thomas. *Fröliche Wissenschaft: Das Archiv Sohm.* Stuttgart: Staatsgalerie Stuttgart, 1986.

Fucked Up + Photocopied
Turcotte, Bryan Ray, and Christopher T. Miller. F*ucked Up + Photocopied: Instant Art of the Punk Rock Movement.* Corte Madera, Calif.: Gingko Press Inc., Corte Madera, 1999.

Happening & Fluxus
Happening & Fluxus. Cologne: Kölnischer Kunstverein, 1970.

High Performance
High Performance, no. 20 (Los Angeles) (1983).

Hundertmark
Zehn Jahre: Edition Hundertmark, 1970–1980, Berlin-Köln. Berlin: DAAD-Galerie, 1980.

Information
McShine, Kynaston L., ed. *Information*. New York: The Museum of Modern Art, 1970.

Konzeption Conception
Konzeption-Conception: Dokumentation einer heutigen Kunstrichung/Documentation of Today's Art Tendency. Leverkusen, Germany: Städtisches Museum; Cologne and Opladen: Westdeutscher, 1969.

L'Art Conceptuel
L'Art Conceptuel: Une Perspective. Paris: Musée d'Art Moderne de la Ville de Paris, 1989. Texts by Claude Gintz, Benjamin H. D. Buchloh, Charles Harrison, Gabriele Guercio, and Seth Siegelaub.

Life/Live
Life/Live. Paris: Musée d'Art Moderne de la Ville de Paris, 1996. Texts by Laurence Bossé, Hans-Ulrich Obrist, David Batchelor, Rebecca Gordon-Nesbitt, et al. 2 volumes.

Lippard
Lippard, Lucy R., ed. *Six Years: The Dematerialization of the Art Object from 1966 to 1972*. London: Studio Vista, 1973.

Lippard (Changing)
Lippard, Lucy R. *Changing: Essays in Art Criticism*. New York: E. P. Dutton, 1971.

Maenz
Paul Maenz: Köln 1970–1975. Cologne: Paul Maenz, 1975. Texts by Paul Maenz and Germano Celant.

Meyer
Meyer, Ursula. *Conceptual Art*. New York: E. P. Dutton, 1972.

Multiples
Buchholz, Daniel, and Gregorio Magnani, eds. *International Index of Multiples from Duchamp to the Present*. Tokyo: Spiral/Wacoal Art Center; Cologne: Walther König, 1993.

NSCAD
NSCAD: The Nova Scotia College of Art and Design. Halifax: Press of the Nova Scotia College of Art and Design, 1982. Texts by Garry N. Kennedy, Kenneth Baker, Eric Cameron, and Benjamin H. D. Buchloh.

Out of Actions
Out of Actions: Between Performance and the Object, 1949–1979. Los Angeles: The Museum of Contemporary Art; New York: Thames and Hudson, 1998. Texts by Kristine Stiles, Guy Brett, Hubert Klocker, Shinichiro Osaki, and Paul Schimmel.

Out of the Box
Ratcliff, Carter. *Out of the Box: The Reinvention of Art, 1965–1975*. New York: Allworth Press, 2000.

Performance Anthology
Loeffler, Carl E., and Darlene Tong, eds. *Performance Anthology: Source Book for a Decade of California Performance Art*. San Francisco: Contemporary Arts Press, 1980.

Postkarten
Postkarten and Kunstlerkarten. Berlin: Galerie Arkade, Staatlicher Kunsthandel der DDR, 1978. Texts by Hartmut Pätzke, Klaus Werner, and Robert Rehfeldt.

Promised Relations
Kinmont, Ben. *Promised Relations; Or Thoughts Concerning a Few Artists' Contracts*. New York: Antinomian Press, 1996.

Reconsidering the Object of Art
Goldstein, Ann, and Anne Rorimer. *Reconsidering the Object of Art: 1965–1975*. Los Angeles: The Museum of Contemporary Art; Cambridge: MIT Press, 1995.

Sackner
The Ruth and Marvin Sackner Archive of Concrete and Visual Poetry, 1984. Miami Beach: Ruth and Marvin Sackner, 1986.

Secret Exhibition
Solnit, Rebecca. *Secret Exhibition: Six California Artists of the Cold War Era*. San Francisco: City Lights Books, 1990.

Something Else Press
Frank, Peter. *Something Else Press: An Annotated Bibliography*. Kingston, N.Y.: McPherson and Company, 1983.

Space/Time/Sound
Foley, Suzanne. *Space, Time, Sound: Conceptual Art in the San Francisco Bay Area—The 1970s*. San Francisco: San Francisco Museum of Modern Art, 1979.

Sperone
Gian Enzo Sperone: Torino Roma New York—35 Anni di Mostre tra Europa e America. Turin, Italy: Hopefulmonster, 2000. Texts by Anna Minola, Maria Cristina Mundici, Francesco Poli, and Maria Teresa Roberto.

Poinsot
Poinsot, Jean-Marc. *Mail Art: Communication à Distance, Concept*. Paris: Éditions CEDIC, 1971.

Pop Store
Glenn, Constance W. *The Great American Pop Store: Multiples of the Sixties*. Santa Monica, Calif.: Smart Art Press; Long Beach, Calif.: University Art Museum, California State University, Long Beach, 1997.

Szeemann
Dokumente zur Aktuellen Kunst 1967–1970: Material aus dem Archiv Szeemann. Lucerne, Switzerland: Kunstkreis AG, 1972. Texts by Georg Jappe, Aurel Schmidt, and Harald Szeemann.

Thinking Print
Wye, Deborah. *Thinking Print: Books to Billboards, 1980–95*. New York: The Museum of Modern Art, 1996.

Wide White Space
Wide White Space, 1966–1976: Hinter dem Museum. Düsseldorf: Richter Verlag, 1995. Texts by Yves Aupetitallot, Anny De Decker, Bernd Lohaus, Daniel Buren, Lawrence Weiner, Martin Visser, Isi Fiszman, and Johannes Cladders.

KEY TO THE EXHIBITION CHECKLIST

CATALOGUE SEQUENCE

The items are arranged alphabetically by artist last name, or by publisher for groups of ephemera produced by a single publisher. Within each artist and publisher grouping, the items are arranged chronologically; undated items are placed at the end of the sequence.

DESCRIPTIVE TITLE

In general, ephemera is not formally titled, and there are no strict conventions for cataloging this type of material. The descriptive titles correspond to the prominent text indicators that are materially important to the identification of each item. In some cases we included more than what was material for identification in order to preserve the integrity of the statement presented.

We have tried to preserve the punctuation and style formatting of the original (e.g., uppercase, lowercase letters) as often as possible. Periods are used to indicate line changes, punctuate endings of sentences or phrases, and demarcate categories of information (e.g., artist name. exhibition title.). Commas are occasionally added to break up strings of words or names that lack punctuation. These additions are intended to promote the readability of the entries.

Brackets [] are used to indicate a formal title given by the artist which does not appear on the item itself (e.g., Kennedy's [Verboten]), or an informal title that has become attached to an item through its discussion in contemporary literature (e.g., Kaltenbach's Artforum Ads). Additionally, bracketed ellipses [. . .] indicate the omission of subsequent text that appears on the item.

Parentheses () are used to indicate any other material information that may or may not be included on the item itself but which does not comprise the formal title. For example, translations of foreign-language titles are provided in parentheses in some cases. In the limited number of instances where no text appears on the item itself, all of the identifying information is placed in parentheses.

For texts presented in multiple languages, we have chosen the English version or the first language presented in the sequence where no English text is given. In general, we have tried to honor foreign-language punctuation conventions as often as possible given the limitations of a standard computer keyboard character set.

PUBLISHER

The publisher name and location (where available) are presented in standardized form: name, city, state/province, country (if outside the United States). We use the term "self-published" for items published by the artists themselves. Publisher information not indicated on the item itself but found through outside research is presented in brackets []. We use the abbreviation "n.p." in the cases where publisher information is not available.

DATE

The date of each item is given by month, day, and/or year, as available. For items associated with a span of time (e.g., announcement cards for exhibitions), the beginning and ending dates for that time period are provided where available. Dates not indicated on the item itself but found through outside research are presented in brackets []. We use the abbreviation "n.d." in cases where date information is not available.

FORMAT

The format of the item is described: e.g., "announcement card," "poster," "postcard." In a limited number of cases, the format is given as a series of items or set of items. A series of postcards is a grouping presented in a specific order by the artist; a set of postcards is a grouping presented in no specific order.

PHYSICAL DESCRIPTION

The physical description includes the printing process and other material physical attributes, such as whether the item is folded, printed on both sides, or stapled. Other miscellaneous details are also included, such as rubber stamps and handwritten additions. Where there is more than one component to the item, the printing process refers to all components unless otherwise indicated.

EDITION SIZE AND SIGNATURE

The edition size provides the number of items printed in the edition. Numbering within the edition is also indicated, as well as the presence of the artist's signature. The vast majority of the ephemera presented here is neither editioned nor signed.

MISCELLANEOUS

This category includes any other information relevant to the description of the item, including information regarding the photographer of the image reproduced, the editor(s) of a publication, contributors to a publication, the designer, and so on.

DIMENSIONS AND PAGE NUMBERS

Dimensions are given in inches in the order of height, width, and depth (where applicable). For relevant formats, the number of pages are provided, and unpaginated items are indicated as such.

NOTES

Notes include any other facts that help to place the item in context, such as information on modes of distribution, multiple or variant versions published, and additional descriptions necessary for identification.

REFERENCE

References to abbreviated titles of monographs, exhibition catalogues, artist's publications, and artist's books are provided where the items are reproduced, cited, or discussed, or where information of related interest is presented. Page numbers are not given in cases where the reference is not paginated. The full bibliographical citations can be found in this catalogue's Selected Bibliography. Publications are arranged alphabetically by artists' names (chronologically within each artist's name) and by abbreviated titles within the general reference material category.

EXHIBITION CHECKLIST

1. **MARTINE ABALLÉA**
 Potion Rose.
 [Montreal LGE, Montreal, Quebec, Canada].
 [1989].
 Beverage coaster.
 Offset lithograph.
 [Edition of 64,000 copies].
 Diameter: 4 inches.

2. **MARTINE ABALLÉA**
 Please do not disturb. Hôtel Passager.
 ARC Musée d'Art Moderne de la Ville de Paris,
 Paris, France. 1999.
 "Do not disturb" sign.
 Offset lithograph. Printed on both sides.
 1 die-cut circle.
 8.25 x 4 inches.

3. **MARTINE ABALLÉA**
 Hôtel Passager.
 ARC Musée d'Art Moderne de la Ville de Paris,
 Paris, France.1999.
 Notepad.
 Offset lithograph.
 6 x 4.25 inches.

4. **BAS JAN ADER**
 Bas Jan Ader. "In Search of the Miraculous".
 Claire S. Copley Gallery, Los Angeles, Calif.
 April 22–May 17, 1975.
 Announcement card.
 Offset lithograph. Printed on both sides.
 4.25 x 6 inches.
 References: Ader (Andriesse), p. 62; Ader (Irvine),
 p. 12; Ader (Braunschweig), p. 4.

4.1. **BAS JAN ADER**
 See also Art & Project/Bas Jan Ader.

5. **FRANCIS ALŸS**
 FRANCIS ALŸS. Narcotourism/Copenhagen, 6-12
 may 1996. Walking and Thinking and Walking.
 Louisiana Museum, [Humlebaek, Denmark].
 May–September 1996.
 Postcard.
 Offset lithograph. Printed on both sides.
 Photograph by Laureana Toledo.
 5.75 x 4.25 inches.

6. **FRANCIS ALŸS**
 Francis Alÿs. The Loop.
 Insite97, [San Diego, Calif.]. 1997.
 Postcard.
 Offset lithograph. Printed on both sides.
 4 x 5.75 inches

7. **FRANCIS ALŸS**
 FRANCIS ALŸS. The Doppelgänger.
 (Mexico, May 1998).
 Lisson Gallery, London, England. 1998.
 Postcard.
 Offset lithograph. Printed on both sides.
 5.75 x 4.25 inches.

8. **FRANCIS ALŸS**
 FRANCIS ALŸS. "the loser/the winner", 1998,
 Stockholm, Sweden.
 @ insertions @ Archipelago. 1998.
 Postcard.
 Offset lithograph. Printed on both sides.
 Photograph by Laureana Toledo/Francis Alÿs.
 5.75 x 4.25 inches.

1.

2.

3.

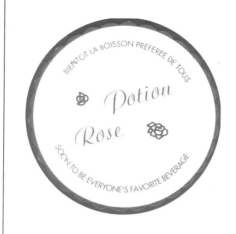

6.

4.

5.

7.

8.

9.

10.

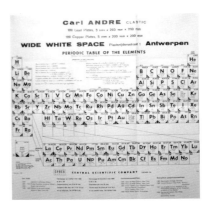

11.

12.

13.

14.

15.

16.

17.

9. **FRANCIS ALŸS**
FRANCIS ALŸS. The Doppelgänger.
(Istanbul, Sept 1999).
Lisson Gallery, London, England. 1999.
Postcard.
Offset lithograph. Printed on both sides.
5.75 x 4.25 inches.

10. **CARL ANDRE**
CARL ANDRE, ROBERT MANGOLD, BRICE
MARDEN, AGNES MARTIN, PAUL MOGENSEN,
DAVID NOVROS.
Bykert Gallery, New York, N.Y. May 16–June 12, [1967].
Poster.
Folded. Offset lithograph. Printed on both sides.
Unfolded: 17.5 x 17.5 inches.

11. **CARL ANDRE**
Carl ANDRE. CLASTIC.
Wide White Space, Antwerp, Belgium.
May 4–25, 1968.
Poster.
Folded. Offset lithograph.
Unfolded: 20 x 20 inches.
Reference: Wide White Space, pp. 248–49.

12. **CARL ANDRE**
CARL ANDRE: WATERBODIES.
The Museum of Modern Art, New York, N.Y.
April 10–May 13, 1973.
Announcement card.
Offset lithograph. Printed on both sides.
4.5 x 6 inches.

13. **CARL ANDRE**
CARL ANDRE. WORDS IN THE FORMS OF POEMS.
John Weber Gallery, New York, N.Y.
January 11–February 5, 1975.
Announcement card.
Offset lithograph.
5.25 x 8.25 inches.

14. **CARL ANDRE**
Carl Andre. Closure of 3 vectors indicates
possibility of art production.
[Lisson Gallery, London, England?]. [1975?].
Poster.
Offset lithograph.
34 x 27.5 inches.

15. **CARL ANDRE**
CARL ANDRE.
John Weber Gallery, New York, N.Y.
January 7–28, 1976.
Announcement card.
Offset lithograph. Printed on both sides.
4 x 6 inches.

16. **CARL ANDRE**
MANET SERIES. IN MEMORY OF THOMAS
MORTON. CARL ANDRE.
Lopoukhine Nayduch Gallery, Boston, Mass.
February 5–March 1, [1980].
Announcement card.
Offset lithograph. Printed on both sides.
4 x 6 inches.

17. **CARL ANDRE**
CARL ANDRE. pair. hearth.
Konrad Fischer, Düsseldorf, Germany.
May 13–June 10, 1980.
Announcement card.
Offset lithograph. Printed on both sides.
6 x 4 inches.

18. CARL ANDRE
CARL ANDRE.
The Clocktower, New York, N.Y.
November 17–December 18, 1983.
Announcement card.
Offset lithograph. Printed on both sides.
6 x 4 inches.

19. ANONYMOUS
(Landslide Print (Bonus Issue)).
Landslide, Los Angeles, Calif. 1969.
Print.
Mimeograph on styrofoam sheet.
Includes a letter from the editors.
9 x 8.5 inches.

20. ANONYMOUS
LANDSLIDE. description of works to be
presented on IHC hillside.
Landslide, Los Angeles, Calif. N.d.
Artists' publication and photograph in envelope.
Artists' publication folded. 2 leaves. Corner
stapled. Mimeograph.
Artists' publication unfolded: 11 x 8.5 inches.
Photograph: 3.5 x 5 inches.
Envelope: 4 x 9.5 inches.
Reference: Ader (Andriesse), p. 74.

21. ELEANOR ANTIN
[100 BOOTS].
Self-published, Solana Beach, Calif. The Museum
of Modern Art, New York, N.Y. 1971–73.
Series of 51 postcards.
Offset lithograph. Printed on both sides.
Photographs by Philip Steinmetz.
4.5 x 7 inches each.
Postcards listed individually (in order sent):

100 BOOTS FACING THE SEA. Feb. 9, 1971.
100 BOOTS ON THE WAY TO CHURCH. Feb. 9, 1971.
100 BOOTS AT THE BANK. Feb. 9, 1971.
100 BOOTS IN THE MARKET. May 17, 1971.
a. 100 BOOTS PARKING. May 17, 1971.
b. 100 BOOTS CIRCLING. May 17, 1971.
100 BOOTS TURN THE CORNER. May 17, 1971.
100 BOOTS TRESPASS. May 17, 1971.
c. 100 BOOTS ON THE ROAD. July 12, 1971.
100 BOOTS IN A MEADOW. July 26, 1971.
100 BOOTS AT THE CORRAL. July 26, 1971.
100 BOOTS ON THE PORCH. Oct. 8, 1971.
100 BOOTS IN THE GROVE. Oct. 8, 1971.
100 BOOTS CROSS COUNTRY. Sept. 8, 1971.
100 BOOTS AT THE POND. July 12, 1971.
100 BOOTS OUTSIDE. Oct. 14, 1971.
100 BOOTS INSIDE. Oct. 13, 1971.
100 BOOTS ON THE WAY DOWN. Oct. 13, 1971.
100 BOOTS IN THE WILD MUSTARD. June 19, 1971.
100 BOOTS IN THE MARSH. Oct. 8, 1971.
100 BOOTS ON THE JOB. Feb. 15, 1972.
100 BOOTS OUT OF A JOB. Feb. 15, 1972.
100 BOOTS IN THE STREET. Feb. 15, 1972.
100 BOOTS TRY AGAIN. June 24, 1972.
100 BOOTS DOING THEIR BEST. June 24, 1972.
100 BOOTS UP. June 28, 1972.
100 BOOTS DOWN. July 6, 1972.
d. 100 BOOTS MOVE ON. June 24, 1972.
100 BOOTS BOARDING. June 13, 1972.
100 BOOTS IN THE SALOON. June 13, 1972.
100 BOOTS ACE HIGH. June 13, 1972.
100 BOOTS IN A FIELD. Feb. 9, 1971.
100 BOOTS UNDER THE BRIDGE. July 26, 1971.
100 BOOTS OVER THE HILL. June 24, 1972.
100 BOOTS ON THE MARCH. July 6, 1972.
100 BOOTS ON RECONAISSANCE. June 24, 1972.
100 BOOTS IN THE BUSH. June 19, 1971.
100 BOOTS BY THE BIVOUAC. Sept. 8, 1971.

18.

19.

20.

21.a.

21.b.

21.c.

21.d.

21.e.　　　　**21.f.**　　　　**21.g.**

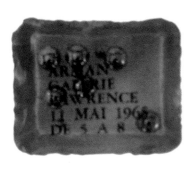

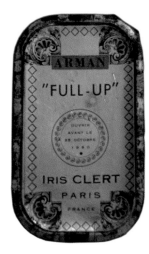

22.　　　　**23.**　　　　**24.**

25.　　　　**26.**　　　　**27.**

100 BOOTS TAKING THE HILL (1). June 13, 1972.
100 BOOTS TAKING THE HILL (2). June 13, 1972.
100 BOOTS TAKING THE HILL (3). June 13, 1972.
100 BOOTS TAKING THE HILL (4). June 13, 1972.
100 BOOTS TAKING THE HILL (5). June 13, 1972.
100 BOOTS TAKE IT. June 22, 1972.
100 BOOTS ALONG THE TIES (GO EAST).
　　Sept. 8, 1971.
e. 100 BOOTS ON THE FERRY. May 16, 1973.
f. 100 BOOTS CROSS HERALD SQUARE.
　　May 13, 1973.
100 BOOTS VISIT THE EGYPTIAN GARDENS.
　　May 15, 1973.
100 BOOTS IN THE PARK. May 16, 1973.
g. 100 BOOTS ENTER THE MUSEUM. May 15, 1973.
100 BOOTS ON VACATION. Feb. 9, 1971.
References: Antin (100 Boots); Antin, pp. 52–57;
Correspondence Art, pp. 32–34.

22. STEPHEN ANTONAKOS
DREAM.
[Charles Byron Gallery, New York, N.Y.]. [1963].
Announcement/pillowcase.
Silkscreen on cloth pillowcase.
[Edition of 500 copies].
13.25 x 17.5 inches.

23. ARMAN
ARMAN. "FULL-UP".
Iris Clert, Paris, France. Opening October 25, 1960.
Announcement/sardine can.
Offset lithograph on sardine can.
Edition of 500 copies. Signed and numbered.
4 x 2.5 x 1 inches.
References: Multiples, p. 25; Fröliche
Wissenschaft, p. 61; Poinsot.

24. ARMAN
ARMAN.
Galerie Lawrence, [Paris, France].
Opening May 11, 1965.
Announcement.
Nails, ball bearing, washers, and printed text
in Lucite cube.
1.5 x 1.75 x 1.25 inches.

25. ART & LANGUAGE
DOCUMENTA MEMORANDUM (INDEXING).
Paul Maenz, Cologne, Germany. June 15, [1972].
Poster.
Offset lithograph on newsprint. Printed on both sides.
28.5 x 20 inches.
Reference: Maenz, p. 48.

26. ART & PROJECT/SOL LEWITT
bulletin 18. Lines and Combinations of Lines /
Sol LeWitt.
Art & Project, Amsterdam, The Netherlands. [1970].
Artist's publication.
Folded sheet. Offset lithograph. Printed on both sides.
Folded: 11.75 x 8.25 inches.
Unfolded: 11.75 x 17 inches.
Reference: LeWitt Retrospective, p. 379.

27. ART & PROJECT/SOL LEWITT
bulletin 32. Sol LeWitt / Ten thousand lines.
Six thousand two hundred and fifty-five lines.
Art & Project, Amsterdam, The Netherlands. [1971].
Artist's publication.
Folded sheet. Offset lithograph. Printed on both sides.
Folded: 11.75 x 8.25 inches.
Unfolded: 11.75 x 17 inches.
Reference: LeWitt Retrospective, p. 379.

28. ART & PROJECT/JOHN BALDESSARI
bulletin 41. art disasters; john baldessari, 1971.
Art & Project, Amsterdam, The Netherlands.
July 3–15, 1971.
Artist's publication.
Folded sheet. Offset lithograph. Printed on both sides.
Folded: 11.75 x 8.25 inches.
Unfolded: 11.75 x 17 inches.

29. ART & PROJECT/SOL LEWITT
bulletin 43. SOL LEWITT / proposal for art & project.
Art & Project, Amsterdam, The Netherlands.
September 7–October 2, 1971.
Artist's publication.
Folded sheet. Offset lithograph. The sheet has
been folded into 48 squares.
Folded: 11.75 x 8.25 inches.
Unfolded: 11.75 x 17 inches.
Reference: LeWitt Retrospective, p. 379.

30. ART & PROJECT/SOL LEWITT
bulletin 60. Sol LeWitt. Lines & Lines, Arcs & Arcs,
& Lines & Arcs.
Art & Project, Amsterdam, The Netherlands. [1972].
Artist's publication.
Folded sheet. Offset lithograph. Printed on both sides.
Folded: 11.75 x 8.25 inches.
Unfolded: 11.75 x 17 inches.
Reference: LeWitt Retrospective, p. 379.

31. ART & PROJECT/BAS JAN ADER
bulletin 89. bas jan ader. "in search of the
miraculous" (songs for the north atlantic; july 1975-).
Art & Project, Amsterdam, The Netherlands. Claire
S. Copley Gallery, Los Angeles, Calif. Groninger
Museum, Groningen, The Netherlands. 1975.
Artist's publication.
Folded sheet. Offset lithograph. Printed on both sides.
Folded: 11.75 x 8.25 inches.
Unfolded: 11.75 x 17 inches.
References: Ader (Andriesse), p. 66; Ader (Irvine),
p. 41; Ader (Braunschweig), pp. 4, 75.

32. ART & PROJECT/LAWRENCE WEINER
bulletin 113. lawrence weiner.
Art & Project, Amsterdam, The Netherlands.
December 11, 1979–January 12, 1980.
Artist's publication.
Poster format. Folded. Offset lithograph.
Folded: 11.75 x 8.25 inches.
Unfolded: 23.25 x 17 inches.
References: Weiner (Buchloh), p. 92; Weiner
(Schwarz), p. 95.

32.1. ART & PROJECT/ROBERT BARRY
See Robert Barry.

33. MICHAEL ASHER
"TOGETHER AGAIN LIKE NEVER BEFORE:
THE COMPLETE POSTER WORKS OF
MARTIN KIPPENBERGER".
1301PE, Los Angeles, Calif.
September 24–October 30, 1999.
Poster.
Folded. Offset lithograph. 4 perforations.
Unfolded: 2 x 32.5 inches.

34. DAVID ASKEVOLD
"Air Mail" by David Askevold. Winner of Post Card
Competition, Jan. 1970.
Anna Leonowens Gallery, Nova Scotia College of
Art and Design, Halifax, Nova Scotia, Canada. [1970].
Postcard.
Offset lithograph. Printed on both sides.
3.5 x 11 inches.

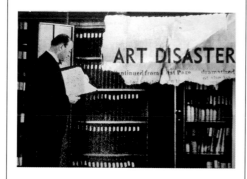

28.

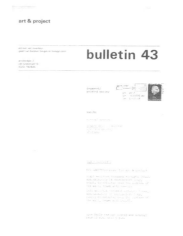

29.

30.

31.

31.

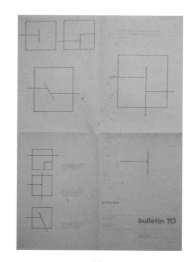

32.

"TOGETHER AGAIN LIKE NEVER BEFORE:THE COMPLETE POSTER WORKS OF MARTIN KIPPENBERGER" 24. SEPTEMBER – 30. OCTOBER 1999, OPENING: 5:00-8:00PM 1301PE 6150 WILSHIRE BLVD., LOS ANGELES, CA 90048 TELEPHONE: 310 938. 5822, FAX: 323 938. 6106

33.

34.

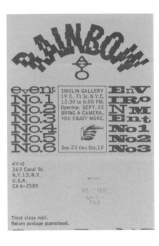

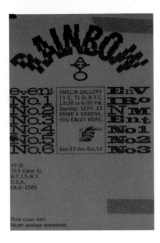

36.

35.

38.

40.

Galleria Sperone
Corso S.Maurizio 27 - Torino
Robert Barry
For the exhibition the gallery
will be closed - per la mostra la
galleria sarà chiusa dal 30.12.1969

41.

35. DAVID ASKEVOLD
DORANATO-INITIATED-HALIFAX, FEBRUARY 1971-
COMPLETED-SAN FRANCISCO, FEBRUARY 1973.
[Self-published]. [1973].
Artist's publication.
1 leaf. Offset lithograph.
11 x 8.5 inches.
Reference: Askevold, p. 43.

36. AY-O
RAINBOW. AY-O. event No. 1, No. 2, No. 3, No. 4,
No. 5, No. 6. EnVIRoNMEnt No 1, No 2, No 3.
Smolin Gallery, New York, N.Y.
September 22–October 10, [1964].
Announcement.
Folded. Offset lithograph.
Designed by Ay-O and George Maciunas.
Unfolded: 7.5 x 5 inches.
Note: 5 versions printed on green, purple, yellow,
fuschia, and blue paper.
Reference: Fluxus Etc., p. 334.

37. AY-O
RAINBOW. AY-O. event No. 1, No. 2, No. 3, No. 4,
No. 5, No. 6. EnVIRoNMEnt No 1, No 2, No 3.
Washington Square Gallery, New York, N.Y.
October 16, [1964].
Announcement.
Folded. Offset lithograph.
Designed by Ay-O and George Maciunas.
Unfolded: 7.5 x 5 inches.
Note: Orange version.
Reference: Fluxus Etc., p. 334.

37.1. TIM AYRES
See Cafe Schiller/Tim Ayres.

38. JOHN BALDESSARI/GEORGE NICOLAIDIS
BOUNDARY.
[Self-published]. [1969].
Sticker.
Offset lithograph?
2 x 3 inches.
Reference: Baldessari, p. 45.

38.1. JOHN BALDESSARI
See also Art & Project/John Baldessari.

39. ROBERT BARRY
ROBERT BARRY / INERT GAS SERIES / HELIUM,
NEON, ARGON, KRYPTON, XENON / FROM A
MEASURED VOLUME TO INDEFINITE EXPANSION.
Seth Siegelaub, Hollywood, Calif. April 1969.
Poster.
Folded. Offset lithograph.
Unfolded: 35 x 23 inches.

40. ROBERT BARRY
bulletin 17. robert barry.
Art & Project, Amsterdam, The Netherlands.
December 17–31, 1969.
Artist's publication.
Folded sheet. Offset lithograph. Printed on both sides.
Folded: 11.75 x 8.25 inches.
Unfolded: 11.75 x 17 inches.
Note: Barry also distributed this artist's publication
as a component of the Closed Gallery Piece, 1969
(unique, signed).
References: L'Art Conceptuel, p. 120;
Denizot/Barry, pp. 108–109; Beyond the Picture,
pp. 98–99.

41. ROBERT BARRY
Robert Barry. For the exhibition the gallery will
be closed.
Galleria Sperone, Turin, Italy. December 30, 1969.
Announcement card.
Offset lithograph.
5 x 7 inches.

41. (CONTINUED)
Note: Barry also distributed this announcement card as a component of the Closed Gallery Piece, 1969 (unique, signed).
References: L'Art Conceptuel, p. 120; Sperone, p. 153; Denizot/Barry, pp. 108–109; Beyond the Picture, pp. 98–99.

42. ROBERT BARRY
ROBERT BARRY. MARCH 10 THROUGH MARCH 21 THE GALLERY WILL BE CLOSED.
Eugenia Butler, Los Angeles, Calif. March 10–21, [1969].
Announcement card.
Offset lithograph.
5.5 x 5.5 inches.
Note: Barry also distributed this announcement card as a component of the Closed Gallery Piece, 1969 (unique, signed).
References: L'Art Conceptuel, p. 120; Denizot/Barry, pp. 108–109; Beyond the Picture, pp. 98–99.

43. ROBERT BARRY
PAUL MAENZ, COLOGNE INVITES YOU TO AN EXHIBITION BY ROBERT BARRY AT ART & PROJECT, AMSTERDAM DURING THE MONTH OF NOVEMBER 1972.
Paul Maenz, Cologne, Germany. November 1972.
Announcement card.
Offset lithograph. Printed on both sides.
4 x 5.75 inches.
Note: Barry also distributed this announcement card as a component of the Invitation Piece, 1972–73 (edition of 8, signed).
References: L'Art Conceptuel, pp. 122–23; Sperone, p. 231; Denizot/Barry, pp. 122–23.

44. ROBERT BARRY
art & project invites you to an exhibition by robert barry at jack wendler gallery, london, during the month of december 1972.
Art & Project, Amsterdam, The Netherlands. December 1972.
Flyer.
Folded. Offset lithograph.
Unfolded: 11.75 x 8.25 inches.
Note: Barry also distributed this flyer as a component of the Invitation Piece, 1972–73 (edition of 8, signed).
References: L'Art Conceptuel, pp. 122–23; Denizot/Barry, pp. 122–23.

45. ROBERT BARRY
jack wendler gallery invites you to an exhibition by robert barry at leo castelli gallery, new york during the month of january, 1973.
Jack Wendler Gallery, London, England. January 1973.
Announcement card.
Offset lithograph.
3.5 x 5.5 inches.
Note: Barry also distributed this announcement card as a component of the Invitation Piece, 1972–73 (edition of 8, signed).
References: L'Art Conceptuel, pp. 122–23; Denizot/Barry, pp. 122–23.

46. ROBERT BARRY
LEO CASTELLI INVITES YOU TO AN EXHIBITION BY ROBERT BARRY AT YVON LAMBERT/PARIS DURING THE MONTH OF FEBRUARY 1973.
Leo Castelli, New York, N.Y. February 1973.
Announcement card.
Offset lithograph. Printed on both sides.
4 x 9 inches.
Note: Barry also distributed this announcement card as a component of the Invitation Piece, 1972–73 (edition of 8, signed).
References: L'Art Conceptuel, pp. 122–23; Denizot/Barry, pp. 122–23.

ROBERT BARRY

MARCH 10 THROUGH MARCH 21
THE GALLERY WILL BE CLOSED

EUGENIA BUTLER 615 N. LA CIENEGA BLVD.
LOS ANGELES, CA. 90069

42.

PAUL MAENZ, COLOGNE INVITES YOU TO AN EXHIBITION BY ROBERT BARRY AT ART & PROJECT, AMSTERDAM DURING THE MONTH OF NOVEMBER 1972

43.

art & project

adriaan van ravesteijn
geert van beijeren bergen en henegouwen

amsterdam 7
van breestraat 18
(020) 792835

drukwerk aan/
printed matter to

michael compton

london sw. england
c/o tate gallery
millbank

art & project invites you to an exhibition
by robert barry at jack wendler gallery, london, during the month of december 1972

44.

jack wendler gallery
invites you to an
exhibition by robert barry
at leo castelli gallery, new york
during the month of
january, 1973

AVALANCHE
93 GRAND ST
NY NY 10013
USA

jack wendler gallery,
164 north gower st.
london, nw1
tel. 01-387 7163

45.

LEO CASTELLI INVITES YOU TO AN EXHIBITION BY **ROBERT BARRY** AT **YVON LAMBERT/PARIS** DURING THE MONTH OF FEBRUARY 1973.

46.

Yvon Lambert invites you to an exhibition by Robert Barry
at Galerie MTL Brussels during the month of March 1973.

47.

galerie MTL invites you to an
exhibition by Robert Barry
at galleria Toselli, Milan during
the month of April 1973

48.

Galerie Toselli invites you to
an exhibition by Robert Barry
at galleria Sperone, Turin du-
ring the month of may 1973.

49.

GIAN ENZO SPERONE
TORINO
C. S. MAURIZIO 27
TEL. 839220

GIAN ENZO SPERONE INVITES YOU
TO AN EXHIBITION BY ROBERT BARRY
AT PAUL MAENZ, COLOGNE, DURING
THE MONTH OF JUNE 1973

GIAN ENZO SPERONE ANNUNCIA
LA MOSTRA DI ROBERT BARRY
PRESSO PAUL MAENZ, COLONIA
DURANTE IL MESE DI GIUGNO 1973

50.

51.

52.

Hommage à M. B., Aigle

53.

47. ROBERT BARRY
Yvon Lambert invites you to an exhibition by Robert
Barry at Galerie MTL Brussels during the month of
March 1973.
Yvon Lambert, [Paris, France]. March 1973.
Announcement card.
Offset lithograph.
4 x 8.25 inches.
Note: Barry also distributed this announcement card
as a component of the Invitation Piece, 1972–73
(edition of 8, signed).
References: L'Art Conceptuel, pp. 122–23;
Denizot/Barry, pp. 122–23.

48. ROBERT BARRY
galerie MTL invites you to an exhibition by Robert
Barry at galleria Toselli, Milan during the month of
April 1973.
Galerie MTL, Brussels, Belgium. April 1973.
Announcement card.
Offset lithograph. Printed on both sides.
3.5 x 5.5 inches.
Note: Barry also distributed this announcement card
as a component of the Invitation Piece, 1972–73
(edition of 8, signed).
References: L'Art Conceptuel, pp. 122–23;
Denizot/Barry, pp. 122–23.

49. ROBERT BARRY
Galerie Toselli invites you to an exhibition by Robert
Barry at galleria Sperone, Turin during the month of
may 1973.
Galleria Toselli, Milan, Italy. May 1973.
Announcement card.
Offset lithograph. Printed on both sides.
3.5 x 6 inches.
Note: Barry also distributed this announcement card
as a component of the Invitation Piece, 1972–73
(edition of 8, signed).
References: L'Art Conceptuel, pp. 122–23;
Denizot/Barry, pp. 122–23.

50. ROBERT BARRY
GIAN ENZO SPERONE INVITES YOU TO AN
EXHIBITION BY ROBERT BARRY AT PAUL MAENZ,
COLOGNE, DURING THE MONTH OF JUNE 1973.
Gian Enzo Sperone, Turin, Italy. June 1973.
Announcement card.
Offset lithograph. Printed on both sides.
5 x 7.5 inches.
Note: Barry also distributed this announcement card
as a component of the Invitation Piece, 1972–73
(edition of 8, signed).
References: L'Art C onceptuel, pp. 122–23;
Sperone, p. 231; Denizot/Barry, pp. 122–23.

50.1. PETER BARTON
See Institute for Art and Urban Resources/Peter
Barton.

51. LOTHAR BAUMGARTEN
LOTHAR BAUMGARTEN.
Konrad Fischer, Düsseldorf, Germany.
September 25–October 15, 1973.
Announcement card in envelope.
Offset lithograph. Printed on both sides.
Announcement card: 4 x 5.75 inches.
Envelope: 4.5 x 6.25 inches.

52. LOTHAR BAUMGARTEN
LOTHAR BAUMGARTEN.
Konrad Fischer, Düsseldorf, Germany.
September 2–23, 1975.
Announcement card.
Offset lithograph. Printed on both sides.
4 x 5.75 inches.
Reference: Fischer, p. 121.

53. LOTHAR BAUMGARTEN/MARKUS OPPITZ
Hommage à M.B., Aigle.
Konrad Fischer, Düsseldorf, Germany.
Opening May 22, 1974.
Announcement card.
Offset lithograph. Printed on both sides.
4 x 5.75 inches.
Reference: Fischer, p. 105.

53.1. IAIN & INGRID BAXTER
See N. E. Thing Co. Ltd.

53.2. BILL BEIRNE
See Institute for Art and Urban Resources/Bill Beirne.

54. BARTON LIDICÉ BENES
Barton Lidicé Benes. stampelbilder, breubilder.
Galerie T, Lund, Sweden. April 12–May 7, 1980.
Announcement/paper bag.
Offset lithograph on paper bag. Printed on both sides.
8.75 x 3.75 inches.

55. BARTON LIDICÉ BENES
BARTON LIDICÉ BENES. SEA BIRDS. SCULPTURE.
BFM Gallery, New York, N.Y.
September 29–November 17, 1980.
Announcement/napkin.
Silkscreen on cloth napkin.
Announcement: 12.75 x 13.5 inches.

56. BARTON LIDICÉ BENES
BARTON LIDICÉ BENES. SHRINES.
Hoshour Gallery, Albuquerque, N.M. June–August 1985.
Announcement card mounted on wooden stick/fan.
Offset lithograph. Printed on both sides.
12.25 x 7.5 inches overall.

57. BARTON LIDICÉ BENES
BARTON LIDICÉ BENES.
Björn Olsson Gallery, Stockholm, Sweden.
March 15–April 14, 1990.
Announcement.
Folder with 2 die-cut ovals containing a
U.S. dollar bill. Offset lithograph.
Dollar bill: 2.5 x 6 inches. Folder folded: 3.25 x
6.25 inches. Folder unfolded: 9 x 6.25 inches.

58. LYNDA BENGLIS
LYNDA BENGLIS.
The Clocktower, New York, N.Y.
December 6–January 20, [1973].
Announcement card.
Offset lithograph.
4.75 x 6 inches.

59. LYNDA BENGLIS
Lynda Benglis.
Hansen Fuller Gallery, San Francisco, Calif.
May 2–26, 1973.
Announcement card.
Offset lithograph. Printed on both sides.
Photograph by Eliot Schwartz.
8.5 x 10 inches.

60. LYNDA BENGLIS
LYNDA BENGLIS PRESENTS METALLIZED KNOTS.
Artforum, New York, N.Y. April 1974.
Artist's advertisement in the periodical *Artforum*
(vol. 12, no. 8 [April 1974], p. 85).
Offset lithograph.
10.5 x 10.5 inches.

61. LYNDA BENGLIS
Lynda Benglis presents Metallized Knots.
Paula Cooper Gallery, New York, N.Y. May 4–29, [1974].
Announcement card.
Offset lithograph. Printed on both sides.
Photograph by Annie Leibovitz.
10 x 6.75 inches.

54.

55.

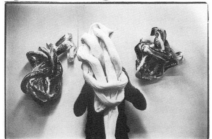

56.

57.

58.

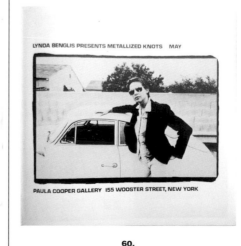

59.

60.

61.

62.

64.

65.

THE BERMANS

63.

66.

67.

68.

69.

62. LYNDA BENGLIS
[Artforum Piece].
Artforum, New York, N.Y. November 1974.
Artist's advertisement in the periodical *Artforum*
(vol. 13, no. 3 [November 1974], pp. 3–4).
Offset lithograph.
Photograph by Arthur Gordon.
10.5 x 21 inches.
Reference: Artforum, p. 272.

63. WALLACE BERMAN
AND THE MATERNAL HAND LIKE THE ARTISTS
TOOL ALWAYS WITHIN A BREATH OF THE PURE.
THE BERMANS.
Self-published. N.d.
Birth announcement/bookmark?
Offset lithograph and embossed?
7.75 x 2 inches.

64. WALLACE BERMAN
2nd Los Angeles film-makers fesTival.
Cinema Theatre, Los Angeles, Calif. N.d.
Poster.
Folded. Offset lithograph on newsprint. Printed
on both sides.
Unfolded: 17.5 x 12.5 inches.
Reference: Berman, p. 170.

**65. JOSEPH BEUYS/JONAS HAFNER/
JOHANNES STÜTTGEN**
Parteien-Wahlverweigerung.
[Self-published?]. June 1970.
Poster.
Folded. Offset lithograph.
Unfolded: 24 x 17 inches.
Reference: Beuys, No. 8.

65.1. JULIEN BLAINE
See Openings Press/Julien Blaine.

66. ALIGHIERO BOETTI
ALIGHIERO BOETTI.
Christian Stein, Turin, Italy. Opening
January 19, 1967.
Announcement card.
Folded. Offset lithograph and mixed media,
including camouflage fabric, cork letter, asbestos
lumber, copper, plywood, Perspex, PVC tube, wire
netting, aluminum, and electric cable mounted on
the inside. Printed on both sides.
Folded: 9.75 x 4.25 inches.
Unfolded: 9.75 x 8.25 inches.
Reference: Boetti, p. 8.

**67. CHRISTIAN BOLTANSKI/PAUL-ARMAND
GETTE/JEAN LE GAC**
Christian Boltanski. P. A. Gette. Jean Le Gac.
Promenade 5. Parc Zoologique du Bois de
Vincennes.
[Self-published]. June 1970.
Announcement card.
Offset lithograph.
3.25 x 5 inches.
References: Boltanski, p. 34;
Bonnefantenmuseum, p. 29.

**68. CHRISTIAN BOLTANSKI/PAUL-ARMAND
GETTE/JEAN LE GAC**
Christian Boltanski. P. A. Gette. Jean Le Gac.
Promenade 8. Musée de l'Assistance Publique -
47, Quai de la Tournelle (5E).
[Self-published]. December 1970.
Announcement card.
Offset lithograph.
3.25 x 5 inches.
References: Boltanski, p. 34;
Bonnefantenmuseum, p. 29.

69. CHRISTIAN BOLTANSKI/PAUL-ARMAND GETTE/JEAN LE GAC
Christian Boltanski. P. A. Gette. Jean Le Gac.
Promenade 9. Passage du Caire Paris-2ᴱ.
[Self-published]. January 1971.
Announcement card.
Offset lithograph.
3.25 x 5 inches.
References: Boltanski, p. 34;
Bonnefantenmuseum, p. 29.

69.1. CHRISTIAN BOLTANSKI
See also Point d'Ironie/Christian Boltanski.

70. JEAN FRANCOIS BORY
A. AU PIED DE LA LETTRE.
Gallery Number Ten, [London, England]. [1967c].
Poster.
Folded. Offset lithograph.
Unfolded: 20 x 15 inches.

70.1. LOUISE BOURGEOIS
See Point d'Ironie/Louise Bourgeois.

71. GEORGE BRECHT
V TRE.
Self-published, Metuchen, N.J. [1963].
Artists' publication.
1 leaf. Offset lithograph on newsprint.
Printed on both sides.
Editor: G. Brecht. Contributions by R. Morris,
D. Rot, C. Oldenburg, R. Krauss, H. Gappmayr,
A. MacLise, and J. MacLow.
12.75 x 9.75 inches.
References: Fluxus Etc., p. 227; Fluxus Codex,
p. 216; Fröliche Wissenschaft, p. 92.

72. GEORGE BRECHT/ROBERT WATTS
YAM FESTIVAL PART 5. DELIVERY EVENT.
Yam Festival, Metuchen, N.J. [1962].
Subscription card.
Folded. Offset lithograph.
Unfolded: 10 x 4.25 inches.
Reference: Fluxus Etc., p. 209.

73. GEORGE BRECHT/ROBERT WATTS
LANTERN EXTRACT.
[Yam Festival Press?], Metuchen, N.J. [1962].
18 event scores in envelope.
Offset lithograph (8 scores) and letterpress
(10 scores).
Event scores: Sizes vary. Envelope: 4 x 9 inches.

74. GEORGE BRECHT/ROBERT WATTS
NewES PAPAYER.
Yam Festival Press, New York, N.Y. [1963].
Artists' publication.
1 leaf. Folded. Offset lithograph.
Printed on both sides.
Editors: G. Brecht and R. Watts.
Unfolded: 28 x 6 inches.
Reference: Fluxus Etc., p. 232.

70.

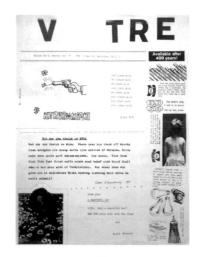

71.

72.

73.

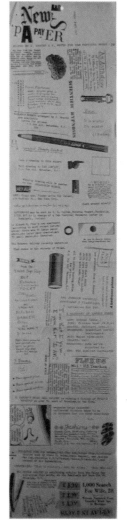

74.

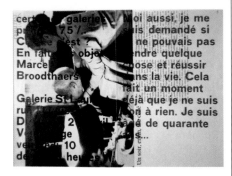

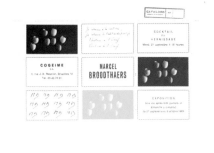

76.

77.

78.

79.

75.

80.

81.

75. GEORGE BRECHT/ROBERT WATTS
MAYTIME / YAMTIME [Yam Festival Calendar].
[Yam Festival Press?]. [May 1963].
Calendar.
Folded. Offset lithograph. Printed on both sides.
Unfolded: 22 x 8.5 inches.
References: Fluxus Etc., p. 324; Happening
and Fluxus.

76. MARCEL BROODTHAERS
Moi aussi, je me suis demandé si je ne pouvais
pas vendre quelque chose [. . .].
Galerie St. Laurent, Brussels, Belgium.
April 10–25, [1964].
Announcement.
Offset lithograph on magazine page.
Printed on both sides.
9.5 x 13 inches.
References: Broodthaers (October), p. 70;
Broodthaers (Walker), endsheets; Broodthaers
(Jeu de Paume), p. 56.

77. MARCEL BROODTHAERS
Je retourne à la matière, Je retrouve la tradition
des primitifs. Peinture à l'Oeuf Peinture à l'Oeuf.
MARCEL BROODTHAERS.
Cogeime, Brussels, Belgium.
September 27–October 9, 1966.
Announcement/sheet of 9 artist's stamps.
Offset lithograph on perforated paper.
6.5 x 10 inches.
Reference: Broodthaers (Jeu de Paume), p. 92.

78. MARCEL BROODTHAERS
DEPARTEMENT DES AIGLES. DUSSELDORF, le 19
septembre 1968. MUSEUM. [. . .] Un directeur
rectangle. Une servante ronde [. . .].
[Self-published]. September 19, 1968.
Open letter.
Folded. Mimeograph?
Unfolded: 10.75 x 8.5 inches.

79. MARCEL BROODTHAERS
Departement des Aigles. Paris, le 29 novembre
1968. Chers Amis, [. . .].
[Self-published]. November 29, 1968.
Open letter.
Folded. Mimeograph? 1 rubber stamp.
Unfolded: 10.75 x 8.5 inches.
References: Broodthaers (October), p. 171;
Broodthaers (Walker), p. 78; Broodthaers
(Jeu de Paume), p. 198.

80. MARCEL BROODTHAERS
MUSEUM VOOR MODERNE KUNSTEN.
Département des Aigles. Antwerpen, 29.
September 1969. Mon cher Immendorf [. . .].
[Self-published]. September 29, 1969.
Cover letter and open letter.
Folded. Mimeograph?
Unfolded: 11.75 x 8.25 inches each.
Reference: Broodthaers (Jeu de Paume), p. 202.

81. MARCEL BROODTHAERS
MUSEE D'ART MODERNE, SECTION LITTERAIRE,
DEPARTEMENT DES AIGLES. BRUXELLES, LE 31
octobre 1969. Mon Cher Lamelas, [. . .].
[Self-published]. October 31, 1969.
Open letter.
Folded. Mimeograph?
Unfolded: 10.75 x 8.5 inches.

81.1. A. A. BRONSON
See General Idea.

82. CHRIS BURDEN
CHRIS BURDEN. "Through the Night Softly".
[Self-published]. September 12, 1973.
Announcement card.
Offset lithograph on cardboard. Rubber stamps
and ink pen on the verso.
3.5 x 5.5 inches.
Reference: Burden 71–73, p. 74.

83. CHRIS BURDEN
POEM FOR L.A. CHRIS BURDEN.
CARP, [Los Angeles, Calif.?]. June 23–27, 1975.
Announcement card.
Offset lithograph.
8.5 x 4 inches.
Reference: Burden 74–77.

84. CHRIS BURDEN
CHRIS BURDEN. PROMO SCHEDULE.
[Self-published?]. September 17–24, 1976.
Announcement card.
Folded. Offset lithograph.
Unfolded: 10 x 7 inches.
Reference: Burden 74–77.

85. DANIEL BUREN
BUREN.
Wide White Space Gallery, Antwerp, Belgium.
January 17–February 6, 1969.
Poster.
Folded. Offset lithograph. Printed on both sides.
Unfolded: 20.5 x 30 inches.
Note: Green version.
Reference: Wide White Space, pp. 89, 255.

86. DANIEL BUREN
BUREN.
Wide White Space Gallery, Antwerp, Belgium.
May 12–June 5, 1971.
Poster.
Folded. Offset lithograph. Printed on both sides.
Unfolded: 20.5 x 30 inches.
Note: Red version.
Reference: Wide White Space, pp. 90, 282.

87. DANIEL BUREN
BUREN.
Wide White Space Gallery, Antwerp, Belgium.
June 2–15, 1972.
Poster.
Folded. Offset lithograph. Printed on both sides.
Unfolded: 20.5 x 30 inches.
Note: Yellow version.
Reference: Wide White Space, p. 292.

88. DANIEL BUREN
BUREN.
Wide White Space Gallery, Antwerp, Belgium.
Opening June 22, 1973.
Poster.
Folded. Offset lithograph. Printed on both sides.
Unfolded: 20.5 x 30 inches.
Note: Blue version.
Reference: Wide White Space, p. 308.

89. DANIEL BUREN
BUREN.
Wide White Space Gallery, Antwerp, Belgium.
[April 23–June, 1974].
Poster.
Folded. Offset lithograph. Printed on both sides.
Unfolded: 20.5 x 30 inches.
Note: Brown version.
Reference: Wide White Space, p. 324.

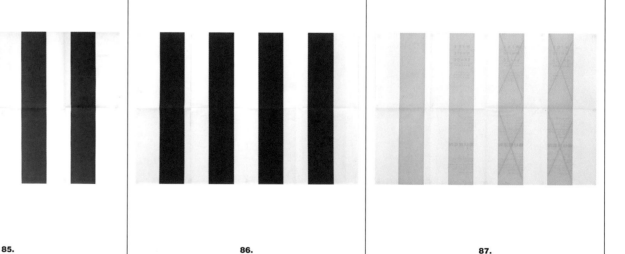

82.

83.

84.

85.

86.

87.

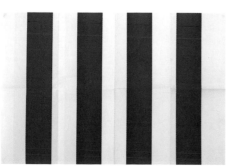

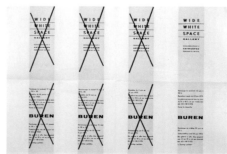

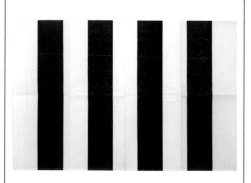

88.

89.

90.

91.

92.

94.

95.

96.

97.

90. **JAMES LEE BYARS**
A WHITE PAPER WILL BLOW THROUGH THE STREETS.
[Kyoto Museum of Art, Kyoto, Japan]. [1967].
Announcement/performance relic.
Offset lithograph on tissue paper.
Diameter: 27 inches.
References: Byars (Valencia), p. 201; Byars (Weserburg), No. 44.

91. **JAMES LEE BYARS**
WWS HAS BEEN RENAMED THE INSTITUTE FOR ADVANCED STUDY OF JAMES LEE BYARS.
Wide White Space, Antwerp, Belgium.
[April 18–May 7, 1969].
Star-shaped announcement card in envelope.
Offset lithograph.
Card: 4.5 x 4.5 inches overall.
Envelope: 5 x 6 inches.
References: Byars (Weserburg), No. 55; Wide White Space, p. 259.

92. **JAMES LEE BYARS**
THE EPITAPH OF CON.ART IS WHICH QUESTIONS HAVE DISAPPEARED?
JAMES LEE BYARS.
Wide White Space, Antwerp, Belgium.
[Summer 1969].
Announcement in envelope.
Offset lithograph.
Announcement: 2.75 x 31.5 inches.
Envelope: 9.5 x 11.75 inches.
References: Byars (Valencia), p. 200; Byars (Weserburg), No. 52; Wide White Space, p. 262.

93. **JAMES LEE BYARS**
THE 5 CONTINENT DOCUMENTA 7.
Coorps de Garde, Groningen, The Netherlands.
1979.
Announcement in folded paper portfolio.
Folded. Offset lithograph on tissue paper.
Unfolded: 87 x 48 inches.
Folded portfolio: 5.5 x 8 inches.
References: Byars (Valencia), p. 153; Byars (Weserburg), No. 84.

94. **CAFE SCHILLER/TIM AYRES**
YOUR DEFINITION OF WHAT IS RIGHT.
TIM AYRES.
Cafe Schiller, [Amsterdam, The Netherlands]. 1995.
Beverage coaster.
Offset lithograph. Printed on both sides.
Diameter: 4.25 inches.

95. **CAFE SCHILLER/SOL LEWITT**
SOL LEWITT.
Cafe Schiller, [Amsterdam, The Netherlands]. 1995.
Beverage coaster.
Offset lithograph. Printed on both sides.
Diameter: 4.25 inches.

96. **CAFE SCHILLER/MARIEN SCHOUTEN**
[MARIEN SCHOUTEN].
[Cafe Schiller, Amsterdam, The Netherlands].
[1995].
Beverage coaster.
Offset lithograph. Printed on both sides.
Diameter: 4.25 inches.

97. **CAFE SCHILLER/LAWRENCE WEINER**
MOI + TOI & NOUS. BINNEN DE KONTEKST VAN WINST & VERLIES. LAWRENCE WEINER.
Cafe Schiller, [Amsterdam, The Netherlands]. 1995.
Beverage coaster.
Offset lithograph. Printed on both sides.
Diameter: 4.25 inches.

97.1. LUIS CAMNITZER
See The New York Graphic Workshop.

98. ERNST CARAMELLE
Ernst Caramelle.
Karin Bolz Galerie, Mülheim-Ruhr, Germany.
November 6, 1986–January 10, 1987.
Announcement card.
Offset lithograph. Printed on both sides.
4 x 5.75 inches.
Reference: Caramelle.

99. ERNST CARAMELLE
ERNST CARAMELLE.
Galerie Erika and Otto Friedrich, Bern, Switzerland.
September 5–October 3, 1986.
Announcement card.
Offset lithograph. Printed on both sides.
5.75 x 4.25 inches.
Reference: Caramelle.

100. ERNST CARAMELLE
ERNST CARAMELLE.
Galerie Cora Hölzl, Düsseldorf, Germany.
March 21–May 12, 1987.
Announcement card.
Offset lithograph. Printed on both sides.
5.75 x 4.25 inches.
Reference: Caramelle.

101. ERNST CARAMELLE
ERNST CARAMELLE.
Galerie Bama, Ninon Robelin, Paris, France.
January 29–March 17, 1987.
Announcement card.
Offset lithograph. Printed on both sides.
4 x 5.75 inches.
Reference: Caramelle.

102. ERNST CARAMELLE
ERNST CARAMELLE.
Zeitkunst, Innsbruck, Austria.
February 6–March 7, 1987.
Announcement card.
Offset lithograph. Printed on both sides.
4 x 5.75 inches.
Reference: Caramelle.

102.1. JOSÉ LUIS CASTILLEJO
See Zaj/José Luis Castillejo.

102.2. JOSE GUILLERMO CASTILLO
See The New York Graphic Workshop.

103. GUGLIELMO ACHILLE CAVELLINI
CAVELLINI'S TEN COMMANDMENTS.
[Self-published, Brescia, Italy]. N.d.
Sticker.
Offset lithograph.
5.5 x 4 inches.

104. GUGLIELMO ACHILLE CAVELLINI
TEN WAYS TO MAKE YOURSELF FAMOUS.
Self-published, Brescia, Italy. N.d.
Postcard.
Offset lithograph. Printed on both sides.
6 x 4.25 inches.
Reference: Correspondence Art, p. 19.

105. GUGLIELMO ACHILLE CAVELLINI
CAVELLINI 1914-2014. VENEZIA-PALAZZO DUCALE.
[Self-published, Brescia, Italy]. N.d.
Sticker.
Offset lithograph.
Diameter: 4 inches.
Reference: Cavellini, back cover.

98.

99.

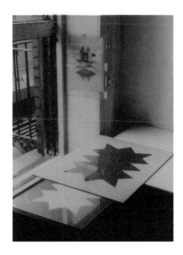

100.

101.

102.

103.

104.

105.

106.

107.

108.

109.

110.

111.

112.

A Black Tie †
for *A Century of Artists' Books* at
the Museum of Modern Art, New York
in October 1994
where the *Livre d'Artiste, Livre de Peintre*
& the *Belle Livre* abuse the convenience
of attached pages of folded prints as
illustration, and disregard the book
as the medium itself or as information
† requested to be worn at the *vernissage*

113.

106. GUGLIELMO ACHILLE CAVELLINI
CAVELLINI 1914 - 2014. INTERNATIONAL
POSTAGE 030. INTERNATIONAL POSTAGE 333.
[Self-published, Brescia, Italy]. N.d.
Sheet of 18 artist's stamps.
Offset lithograph on perforated paper.
9.75 x 13.75 inches.
Reference: Correspondence Art, p. 441.

107. JUDY CHICAGO
JUDY CHICAGO, Exhibition.
California State University, Fullerton, Fullerton, Calif.
October 23–November 25, [1970].
Poster.
Folded. Offset lithograph.
Photograph by Jerry McMillan.
Unfolded: 11 x 11 inches.
References: Chicago (Through the Flower);
Chicago (Beyond the Flower).

107.1. GARY CHITTY
See Nice Style.

108. CLAUDE CLOSKY
I ♥ CLOSKY.
[Self-published]. [1984].
Sticker.
Offset lithograph.
1.5 x 10.5 inches.
Reference: Closky, p. 7.

109. CLAUDE CLOSKY
claude closky.
FRAC Limousin, Limoges, France.
Opening June 17, 1999.
Announcement card.
Offset lithograph. Printed on both sides.
6 x 8.25 inches.

110. CLAUDE CLOSKY
claude closky.
FRAC Limousin, Limoges, France. Opening
June 17, 1999.
Announcement card.
Offset lithograph. Printed on both sides.
6 x 8.25 inches.

111. BRUCE CONNER
Seasons wishes. I AM NOT BRUCE CONNER.
I AM BRUCE CONNER.
Self-published. [1964].
Christmas card.
2 metal buttons mounted on folded card.
Offset lithograph.
Card folded: 2.75 x 4.75 inches.
Card unfolded: 5.75 x 4.75 inches.
Button diameter: 1.25 inches each.
Reference: Conner, pp. 161, 167.

112. BRUCE CONNER
BRUCE CONNER for SUPERVISOR.
[Self-published]. [1967].
Flyer.
Offset lithograph.
11 x 7.5 inches.
Reference: Conner, p. 161.

113. CORACLE PRESS/WORKFORTHEEYETODO
A Black Tie † for A Century of Artists' Books
at the Museum of Modern Art, New York in
October 1994 [. . .].
Workfortheeyetodo, London, England. October 1994.
Postcard.
Letterpress. Printed on both sides.
4 x 6 inches.

114. CORACLE PRESS/WORKFORTHEEYETODO
NO FREE READING.
Workfortheeyetodo, London, England. 1996.
Postcard.
Offset lithograph. Printed on both sides.
4 x 6 inches.

114.1. MARTIN CREED
See Imprint 93/Martin Creed.

115. CHRIS D'ARCANGELO
, Louise Lawler, Adrian Piper and
Cindy Sherman have agreed to participate in an
exhibition organized by Janelle Reiring.
Artists Space, New York, N.Y.
September 23–October 28, 1978.
Announcement card.
Offset lithograph. Printed on both sides.
3.5 x 5.5 inches.
Note: Chris D'Arcangelo intentionally removed his
name from the announcement card.
Reference: Crow, p. 234.

116. LOWELL DARLING
Fat City School of Finds Art. Master of Finds Art.
[Self-published]. [1971].
Diploma.
Offset lithograph.
Signed.
8.5 x 9 inches.
Reference: Correspondence Art, p. 202.

117. LOWELL DARLING
ELECT DARLING GOVERNOR.
[Self-published]. [1978c].
Metal button.
Offset lithograph.
[Designed by Ilene Segalove].
Diameter: 1.75 inches.

118. LOWELL DARLING
THE NEXT GOVERNOR LOWELL DARLING.
A FUND RAISING ONE THOUSAND DOLLAR
A PLATE DINNER. BREEN'S CAFE. THE
SALOON OF MOCA.
Museum of Conceptual Art, San Francisco, Calif.
March 8, 1978.
Poster.
Folded. Offset lithograph.
[Designed by Tom Marioni].
Unfolded: 22 x 17 inches.
Reference: Performance Anthology, pp. 290–91.

119. AUGUSTO DE CAMPOS
cidade city cité. augusto de campos.
Wild Hawthorn Press, [Lanark, Scotland]. 1964.
Artist's publication.
Folded sheet. Letterpress? Printed on both sides.
Folded: 8 x 10 inches. Unfolded: 8 x 20 inches.
References: Buchstäblich Wörtlich, p. 46;
Sackner, p. 230.

120. JAN DIBBETS
On May 9 (friday), May 12 (monday) and May 30
(friday) 1969 at 3:00 Greenwich Mean Time (9:00
EST) Jan Dibbets will make the gesture indicated
on the overside at the place marked "X" in
Amsterdam, Holland.
Seth Siegelaub, New York, N.Y. 1969.
Announcement card.
Offset lithograph. Printed on both sides.
4 x 6 inches.
References: Meyer, p. 116; Konzeption
Conception; Lippard, p. 103.

NO FREE READING

114.

, Louise Lawler,
Adrian Piper and Cindy Sherman
have agreed to participate in an
exhibition organized by Janelle Reiring
at Artists Space, September 23
through October 28, 1978.

115.

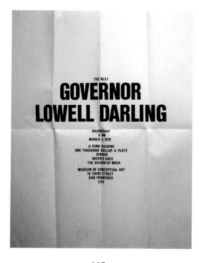

116.

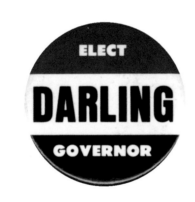

117.

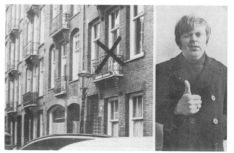

118.

ARTIST STATEMENT

I HOPE YOU PUT THE DEGREE
IN THE BOOK, EFFECTIVELY
GRADUATING EVERYONE WHO
BUYS IT. IT WAS THE ONLY
DEGREE PRINTED IN *ART IN
AMERICA*, AND IT WAS PROBABLY
AS WIDELY PRINTED AS ANY PRINT
OF ITS TIME.

IF YOU INCLUDE THE TV GRADUATIONS,
THERE WERE MILLIONS ON MY FACULTY,
ALL ON UNPAID SABBATICAL LEAVE
DUE TO BUDGETARY CONCERNS. THE
FACULTY INCLUDED THE FIRST MAN ON
THE MOON, DEBBIE REYNOLDS, HENRY
AARON, BILL WALTON, LARRY HAGMAN,
TOM HAYDEN, WATERMELONS, DOGS . . .

—LOWELL DARLING

119.

120.

121.

122.

123.

124.

125.

126.

127.

121. JAN DIBBETS/GER VAN ELK/ REINER LUCASSEN
Internationaal Instituut voor herscholing van Kunstenaars (International Institute for the Reeducation of Artists).
I.I. v. H. V. K., Amsterdam, The Netherlands. [1967].
Flyer.
Folded. Offset lithograph on newsprint.
Unfolded: 10 x 13 inches.
Reference: Lippard, p. 22.

122. JAN DIBBETS/GER VAN ELK/ REINER LUCASSEN
UW BEROEMDE LERAREN VAN HET INTERNATIONAAL INSTITUUT VOOR HERSCHOLING VAN KUNSTENAARS. v.l.n.r. LUCASSEN, DIBBETS, GER VAN ELK. DEZE KAART WORDT U AANGEBODEN DOOR GALERIE ESPACE TER ERE VAN DE KERSTTENTOONSTELLING 'GANS ZIJN AARDE IS VAN ZIJN HEERLIJKHEID VOL' INGERICHT DOOR DE LERAREN VAN HET INSTITUUT (This postcard is offered to you by Galerie Espace in honour of the Christmas exhibition "Whole his earth is full of his Glory" installed by the [famous] teachers of The Institute).
Galerie Espace, [Amsterdam, The Netherlands]. [1967].
Announcement card.
Offset lithograph. Printed on both sides.
3.75 x 5.75 inches.

123. JAN DIBBETS/GER VAN ELK/ REINER LUCASSEN
Tips voor verzamelaars (Tips for collectors).
[Self-published, Amsterdam, The Netherlands]. 1968.
Artists' publication.
Wrappers.
9.75 x 7.25 inches. Unpaginated, 6 pages.
Note: This publication was distributed in the periodical *Museumjournaal* (vol. 13, no. 2 [1968]).

124. PETER DOWNSBROUGH
PETER DOWNSBROUGH.
Galerie Maier-Hahn, Düsseldorf-Oberkassel, Germany. March 19–April 18, 1977.
Announcement card.
Offset lithograph. Printed on both sides.
4 x 5.75 inches.

125. PETER DOWNSBROUGH
peter downsbrough. à DIJON ville.
Le Coin du Miroir, Dijon, France. Opening April 20, 1980.
Poster.
Folded. Silkscreen.
Unfolded: 15.75 x 23.5 inches.

126. PETER DOWNSBROUGH
HAPPY NEW YEAR 1999.
APLIX. [1998].
New Year's card.
Folded. Offset lithograph. Printed on both sides.
Edition of 700 copies.
Folded: 6 x 6 inches. Unfolded: 6 x 12.25 inches.
Note: 3 versions printed in red, blue, and yellow.

127. MARCEL DUCHAMP
["A Poster Within a Poster"].
Pasadena Art Museum, Pasadena, Calif. October 8–November 3, 1963.
Poster.
Folded. Offset lithograph.
[Edition of 300 copies].
Unfolded: 34.5 x 27.25 inches.
Reference: Duchamp, p. 540.

128. MARCEL DUCHAMP
[L.H.O.O.Q Shaved].
Cordier and Ekstrom Gallery, New York, N.Y.
January 13, 1965.
Announcement card.
Folded. Offset lithograph. Printed on both sides.
A playing card is mounted on the front.
[Edition of 100 copies]. Signed.
Folded: 8.5 x 5.5 inches.
Reference: Duchamp, p. 546.

129. SAM DURANT
LIQUOR Jr. MARKT.
[Self-published]. 1997.
Poster.
Offset lithograph.
22.5 x 17.5 inches.

130. SAM DURANT
Robert Smithson Partially Buried Woodshed.
[Self-published]. 1999.
Poster.
Offset lithograph.
17 x 22 inches.

131. DONALD EVANS
TIMBRES-POSTE DU MONDE DE DONALD
EVANS.
Galerie Germain, Paris, France. [1974c].
Flyer.
Folded. Offset lithograph on perforated paper.
Unfolded: 11.75 x 8.25 inches.
Reference: Evans, pp. 48–52.

132. JOHN FEKNER
JOHN FEKNER. SELECTIONS 78-88. <<WALL
RELIEFS>>.
Björn Olsson Gallery, Stockholm, Sweden.
March 2–22, 1989.
Announcement/artist's record.
Flexidisk. Sleeve. Offset lithograph.
Note: The record is titled THE BEAT [89 REMIX],
JOHN FEKNER, CITY SQUAD.
7 x 7 inches.

133. HANS-PETER FELDMANN
Hans-Peter Feldmann. 6 Postkarten.
[Self-published]. [1974].
Set of 6 postcards.
Offset lithograph. Printed on both sides.
[Edition of 200 copies].
4 x 5.75 inches each.
Note: Distributed individually. Feldmann himself
gives the date as 1974, while Werner Lippert (see
Feldmann reference) gives the date as 1972.
Reference: Feldmann, p. 104.

128.

129.

130.

131.

132.

133.

FEBRUAR

MAI

ARTFORHUM

134.

135.

tye
cringle
fall
shippon
parrel
carling
bitt
gooseneck
traveller
beam
tabernacle
manger
crib

25 December

136.

THE DESMOULINS CONNECTION

How the loaded syringe likes to moralise
about The Blade.

Committee of Public Safety, Little Sparta, Dunsyre, Lanark, Scotland.

137.

THE DESMOULINS CONNECTION

It took The Blade to make temporary Spartans
of the Athenian French.

Committee of Public Safety, Little Sparta, Dunsyre, Lanark, Scotland.

138.

THE DESMOULINS CONNECTION

Liberalism, *n.* a state of affairs in which the
tree cuts down the axe.

Committee of Public Safety, Little Sparta, Dunsyre, Lanark, Scotland.

139.

THE DESMOULINS CONNECTION

One speaks cynically of Fair Play till one has
had to deal with the French.

Committee of Public Safety, Little Sparta, Dunsyre, Lanark, Scotland.

140.

134. HANS-PETER FELDMANN
Hans-Peter Feldmann. 12 Postkarten.
[Galerie Paul Maenz, Cologne, Germany]. [1974].
Set of 12 postcards.
Offset lithograph. Printed on both sides.
5.75 x 4.25 inches each.
Postcards listed individually:

JANUAR.	FEBRUAR.	MÄRZ.
APRIL.	MAI.	JUNI.
JULI.	AUGUST.	SEPTEMBER.
OKTOBER.	NOVEMBER.	DEZEMBER.

Note: Distributed individually monthly.
References: Feldmann, pp. 43–46, 104; Maenz, p. 72.

134.1 HANS-PETER FELDMANN
See also Point d'Ironie/Hans-Peter Feldmann.

135. RAFAEL FERRER
ARTFORHUM.
Pasadena Art Museum, Pasadena, Calif. 1972.
Postcard.
Offset lithograph. Printed on both sides.
4 x 6 inches.

136. IAN HAMILTON FINLAY
tye cringle.
Wild Hawthorn Press, Lanark, Scotland. 1972.
Christmas card.
Folded. Silkscreen.
Signed.
[Made in collaboration with Michael Harvey].
Folded: 10.25 x 4.5 inches. Unfolded: 10.25 x 9 inches.
References: Finlay, p. 11; Finlay (Abrioux), p. 12.

137. IAN HAMILTON FINLAY
THE DESMOULINS CONNECTION. How the
loaded syringe likes to moralise about The Blade.
Committee of Public Safety, Little Sparta, Dunsyre,
Lanark, Scotland.
[Wild Hawthorn Press], Lanark, Scotland. [1988].
Card.
Folded. Offset lithograph.
Unfolded: 3.75 x 4 inches. Folded: 1.75 x 4 inches.
References: Finlay, p. 18; Finlay (Abrioux), pp. 15–18.

138. IAN HAMILTON FINLAY
THE DESMOULINS CONNECTION. It took The
Blade to make temporary Spartans of the Athenian
French. Committee of Public Safety, Little Sparta,
Dunsyre, Lanark, Scotland.
[Wild Hawthorn Press], Lanark, Scotland. [1988].
Card.
Folded. Offset lithograph.
Unfolded: 3.75 x 4 inches. Folded: 1.75 x 4 inches.
References: Finlay, p. 18; Finlay (Abrioux), pp. 15–18.

139. IAN HAMILTON FINLAY
THE DESMOULINS CONNECTION. Liberalism, n.
a state of affairs in which the tree cuts down the
axe. Committee of Public Safety, Little Sparta,
Dunsyre, Lanark, Scotland.
[Wild Hawthorn Press], Lanark, Scotland. [1988].
Card.
Folded. Offset lithograph.
Unfolded: 3.75 x 4 inches. Folded: 1.75 x 4 inches.
References: Finlay, p. 18; Finlay (Abrioux), pp. 15–18.

140. IAN HAMILTON FINLAY
THE DESMOULINS CONNECTION. One speaks
cynically of Fair Play till one has had to deal with
the French. Committee of Public Safety, Little
Sparta, Lanark, Scotland.
[Wild Hawthorn Press], Lanark, Scotland. [1988].
Card.
Folded. Offset lithograph.
Unfolded: 3.75 x 4 inches. Folded: 1.75 x 4 inches.
References: Finlay, p. 18; Finlay (Abrioux), pp. 15–18.

141. IAN HAMILTON FINLAY
THE DESMOULINS CONNECTION. Since 1944 Paris
has been occupied by the French. Committee of
Public Safety, Little Sparta, Dunsyre, Lanark, Scotland.
[Wild Hawthorn Press], Lanark, Scotland. [1988].
Card.
Folded. Offset lithograph.
Unfolded: 3.75 x 4 inches. Folded: 1.75 x 4 inches.
References: Finlay, p. 18; Finlay (Abrioux), pp. 15–18.

142. IAN HAMILTON FINLAY
THE DESMOULINS CONNECTION. "Strathclyde
Region can only make political statements." —
Strathclyde Regional Council Press Office, during
The Little Spartan War. Committee of Public Safety,
Little Sparta, Dunsyre, Lanark, Scotland.
[Wild Hawthorn Press], Lanark, Scotland. [1988].
Card.
Folded. Offset lithograph.
Unfolded: 3.75 x 4 inches. Folded: 1.75 x 4 inches.
References: Finlay, p. 18; Finlay (Abrioux), pp. 15–18.

143. IAN HAMILTON FINLAY
THE DESMOULINS CONNECTION. The Blade was
necessary to put the V into Parisian Virtue.
Committee of Public Safety, Little Sparta, Dunsyre,
Lanark, Scotland.
[Wild Hawthorn Press], Lanark, Scotland. [1988].
Card.
Folded. Offset lithograph.
Unfolded: 3.75 x 4 inches. Folded: 1.75 x 4 inches.
References: Finlay, p. 18; Finlay (Abrioux), pp. 15–18.

144. IAN HAMILTON FINLAY
THE DESMOULINS CONNECTION. One letter soothes
the liberal's conscience. Three hundred letters may
actually get something done. Committee of Public
Safety, Little Sparta, Dunsyre, Lanark, Scotland.
[Wild Hawthorn Press], Lanark, Scotland. [1988].
Card.
Folded. Offset lithograph.
Unfolded: 3.75 x 4 inches. Folded: 1.75 x 4 inches.
References: Finlay, p. 18; Finlay (Abrioux), pp. 15–18.

145. IAN HAMILTON FINLAY
THE DESMOULINS CONNECTION. "Saint-Just
appears to the present-day French as a terrible
example of clarity and uprightness." — Saint-Just
Vigilante, during the War between the Jacobin and
Cocktail Left. Committee of Public Safety, Little
Sparta, Dunsyre, Lanark, Scotland.
[Wild Hawthorn Press], Lanark, Scotland. [1988].
Card.
Folded. Offset lithograph.
Unfolded: 3.75 x 4 inches. Folded: 1.75 x 4 inches.
References: Finlay, p. 18; Finlay (Abrioux), pp. 15–18.

146. IAN HAMILTON FINLAY
THE DESMOULINS CONNECTION. Irony, n. saying
one thing to mean another as, i.e., in the title Ligue
des Droits de l'Homme. Committee of Public
Safety, Little Sparta, Dunsyre, Lanark, Scotland.
[Wild Hawthorn Press], Lanark, Scotland. [1988].
Card.
Folded. Offset lithograph.
Unfolded: 3.75 x 4 inches. Folded: 1.75 x 4 inches.
References: Finlay, p. 18; Finlay (Abrioux), pp. 15–18.

147. IAN HAMILTON FINLAY
THE DESMOULINS CONNECTION. Robespierre was
the first, and only, President of France. Committee of
Public Safety, Little Sparta, Dunsyre, Lanark, Scotland.
[Wild Hawthorn Press], Lanark, Scotland. [1988].
Card.
Folded. Offset lithograph.
Unfolded: 3.75 x 4 inches. Folded: 1.75 x 4 inches.
References: Finlay, p. 18; Finlay (Abrioux), pp. 15–18.

THE DESMOULINS CONNECTION

Since 1944 Paris has been occupied by the French.

Committee of Public Safety, Little Sparta, Dunsyre, Lanark, Scotland.

141.

THE DESMOULINS CONNECTION

"Strathclyde Region can only make political
statements." — Strathclyde Regional Council
Press Office, during *The Little Spartan War.*

Committee of Public Safety, Little Sparta, Dunsyre, Lanark, Scotland.

142.

THE DESMOULINS CONNECTION

The Blade was necessary to put the V into
Parisian Virtue.

Committee of Public Safety, Little Sparta, Dunsyre, Lanark, Scotland.

143.

THE DESMOULINS CONNECTION

One letter soothes the liberal's conscience.
Three hundred letters may actually get
something done.

Committee of Public Safety, Little Sparta, Dunsyre, Lanark, Scotland.

144.

THE DESMOULINS CONNECTION

"Saint-Just appears to the present-day French as
a *terrible example* of clarity and uprightness."
— Saint-Just Vigilante, during the War between
the Jacobin and Cocktail Left.

Committee of Public Safety, Little Sparta, Dunsyre, Lanark, Scotland.

145.

THE DESMOULINS CONNECTION

Irony, n. saying one thing to mean another,
as, i.e., in the title *Ligue des Droits de l'Homme.*

Committee of Public Safety, Little Sparta, Dunsyre, Lanark, Scotland.

146.

THE DESMOULINS CONNECTION

Robespierre was the first, and only, President
of France.

Committee of Public Safety, Little Sparta, Dunsyre, Lanark, Scotland.

147.

THE DESMOULINS CONNECTION

"Don't be overheard saying that violence exists
in the universe: you may get shot." — Saint-Just
Vigilante, after listening to Julian Spalding's
radio interview with Ian Hamilton Finlay.

Committee of Public Safety, Little Sparta, Dunsyre, Lanark, Scotland.

148.

potatocut robin
linocut garden fork
wood-engraved tree

Christmas 1990, Little Sparta

149.

the October-coloured sails of old Thames barges
the water-filled footprints of old Thames barges
the cold Christmas stables of old Thames barges
the Georgian pastorals of old Thames barges

150.

14 February

So
many

boats'
girls'

names

151.

152.

153.

154.

155.

148. **IAN HAMILTON FINLAY**
THE DESMOULINS CONNECTION. "Don't be
overheard saying that violence exists in the
universe: you may get shot." — Saint-Just Vigilante,
after listening to Julian Spalding's radio interview
with Ian Hamilton Finlay. Committee of Public Safety,
Little Sparta, Dunsyre, Lanark, Scotland. [Wild
Hawthorn Press], Lanark, Scotland. [1988].
Card.
Folded. Offset lithograph.
Unfolded: 3.75 x 4 inches. Folded: 1.75 x 4 inches.
References: Finlay, p. 18; Finlay (Abrioux), pp. 15–18.

149. **IAN HAMILTON FINLAY**
potatocut robin. linocut garden fork. wood-
engraved tree. Christmas 1990, Little Sparta.
[Wild Hawthorn Press, Lanark, Scotland]. 1990.
Christmas card.
Folded. Offset lithograph.
Folded: 3.5 x 2.5 inches. Unfolded: 3.5 x 5 inches.

150. **IAN HAMILTON FINLAY**
the October-coloured sails of old Thames barges.
the water-filled footprints of old Thames barges.
the cold Christmas stables of old Thames barges.
the Georgian pastorals of old Thames barges.
Little Sparta, Christmas 1994.
[Wild Hawthorn Press, Lanark, Scotland]. 1994.
Christmas card.
Folded. Offset lithograph.
Folded: 2.5 x 5.25 inches.
Unfolded: 2.5 x 10.5 inches.

151. **IAN HAMILTON FINLAY**
14 February. So many boats' girls' names.
[Wild Hawthorn Press, Lanark, Scotland]. N.d.
Valentine card.
Folded. Offset lithograph.
Folded: 4 x 2.25 inches. Unfolded: 4 x 4.5 inches.

152. **IAN HAMILTON FINLAY**
A VALENTINE. A, E, I, O, YOU.
[Wild Hawthorn Press, Lanark, Scotland]. N.d.
Valentine card.
Folded. Offset lithograph.
Folded: 3.25 x 6 inches.
Unfolded: 3.25 x 11.75 inches.

153. **JOEL FISHER**
ACKI VON JOEL. JOEL VON ACKi.
Galerie Ernst, Hannover, Germany.
May 15–June 12, 1975.
2 announcement cards.
Offset lithograph. Printed on both sides.
3.75 x 5.75 inches each.

154. **JOEL FISHER**
PHOTOGRAPHIE: FOLKER SKULIMA VON JOEL
FISHER. PHOTOGRAPHIE: JOEL FISHER VON
FOLKER SKULIMA. JOEL FISHER: CUP
DRAWINGS.
Galerie Folker Skulima, Berlin, Germany. 1975.
2 announcement cards.
Offset lithograph. Printed on both sides.
1 rubber stamp.
4 x 6 inches each.
Reference: Postkarten, p. 67.

155. **JOEL FISHER**
NIGEL GREENWOOD. Photograph by Joel Fisher.
JOEL FISHER. Photograph by Nigel Greenwood.
Nigel Greenwood Inc., Ltd., London, England.
1976.
2 announcement cards.
Offset lithograph. Printed on both sides.
4.25 x 6.25 inches each.

156. JOEL FISHER
ROGER MATTHYS. Foto door Joël Fisher. Joel
Fisher. Foto door ROGER MATTHYS.
Cultureel Informatief Centrum, Gent, Belgium.
1977.
2 announcement cards.
Offset lithograph. Printed on both sides.
4 x 5.75 inches each.

157. JOEL FISHER
KIKI MAIER-HAHN. PHOTO VON JOEL FISHER.
JOEL FISHER. PHOTO VON KIKI MAIER-HAHN.
Galerie Maier-Hahn, Düsseldorf-Oberkassel,
Germany. 1977.
2 announcement cards.
Offset lithograph. Printed on both sides.
4 x 5.75 inches each.

158. DAN FLAVIN
FOUR "MONUMENTS" FOR V. TATLIN 1964-1969.
FROM DAN FLAVIN.
Leo Castelli, New York, N.Y. February 7–28, 1970.
Poster.
Folded. Offset lithograph. Printed on both sides.
Unfolded: 17 x 11 inches.

159. DAN FLAVIN
I BELIEVE HIM.
[Art for McGovern, Houston, Tex.]. [1972].
Poster. Offset lithograph and silkscreen.
Photograph by Barbara Duff.
26.75 x 21 inches.
Reference: Flavin, p. 60.

159.1. ROBIN FLETCHER
See Nice Style.

160. FLUXUS
cc V TRE (Fluxus Newspaper No. 1).
Fluxus, [New York, N.Y.]. January 1964.
Artists' periodical.
Newspaper format. Offset lithograph on newsprint.
Editors: George Brecht and the Fluxus Editorial
Council. Contributions by G. Ligeti, G. Brecht,
B. Patterson, T. Kosugi, C. Shiomi, J. Mac Low,
T. Schmit, E. Williams, A. Knowles, D. Higgins,
B. Vautier, W. de Ridder, E. Gomringer, and others.
Unpaginated, 4 pages.
18 x 23 inches.
References: Fluxus Codex, p. 93; Fluxus Etc., p. 234.

161. FLUXUS
cc V TRE (Fluxus Newspaper No. 2).
Fluxus, [New York, N.Y.]. February 1964.
Artists' periodical.
Newspaper format. Offset lithograph on newsprint.
Editors: George Brecht and the Fluxus Editorial
Council. Contributions by G. Brecht, E. Williams,
R. Johnson, J. Mac Low, D. Higgins, C. Shiomi,
Y. Ono, B. Patterson, T. Kosugi, R. Watts, and others.
Unpaginated, 4 pages.
22.5 x 17.5 inches.
References: Fluxus Codex, p. 94; Fluxus Etc., p. 238.

162. FLUXUS
cc Valise e TRanglE (Fluxus Newspaper No. 3).
Fluxus, [New York, N.Y.]. March 1964.
Artists' periodical.
Newspaper format. Offset lithograph on newsprint.
Editor: Fluxus Editorial Council. Contributions
by G. Brecht, R. Filliou, H. Flynt, H. Gappmayr,
N. J. Paik, B. Vautier, and others.
Unpaginated, 4 pages.
22.5 x 17.5 inches.
References: Fluxus Codex, p. 94; Fluxus Etc., p. 242.

ARTIST STATEMENT

THE EYES WERE ALWAYS
(PRESENTED) IN SETS OF
TWO: I PHOTOGRAPHED THE
DEALER, AND THE DEALER
PHOTOGRAPHED ME. THE
ONLY EXCEPTION (AS I
REMEMBER) WAS THE VERY FIRST
ONE, WHICH WAS NOT A POSTCARD
BUT AN AD IN SOME MAGAZINE;
I FORGET WHICH MAGAZINE.
THOUGH THE POSTCARDS ALWAYS
CAME IN SETS OF TWO, THE FORMAT
VARIED: SOMETIMES THEY WERE
ATTACHED TO EACH OTHER WITH
PERFORATIONS, SOMETIMES THEY
WERE SEPARATE. THEY WERE
MOSTLY POSTCARD-SIZED,
ALTHOUGH ONE SET WAS LONG AND
THIN. I SEEM TO REMEMBER ONE
SET ON A4 PAPER. THEY ALWAYS
CAME IN ENVELOPES; OFTEN THE
EXHIBITION DETAILS (DATES, ETC.)
WERE PRINTED ON THE OUTSIDE OF
THE ENVELOPE, RATHER THAN ON
THE POSTCARDS. I PREFERRED THE
SEPARATION OF CONTENT FROM
INFORMATION, MAKING THE
INFORMATION EXTERNAL.
—JOEL FISHER

156. **157.**

158. **159.**

160. **161.** **162.**

163.

164.

165.

ARTIST STATEMENT

I MADE THIS CARD IN 1968.
I GAVE IT TO FRIENDS AND
MAILED ONE TO EVERYONE
I KNEW OR WHOSE ADDRESS
I HAD, INCLUDING JOSEPH
BEUYS, DICK HIGGINS, ETC.
BREATH, MARIJUANA SMOKE,
CIGARETTE SMOKE, AND WHO
KNOWS WHAT ELSE WAS
BLOWN THROUGH THE HOLE.
EACH BECAME AN UNSIGNED
EPHEMERAL SCULPTURE BY ME.
—TERRY FOX

166.

167.

BLOW THROUGH THIS HOLE

TERRY FOX DECEMBER 1969

168.

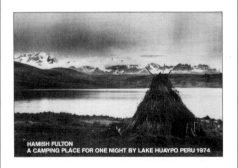

HAMISH FULTON
A CAMPING PLACE FOR ONE NIGHT BY LAKE HUAYPO PERU 1974

169.

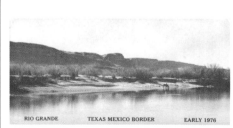

RIO GRANDE TEXAS MEXICO BORDER EARLY 1976

170.

163. FLUXUS
3 newspaper eVenTs for the pRicE of $1
(Fluxus Newspaper No. 7).
Fluxus, [New York, N.Y.]. February 1, 1966.
Artists' periodical.
Newspaper format. Offset lithograph.
[Editor: George Maciunas]. Contributions by
Y. Ono, B. Vautier, J. Riddle, and others.
Unpaginated, 4 pages.
22.5 x 17.5 inches.
References: Fluxus Codex, p. 97; Fluxus Etc.,
p. 262.

164. FLUXUS
Vaseline sTREet (Fluxus Newspaper No. 8).
Fluxus, [New York, N.Y.]. May 1966.
Artists' periodical.
Newspaper format. Offset lithograph.
[Editor: George Maciunas]. Contributions by
Hi Red Center and Wolf Vostell.
Unpaginated, 4 pages.
22.75 x 17 inches.
References: Fluxus Codex, p. 98; Fluxux Etc.,
p. 266.

165. FLUXUS
I WISH TO REMAIN ON FLUXUS MAILING LIST
AND RECEIVE FUTURE ANNOUNCEMENTS.
Fluxus, New York, N.Y. [1965c].
Card.
Offset lithograph. 1 rubber stamp on the verso.
Designed by George Maciunas.
2.75 x 4.75 inches.
Reference: Fluxus Etc., p. 112.

166. FLUXUS
FLUXUS HQ P.O. BOX 180 NEW YORK 10013.
Fluxus, New York, N.Y. [1966?].
Calling card/manifesto/information card.
Offset lithograph.
Designed and written by George Maciunas.
2.5 x 1.5 inches.
Reference: Fluxus Etc., p. 272.

167. FLUXUS
INDEX: [. . .] .
[Fluxus, New York, N.Y.] [1973].
Newsletter/encoded mailing list.
Photocopy?
11 x 8.5 inches.
Reference: Fluxus Etc. Addenda I, p. 241.

168. TERRY FOX
BLOW THROUGH THIS HOLE. TERRY FOX.
DECEMBER 1969.
[Self-published]. [1968?].
Card.
Offset lithograph. 1 die-cut circle.
5 x 7 inches.

169. HAMISH FULTON
HAMISH FULTON. A CAMPING PLACE FOR ONE
NIGHT BY LAKE HUAYPO PERU 1974.
Konrad Fischer, Düsseldorf, Germany.
November 23–December 19, 1974.
Announcement card.
Offset lithograph. Printed on both sides.
4 x 5.75 inches.

170. HAMISH FULTON
RIO GRANDE TEXAS MEXICO BORDER EARLY
1976. HAMISH FULTON.
Cusack Gallery, Houston, Tex. Opening
January 24, 1976.
Announcement card.
Offset lithograph. Printed on both sides.
3.25 x 6.5 inches.

171. HAMISH FULTON
DAKOTA DUSK. PROJECTS: HAMISH FULTON.
The Museum of Modern Art, New York, N Y
October 3–November 26, 1978.
Announcement card.
Offset lithograph. Printed on both sides.
3.75 x 6.75 inches.

172. HAMISH FULTON
EVENING LIGHT. A MAN AND A MULE RETURNING
HOME AFTER A DAY OF WORK. BISACCIA ITALY
SUMMER 1979. HAMISH FULTON.
Galerie Nancy Gillespie–Elisabeth de Laage, Paris,
France. January 26–February 21, 1980.
Announcement card.
Offset lithograph. Printed on both sides.
4.25 x 6 inches.

173. HAMISH FULTON
HEAD FOR THE HILLS HEAD IN THE CLOUDS.
CLOUD-CUCKOO-LAND. SNAILS PACE BLIND AS
A BAT CHASING RAINBOWS. STICK IN THE MUD
ONE TRACK MIND BITE THE DUST. SEVENTH
HEAVEN STONY SILENCE. WALKS ARE LIKE
CLOUDS. THEY COME AND GO. HAMISH FULTON.
Galerie Laage-Salomon, Paris, France.
October 11–November 17, 1990.
Announcement card.
Offset lithograph. Printed on both sides.
5.75 x 7 inches.

174. HAMISH FULTON
ROCK FALL ECHO DUST. HAMISH FULTON.
FOURTEEN WORKS 1982-1989.
Galerie Tanit, Munich, Germany.
November 7–December 8, 1990.
Announcement card.
Offset lithograph. Printed on both sides.
5.75 x 4 inches.

175. HAMISH FULTON
TIME. INDOORS. OUTDOORS. HAMISH FULTON.
Kanransha, Tokyo, Japan.
October 14–November 9, 1991.
Announcement card.
Offset lithograph. Printed on both sides.
4.25 x 6 inches.

**176. GENERAL IDEA (A. A. BRONSON/
FELIX PARTZ/JORGE ZONTAL)**
GOLD DIGGERS OF '84.
Self-published, Toronto, Ontario, Canada. [1972].
Card and folded certificate.
Offset lithograph. Rubber stamps on the
verso of the card.
Card: 5.5 x 5.25 inches.
Certificate unfolded: 8.5 x 11 inches.
Reference: General Idea, No. 25.

**177. GENERAL IDEA (A. A. BRONSON/
FELIX PARTZ/JORGE ZONTAL)**
AIDS.
[General Idea, Toronto, Ontario, Canada. Koury
Wingate Gallery, New York, N.Y. Artspace,
San Francisco, Calif.]. [1987].
Poster.
Serigraph.
[Edition of 1,000 copies].
27 x 27 inches.
Reference: General Idea, No. 105.

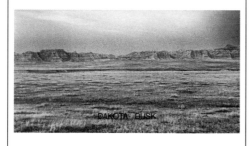

171.

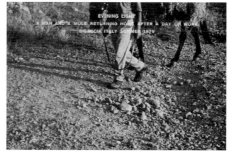

172.

HEAD FOR THE HILLS HEAD IN THE CLOUDS

CLOUD-CUCKOO-LAND

SNAILS PACE BLIND AS A BAT CHASING RAINBOWS

STICK IN THE MUD ONE TRACK MIND BITE THE DUST

SEVENTH HEAVEN STONY SILENCE

WALKS ARE LIKE CLOUDS

THEY COME AND GO

173.

R O C K

F A L L

E C H O

D U S T

174.

時
TIME

家の中で
INDOORS

家の外で
OUTDOORS

175.

176.

177.

ARTIST STATEMENT

WE PRODUCED THIS POSTER FOR A STREET PROJECT IN NEW YORK
CITY AND SAN FRANCISCO. WE PLASTERED BOTH CITIES WITH THE
POSTER AS A SORT OF "ADVERTISING CAMPAIGN" FOR THE DISEASE.
THIS WAS AT A TIME WHEN THE PRESIDENT OF THE UNITED STATES
HAD NOT PUBLICLY UTTERED THE WORD "AIDS," AND THE DISEASE
WAS OFTEN HIDDEN AS SHAMEFUL. WE SET OUT TO MAKE THE NAME
VISIBLE, TO GIVE IT AN IMAGE. WE USED ROBERT INDIANA'S *LOVE*
PAINTING AS A MODEL FOR TWO REASONS: BECAUSE HE HAD LOST
CONTROL OF THE IMAGE AND IT HAD FLOODED THROUGH THE GENERAL
CULTURE AS AN ICON FOR AN ERA—AS A VIRUS, IN FACT; AND BECAUSE
WE FELT THAT LOVE WAS WHAT WAS NEEDED TO OVERCOME THIS
EPIDEMIC. AS CANADIANS, WE INTERPRETED INDIANA'S *LOVE* AS
REPRESENTATIVE OF UNIVERSAL LOVE OR "BROTHERLY LOVE," BUT MOST
AMERICANS SAW THE LOVE LOGO AS CELEBRATING "FREE LOVE," OR SEX.
HENCE, MANY AMERICANS MISINTERPRETED THE POSTER AS A CYNICAL
COMMENT—SEX=AIDS—WHEREAS CANADIANS AND EUROPEANS READ IT
QUITE DIFFERENTLY, AS A HUMANISTIC STATEMENT.

—GENERAL IDEA

ACHTUNG KUNST KORRUMPIERT

178.

CAUTION ART CORRUPTS

179.

Paul-Armand Gette

LA NOMENCLATURE BINAIRE

Hommage à Carl von Linné

UNIVERSITÉ DE NANTERRE
PARIS X

le Samedi 29 Novembre 1975
de 10 à 18 heures
Bâtiment F, 2e étage
Salle 215
(R.E.R. Nanterre Université)

180.

181.

182.

EXTRAIT DU BULLETIN MENSUEL
DE LA
SOCIÉTÉ LINNÉENNE DE BRUXELLES & PARIS

1ère. Année Mars 1995

CAPTURE DE
NYMPHA NOCTURNA ssp. *ROSEA* P.-A. G.
LEPIDOPTERA NYMPHALIDIDAE
par
Paul-Armand Gette

184.

183.

O m.

185.

186. PAUL-ARMAND GETTE
PAUL-ARMAND GETTE. American and Japanese panties in New York.
[Self-published]. January 25–30, 1998.
Announcement card in envelope.
Folded. Offset lithograph. Two plates mounted on inside of the card.
Card folded: 3.25 x 4 inches. Card unfolded: 3.25 x 8.25 inches. Envelope: 3.5 x 5.5 inches.

186.1. PAUL-ARMAND GETTE
See also Christian Boltanski/Paul-Armand Gette/Jean Le Gac.

187. GILBERT & GEORGE
The Sadness in Our Art.
"Art for All," London, England. 1970.
Print/"postal sculpture" in envelope.
Folded. Offset lithograph on distressed and burned paper. 1 rubber stamp.
Unfolded: 14.5 x 10 inches.
Envelope: 4.5 x 10.5 inches.

188. GILBERT & GEORGE
THE PINK ELEPHANTS. "The Greeting Cards".
"Art for All," London, England. Summer 1973.
Series of 8 greeting cards/"postal sculpture" in envelopes.
Offset lithograph. Printed on both sides. Each envelope is rubber-stamped "PINK ELEPHANTS" on the front and "GG" on the verso.
Each card is signed.
Cards: 8 x 5 inches each.
Envelopes: 5.25 x 8.25 inches each.

Greeting cards listed individually (in order sent):
LONDON DRY (We dropped by at quite a [. . .]).
THE MAJORS PORT (Had two dizzy spells [. . .]).
DOM PERIGNON (There's not an awful [. . .]).
THE MAJORS PORT (After a certain number of [. . .]).
DOM PERIGNON (Made a fair number [. . .]).
LONDON DRY (Felt a trifle queer last night [. . .]).
BRISTOL CREAM (Nice beano last night- [. . .]).
BRISTOL CREAM (Went up to the bar [. . .]).
References: Gilbert & George (Violette), pp. 74–76; Gilbert & George, p. XV.

189. GILBERT & GEORGE
THE RED BOXERS.
"Art for All," London, England. Summer 1975.
Series of 8 greeting cards/"postal sculpture" in envelopes.
Offset lithograph. Printed on both sides. Each envelope is rubber-stamped "RED BOXERS" (8th envelope is rubber-stamped "THE LAST OF THE RED BOXERS") on the front and embossed "ART FOR ALL" on the verso.
Each card is signed.
Cards: 8 x 5 inches each.
Envelopes: 5.25 x 8.25 inches each.

Greeting cards listed individually (in order sent):
WOODEN. ANYTHING.
STONE-ISH. MOVED.
STILLNESS. COME.
STUDY. CHAPEL.
References: Gilbert & George (Violette), pp. 94–95; Gilbert & George, p. 35.

189.1. GILBERT & GEORGE
See also Point d'Ironie/Gilbert & George.

190. FELIX GONZALEZ-TORRES*
Detail from: "Untitled" (Death by Gun), 1990.
Offset print on paper.
Endless copies.
9 inches at ideal height x 33 x 45 inches.
References: Gonzalez-Torres, pp. 50–51; Thinking Print, p. 23.

186.

187.

188.

189.

190.

191.

Homes for America

Early 20th-Century
Possessable House
to the Quasi-Discrete
Cell of '66

D. GRAHAM

192.

FIGURATIVE
BY
DAN
GRAHAM

If nature didn't, Warner's will.

193.

PRINTED MATTER
+
ART METROPOLE

This bookmark may be inserted between
pp 56-57 of *Dr. No* by Ian Fleming
(General Paperbacks, Toronto, 1988)
and read as a supplement
to those pages.

BASEL
12-17.6.1991

LEARN TO READ ART

Christine Burgin Gallery N.Y. Rodney Graham 1991

194.

WITH 42,000 DEAD
**ART
IS NOT ENOUGH**
**TAKE
COLLECTIVE
DIRECT
ACTION
TO END
THE AIDS
CRISIS**

195.

**WHEN RACISM & SEXISM ARE
NO LONGER FASHIONABLE,
WHAT WILL YOUR ART
COLLECTION BE WORTH?**

The art market won't bestow mega-buck prices on the work
of a few white males forever. For the 17.7 million you just spent
on a single Jasper Johns painting, you could have bought at
least one work by all of these women and artists of color:

Please send $ and comments to:
Box 1056 Cooper Sta. N.Y., N.Y. 10276. **GUERRILLA GIRLS** CONSCIENCE OF THE ART WORLD

196.

**191. FELIX GONZALEZ-TORRES/
CHRISTOPHER WOOL***
Detail from: "Untitled", 1993
Offset print on paper
Endless copies
8 inches at ideal height x 37 x 55.5 inches.

*The catalogue descriptions for entries 190 and 191
are provided by Andrea Rosen Gallery, New York.

191.1. DOUGLAS GORDON
See Point d'Ironie/Douglas Gordon.

192. DAN GRAHAM
Homes for America.
Art Digest, Inc., New York, N.Y.
December 1966–January 1967.
Magazine work in the periodical *Arts Magazine*
(vol. 41, no. 3 [December 1966–January 1967],
pp. 21–22).
Offset lithograph. Printed on both sides.
Page size: 11.75 x 8.5 inches.
References: Graham; NSCAD, pp. 21–22; Lippard,
p. 20; Out of the Box, p. 72.

193. DAN GRAHAM
FIGURATIVE. BY DAN GRAHAM.
Hearst Corporation, New York, N.Y. March 1968.
Proposal for artist's advertisement in the periodical
Harper's Bazaar (no. 3076 [March 1968], p. 90).
Offset lithograph.
Image size: 12.5 x 6.75 inches. Page size:
12.5 x 9.5 inches.
References: Graham; Reconsidering the Object
of Art, p. 124; Out of the Box, pp. 71–73.

193.1 DAN GRAHAM
See also Institute for Art and Urban Resources/
Dan Graham; Point d'Ironie/Itsuko Hasegawa/
Dan Graham.

194. RODNEY GRAHAM
PRINTED MATTER + ART METROPOLE. This
bookmark may be inserted between pp 56-57 of
Dr. No by Ian Fleming (General Paperbacks, Toronto,
1988) and read as a supplement to those pages.
Christine Burgin Gallery, New York, N.Y. 1991.
Bookmark.
Offset lithograph. Printed on both sides.
8.25 x 4.25 inches overall.
Reference: Multiples, p. 83.

195. GRAN FURY
WITH 42,000 DEAD ART IS NOT ENOUGH.
TAKE COLLECTIVE DIRECT ACTION TO END
THE AIDS CRISIS.
The Kitchen, New York, N.Y. 1988.
Poster.
Offset lithograph. Printed on both sides.
21.5 x 13.5 inches.

195.1. JOSEPH GRIGELY
See Point d'Ironie/Joseph Grigely.

196. GUERRILLA GIRLS
WHEN RACISM & SEXISM ARE NO LONGER
FASHIONABLE, WHAT WILL YOUR ART
COLLECTION BE WORTH?
Self-published. [1989].
Poster.
Folded. Offset lithograph.
Unfolded: 17 x 22 inches.

197. GUERRILLA GIRLS
Do women have to be naked to get into the Met.
Museum? Less than 5% of the artists in the
Modern Art Sections are women, but 85% of the
nudes are female.
Self-published. [1989].
Poster.
Folded. Offset lithograph.
Unfolded: 11 x 28 inches.

198. GUERRILLA GIRLS
THESE ARE THE MOST BIGOTED GALLERIES IN
NEW YORK. Why? Because they show the fewest
women & artists of color.
Self-published. [1991].
Poster.
Folded. Offset lithograph.
Unfolded: 22 x 17 inches.

199. GUERRILLA GIRLS
"I can survive on the street." - RESIDENT OF
N.Y.C. WOMEN'S SHELTER IN COLLABORATION
WITH GUERRILLA GIRLS AND ARTIST &
HOMELESS COLLABORATIVE.
Guerrilla Girls and Artist and Homeless
Collaborative, New York, N.Y. [1991].
Poster.
Folded. Offset lithograph.
Unfolded: 22 x 17 inches.

200. GUERRILLA GIRLS
HOLD ON TO YOUR WALLETS! CROSS YOUR
LEGS! THESE WHITE MEN HAVE BEEN
VIDEOTAPED LOOTING YOUR NEIGHBORHOOD:
[. . .].
Self-published. [1992].
Poster.
Folded. Offset lithograph.
Unfolded: 17 x 22 inches.

201. HANS HAACKE
Results of Primary Election. Hans Haacke.
Howard Wise Gallery, New York, N.Y.
November 1–29, 1969.
Announcement card.
Folded. Offset lithograph. Printed on both sides.
Unfolded: 14.5 x 7.25 inches.
Reference: Haacke (Unfinished Business), p. 82.

202. HANS HAACKE
JOHN WEBER GALLERY VISITORS' PROFILE 2.
by Hans Haacke.
John Weber Gallery, New York, N.Y.
April 28–May 17, 1973.
Announcement card.
Offset lithograph. Printed on both sides.
Die-cut circles on the border of the card.
6.5 x 7.5 inches.
References: Haacke, pp. 39–40; Haacke
(Unfinished Business), p. 103.

202.1. JONAS HAFNER
See Joseph Beuys/Jonas Hafner/Johannes Stüttgen.

203. KEITH HARING
KEITH HARING INVITES YOU TO THE SECOND
ANNUAL "PARTY OF LIFE" AT THE PALLADIUM.
The Palladium, New York, N.Y. May 22, 1985.
Invitation.
Cardboard box containing 1 puzzle, 1 button, and
1 slip of paper. Each item is offset lithograph.
Puzzle constructed: 7 x 7 inches.
Button: 1.5 x 1.5 inches. Paper: 0.75 x 2.75 inches.
Box: 4 x 4 x 1.5 inches.

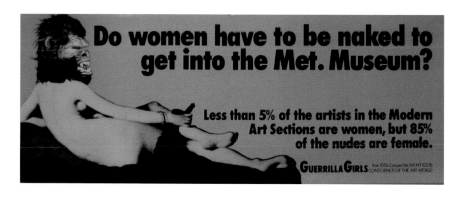

197.

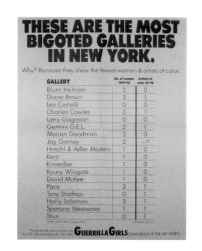

198.

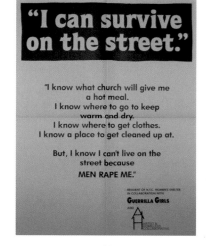

199.

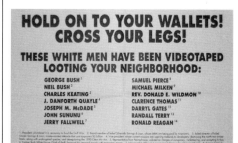

200.

201.

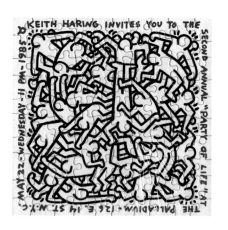

202.

203.

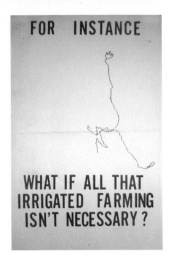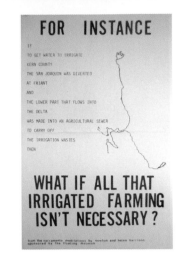

204.

205. **206.**

207. **208.**

204. NEWTON AND HELEN MAYER HARRISON
[Sacramento Meditations].
[The Floating Museum?]. [1976].
Set of 12 posters.
Folded. Offset lithograph.
Unfolded: 17 x 11 inches each.
Posters listed individually:

FOR INSTANCE. WHAT IF ALL THAT
IRRIGATED FARMING ISN'T NECESSARY?

FOR INSTANCE IF TO GET WATER TO
IRRIGATE KERN COUNTY THE SAN
JOAQUIN WAS DIVERTED AT FRIANT AND
THE LOWER PART THAT FLOWS INTO THE
DELTA WAS MADE INTO AN AGRICULTURAL
SEWER TO CARRY OFF THE IRRIGATION
WASTES THEN WHAT IF ALL THAT
IRRIGATED FARMING ISN'T NECESSARY?

FOR INSTANCE IF IRRIGATED FARMING USES
UP TOPSOIL AT THE RATE OF AT LEAST 1"
EVERY 5 YEARS AND IT TAKES 300 TO 1000
YEARS FOR NATURE TO MAKE 1" OF
TOPSOIL THEN WHO IS GOING TO REPLACE
ALL THAT TOPSOIL? WHAT IF ALL THAT
IRRIGATED FARMING ISN'T NECESSARY?

FOR INSTANCE IF 85% OF THE WATER
INTENTIONALLY TAKEN FROM THE
SACRAMENTO-SAN JOAQUIN VALLEY GOES
TO INTENSIVE IRRIGATED FARMING OF 6
AND 1/2 MILLION ACRES THEN 85% OF THE
DAMS, DIVERSIONS, CANALS AND PUMPING
STATIONS HAVE BEEN BUILT TO SUPPORT
IRRIGATED FARMING BUT WHAT IF ALL THAT
IRRIGATED FARMING ISN'T NECESSARY?

FOR INSTANCE IF ABOUT 1/3 OF THE
FARMS IN THE NATION ARE NOW OUT OF
PRODUCTION AND THE FARMERS IN THE
SOUTH WHO USED TO PRODUCE COTTON
PUT OUT OF WORK BECAUSE THEY
COULDN'T COMPETE WITH GOVERNMENT
SUBSIDIZED IRRIGATED AGRICULTURE
THEN WHAT IF ALL THAT IRRIGATED
FARMING ISN'T NECESSARY?

FOR INSTANCE IN THE PROCESS OF
IRRIGATION WATER BECOMES FOULED BY
DISSOLVED SOLIDS-SALTS, PESTICIDES,
HERBICIDES, FERTILIZERS AND TOPSOIL
AND THAT WATER AS IT RETURNS FOULS
THE RIVERS THE WATER BASINS THE DELTA
AND THE BAYS BUT WHAT IF ALL THAT
IRRIGATED FARMING ISN'T NECESSARY?

FOR INSTANCE IF 2,516 LANDOWNERS IN
THE WESTLANDS WATER DISTRICT OWN
556,760 ACRES OF LAND (NADER'S
FIGURES) AND THE FEDERAL BUREAU OF
RECLAMATION WITH THE CENTRAL VALLEY
PROJECT INCREASED THE WORTH OF
EACH ACRE BY $300 (REAL ESTATE
FIGURES) THEN 2,516 LANDOWNERS WERE
GIVEN A GIFT BY THE GOVERNMENT OF
$167,028,000 WHAT IF ALL THAT IRRIGATED
FARMING ISN'T NECESSARY?

FOR INSTANCE IN THE WESTLANDS WATER
DISTRICT THE FEDERAL GOVERNMENT
PAYS $84 PER YEAR PER ACRE TO BRING
WATER TO THE LAND AND 16
CORPORATIONS OWN 291,449 ACRES
THEN THE FEDERAL GOVERNMENT IS
PAYING 16 CORPORATIONS A TOTAL OF
$9,464,616 PER YEAR WHAT IF ALL THAT
IRRIGATED FARMING ISN'T NECESSARY?

FOR INSTANCE IF THEY DAMMED ALL THE
RIVERS AND MOST OF THE CREEKS THAT
FLOW INTO THE DELTA AND THE BAYS AND
EVEN REVERSED THE FLOW OF THE
SACRAMENTO AT THE DELTA TO GET
WATER TO IRRIGATE THE LAND THEN WHAT
IF ALL THAT IRRIGATED FARMING ISN'T
NECESSARY?

FOR INSTANCE IF THERE ARE ABOUT
360,000 ACRES OF COTTON GROWN
UNDER IRRIGATION AND THE
GOVERNMENT SPENDS ABOUT $360,000 IN
FEDERAL SUBSIDY TO IRRIGATE THOSE
ACRES AND BY GENERATING SURPLUS THE
GOVERNMENT SPENDS ANOTHER
$50,000,000 IN PRICE SUPPORTS AND
SUBSIDIES THEN WHAT IF ALL THAT
IRRIGATED FARMING ISN'T NECESSARY?

FOR INSTANCE IF WE KNOW THAT ANY
CONSTRUCTION INVOLVING WATER FOULS
THAT WATER AND THAT DAMS POLLUTE BY
SEDIMENT RETENTION THERMAL
STRATIFICATION DECOMPOSITION OF
TRAPPED MATERIALS AND NITROGEN
SATURATION THEN BUILDING ALL THOSE
DAMS AND CANALS POLLUTES THE WATER
SYSTEM OF CALIFORNIA WHAT IF ALL THAT
IRRIGATED FARMING ISN'T NECESSARY?

FOR INSTANCE WHY ARE WE NOT
LEARNING FROM THE NILE THE TIGRIS AND
EUPHRATES THE COLORADO AND THE
SNAKE THAT INTENSIVE IRRIGATED
FARMING RUINS WATER AND DESTROYS
LAND WHAT IF ALL THAT IRRIGATED
FARMING ISN'T NECESSARY?

Reference: Performance Anthology, p. 203.

204.1. ITSUKO HASEGAWA
See Point d'Ironie/Itsuko Hasegawa/Dan Graham.

205. MICHAEL HEIZER
DOUBLE NEGATIVE. 1,100' X 42' X 30'. 40,000
TONS DISPLACEMENT. MICHAEL HEIZER.
Dwan, Nevada and New York, N.Y. 1970.
Poster.
Offset lithograph.
35.5 x 60 inches.
Reference: Dwan.

206. GEORGE HERMS
The Tap City Circus presents RAFFLE.
Self-published. June 6, 1965.
Announcement card.
Folded. Ink pen, felt pen, woodblock, and rubber
stamp. Printed on both sides. 1 gelatin silver print
is mounted on inside right.
Folded: 7.5 x 5.5 inches. Unfolded: 7.5 x 11 inches.

207. GEORGE HERMS
THE TAP CITY CIRCUS PRESENTS ROOFLE.
[Self-published]. October 30, 1966.
Announcement card.
Letterpress, woodblock, and rubber stamp.
4 x 6 inches.

208. GEORGE HERMS
THE TAP CITY CIRCUS PRESENTS BAFFLE.
[Self-published]. April 28, 1968.
Announcement card.
Letterpress, woodblock, and rubber stamp.
4 x 7 inches.

209. GEORGE HERMS
GEORGE HERMS EXHIBITION
Molly Barnes Gallery, Los Angeles, Calif.
March 17–April 11, 1969.
Announcement/3 cards/"moonbeam" (to be
constructed).
Offset lithograph. Printed on both sides.
5 x 5 inches; 5 x 7 inches; and 5 x 7 inches.
Constructed: 5 x 5 x 5 inches overall.

210. GEORGE HERMS
THE TAP CITY CIRCUS PRESENTS EARFUL.
[Self-published]. February 20, 1972.
Announcement card.
Letterpress, woodblock, and rubber stamp.
8.5 x 5.5 inches.

211. DICK HIGGINS
the something else NEWSLETTER. Volume 1,
Number 1.
Something Else Press, Inc., New York, N.Y.
February 1966.
Newsletter.
Folded sheet. Offset lithograph.
Printed on both sides.
Folded: 11 x 8.5 inches. Unfolded: 11 x 17 inches.
References: Something Else Press, p. 80; Fröliche
Wissenschaft, p. 15.

212. DICK HIGGINS
FREE DICK HIGGINS.
[Something Else Press]. [1969].
Metal button.
Offset lithograph.
Diameter: 1.5 inches.
Reference: Something Else Press, p. 83.

213. DICK HIGGINS
the ∫nowflakes of giordano bruno. by dick higgins.
Self-published, New York, N.Y. 1977.
Christmas card in envelope.
Folded. Offset lithograph. Printed on both sides.
Folded: 6 x 4.5 inches. Unfolded: 6 x 13.5 inches.
Envelope: 4.75 x 6.5 inches.

214. JENNY HOLZER
[Inflammatory Essays].
[Self-published]. [1979–82].
Set of 27 posters.
Offset lithograph.
17 x 17 inches each.
Reference: Thinking Print, p. 20.

215. JENNY HOLZER
TRUISM STAMPS.
Art Matters Inc., New York, N.Y. N.d.
Sheet of 10 artist's stamps in envelope.
Offset lithograph on gummed, perforated paper.
Includes a form letter.
3.5 x 8.5 inches.

216. IMPRINT 93
Imprint 93 desert island discs city racing. Eight
Records One Book One Luxury.
Imprint 93/City Racing, London, England. [1995].
Poster in envelope.
Folded. Photocopy.
Artists included F. Banner, P. Bloodgood,
J. Burgess, B. Childish, M. Collings, K. Coventry,
M. Creed, J. Deller, P. Doig, M. Hale, M. Higgs,
S. Home, A. Kane, H. Lloyd, C. Lowe &
R. Thomson, J. Luke, M. McGeown, P. Noble,
P. Owen, S. Periton, E. Peyton, J. Pyman,
M. Roberts, B. & R. Smith, J. Voorsanger,
A. Wheatley, S. Willats, and E. Wright.
Unfolded: 16.5 x 11.75 inches.
Envelope: 9 x 6.25 inches.
Reference: Life/Live, pp. 76–78, 198–201.

209.

210.

211.

212.

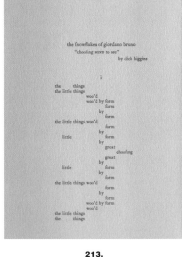

213.

214.

215.

216.

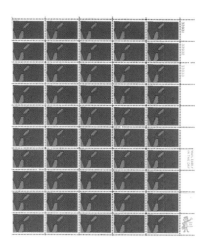

217.

218.

219.

NEW URBAN LANDSCAPES #2 PETER BARTON
INSTITUTE FOR ART AND URBAN RESOURCES

220.

221.

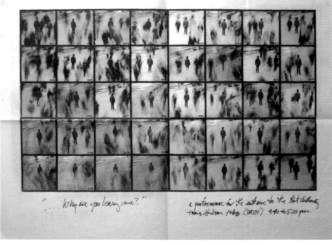

222.

223.

217. IMPRINT 93/MARTIN CREED
Work No. 118.
Imprint 93/City Racing, London, England. 1995.
Score in manila envelope.
Folded. Photocopy.
Score unfolded: 11.75 x 8.25 inches.
Envelope: 7.5 x 5.5 inches.
Reference: Life/Live, pp. 76–78, 198–201.

218. IMPRINT 93/MARTIN CREED
CHRISTMAS 98. WORK NO. 140 REVISITED.
Imprint 93, London, England. 1998.
Christmas card.
Folded card, sheet of torn-up A4 paper, and
certificate in envelope. Photocopy. The card is
rubber-stamped.
The certificate is signed and numbered.
Torn paper: Sizes vary. Card folded: 8.25 x 5.75
inches. Certificate: 11.75 x 8.25 inches.
Envelope: 9 x 6.25 inches.
Reference: Life/Live, pp. 76–78, 198–201.

219. IMPRINT 93/JESSICA VOORSANGER
MY CHRISTMAS CARD TO YOU.
Imprint 93, London, England. 1995.
Envelope containing color photograph and record
shard in a Ziploc bag and flyer in manila envelope.
The photograph and envelope are rubber-stamped.
White envelope: 3.5 x 6 inches.
Photograph: 5 x 3.5 inches.
Record shard: 0.75 x 1 inches.
Certificate: 11.75 x 8.25 inches.
Envelope: 9 x 6.25 inches.
Reference: Life/Live, pp. 76–78, 198–201.

220. ROBERT INDIANA
[LOVE POSTAGE STAMP].
[United States Postal Service, Washington, D.C.].
[1973].
Sheet of 50 artist's stamps.
Offset lithograph on gummed, perforated paper.
[Edition of 330,000,000 copies].
10 x 9 inches.
Reference: Indiana, p. 50.

**221. INSTITUTE FOR ART AND URBAN
RESOURCES/KLAUS RINKE**
NEW URBAN LANDSCAPES #1. KLAUS RINKE.
Institute for Art and Urban Resources, New York,
N.Y. October 1975.
Artist's publication.
Folded sheet. Offset lithograph on newsprint.
Printed on both sides.
Folded: 16.5 x 11.5 inches.
Unfolded: 16.5 x 22.5 inches.

**222. INSTITUTE FOR ART AND URBAN
RESOURCES/PETER BARTON**
NEW URBAN LANDSCAPES #2. PETER BARTON.
Institute for Art and Urban Resources,
New York, N.Y. January 1976.
Artist's publication.
Folded sheet. Offset lithograph on newsprint.
Printed on both sides.
Folded: 16.5 x 11.5 inches.
Unfolded: 16.5 x 22.5 inches.

**223. INSTITUTE FOR ART AND URBAN
RESOURCES/BILL BEIRNE**
NEW URBAN LANDSCAPES #3. BILL BEIRNE.
Institute for Art and Urban Resources, New York,
N.Y. January 1976.
Artist's publication.
Folded sheet. Offset lithograph on newsprint.
Printed on both sides.
Folded: 16.5 x 11.5 inches.
Unfolded: 16.5 x 22.5 inches.

224. INSTITUTE FOR ART AND URBAN RESOURCES/LUCIO POZZI
#4 LUCIO POZZI. NEW URBAN LANDSCAPES.
Institute for Art and Urban Resources,
New York, N.Y. March 1976.
Artist's publication.
Folded sheet. Offset lithograph on newsprint.
Printed on both sides.
Folded: 16.5 x 11.5 inches.
Unfolded: 16.5 x 22.5 inches.

225. INSTITUTE FOR ART AND URBAN RESOURCES/DAN GRAHAM
NEW URBAN LANDSCAPES #5. DAN GRAHAM.
a focus on lower manhattan through a series of
documented projects, proposals, and events.
Institute for Art and Urban Resources,
New York, N.Y. July 1976.
Artist's publication.
Folded sheet. Offset lithograph on newsprint.
Printed on both sides.
Folded: 16.5 x 11.5 inches.
Unfolded: 16.5 x 22.5 inches.

226. INSTITUTE FOR ART AND URBAN RESOURCES/LAWRENCE WEINER
NEW URBAN LANDSCAPES #6. LAWRENCE WEINER.
a focus on lower manhattan through a series of
documented projects, proposals, and events.
Institute for Art and Urban Resources,
New York, N.Y. May 1976.
Artist's publication.
Folded sheet. Offset lithograph on newsprint.
Printed on both sides.
Folded: 16.5 x 11.5 inches.
Unfolded: 16.5 x 22.5 inches.
References: Weiner (Buchloh), p. 48; Weiner
(Schwarz), p. 92.

227. INSTITUTE FOR ART AND URBAN RESOURCES/MAX NEUHAUS
NEW URBAN LANDSCAPES #7. MAX NEUHAUS.
a focus on lower manhattan through a series of
documented projects, proposals, and events.
Institute for Art and Urban Resources,
New York, N.Y. September 1976.
Artist's publication.
Folded sheet. Offset lithograph on newsprint.
Printed on both sides.
Folded: 16.5 x 11.5 inches.
Unfolded: 16.5 x 22.5 inches.

228. INSTITUTE FOR ART AND URBAN RESOURCES/PHILLIPS SIMKIN
NEW URBAN LANDSCAPES #8. PHILLIPS SIMKIN.
a focus on lower manhattan through a series of
documented projects, proposals, and events.
Institute for Art and Urban Resources,
New York, N.Y. October 1976.
Artist's publication.
Folded sheet. Offset lithograph on newsprint.
Printed on both sides.
Folded: 16.5 x 11.5 inches.
Unfolded: 16.5 x 22.5 inches.

229. INSTITUTE FOR ART AND URBAN RESOURCES/JUDITH SHEA
NEW URBAN LANDSCAPES #9. JUDITH SHEA.
a focus on lower manhattan through a series of
documented projects, proposals, and events.
Institute for Art and Urban Resources,
New York, N.Y. January 1977.
Artist's publication.
Folded sheet. Offset lithograph on newsprint.
Printed on both sides.
Folded: 16.5 x 11.5 inches.
Unfolded: 16.5 x 22.5 inches.

224.

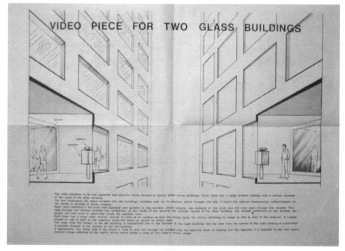

225.

226.

227.

228.

229.

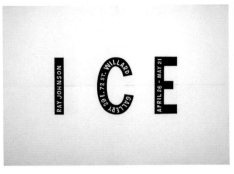

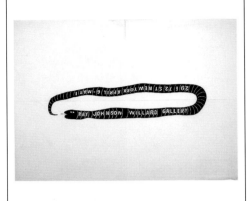

230.

231.

233.

8 MAN SHOW

GEORGE BRECHT

GEORGE HERMS

RAY JOHNSTON

ROBIN GALLERY

234.

8 MAN SHOW 2

RAY CHARLES

RAY JOHNSTON

CHARLES STANLEY

ROBIN GALLERY

235.

8 MAN SHOW 3

MRS. BRECHT

IDA FINE

KAY JOHNSON

WOODPECKER GALLERY

236.

8 MAN SHOW 4

ROBERT BENTON

RICHARD C.

RAY JOHNSON

WOODPECKER GALLERY

237.

8 MAN SHOW 5

ROBERT BENSONG

RAY JOHNSONG

MAY WILSONG

WILLENPECKER GALLERY

238.

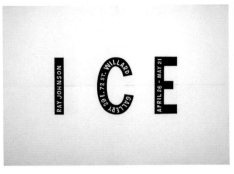

ICE

232.

230. **JIM ISERMANN**
JIM ISERMANN FLOWERS. NEW WORK.
Kuhlenschmidt Simon Gallery, Los Angeles, Calif.
January 11–February 8, 1986.
Announcement/flower key ring.
Offset lithograph on plastic with metal key ring.
4 x 3 inches overall.
Note: The flower key ring announcement was
produced in 12 versions/color combinations:
Green/white, orange/yellow-orange, orange/blue,
yellow/yellow-orange, yellow/orange, yellow/pink,
pink/yellow-orange, pink/orange, pink/white,
white/pink, white/turquoise, and white/blue.

231. **RAY JOHNSON**
RAY JOHNSON.
Willard Gallery, New York, N.Y. April 6–May 1, [1965].
Poster.
Folded. Offset lithograph.
Unfolded: 10 x 14 inches.

232. **RAY JOHNSON**
ICE. RAY JOHNSON.
Willard Gallery, New York, N.Y. April 26–May 21, [1966].
Poster.
Folded. Offset lithograph.
14 x 10 inches.

233. **RAY JOHNSON**
RAY JOHNSON. FIVE NEW PAINTINGS.
Willard Gallery, New York, N.Y. N.d.
Flyer.
Folded. Offset lithograph.
Unfolded: 8.5 x 11 inches.
Reference: Johnson, p. 205.

234. **RAY JOHNSON**
8 MAN SHOW. GEORGE BRECHT GEORGE
HERMS RAY JOHNSTON. ROBIN GALLERY.
[Self-published]. [1971].
Card.
Offset lithograph.
4 x 6 inches.
Reference: Fröliche Wissenschaft, p. 122.

235. **RAY JOHNSON**
8 MAN SHOW 2. RAY CHARLES RAY JOHNSTON
CHARLES STANLEY. ROBIN GALLERY.
[Self-published]. [1971].
Card.
Offset lithograph.
4 x 6 inches.

236. **RAY JOHNSON**
8 MAN SHOW 3. MRS. BRECHT IDA FINE KAY
JOHNSON. WOODPECKER GALLERY.
[Self-published]. [1971].
Card.
Offset lithograph.
4 x 6 inches.

237. **RAY JOHNSON**
8 MAN SHOW 4. ROBERT BENTON RICHARD C.
RAY JOHNSON. WOODPECKER GALLERY.
[Self-published]. [1971].
Card.
Offset lithograph.
4 x 6 inches.

238. **RAY JOHNSON**
8 MAN SHOW 5. ROBERT BENSONG RAY JOHNSONG
MAY WILSONG. WILLENPECKER GALLERY.
[Self-published]. [1971].
Card.
Offset lithograph.
4 x 6 inches.

239. DONALD JUDD
De Tocqueville: All those who seek to destroy the
liberties of a democratic nation [. . .].
[Self-published]. [1970].
Poster.
Mimeograph.
22 x 17 inches.
Reference: Judd, pp. 205–207.

240. STEPHEN KALTENBACH
[Artforum Ads]. November 1968–December 1969.
Series of 12 artist's advertisements (listed
individually in order published):

ART WORKS.
Artforum, New York, N.Y. November 1968.
Artist's advertisement published in the
periodical *Artforum* (vol. 7, no. 3
[November 1968], p. 72).
Offset lithograph.
Page size: 10.5 x 10.5 inches.
Image size: 2.25 x 4.5 inches.

JOHNNY APPLESEED.
Artforum, New York, N.Y. December 1968.
Artist's advertisement in the periodical
Artforum (vol. 7, no. 4 [December 1968], p. 74).
Offset lithograph.
Page size: 10.5 x 10.5 inches.
Image size: 1.5 x 2.25 inches.

ART.
Artforum, New York, N.Y. January 1969.
Artist's advertisement in the periodical
Artforum (vol. 7, no. 5 [January 1969], p. 15).
Offset lithograph.
Page size: 10.5 x 10.5 inches.
Image size: 5.5 x 10.5 inches.

Tell a lie.
Artforum, New York, N.Y. February 1969.
Artist's advertisement in the periodical
Artforum (vol. 7, no. 6 [February 1969], p. 71).
Offset lithograph.
Page size: 10.5 x 10.5 inches.
Image size: 2.25 x 4.5 inches.

Start a rumor.
Artforum, New York, N.Y. March 1969.
Artist's advertisement in the periodical
Artforum (vol. 7, no. 7 [March 1969], p. 96).
Offset lithograph.
Page size: 10.5 x 10.5 inches.
Image size: 2.25 x 4.5 inches.

Perpetrate a hoax.
Artforum, New York, N.Y. April 1969.
Artist's advertisement in the periodical
Artforum (vol. 7, no. 8 [April 1969], p. 80).
Offset lithograph.
Page size: 10.5 x 10.5 inches.
Image size: 2.25 x 4.5 inches.

Build a reputation.
Artforum, New York, N.Y. May 1969.
Artist's advertisement in the periodical
Artforum (vol. 7, no. 9 [May 1969], p. 73).
Offset lithograph.
Page size: 10.5 x 10.5 inches.
Image size: 2.25 x 4.5 inches.

Become a legend.
Artforum, New York, N.Y. Summer 1969.
Artist's advertisement in the periodical
Artforum (vol. 7, no. 10 [summer 1969],
p. 11).
Offset lithograph
Page size: 10.5 x 10.5 inches.
Image size: 10.5 x 10.5 inches.

a. Teach Art.
Artforum, New York, N.Y. September 1969.
Artist's advertisement in the periodical
Artforum (vol. 8, no. 1 [September 1969],
p. 69).
Offset lithograph.
Page size: 10.5 x 10.5 inches.
Image size: 2.25 x 4.5 inches.

b. Smoke.
Artforum, New York, N.Y. October 1969.
Artist's advertisement in the periodical
Artforum (vol. 8, no. 2 [October 1969], p. 79).
Offset lithograph.
Page size: 10.5 x 10.5 inches.
Image size: 5 x 2.25 inches.

Trip.
Artforum, New York, N.Y. November 1969.
Artist's advertisement in the periodical
Artforum (vol. 8, no. 3 [November 1969],
p. 85).
Offset lithograph.
Page size: 10.5 x 10.5 inches.
Image size: 5 x 2.25 inches.

c. You are me.
Artforum, New York, N.Y. December 1969.
Artist's advertisement in the periodical
Artforum (vol. 8, no. 4 [December 1969], p. 75).
Offset lithograph.
Page size: 10.5 x 10.5 inches.
Image size: 2.25 x 4.5 inches.
References: Reconsidering the Object of Art,
pp. 140–41, 143; Artforum, Cover.

241. ALLAN KAPROW
an. apple shrine. environment. by Allan Kaprow.
Judson Gallery, New York, N.Y.
November 30–December 24, [1960].
Flyer.
Offset lithograph.
8.5 x 13 inches.

239.

241.

240.a.

240.b.

240.c.

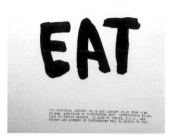

EAT
AN ENVIRONMENT BY
ALLAN KAPROW

EAT

242.

ARTIST STATEMENT

THE POSTERS OF MINE
EXHIBITED IN THE EXTRA
ART EXHIBITION AT CCAC
WERE DESIGNED TO
SPELL OUT THE "MOVES"
OF PARTICULAR EVENTS, AS
WELL AS TO COMMUNICATE
THEM TO A SMALL PUBLIC.
AS SUCH, THE POSTERS
WERE TRADITIONAL ART-
WORKS, WHILE THE ACTUAL
EVENTS, WHEN CARRIED OUT,
WERE INTENTIONALLY
NONART ACTIVITIES THAT
SIMPLY VANISHED.
—ALLAN KAPROW

FLUIDS
A HAPPENING BY
ALLAN KAPROW

243.

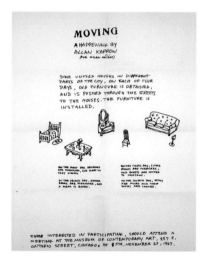

244.

245.

ROUND TRIP
A HAPPENING BY ALLAN KAPROW

246.

POSTED
HUNTING, FISHING, TRAPPING
or TRESPASSING
FORBIDDEN
UNDER PENALTY OF THE LAW
VIOLATORS WILL BE PROSECUTED.

DIA Art Foundation
ROUTE 9D, GARRISON, NEW YORK

247.

GARRY NEILL KENNEDY

FIGURE PAINTINGS

1 DECEMBER TO 22 DECEMBER

4 9 T H P A R A L L E L
CENTRE FOR CANADIAN CONTEMPORARY ART
420 W BROADWAY NEW YORK NEW YORK

248.

249.

242. **ALLAN KAPROW**
EAT. AN ENVIRONMENT BY ALLAN KAPROW.
Smolin Gallery, New York, N.Y. January 18, 19 and
25, 26, [1964].
Flyer.
Offset lithograph.
13 x 9 inches.

243. **ALLAN KAPROW**
FLUIDS. A HAPPENING BY ALLAN KAPROW.
Pasadena Art Museum, Pasadena, Calif.
October 10, 1967.
Poster.
Folded. Offset lithograph.
Unfolded: 19 x 14 inches.
Reference: Happening and Fluxus.

244. **ALLAN KAPROW**
MOVING. A HAPPENING BY ALLAN KAPROW
(FOR MILAN KNIZAK).
Museum of Contemporary Art, Chicago, Ill.
November 27, 1967.
Poster.
Folded. Offset lithograph. Printed on both sides.
Unfolded: 18 x 14 inches.

245. **ALLAN KAPROW**
runner. A HAPPENING BY ALLAN KAPROW.
Washington University, St. Louis, Mo.
February 8, 9, 10, 11, [1968].
Poster.
Folded. Offset lithograph.
Unfolded: 18 x 14 inches.

246. **ALLAN KAPROW**
ROUND TRIP. A HAPPENING BY ALLAN KAPROW.
The State University of New York at Albany,
Albany, N.Y. March 27, 1968.
Poster.
Folded. Offset lithograph.
Photograph by Peter Moore.
Unfolded: 17 x 22 inches.

247. **GARRY NEILL KENNEDY**
[Verboten].
[Self-published]. [1980].
Poster.
Folded. Offset lithograph.
Unfolded: 12 x 12 inches.

248. **GARRY NEILL KENNEDY**
GARRY NEILL KENNEDY. FIGURE PAINTINGS.
49th Parallel, Centre for Canadian Contemporary
Art, New York, N.Y. December 1–22, [1984].
Announcement card.
Offset lithograph.
5 x 7 inches.

249. **GARRY NEILL KENNEDY**
GARRY NEILL KENNEDY. FUTURES (SIXTEEN OIL
PAINTINGS).
Truck, Calgary, Alberta, Canada.
February 5–March 6, 1999.
Announcement.
Folded. Photocopy. Printed on both sides.
Folded: 7 x 5.5 inches. Unfolded: 7 x 11 inches.

250. BEN KINMONT
FOR YOU FOR ME FOR PAINTING by
Ben Kinmont.
[Self-published, New York, N.Y.]. 1993.
Artist's publication/"catalytic text."
1 leaf. Photocopy.
11 x 8.5 inches.

251. BEN KINMONT
I will wash your dirty dishes [. . .].
[Self-published, New York, N.Y.] [1994].
Artist's publication/"catalytic text."
1 leaf. Photocopy. Printed on both sides.
11 x 8.5 inches.

252. BEN KINMONT
Forse. Perhaps.
[Self-published]. [June 1995].
Artist's publication/"catalytic text."
1 leaf. Photocopy.
11.75 x 8.25 inches.

253. YVES KLEIN
Dimanche. 27 NOVEMBRE 1960. NUMÉRO
UNIQUE.
[Self-published]. November 27, 1960.
Artist's publication.
Folded. Newspaper format.
Unfolded: 22 x 15 inches. Unpaginated, 4 pages.
References: Klein, pp. 359–63, 365.

254. KOMAR AND MELAMID
KOMAR AND MELAMID INC., NEW YORK, NY. I,
___ hereby exclusively consign my immortal soul to
Komar and Melamid Inc. for a period of five years
for the sum of $___.
[Self-published, New York, N.Y.]. 1979c.
Card.
Offset lithograph. Printed on both sides.
5.5 x 8.5 inches.
Reference: Promised Relations, p. 21.

255. WALTHER KÖNIG/CHRISTIAN BOLTANSKI
If you recognize yourself or if you know, who the
children are, please write to Christian Boltanski.
Buchhandlung Walther König, Cologne, Germany.
N.d.
Bookmark.
Offset lithograph. Printed on both sides.
8.25 x 1.75 inches.

256. WALTHER KÖNIG/WERNER BÜTTNER
ÜBER DAS FINDEN EINER SCHÖNEN STELLE IN
EINEM BUCH. Werner Büttner.
Buchhandlung Walther König, Cologne, Germany.
N.d.
Bookmark.
Offset lithograph. Printed on both sides.
8.25 x 2 inches.

257. WALTHER KÖNIG/JIRI GEORG DOKOUPIL
dokoupil 2034.
Buchhandlung Walther König, Cologne, Germany.
N.d.
Bookmark.
Offset lithograph. Printed on both sides.
8 x 1.75 inches.

250.

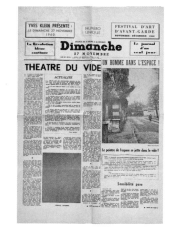

251.

252.

253.

254.

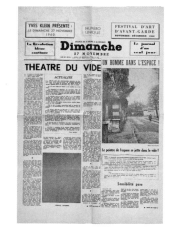

255.

256.

257.

258.

259.

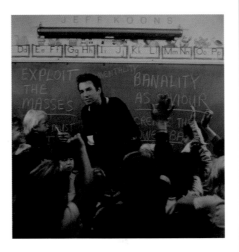

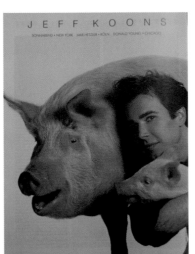
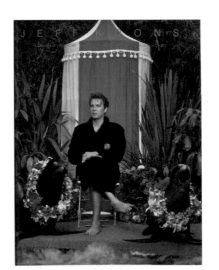

260.

258. WALTHER KÖNIG/ISA GENZKEN
Isa Genzken, 1990.
Buchhandlung Walther König, Cologne, Germany.
1990?
Bookmark.
Offset on plastic.
8.25 x 1.5 inches.

259. WALTHER KÖNIG/MARTIN KIPPENBERGER
KING SIZE. Kippenberger Martin.
Buchhandlung Walther König, Cologne, Germany.
N.d.
Bookmark (sock shape).
Offset lithograph. Printed on both sides.
6.5 x 3 inches overall.

260. JEFF KOONS
JEFF KOONS. SONNABEND, NEW YORK. MAX
HETZLER, KÖLN. DONALD YOUNG, CHICAGO. 1988.
Series of 4 artist's advertisements (listed individually):

JEFF KOONS. SONNABEND, NEW YORK. MAX
HETZLER, KÖLN. DONALD YOUNG, CHICAGO.
Brant Art Publications Incorporated, New York, N.Y.
November 1988.
Artist's advertisement in the periodical *Art in
America* (vol. 76, no. 11 [November 1988], p. 51).
Offset lithograph.
10.75 x 9 inches.

JEFF KOONS. SONNABEND, NEW YORK. MAX
HETZLER, KÖLN. DONALD YOUNG, CHICAGO.
Artforum, New York, N.Y. November 1988.
Artist's advertisement in the periodical *Artforum*
(vol. 27, no. 3 [November 1988], p. 23).
Offset lithograph.
10.5 x 10.5 inches.

JEFF KOONS. SONNABEND, NEW YORK. MAX
HETZLER, KÖLN. DONALD YOUNG, CHICAGO.
Giancarlo Politi Editore, Milan, Italy.
November/December 1988.
Artist's advertisement in the periodical *Flash Art*
(no. 143 [November/December 1988], p. 86).
Offset lithograph.
10.5 x 8 inches.

JEFF KOONS. SONNABEND, NEW YORK. MAX
HETZLER, KÖLN. DONALD YOUNG, CHICAGO.
Arts Magazine, New York, N.Y. November 1988.
Artist's advertisement in the periodical *Arts
Magazine* (vol. 63, no. 3 [November 1988], p. 23).
Offset lithograph.
10.75 x 8.5 inches.

260.1. HARMONY KORINE
See Point d'Ironie/Harmony Korine.

261. JOSEPH KOSUTH
Joseph Kosuth requested the removal of these
works from this publication and this exhibition.

262. JOSEPH KOSUTH
Joseph Kosuth requested the removal of these
works from this publication and this exhibition.

263. BARBARA KRUGER
Your manias become science.
[Rhona Hoffmann Gallery, Chicago, Ill.]. [1984].
Matchbook.
Offset lithograph.
2 x 2 inches.
Reference: Kruger, p. 109.

264. BARBARA KRUGER
You are an experiment in terror.
[Rhona Hoffmann Gallery, Chicago, Ill.]. [1984].
Matchbook.
Offset lithograph.
2 x 2 inches.
Reference: Kruger, p. 109.

265. BARBARA KRUGER
You construct intricate rituals which allow you to touch the skin of other men.
[Rhona Hoffmann Gallery, Chicago, Ill.]. [1984].
Matchbook.
Offset lithograph.
2 x 2 inches.
Reference: Kruger, p. 109.

266. BARBARA KRUGER
Charisma is the perfume of your gods.
[Rhona Hoffmann Gallery, Chicago, Ill.]. [1984].
Matchbook.
Offset lithograph.
2 x 1.5 inches.
Reference: Kruger, p. 109.

267. BARBARA KRUGER
We have received orders not to move.
[Rhona Hoffmann Gallery, Chicago, Ill.]. [1984].
Matchbook.
Offset lithograph.
2 x 1.5 inches.
Reference: Kruger, p. 109.

268. BARBARA KRUGER
Your comfort is my silence.
[Rhona Hoffmann Gallery, Chicago, Ill.]. [1984].
Matchbook.
Offset lithograph.
2 x 1.5 inches.
Reference: Kruger, p. 109.

269. BARBARA KRUGER
Surveillance is your busywork.
[Rhona Hoffmann Gallery, Chicago, Ill.]. [1984].
Matchbook.
Offset lithograph.
2 x 1.5 inches.
Reference: Kruger, p. 109.

270. BARBARA KRUGER
I hate myself and you love me for it.
Esquire, New York, N.Y. May 1992.
Periodical cover for *Esquire*, May 1992.
Offset lithograph.
10.75 x 9 inches.
References: Kruger, p. 224; Thinking Print, p. 22.

263.

264.

265.

266.

267.

268.

269.

270.

271.

272.

273.

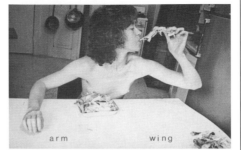

274.

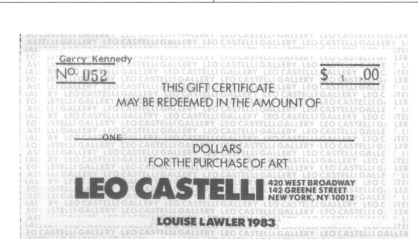

275.

276.

271. **SUZANNE LACY**
Mona-by-Number, Suzanne Lacy.
[The Floating Museum?]. July 1978.
Announcement card.
Offset lithograph. Printed on both sides.
5.75 x 4 inches.

272. **SUZANNE LACY**
Suzanne Lacy. Anatomy Lesson no. 1: Chickens
Coming Home to Roost, for Rose Mountain and
Pauline.
Self-published. N.d.
4 cards.
Offset lithograph. Printed on both sides.
4.5 x 6.75 inches each.
Cards listed individually:

breast.
wing arm.
arm wing.
leg.

273. **LOUISE LAWLER**
METRO PICTURES. ARRANGEMENTS OF
PICTURES. LOUISE LAWLER.
Metro Pictures, New York, N.Y. [1982].
Matchbook.
Offset lithograph. Printed on both sides.
2 x 2 inches.

274. **LOUISE LAWLER**
BORROWED TIME.
Baskerville and Watson, [New York, N.Y.].
March 9–April 9, 1983.
Matchbook.
Offset lithograph. Printed on both sides.
2 x 2 inches.

275. **LOUISE LAWLER**
THIS GIFT CERTIFICATE MAY BE REDEEMED IN
THE AMOUNT OF _____ DOLLARS FOR THE
PURCHASE OF ART. LOUISE LAWLER 1983.
Leo Castelli, New York, N.Y. 1983.
Gift certificate.
Offset lithograph.
[Edition of 500 copies]. Numbered.
3.5 x 6.5 inches.

276. **LOUISE LAWLER**
GALLERY NATURE MORTE.
Gallery Nature Morte, New York, N.Y. April 1985.
Press release.
Folded. Photocopy.
Unfolded: 11 x 8.5 inches.

277. LOUISE LAWLER
DID YOU TAKE THIS AIRPLANE HOME? Enough.
Louise Lawler. Project: Moma, 1987.
Self-published. 1987.
Artist's publication.
Folded. Offset lithograph and imprinted (hot
stamp). Printed on both sides.
Folded: 11 x 4 inches. Unfolded: 11 x 8 inches.

278. LOUISE LAWLER
LOUISE LAWLER. HOW MANY PICTURES.
Metro Pictures, New York, N.Y. April 29–May 27, 1989.
Announcement card/decal.
Offset lithograph. Printed on both sides.
2 x 3.5 inches.

279. LOUISE LAWLER
The Museum as Muse.
[The Museum of Modern Art, New York, N.Y.]. [1999].
Napkin.
Folded. Offset lithograph on paper napkin.
Folded: 5 x 5 inches.

280. JEAN LE GAC
JEAN LE GAC. Le Jardin le 5 Octobre.
"Work in Progress," Paris, France. October 5, 1969.
Announcement card.
Offset lithograph. Printed on both sides.
4 x 5.75 inches.

281. JEAN LE GAC
JEAN LE GAC. EXPOSITION NOMINALE.
SOCIÉTÉ INFRA-WATT, CENTRE D'ÉTUDES ET
RECHERCHES POUR APPLICATIONS DU
RAYONNEMENT INFRA-ROUGE.
[Self-published]. November 2–27, 1971.
Announcement card.
Offset lithograph.
5.25 x 8.25 inches.

281.1 JEAN LE GAC
See also Christian Boltanski/Paul-Armand
Gette/Jean Le Gac.

282. CARY LEIBOWITZ
OFFICIAL CANDYASS LECTURE PASS.
House of Leibowitz. 1993.
Ticket.
Offset lithograph.
2 x 3.5 inches.

283. CARY LEIBOWITZ
SCHLOCK OF THE NEW. cary s leibowitz/candyass.
Bravin Post Lee Gallery, New York, N.Y.
November 17–December 23,1994.
Poster.
Folded. Offset lithograph. Printed on both sides.
Unfolded: 17 x 11 inches.

284. CARY LEIBOWITZ
1994 1995 1996 OFFICIAL Candyass
LECTURE PASS.
[Self-published]. 1994.
Ticket.
Offset lithograph.
3.5 x 2 inches.

285. CARY LEIBOWITZ
OFFICIAL Candyass DRINK TICKET.
House of Leibowitz. 1994.
Ticket.
Offset lithograph.
2 x 3.5 inches.

277.

278.

279.

280.

281.

282.

283.

284.

285.

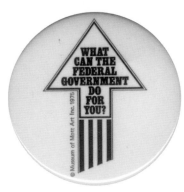

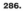

286.

287.

289.

290.

288.

291.

292.

293.

294. ROY LICHTENSTEIN
[Paper Plate].
[On First Inc., New York, N.Y.]. [1969].
Paper plate.
Screenprint.
Diameter: 10.25 inches.
Reference: Pop Store, pp. 82, 110.

295. SHARON LOCKHART
[Goshogaoka film poster. Sharon Lockhart.]
John Spotton Cinema, Toronto, Ontario, Canada.
S. L. Simpson Gallery, Toronto, Ontario, Canada.
October 7 and 22, 1997.
Poster.
Folded. Offset lithograph.
Unfolded: 23.5 x 16.75 inches.

296. SHARON LOCKHART
[Goshogaoka film poster. Sharon Lockhart.]
Cinema Paris, Berlin-Charlottenburg, Germany.
Neugerriemschneider, Berlin, Germany.
November 1 and 2, 1997.
Poster.
Folded. Offset lithograph.
Unfolded: 23.5 x 16.75 inches.

297. SHARON LOCKHART
[Goshogaoka film poster. Sharon Lockhart.]
ICA Cinematheque, London, England. Institute
of Contemporary Arts, London, England.
January 12 and 13, 1998.
Poster.
Folded. Offset lithograph.
Unfolded: 23.5 x 16.75 inches.

298. SHARON LOCKHART
[Goshogaoka film poster. Sharon Lockhart.]
Museum of Contemporary Art, Tokyo, Japan.
Wako Works of Art, Tokyo, Japan. January 30 and
February 8, 1998.
Poster.
Folded. Offset lithograph.
Unfolded: 23.5 x 16.75 inches.

299. SHARON LOCKHART
[Goshogaoka film poster. Sharon Lockhart.]
The Museum of Contemporary Art, Los Angeles,
Calif. Blum and Poe, Santa Monica, Calif.
February 19, 21, and 22, 1998.
Poster.
Folded. Offset lithograph.
Unfolded: 23.5 x 16.75 inches.

300. SHARON LOCKHART
[Goshogaoka film poster. Sharon Lockhart.]
Studio des Ursulines, Paris, France. Yvon Lambert,
Paris, France. Opening April 24, 1998.
Poster.
Folded. Offset lithograph.
Unfolded: 23.5 x 16.75 inches.

301. RICHARD LONG
CLIFTON SUSPENSION BRIDGE, BRISTOL.
RICHARD J. LONG. SCULPTURE.
Konrad Fischer, Düsseldorf, Germany.
September 21–October 18, [1968].
Announcement card.
Offset lithograph on found postcard. Printed on
both sides.
3.5 x 5.5 inches.
References: Long; Fischer, p. 23.

294.

295.

296.

297.

298.

299.

300.

301.

302.

303.

304.

305.

306.

307.

308.

309.

310.

302. RICHARD LONG
Richard Long. Village Bay, St. Kilda, Western Isles.
EINE SKULPTUR VON RICHARD LONG.
Konrad Fischer, Düsseldorf, Germany.
May 11–June 9, 1970.
Announcement card.
Offset lithograph on found postcard. Printed on both sides.
3.75 x 5.75 inches.
References: Long; Fischer, p. 47.

303. RICHARD LONG
RICHARD LONG.
Dwan Gallery, New York, N.Y. October 3–29, 1970.
2 announcement cards.
Offset lithograph on cardboard.
3.5 x 11 inches each.
Reference: Long.

304. RICHARD LONG
Look the ground in the eye. RICHARD LONG.
Galerie Yvon Lambert, Paris, France. Opening
May 3, 1972.
Announcement card.
Offset lithograph. Printed on both sides.
4 x 6.25 inches.
Reference: Long.

305. RICHARD LONG
RICHARD LONG.
Wide White Space, Antwerp, Belgium.
March 15–April 12, 1973.
Announcement card.
Offset lithograph. Printed on both sides.
3 x 8.75 inches.
Reference: Long.

306. RICHARD LONG
RIVER AVON DRIFTWOOD. RICHARD LONG.
Konrad Fischer, Düsseldorf, Germany.
May 15–June 11, 1976.
Announcement card.
Offset lithograph. Printed on both sides.
4 x 5.75 inches.
Reference: Long.

307. RICHARD LONG
LOW WATER CIRCLE WALK. RICHARD LONG.
Konrad Fischer, Düsseldorf, Germany.
November 8–29, 1980.
Announcement card.
Offset lithograph. Printed on both sides.
7.5 x 6 inches.
Reference: Long.

308. RICHARD LONG
RICHARD LONG.
Konrad Fischer, Zurich, Switzerland. May 8–June 6, 1981.
Announcement card.
Offset lithograph. Printed on both sides.
4 x 5.75 inches.
Reference: Long.

309. RICHARD LONG
FULL MOON CIRCLE OF GROUND. RICHARD LONG.
Art Agency Tokyo, Tokyo, Japan. April 20–May 31, 1983.
Announcement card.
Offset lithograph. Printed on both sides.
4.75 x 7.75 inches.

310. RICHARD LONG
PLATONIC WALKS. RICHARD LONG.
Bernier/Eliades, Athens, Greece. 1999.
Announcement card.
Offset lithograph. Printed on both sides.
7.75 x 5.75 inches.

310.2. REINER LUCASSEN
See Jan Dibbets/Ger van Elk/Reiner Lucassen.

311. GEORGE MACIUNAS
anTHOLOGY OF [. . .].
[Self-published, Germany]. [1962].
Announcement card/subscription form.
Open paper cube. Offset lithograph. Printed on all sides.
2.5 x 2.5 x 2.5 inches.
Reference: Fluxus Etc., p. 226.

312. GEORGE MACIUNAS
U.S. SURPASSES ALL NAZI GENOCIDE RECORDS!
Self-published, New York, N.Y. [1966].
Flyer.
Offset lithograph.
11 x 8.5 inches.
References: Fluxus Etc., p. 143; Fluxus Codex, p. 390.

313. GEORGE MACIUNAS
U.S.A. SURPASSES ALL THE GENOCIDE RECORDS - CALCULATIONS AND REFERENCES.
[Self-published, New York, N.Y.]. [1970c].
Flyer.
Offset lithograph.
11 x 8.5 inches.

314. GEORGE MACIUNAS
Composition 1971 by George Maciunas, dedicated to all avant garde artists such as: [. . .].
[Self-published, New York, N.Y.]. 1971.
Score.
Offset lithograph.
6.75 x 8.5 inches.
Reference: Fluxus Codex, p. 326.

315. GEORGE MACIUNAS
G. MACIUNAS. IMPLOSIONS INC+FLUXUS+YAM. 54 BOND ST. NY. 10012. TEL:4770137 AND 7551592.
[Self-published, New York, N.Y.]. N.d.
Business card.
Offset lithograph.
2 x 3.25 inches.

315.1. WALTER MARCHETTI
See Zaj/Walter Marchetti.

316. BRICE MARDEN
BRICE MARDEN / BACK SERIES.
Bykert Gallery, New York, N.Y. January 6–31, 1968.
Poster.
Folded. Offset lithograph.
Unfolded: 16.5 x 19 inches.
Reference: Marden, p. 47.

317. BRICE MARDEN
Brice Marden. Recent Drawings and Etchings.
Matthew Marks, New York, N.Y. May 7–June 28, 1991.
Announcement card.
Folded. Letterpress. Printed on both sides.
Folded: 9.75 x 6.5 inches. Unfolded: 9.75 x 13 inches.

318. TOM MARIONI
ABSTRACT EXPRESSIONISTIC performance sculpture. TO BE PERFORMED ON ANY BLACK TOP SURFACE BETWEEN THE HOURS OF 10am AND 3pm LOADED. TOM MARIONI.
[Self-published, San Francisco, Calif.]. Summer 1969.
Announcement card.
Offset lithograph.
5.5 x 7.25 inches.
Reference: Marioni.

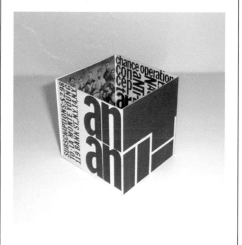

311.

312.

313.

314.

G · M A C I U N A S
I M P L O S I O N S
I N C + F L U X U S +
Y A M · 5 4 B O N D
S T · N Y · 1 0 0 1 2
T E L : 4 7 7 0 1 3 7
A N D 7 5 5 1 5 9 2

315.

316.

317.

318.

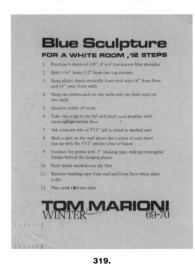

319.

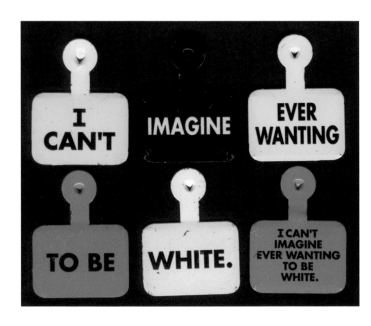

CONCEPTUAL ART

*Idea oriented situations
not directed at the production
of static objects.*

320.

*The Board of Trustees of The San Francisco Museum of Art
are pleased to announce the appointment of Thomas Marioni
as Director, January 3, 1973.*

321.

ARTFORUM 667 Madison Avenue, New York, N.Y. 10021 (212) 838-6820
Please reserve advertising space for our March issue by February 1st. The deadline
for copy is February 8th. Thank you. John H. Liesveld, Jr., Robin F. White

323.

322.

324.

319. TOM MARIONI
Blue Sculpture FOR A WHITE ROOM, 12 STEPS.
TOM MARIONI. WINTER 69-70.
[Self-published, San Francisco, Calif.]. [1969].
Announcement card.
Offset lithograph.
7.25 x 5.75 inches.
Reference: Marioni.

320. TOM MARIONI
CONCEPTUAL ART. Idea oriented situations not
directed at the production of static objects.
[Self-published, San Francisco, Calif.]. [1970].
Card.
Offset lithograph.
[Edition of 500 copies].
1.75 x 3 inches.
Reference: Marioni.

321. TOM MARIONI
The Board of Trustees of the San Francisco Museum
of Art are pleased to announce the appointment of
Thomas Marioni as Director, January 3, 1973.
[Self-published, San Francisco, Calif.]. 1973.
Card.
Offset lithograph.
[Edition of 500 copies].
3.75 x 5.75 inches.
References: Marioni; Correspondence Art, p. 109.

322. DANIEL JOSEPH MARTINEZ
["Study for Museum Tags: Second Movement
(Overture) or Overture con Claque - Overture with
Hired Audience Members"].
[Whitney Museum of American Art, New York, N.Y.].
[1993].
6 museum admission tags.
Offset lithograph on metal tag.
1.25 x 1 inch each overall.
Tags listed individually:

I CAN'T.
IMAGINE.
EVER WANTING.
TO BE.
WHITE.
I CAN'T IMAGINE EVER WANTING TO BE WHITE.
Note: 6 versions printed in blue, yellow, white,
gold, red, and black.
Reference: Martinez, pp. 48–50.

322.1. LUIS MATAIX
See Zaj/Luis Mataix.

323. GORDON MATTA-CLARK
Gordon Matta Clark, Sycle Cuts, 1976.
Artforum, New York, N.Y. 1977.
Advertisement order form.
Offset lithograph.
6.25 x 6.25 inches.

323.1. BRUCE MCLEAN
See Nice Style.

323.2. JONAS MEKAS
See Point d'Ironie/Jonas Mekas.

323.3. ANNETTE MESSAGER
See Point d'Ironie/Annette Messager.

324. GUSTAV METZGER
[South Bank Manifesto].
[Self-published?]. June 23, 1961.
Manifesto.
Folded. Offset lithograph on newsprint.
[Edition of 1,000 copies].
11.25 x 8.5 inches.
References: Metzger, p. 99; Fröliche Wissenschaft, p. 54.

325. PIETER LAURENS MOL
THIS PAPER IS YOURS.
[Self-published]. 1974.
Relic/print in open-ended tube.
Offset lithograph on newsprint. 1 die-cut circle.
Edition of 100 copies.
16.75 x 11.5 inches.

326. PIETER LAURENS MOL
PIETER MOL, Sculpture, 1975. WHY CAN'T YOU
JUST TELL ME?
[Self-published]. 1975.
Card in envelope.
Offset lithograph.
Card: 4.5 x 4.5 inches. Envelope: 4.75 x 4.75
inches.

327. PIETER LAURENS MOL
Ik zou je ogen willen kussen (I should like to kiss
your eyes). PIETER MOL.
De Appel, Amsterdam, The Netherlands.
June 4–11, 1976.
Announcement card.
Folded. Offset lithograph. Printed on both sides.
Folded: 4 x 6 inches. Unfolded: 8.75 x 5 inches.

328. PIETER LAURENS MOL
EXPEDITION POLAIRE.
Haags Centrum voor Aktuele Kunst, [The Hague,
The Netherlands]. 1994.
Envelope containing 4 grams of salt and sugar.
Offset lithograph. Printed on both sides.
4 x 2.5 inches.

329. LINDA MONTANO
Match the word with the correct picture. Please
send me a word from childhood - one that you do
not hear or use now. linda.
[Self-published?]. N.d.
Card.
Offset lithograph. Printed on both sides.
5 x 7 inches.

330. ROBERT MORRIS
FLOOR PLAN WITH DATES OF CHANGES
DURING THE EXHIBITION. ROBERT MORRIS.
Leo Castelli, New York, N.Y. Opening
March 4, 1967.
Poster.
Folded. Offset lithograph. Printed on both sides.
Unfolded: 28.5 x 22.5 inches.
Reference: Morris, p. 128.

331. ROBERT MORRIS
THERE ARE TWO TEMPERATURES: ONE
OUTSIDE, ONE INSIDE.
[Self-published]. 1969.
Relic/print.
Folded. Rubber stamp on paper towel.
Unfolded: 14.5 x 9.5 inches.
References: Kosuth/Morris; Lippard, p. 93.

332. ROBERT MORRIS
LABYRINTHS-VOICE-BLIND TIME. ROBERT
MORRIS.
Castelli-Sonnabend, New York, N.Y.
April 6–27, 1974.
Poster.
Offset lithograph.
36 x 24 inches.
References: Morris, p. 129; Morris (Labyrinths),
p. 159.

325.

WHY CAN'T YOU JUST TELL ME?

326.

327.

EXPEDITION
POLAIRE

328.

Match the word with the correct picture.

1. tomte gubbe 2. trossy 3. baceda
 (tom-teh-goo-beh) (traw-see) (bay-keh-duh)

A. B. C.

329.

330.

331.

332.

333.

334.

337.

335.

336.

338.

339.

340.

333. **DAVE MULLER**
SUMMER GROUP SHOW.
Three Day Weekend, Los Angeles, Calif.
April 1–3, 1994.
Flyer.
Folded. Photocopy. Printed on both sides.
Unfolded: 11 x 8.5 inches.

334. **DAVE MULLER/JORY FELICE**
Dave's Not Here SHOW.
Three Day Weekend, Los Angeles, Calif.
July 1–4, 1994.
Flyer.
Folded. Photocopy.
Unfolded: 8.5 x 10.75 inches.

335. **DAVE MULLER**
-THANKS- THE WORK IS NOT FOR SALE BUT UP
FOR BARTER. . . .
Three Day Weekend, Los Angeles, Calif.
November 25–27, 1994.
Poster.
Folded. Photocopy.
Unfolded: 17 x 11 inches.

336. **DAVE MULLER**
JORY FELICE. corollaoverninety-four.
Three Day Weekends, Los Angeles, Calif.
January 8–29, 1995.
Flyer.
Folded. Photocopy.
Unfolded: 11 x 8.5 inches.

337. **DAVE MULLER**
Her Eyes Are A Blue Million Miles.
Three Day Weekend, Los Angeles, Calif.
November 7–9 and 11, 1997.
Poster.
Folded. Photocopy.
Unfolded: 17 x 5.5 inches.

338. **N. E. THING CO. LTD. (IAIN &
INGRID BAXTER)**
IQ.
[Self-published]. [1968].
Metal button.
Offset lithograph.
[Edition of approximately 500 copies].
Diameter: 1.5 inches.
Reference: N. E. Thing Co. Ltd., p. 27.

339. **N. E. THING CO. LTD. (IAIN &
INGRID BAXTER)**
ART ATTACK. N.E. THING CO. LTD.
[Self-published]. [1969].
Metal button.
Offset lithograph.
[Edition of approximately 500 copies].
Diameter: 1.25 inches.
Reference: N. E. Thing Co. Ltd., p. 27.

340. **N. E. THING CO. LTD. (IAIN &
INGRID BAXTER)**
GNG. GROSS NATIONAL GOOD.
N. E. Thing Co. Ltd.
[Self-published]. [1969].
Metal button.
Offset lithograph.
[Edition of approximately 500 copies].
Diameter: 1.25 inches.
Reference: N. E. Thing Co. Ltd., p. 27.

341. N. E. THING CO. LTD. (IAIN & INGRID BAXTER)
N.E. THING CONSULTS WITH 1% OF YOU [. . .].
Self-published, Vancouver, B.C., Canada. [1970].
File folder.
Offset lithograph. A label is mounted on the folder tab.
Edition of 500 copies.
9.5 x 11.75 inches.
Reference: N. E. Thing Co. Ltd., p. 55.

342. N. E. THING CO. LTD. (IAIN & INGRID BAXTER)
[N.E. THING COMPANY, HOCKEY TEAM].
[Self-published, Toronto, Ontario, Canada. [1972].
Announcement/color photograph in cardboard frame.
[Edition of 250 copies].
4.5 x 6 inches.
Reference: N. E. Thing Co. Ltd., p. 78.

343. N. E. THING CO. LTD. (IAIN & INGRID BAXTER)
WHAT IS ART?
Self-published, Vancouver, B.C., Canada. [1972].
Postcard.
Offset lithograph. Printed on both sides.
[Edition of 3,000 copies].
5.5 x 8.5 inches.
Reference: N. E. Thing Co. Ltd., p. 75.

344. N. E. THING CO. LTD. (IAIN & INGRID BAXTER)
Eunuchversity. N. E. THING CO. LTD.
[Self-published]. [1973].
Metal button.
Offset lithograph.
[Edition of approximately 500 copies].
Diameter: 2.25 inches.
Reference: N. E. Thing Co. Ltd., p. 27.

345. N. E. THING CO. LTD. (IAIN & INGRID BAXTER)
[VIP button].
[Self-published]. N.d.
Metal button.
Offset lithograph.
[Edition of 500 copies].
Diameter: 1.5 inches.

346. MAURIZIO NANNUCCI
ART AS SOCIAL ENVIRONMENT (MAURIZIO NANNUCCI/ZONA).
[Self-published?]. [1978c].
Poster.
Folded. Offset lithograph.
Unfolded: 19.25 x 27 inches.

347. BRUCE NAUMAN
B. NAUMAN.
Sacramento State College Art Gallery, Sacramento, Calif. April 1968.
Poster.
Folded. Offset lithograph.
Unfolded: 34.5 x 45 inches.

348. BRUCE NAUMAN
Cones. Cojones.
[Leo Castelli, New York, N.Y.]. [1975].
2 posters/printed texts.
Offset lithograph.
20 x 13 inches each.
References: Nauman (Walker), p. 264; Nauman, pp. 208–209.

348.1. TONI NEGRI
See Point d'Ironie/Toni Negri/Antoinette Ohannessian.

341.

342.

WHAT IS ART?

name: residence:
occupation: age:

343.

344.

345.

346.

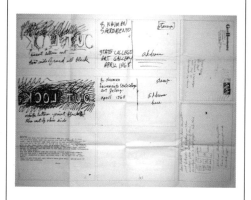

347.

348.

one hundred five

250 METERS OF THICK CHAIN ACCUMULATED IN A CUBE OF HEAVY GLASS, IN ORDER THAT HALF OF THE SPACE IS FILLED.	A PRISMATIC BEAM OF BLUE LIGHT, WITH A SECTION OF 10 METERS SQUARE, THAT GOES FROM ONE HOUSE FRONT TO THE ONE ACROSS THE STREET.	A PERFECT CIRCULAR HORIZON.
A STRAIGHT THICK LINE THAT RUNS FROM HERE THROUGH YOU TO THE END OF THE ROOM.	A SURROUNDED SPACE THAT EXPANDS IN THE DIRECTION YOU WALK.	A ROOM WITH THE CENTER POINT OF THE CEILING TOUCHING THE FLOOR.
THIS IS A MIRROR. YOU ARE A WRITTEN SENTENCE.	FOUR BRIDGES, 1 KILOMETER LONG, FORMING A SQUARE WITHOUT EXIT, OVER POPULATED AREA.	A TEN STORY BUILDING WITH STYROFOAM FLOWING OUT OF THE WINDOWS.

349.

THE LABELS WERE MAILED (IN ENVELOPES) AS PART OF A SERIES OF MAILINGS WHICH INCLUDED BOTH JOSE GUILLERMO'S AND LILIANA'S PIECES. WE DIDN'T HAVE A GALLERY AND FIGURED THAT THIS WAS A GOOD WAY TO EXHIBIT (WITHOUT YET KNOWING ABOUT RAY JOHNSON, WITH WHOM I BECAME FRIENDS IN 1969). WE CALLED OURSELVES THE NEW YORK GRAPHICS WORKSHOP (WITH INTENDED POMPOSITY, PARTICULARLY THE "THE"), AND WE HAD HAD A PRINTMAKING STUDIO IN WHICH WE EXPERIMENTED, HAD STUDENTS, AND WORKED WITH FRIENDS (LEON POLK SMITH, AMONG OTHERS). WE WERE AGAINST THE TRADITIONAL CONSTRAINTS OF PRINTMAKING AND PRODUCED SOMETHING CALLED A FANDSO (FREE ASSEMBLABLE NONFUNCTIONAL DISPOSABLE SERIAL OBJECTS). THE PROPOSITIONS ON THE STICKERS WERE "DESCRIPTIONS OF VISUAL SITUATIONS," WHICH I THEREFORE DIDN'T HAVE TO EXECUTE BECAUSE THEY WERE BUILT IN THE IMAGINATION OF THE SPECTATOR. THE STICKERS WERE ALSO STUCK IN ELEVATORS AND BATHROOMS.
—LUIS CAMNITZER

348.2. MAX NEUHAUS
See Institute for Art and Urban Resources/Max Neuhaus.

349. THE NEW YORK GRAPHIC WORKSHOP (LUIS CAMNITZER/JOSE GUILLERMO CASTILLO/LILIANA PORTER)
250 METERS OF THICK CHAIN ACCUMULATED IN A CUBE OF HEAVY GLASS, IN ORDER THAT HALF OF THE SPACE IS FILLED [. . .]. (First Class Mail Art Exhibition).
[Self-published]. [1967].
Sheet of 9 stickers.
Offset lithograph.
Stickers: 1.25 x 1.75 inches each. Sheet: 4.25 x 5.5 inches.
References: Lippard (Changing), p. 263; Information, p. 93.

350. NICE STYLE (GARY CHITTY/ROBIN FLETCHER/BRUCE MCLEAN/ PAUL RICHARDS)
The Final Pose Piece.
P. M. J. Self and Company. 1975.
Vintage gelatin silver print in sleeve.
Sleeve: Offset lithograph. 1 die-cut triangle.
Print: 9.25 x 11.25 inches. Sleeve: 12 x 10 inches.

350.1. B. P. NICHOL
See Openings Press/B. P. Nichol.

351. RICHARD NONAS
Richard Nonas.
The Clocktower, New York, N.Y.
October 18–November 8, [1973].
Poster.
Offset lithograph.
23 x 29 inches.

352. RICHARD NONAS
RICHARD NONAS. EQUALIZER. THE THIRD SCULPTURE OF THE BOUNDRY MAN SERIES.
Idea Warehouse, New York, N.Y.
May 22–24 and 29–31, [1975].
Announcement card.
Offset lithograph.
8.5 x 9.75 inches.

353. RICHARD NONAS
RICHARD NONAS/SCULPTURE.
John Weber Gallery, New York, N.Y.
January 1–31, [1977].
Flyer.
Folded. Offset lithograph.
Unfolded: 11 x 9 inches.

354. RICHARD NONAS
RICHARD NONAS. MONTEZUMA'S BREAKFAST.
P.S. 1 Exhibition Space, [Long Island City, Queens, N.Y.]. [1977].
Poster.
Folded. Offset lithograph.
Unfolded: 14 x 9.5 inches.

355. RICHARD NONAS
RICHARD NONAS / NEW SCULPTURE AND DRAWINGS.
Richard Bellamy/Oil and Steel Gallery, New York, N.Y. October 17–November [1980].
Poster.
Folded. Offset lithograph.
Unfolded: 11.75 x 20.5 inches.

350.

351.

352.

353.

354.

355.

356. RICHARD NONAS
SCULPTURES WORKING.
Socrates Sculpture Park, Long Island City, N.Y. [1987].
Matchbook.
Offset lithograph.
1.5 x 2 inches.

357. RICHARD NONAS
MABOU MINES.
The Ontological at Saint Mark's Theatre, Saint
Mark's Church-in-the-Bowery, New York, N.Y.
October 15–November 15, 1992.
Poster.
Offset lithograph.
30 x 23 inches.

358. RICHARD NONAS
COLD COFFEE: FIRST IN THE MORNING, LAST
AT NIGHT. RICHARD NONAS.
Anders Tornberg, [Lund, Sweden].
September 2–October 4, 1995.
Announcement card.
Double folded. Offset lithograph. Printed on both sides.
Folded: 5 x 7.5 inches.
Unfolded: 6.75 x 7.5 inches.

358.1. ANTOINETTE OHANNESSIAN
See Point d'Ironie/Toni Negri/Antoinette
Ohannessian.

359. CLAES OLDENBURG
CLAES PAT OLDENBURG.
Green Gallery, New York, N.Y.
September 24–October 20, [1962].
Poster.
Folded. Offset lithograph.
Unfolded: 22.5 x 17.5 inches.
Reference: Oldenburg, p. 85.

360. CLAES OLDENBURG
["Airflow" Box]. ARTNEWS. February 1966.
Newsweek, Inc., New York, N.Y. [January 1966].
Cover for the periodical *ArtNews* (vol. 64, no. 10).
Offset lithograph.
Edition of approximately 36,000 copies.
Cover: 12 x 9 inches.
Constructed "box": 0.5 x 4.75 x 2 inches.
Reference: Oldenburg, p. 99.

361. CLAES OLDENBURG
CLAES OLDENBURG.
Sidney Janis Gallery, New York, N.Y.
April 26–May 27, 1967.
Poster.
Offset lithograph.
23 x 29 inches.
Reference: Oldenburg, p. 109.

362. YOKO ONO
MORNING PIECE (1964) to George Maciunas.
by Yoko Ono.
Self-published. September 12 and 19, 1965.
Flyer.
Offset lithograph.
8.25 x 8.5 inches.
Reference: Ono, p. 44.

363. YOKO ONO
FOUNTAIN PIECE.
Hansom Books, London, England. October 1966.
Artist's advertisement in the periodical *Art and
Artists* (vol. 1, no. 7 [October 1966], p. 44).
Offset lithograph.
Image size: 2.5 x 2.5 inches approximately.
Page size: 11 x 8.25 inches.
Reference: Ono, p. 188.

356.

357.

358.

359.

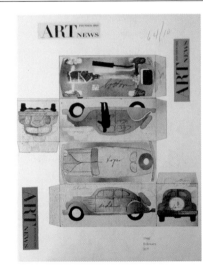

360.

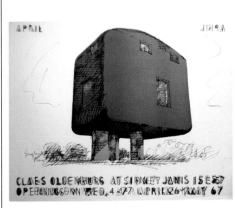

361.

362.

363.

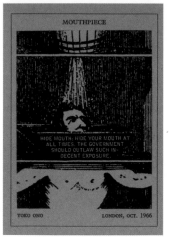

364.

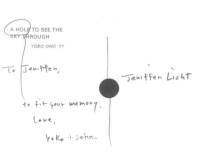

365.

WAR
IS
OVER!

IF YOU WANT IT

Happy Christmas from John & Yoko

366.

plakat 4 calendar

b. p. nichol

openings press May 66
rooksmoor house
woodchester: glos.

477 brunswick ave.
toronto 4
ontario
canada

367.

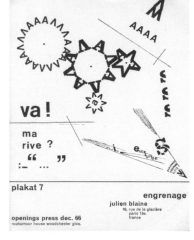

plakat 7

engrenage
julien blaine
16, rue de la glacière
paris 13e.
france

openings press dec. 66
rooksmoor house woodchester glos.

368.

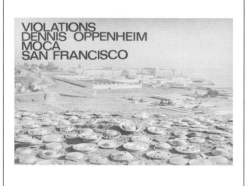

VIOLATIONS
DENNIS OPPENHEIM
MOCA
SAN FRANCISCO

369.

370.

371.

364. YOKO ONO
MOUTHPIECE.
Hansom Books, London, England. November 1966.
Artist's advertisement in the periodical *Art and Artists* (vol. 1, no. 8 [November 1966], p. 39).
Offset lithograph.
Image size: approximately 4.75 x 3.2 inches.
Page size: 11 x 8.25 inches.
Reference: Ono, p. 188.

365. YOKO ONO
A HOLE TO SEE THE SKY THROUGH. YOKO ONO '71.
Self-published. 1971.
Card.
Offset lithograph. 1 die-cut circle.
3.75 x 5.75 inches.
References: Ono (Arias and Objects), endpapers; Correspondence Art, p. 14.

366. YOKO ONO/JOHN LENNON
WAR IS OVER! IF YOU WANT IT. Happy Christmas from John & Yoko.
Self-published. 1970.
Postcard.
Offset lithograph. Printed on both sides.
8 x 6 inches.
References: Ono, pp. 317–18; Ono (Arias and Objects), pp. 106–107.

367. OPENINGS PRESS/B. P. NICHOL
plakat 4. calendar. b. p. nichol.
Openings Press, Gloucestershire, England. May 1966.
Poster.
Offset lithograph.
10.5 x 8 inches.

368. OPENINGS PRESS/JULIEN BLAINE
plakat 7. engrenage. julien blaine.
Openings Press, Gloucestershire, England. December 1966.
Poster.
Offset lithograph.
10.5 x 8 inches.

369. DENNIS OPPENHEIM
VIOLATIONS. DENNIS OPPENHEIM.
MOCA, San Francisco, Calif. January 1972.
Card.
Offset lithograph. Printed on both sides. Designed by Tom Marioni.
6.75 x 10 inches.

369.1 MARKUS OPPITZ
See Lothar Baumgarten/Markus Oppitz.

369.2 GABRIEL OROZCO
See Point d'Ironie/Gabriel Orozco.

370. NAM JUNE PAIK
THE MONTHLY REVIEW of the UNIVERSITY for Avant-Garde Hinduism!
Fluxus. [1963].
Artist's periodical.
1 leaf. Offset lithograph on newsprint. Printed on both sides.
Editor: N. J. Paik.
12 x 8.5 inches.
References: Fluxus Codex, p. 431. Fluxus Etc. Addenda II, pp. 57–59; Correspondence Art, p. 125.

371. NAM JUNE PAIK
MOVING THEATER NO. 2 (N.J. PAIK). Monthly Review of University of Avangarde [*sic*] Hinduism.
[Self-published]. [1963].
Manifesto/score.
Folded. Mimeograph. 1 rubber stamp.
Unfolded: 10 x 14.25 inches.
Reference: Fluxus Etc. Addenda II, pp. 73, 76.

371.1. MARTIN PARR
See Point d'Ironie/Martin Parr.

371.2. FELIX PARTZ
See General Idea.

372. IZHAR PATKIN
IZHAR PATKIN. THE BLACK PAINTINGS
Limbo Gallery, New York, N.Y. April 4–May 4, 1986.
Poster/announcement.
Folded. Offset lithograph. Several die-cut circles
and flower shapes.
Unfolded: 31 x 21 inches.

373. IZHAR PATKIN
Izhar Patkin. "Judenporzellan".
Refusalon, San Francisco, Calif. October 1–31, [1998].
Announcement.
Folded. Offset lithograph and watercolor. Printed
on both sides.
Folded: 5.5 x 4.25 inches.
Unfolded: 10.75 x 8.5 inches.

374. IZHAR PATKIN
IZHAR PATKIN. "Five Piece suit".
Holly Solomon Gallery, New York, N.Y. N.d.
Poster.
Folded. Offset lithograph on perforated paper.
Unfolded: 7.5 x 9.5 inches.

375. RAYMOND PETTIBON
BLACK FLAG. Tues WITH THE MiDdle Class and
Social Distortion. Weds WITH THE Adolescents
and China White. STARWOOD.
[Black Flag. SST Records]. N.d.
Flyer.
Photocopy.
11 x 8.5 inches.

376. RAYMOND PETTIBON
I DREAM IN MARBLE.
[Richard/Bennett Gallery, Los Angeles, Calif.]. [1988].
Metal button.
Offset lithograph.
Edition of 100 copies. Signed and numbered.
Diameter: 1 inch.

377. RAYMOND PETTIBON
BLACK FLAG. The ENEMY. The COSMETICS.
SOCIAL UNREST. At THE MABUHAY.
[Black Flag. SST Records]. N.d.
Flyer.
Photocopy.
8.5 x 11 inches.

378. RAYMOND PETTIBON
BLACK FLAG AND D.O.A. FROM CANADA.
AT THE WHISKY.
[Black Flag. SST Records]. N.d.
Flyer.
Photocopy.
11 x 8.5 inches.

379. RAYMOND PETTIBON
BLACK FLAG. YOU DIDN'T LOVE HIM ENOUGH.
[Black Flag. SST Records]. N.d.
Flyer.
Photocopy.
11 x 8.5 inches.

380. ADRIAN PIPER
Dear Friend, I am not here to pick anyone up, or
to be picked up [. . .].
ANGRY ART. 1986.
Calling card.
Offset lithograph. Printed on both sides.
2 x 3.5 inches.

372.

373.

374.

375.

376.

377.

378.

379.

Dear Friend,

I am not here to pick anyone up, or to be picked up. I am here alone because I want to be here, ALONE.

This card is not intended as part of an extended flirtation.

Thank you for respecting my privacy.

380.

Dear Friend,
 I am black.
 I am sure you did not realize this when you made/laughed at/agreed with that racist remark. In the past, I have attempted to alert white people to my racial identity in advance. Unfortunately, this invariably causes them to react to me as pushy, manipulative, or socially inappropriate. Therefore, my policy is to assume that white people do not make these remarks, even when they believe there are no black people present, and to distribute this card when they do.
 I regret any discomfort my presence is causing you, just as I am sure you regret the discomfort your racism is causing me.

381.

382.

383.

385.

386.

387.

388.

389.

381. **ADRIAN PIPER**
Dear Friend, I am black [. . .].
ANGRY ART. 1986.
Calling card.
Offset lithograph. Printed on both sides.
2 x 3.5 inches.

382. **POINT D'IRONIE/JONAS MEKAS**
[point d'ironie n°0]. Jonas Mekas.
agnès b. and Hans-Ulrich Obrist, Paris, France.
May 1997.
Artist's periodical.
Tabloid format. Unpaginated.
[Edition of 100,000 copies].
17 x 12 inches.

383. **POINT D'IRONIE/JOSEPH GRIGELY**
[point d'ironie] 1. Joseph Grigely.
agnès b. and Hans-Ulrich Obrist, Paris, France.
June 1997.
Artist's periodical.
Tabloid format. Unpaginated.
[Edition of 100,000 copies].
17 x 12 inches.

384. **POINT D'IRONIE/CHRISTIAN BOLTANSKI**
[point d'ironie]. amicale des témoins, C.B.
[agnès b. and Hans-Ulrich Obrist, Paris, France].
September 1, 1997.
Artist's periodical.
1 leaf. Offset lithograph. Printed on both sides.
[Edition of 100,000 copies].
17 x 12 inches.

385. **POINT D'IRONIE/GILBERT & GEORGE**
[point d'ironie] 2. Gilbert and George.
agnès b. and Hans-Ulrich Obrist, Paris, France.
October 1997.
Artist's periodical.
Tabloid format. Unpaginated.
[Edition of 100,000 copies].
17 x 12 inches.

386. **POINT D'IRONIE/DOUGLAS GORDON**
[point d'ironie] 3. Douglas Gordon.
agnès b. and Hans-Ulrich Obrist, Paris, France.
November 1997.
Artist's periodical.
Tabloid format. Unpaginated.
[Edition of 100,000 copies].
17 x 12 inches.

387. **POINT D'IRONIE/MARLENE STEERUWITZ**
[point d'ironie] 4. Marlene Streeruwitz.
agnès b. and Hans-Ulrich Obrist, Paris, France.
February 1998.
Artist's periodical.
Tabloid format. Unpaginated.
[Edition of 100,000 copies].
17 x 12 inches.

388. **POINT D'IRONIE/ANNETTE MESSAGER**
[point d'ironie] 5. Annette Messager.
agnès b. and Hans-Ulrich Obrist, Paris, France.
April 1998.
Artist's periodical.
Tabloid format. Unpaginated.
[Edition of 100,000 copies].
17 x 12 inches.

389. **POINT D'IRONIE/LAWRENCE WEINER**
[point d'ironie] 6. Lawrence Weiner.
agnès b. and Hans-Ulrich Obrist, Paris, France.
May 1998.
Artist's periodical.
Tabloid format. Unpaginated.
[Edition of 100,000 copies].
17 x 12 inches.

390. POINT D'IRONIE/CHRISTIAN BOLTANSKI
[point d'ironie] 7. Christian Boltanski, L'Ecole de Hamburgerstrasse.
agnès b. and Hans-Ulrich Obrist, Paris, France.
July 1998.
Artist's periodical.
Tabloid format. Unpaginated.
[Edition of 100,000 copies].
17 x 12 inches.

391. POINT D'IRONIE/ITSUKO HASEGAWA/ DAN GRAHAM
[point d'ironie] 8. Itsuko Hasegawa et Dan Graham.
agnès b. and Hans-Ulrich Obrist, Paris, France.
September 1998.
Artist's periodical.
Tabloid format. Unpaginated.
[Edition of 100,000 copies].
17 x 12 inches.

392. POINT D'IRONIE/GABRIEL OROZCO
[point d'ironie] 9. Gabriel Orozco.
agnès b. and Hans-Ulrich Obrist, Paris, France.
December 1998.
Artist's periodical.
Tabloid format. Unpaginated.
[Edition of 100,000 copies].
17 x 12 inches.

393. POINT D'IRONIE/CLAUDE LÉVÊQUE
[point d'ironie] 10. Claude Lévêque.
agnès b. and Hans-Ulrich Obrist, Paris, France.
January 1999.
Artist's periodical.
Tabloid format. Unpaginated.
[Edition of 100,000 copies].
17 x 12 inches.

394. POINT D'IRONIE/HANS-PETER FELDMANN
[point d'ironie] 11. Hans-Peter Feldmann.
agnès b. and Hans-Ulrich Obrist, Paris, France.
March 1999.
Artist's periodical.
Tabloid format. Unpaginated.
[Edition of 100,000 copies].
17 x 12 inches.

395. POINT D'IRONIE/MARTIN PARR
[point d'ironie]. a special Martin Parr.
agnès b. and Hans-Ulrich Obrist, Paris, France.
April 1999.
Artist's periodical.
Tabloid format. Unpaginated. The pages are scored.
[Edition of 100,000 copies].
17 x 12 inches.

396. POINT D'IRONIE/HARMONY KORINE
[point d'ironie] 12. Harmony Korine.
agnès b. and Hans-Ulrich Obrist, Paris, France.
May 1999.
Artist's periodical.
Tabloid format. Unpaginated.
[Edition of 100,000 copies].
17 x 12 inches.

397. POINT D'IRONIE/TONI NEGRI/ ANTOINETTE OHANNESSIAN
[point d'ironie] 13. Toni Negri / Antoinette Ohannessian.
agnès b. and Hans-Ulrich Obrist, Paris, France.
June 1999.
Artist's periodical.
Tabloid format. Unpaginated.
[Edition of 100,000 copies].
17 x 12 inches.

390.

391.

392.

393.

394.

395.

396.

397.

398.

399.

400.

401.

ARTIST STATEMENT

I DESIGNED THE BLACKKAT CARD TO ANNOUNCE A NEW YORK EXHIBITION OF MINE AT THE THEN NEW MORRIS HEALY GALLERY (NOW PAUL MORRIS GALLERY) IN 1995. AFTER THE CARDS WERE MAILED, I NOTICED THAT SOME BAD THINGS BEGAN HAPPENING IN MY LIFE. NOTHING SERIOUS—IN FACT, I CAN'T EVEN REMEMBER WHAT THEY WERE NOW, BUT THEY WERE PERSISTENT ENOUGH TO MAKE ME NOTICE. I BEGAN TO SUSPECT THAT THE BLACKKAT CARD MIGHT BE GENERATING A CURSE, THAT THE PHYSICAL MANIFESTATION OF BAD LUCK—THE WORD "BLACKKAT"—HAD BECOME A SELF-FULFILLING PROPHESY, AND PAUL MORRIS HAD SENT ME A FEW HUNDRED EXTRA CARDS! I REMEMBERED A FRIEND OF MINE FROM CHICAGO, CHRIS MILTON, WHO USED ROADKILL IN HER ARTWORK. SHE WAS LATER KILLED ON THE ROAD BY A BLOW TO THE HEAD FROM THE REARVIEW MIRROR OF A PASSING TRUCK AS SHE WAS JOGGING EARLY ONE MORNING. I ALSO REMEMBERED THAT I HAD BURNED AN ARTWORK IN MY FIREPLACE IN AN EFFORT TO WARD OFF HARM TO MY SON, WHO WAS IN A DANGEROUS SITUATION. (THE ARTWORK WAS RELATED TO HIS SITUATION.) A SHARD OF THE WORK DID NOT BURN, SO WHILE HE ESCAPED SERIOUS HARM, HIS FRONT TOOTH WAS KNOCKED OUT BY THE BUTT OF AN AUTOMATIC RIFLE. I DECIDED TO BURN ALL OF THE BLACKKAT CARDS IN AN ATTEMPT TO DISPEL MY BAD LUCK. I TOOK THEM OUTDOORS, DUMPED THEM INTO A METAL GARBAGE CAN, DOUSED THEM WITH GASOLINE, AND SET FIRE TO THEM. I TENDED THE FIRE FOR HOURS TO MAKE SURE THAT EVERY LAST PIECE OF PAPER WAS DESTROYED. I HOPE THAT BY RETELLING THIS STORY AND BRINGING ATTENTION TO THE BLACKKAT THAT I AM NOT REACTIVATING THE BAD LUCK, BUT PERHAPS MY ACKNOWLEDGMENT OF THE FEAR WILL HELP TO WARD IT OFF. ANYWAY, THE BLACKKAT CARD IS SCARCE . . . I KNOW I DON'T HAVE ONE. —KAY ROSEN

402.

403.

404.

398. POINT D'IRONIE/LOUISE BOURGEOIS
[point d'ironie] 14. Louise Bourgeois.
agnès b. and Hans-Ulrich Obrist, Paris, France.
September 1999.
Artist's periodical.
Tabloid format. Unpaginated.
[Edition of 100,000 copies].
17 x 12 inches.

398.1. LILIANA PORTER
See The New York Graphic Workshop.

398.2. LUCIO POZZI
See Institute for Art and Urban Resources/Lucio Pozzi.

399. ROBERT RAUSCHENBERG
[Jewish Museum Poster].
The Jewish Museum, New York, N.Y.
March 31–May 8, 1963.
Poster.
Offset lithograph.
[Edition of 3,000 copies].
32 x 22 inches.
Reference: Rauschenberg, No. 14.

400. ROBERT RAUSCHENBERG
JAMMERS. RAUSCHENBERG.
Castelli, New York, N.Y. Opening
February 21, 1976.
Poster.
Folded. Offset lithograph.
Unfolded: 24 x 24 inches overall.

401. ROBERT RAUSCHENBERG
JAMMERS. RAUSCHENBERG.
Ace, Vancouver, B.C., Canada; Los Angeles, Calif.;
and Venice, Calif. 1976.
Announcement/napkin.
Folded. Silkscreen on cloth napkin.
Unfolded: 15 x 15.75 inches.

402. ROBERT RAUSCHENBERG
R.R. AT LEO'S.
Leo Castelli Gallery, Inc., New York, N.Y. Opening
March 29, [1980].
Poster.
Folded. Offset lithograph.
Unfolded: 30.75 x 22 inches.

402.1. PAUL RICHARDS
See Nice Style.

402.2. KLAUS RINKE
See Institute for Art and Urban Resources/Klaus Rinke.

403. KAY ROSEN
Kay Rosen, Homophonia.
[Self-published]. 1989.
Flyer.
Folded. Photocopy?
Unfolded: 14 x 8.5 inches.

404. KAY ROSEN
blac-kat. Kay Rosen. drawings.
Paul Morris Gallery, New York, N.Y.
March 18–April 23, 1995.
Announcement card.
Offset lithograph. Printed on both sides.
3.5 x 5.5 inches.

405. KAY ROSEN
["Ho, Ho, Ho"].
Self-published. [1995].
Christmas card.
Rubber stamp on printed postcard.
3.5 x 5.5 inches.

406. MARTHA ROSLER
season's greetings from our house to your house.
GRATER.
[Self-published]. [1976].
Christmas card/photo postcard.
1 rubber stamp on the verso.
3.5 x 6.75 inches.
Reference: Rosler, pp. 93–94.

407. ALLEN RUPPERSBERG
AL'S GRAND HOTEL.
[Self-published. 1971].
Artist's publication/brochure and form letter in envelope.
Offset lithograph. The brochure is folded and printed on both sides.
Brochure folded: 9 x 4 inches. Letter: 10.5 x 7.25 inches. Envelope: 4 x 9.5 inches.
Reference: Ruppersberg, pp. 104–105.

408. EDWARD RUSCHA
Surrealism Soaped and Scrubbed.
Artforum, Los Angeles, Calif. September 1966.
Periodical cover for *Artforum* (vol. 5, no. 1 [September 1966]).
Offset lithograph.
Photograph by Patrick Blackwell.
10.5 x 10.5 inches.
Reference: Ruscha, No. M9.

409. EDWARD RUSCHA
ED RUSCHA SAYS GOODBYE TO COLLEGE JOYS.
Artforum, Los Angeles, Calif. January 1967.
Artist's advertisement in the periodical *Artforum* (vol. 5, no. 5 [January 1967], p. 7).
Offset lithograph.
Photograph by Jerry McMillan.
10.5 x 10.5 inches.

409.1. MARIEN SCHOUTEN
See Cafe Schiller/Marien Schouten.

410. RICHARD SERRA
Richard Serra. 8 Drawings: Weights and Measures.
Leo Castelli, New York, N.Y.
September 23–October 14, 1989.
Poster.
Folded. Offset lithograph.
Unfolded: 17.5 x 23.5 inches.

410.1. JUDITH SHEA
See Institute for Art and Urban Resources/Judith Shea.

411. CINDY SHERMAN
Our fall/winter 93-94 collections arrive on Saturday 24 July 1993.
Comme des Garçons, New York, N.Y. 1993.
Postcard.
Offset lithograph. Printed on both sides.
[Edition of 5,000 copies].
9 x 6.25 inches.

412. CINDY SHERMAN
New selections from our winter '94 collections have arrived.
Comme des Garçons, New York, N.Y. 1993.
Postcard.
Offset lithograph. Printed on both sides.
[Edition of 5,000 copies].
9 x 6.25 inches.

IDAHO
FRIJOLES
MOHOLY - NAGY

405.

406.

408.

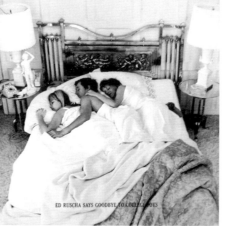

409.

407.

410.

411.

412.

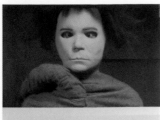
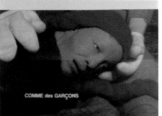

413.

414.

415.

416.

417.

418.

419.

420.

421.

413. CINDY SHERMAN
Our fall-winter 94-95 collections arrive on
Saturday 23 July 1994.
Comme des Garçons, New York, N.Y. 1994.
Poster.
Folded. Offset lithograph. Printed on both sides.
[Edition of 5,000 copies].
Unfolded: 14.25 x 20.25 inches.

414. CINDY SHERMAN
New selections from our fall-winter 95 collections
have arrived.
Comme des Garçons, New York, N.Y. 1994.
Poster.
Folded. Offset lithograph. Printed on both sides.
[Edition of 5,000 copies].
Unfolded: 20.25 x 14.25 inches.

415. MIEKO (CHIEKO) SHIOMI
SPATIAL POEM NO. I. word event.
[Self-published]. 1965.
Event score.
Folded. Carbon copy?
Unfolded: 6 x 8.25 inches.
Reference: Shiomi, pp. 2–9.

416. MIEKO (CHIEKO) SHIOMI
SPATIAL POEM No. 2 [direction event].
[Self-published]. 1965.
Event score.
Folded. Letterpress on tissue paper?
Folded: 10 x 7 inches
References: Shiomi, pp. 10–13; Poinsot.

417. MIEKO (CHIEKO) SHIOMI
SPATIAL POEM NO. 3 [falling event].
[Self-published]. 1966.
Event score.
Folded. Letterpress on tissue paper?
Unfolded: 6.25 x 9.75 inches.
References: Shiomi, pp. 14–27; Poinsot.

418. MIEKO (CHIEKO) SHIOMI
SPATIAL POEM No. 4. [color event].
[Self-published]. N.d.
Event score.
Folded. Offset lithograph.
Unfolded: 6.25 x 10 inches.
Note: Color event is the initial version of Spatial
Poem No. 4, which was later omitted and replaced
with Shadow Event.

419. MIEKO (CHIEKO) SHIOMI
SPATIAL POEM NO. 4. shadow event.
[Self-published]. 1971.
Event score and printed sheet.
Score: Folded. Letterpress?
Sheet: Offset lithograph on clear plastic.
Score unfolded: 7.5 x 7.5 inches.
Sheet: 3.5 x 7 inches.
References: Shiomi, pp. 28–37; Fluxus Etc.,
p. 193; Correspondence Art, p. 100.

420. MIEKO (CHIEKO) SHIOMI
SPATIAL POEM NO. 5. open event.
[Self-published]. 1972.
Event score.
Folded. Letterpress?
Unfolded: 7.5 x 7.5 inches.
References: Shiomi, pp. 38–45; Fluxus Etc., p. 193.

421. MIEKO (CHIEKO) SHIOMI
SPATIAL POEM NO. 6. orbit event.
[Self-published]. 1973.
Event score.
Folded. Letterpress?
Unfolded: 7 x 7 inches.
References: Shiomi, pp. 46–49; Fluxus Etc., p. 193.

422. MIEKO (CHIEKO) SHIOMI
SPATIAL POEM NO. 7. sound event.
[Self-published]. 1974.
Event score.
Folded. Letterpress?
Unfolded: 10.25 x 7 inches.
References: Shiomi, pp. 50–55; Fluxus Etc., p. 193.

423. MIEKO (CHIEKO) SHIOMI
SPATIAL POEM NO. 8. wind event.
[Self-published]. 1974.
Event score.
Folded. Letterpress?
Unfolded: 7 x 7 inches.
References: Shiomi, pp. 56–59; Fluxus Etc., p. 193.

424. MIEKO (CHIEKO) SHIOMI
SPATIAL POEM NO. 9. disappearing event.
[Self-published]. 1975.
Event score.
Folded. Letterpress?
Unfolded: 7 x 7.25 inches.
References: Shiomi, pp. 60–69; Fluxus Etc., p. 193.

425.1. PHILLIPS SIMKIN
See Institute for Art and Urban Resources/Phillips Simkin.

425. ROBERT SMITHSON
ROBERT SMITHSON.
Dwan Gallery, New York, N.Y.
November 29, 1966–January 5, 1967.
Poster.
Folded. Offset lithograph. Printed on both sides.
Folded: 7.5 x 4.25 inches.
Unfolded: 7.5 x 33.75 inches.

426. ROBERT SMITHSON
THE MONUMENTS OF PASSAIC.
Artforum, New York, N.Y. December 1967.
Magazine sculpture in the periodical *Artforum*
(vol. 6, no. 4 [December 1967], pp. 48–51).
Offset lithograph.
Page size: 10.5 x 10.5 inches each.
References: Smithson (Writings), pp. 52–57;
Smithson, pp. 28–29; Lippard, p. 34.

427. ROBERT SMITHSON
MONO LAKE SITE MONO LAKE NONSITE.
ROBERT SMITHSON. NONSITES.
Dwan Gallery, New York, N.Y. February 1–27, 1969.
Announcement.
Folded. Offset lithograph. Printed on both sides.
Folded: 0.75 x 4.25 inches.
Unfolded: 0.75 x 34.5 inches.
Reference: Out of the Box, p. 54.

428. ROBERT SMITHSON
ROBERT SMITHSON. GREAT SALT LAKE UTAH.
Dwan, New York, N.Y.
October 31–November 25, [1970].
Poster.
Folded. Offset lithograph.
Unfolded: 38 x 22 inches.

429. KEITH SONNIER
SIMULTANEOUS REGIONAL EDITIONS.
KEITH SONNIER.
Rosamund Felsen Gallery, Los Angeles, Calif.
July 8–August 5, 1978.
Poster.
Folded. Silkscreen on sheet from the *Los Angeles Times* newspaper (16 June 1978).
Unfolded: 22.5 x 27.5 inches.

422.

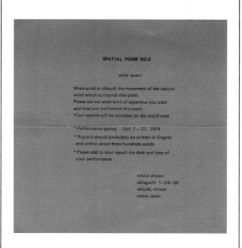

423.

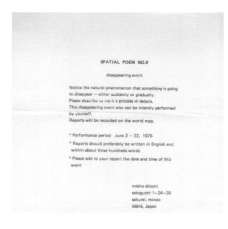

424.

425.

426.

427.

428.

429.

S

430.

431.

432.

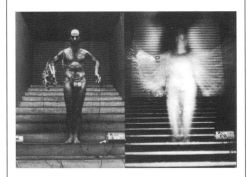

A PLIED ART

Mitchell Syrop
New Work

October 18 – November 15, 1986

Reception for the artist:
Saturday, October 18, 3-5 pm.

Kuhlenschmidt/Simon
9000 Melrose Ave. / Los Angeles, CA 90069
(213) 276-9786

SITUATIONAL ADJUSTMENT VIA LINGUISTIC ENHANCEMENT

A PLIED ART.

DESIGN AND INSTALLATION OF CUSTOM GRAPHIC,
ENVIRONMENTAL AND ARCHITECTONIC LINGUISTIC COMPONENTS

MITCHELL SYROP
CONSULTANT

CONTACT KUHLENSCHMIDT · SIMON GALLERY
9000 MELROSE AVENUE
LOS ANGELES, CALIFORNIA 90069
(213) 276-9786

433.

434.

435.

436.

437.

430. DANIEL SPOERRI
RESTAURANT DE LA GALERIE J. A l'occasion de
l'Exposition de Daniel SPOERRI "723 USTENSILES
DE CUISINE".
Galerie J., Paris, France. March 2–13, 1963.
Invitation/menu.
Menu: Folded sheet. Offset lithograph. Printed on
both sides.
Reservation form: Offset lithograph.
Menu folded: 10.5 x 8.25 inches. Menu unfolded:
10.5 x 16.25 inches. Form: 5.25 x 8.25 inches.
References: Spoerri, p. 5; Spoerri (CNAC), pp. 86–87.

430.1. MARLENE STEERUWITZ
See Point d'Ironie/Marlene Steeruwitz.

431. STELARC
EVENT FOR LATERAL SUSPENSION.
Tamura Gallery, Tokyo, Japan. March 12, 1978.
Announcement card.
Offset lithograph. Printed on both sides.
Photograph by Tony Figallo.
5.75 x 4 inches.
Reference: www.stelarc.va.com.au.

432. STELARC
EVENT FOR PROPPED BODY.
Tokiwa Gallery, Tokyo, Japan. May 14, 1978.
Postcard.
Offset lithograph. Printed on both sides.
Photograph by Shigeo Anzai.
5.75 x 4 inches.
Reference: www.stelarc.va.com.au.

433. STELARC
EVENT FOR AMPLIFIED HANDS.
Hosei University, Japan. September 18 and 19, 1982.
Announcement card.
Offset lithograph. Printed on both sides.
Photograph by Minoru Watanabe.
4 x 5.75 inches.
Reference: www.stelarc.va.com.au.

433.1. JOHANNES STÜTTGEN
See Joseph Beuys/Jonas Hafner/Johannes Stüttgen.

434. MITCHELL SYROP
A PLIED ART. Mitchell Syrop. New Work.
Kuhlenschmidt/Simon, Los Angeles, Calif.
October 18–November 15, 1986.
Announcement/sticker.
Offset lithograph on clear plastic.
3 x 12 inches.

435. MITCHELL SYROP
A PLIED ART. DESIGN AND INSTALLATION OF
CUSTOM GRAPHIC, ENVIRONMENTAL AND
ARCHITECTONIC LINGUISTIC COMPONENTS.
Kuhlenschmidt/Simon Gallery, Los Angeles, Calif.
N.d.
Business card.
Offset lithograph.
2 x 3.5 inches.

436. ERNEST T.
CLOACA MAXIMA Nº 2. ERNEST T.
Self-published. February 1986.
Artist's publication.
1 leaf. Offset lithograph.
11.75 x 8.25 inches.

437. ERNEST T./NOËLLE CHARBAUD
CLOACA MAXIMA Nº 13. NOËLLE CHARBAUD /
ERNEST T.
Self-published. March 1987.
Artist's publication.
1 leaf. Offset lithograph.
11.75 x 8.25 inches.

438. ERNEST T./RENÉ METTLER
CLOACA MAXIMA Nº 16. RENÉ METTLER / ERNEST T.
Self-published. June 1987.
Artist's publication.
1 leaf. Offset lithograph.
11.75 x 8.25 inches.

439. TAROOP & GLABEL
D'ici peu, la secte des Théophages célèbrera le
bi-millénaire de son homme-dieu [. . .].
LA CONTRE-RÉFORME SCATOLIQUE, SAINT-
PARRES-LÈS-VAUDES. TAROOP & GLABEL.
Self-published. N.d.
Flyer.
Offset lithograph. Printed on both sides. 1 gold dot
is mounted on the front.
11.75 x 8.25 inches.

440. TAROOP & GLABEL
Nous croyons en Jésus-Christ, à son existence
terrestre, à ses miracles, à sa mort et à sa
résurrection [. . .]. LA RENAISSANCE
SCATOLIQUE, Issy-les-Moulineaux. TAROOP &
GLABEL.
Self-published. N.d.
Flyer.
Offset lithograph. Printed on both sides. 1 gold dot
is mounted on the front.
11.75 x 8.25 inches.

441. TAROOP & GLABEL
On fait semblant de croire que l'Eucharistie fut
instituée par Jésus lui-même quand il prononça la
formule <<mangez, ceci est mon corps, buvez,
ceci est mon sang, etc.>> [. . .] SCATOLIQUES
POUR LES LIBERTÉS, PARIS. TAROOP & GLABEL.
Self-published. N.d.
Flyer.
Offset lithograph. Printed on both sides. 1 gold dot
is mounted on the front.
11.75 x 8.25 inches.

442. ENDRE TÓT
WE ARE GLAD IF WE CAN DEMONSTRATE. Endre
Tót. GLADNESS DEMONSTRATIONS. Paris,
Aug. 1979 and Amsterdam, Sept. 1979.
Edition Herta, Berlin-Schöneberg, Germany. 1979.
Postcard.
Offset lithograph. Printed on both sides.
Photograph by Herta.
5.75 x 4 inches.

443. ENDRE TÓT
endre tót. I'AM GLAD IF I CAN STAMP 1971.
stamping action at stempelplaats. 13.12.1980
(stamped on 500 sheets, format A 4).
Stempelplaats, Amsterdam, The Netherlands. N.d.
Postcard.
Offset lithograph. Printed on both sides.
4.25 x 6 inches.

444. DAVID TREMLETT
"The Art of Searching". DAVID TREMLETT.
Galerie Folker Skulima, Berlin, Germany.
January 19–February 19, 1971.
Announcement card.
Offset lithograph. Printed on both sides.
8.25 x 5.75 inches.
Reference: Tremlett.

445. DAVID TREMLETT
TRE * POL * PEN ST. DAVID TREMLETT.
Nigel Greenwood Inc., Ltd., London, England.
May 23–June 9, 1973.
Announcement card.
Offset lithograph. Printed on both sides.
3.5 x 5.5 inches.
Reference: Tremlett.

438.

439.

440.

441.

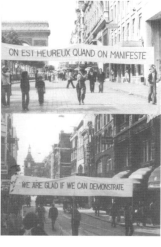

442.

443.

"The Art of Searching"

444.

ARTIST STATEMENT

**444. FIRST GERMAN EXHIBITION
MADE, CARD SPEAKS FOR ITSELF,
NOT SURE WHAT I WAS DOING!**

**449. GILBERT A GOOD FELLA I
MET IN MOZAMBIQUE WITH A FEW
TATTOOS ON HIM, ALSO GOOD FRIENDS
WITH GILBERT & GEORGE AT THE TIME.**

**451. SPENT SOME TIME IN MALAWI AND
CYCLED MOST OF THE COUNTRY, THUS
THE CARD.**

**446. FIRST SOLO SHOW IN THE U.S.,
NICE GALLERY AND DIRECTOR, DON'T
KNOW WHAT HAPPENED TO HIM, COME
BACK HAROLD.**

—DAVID TREMLETT

445.

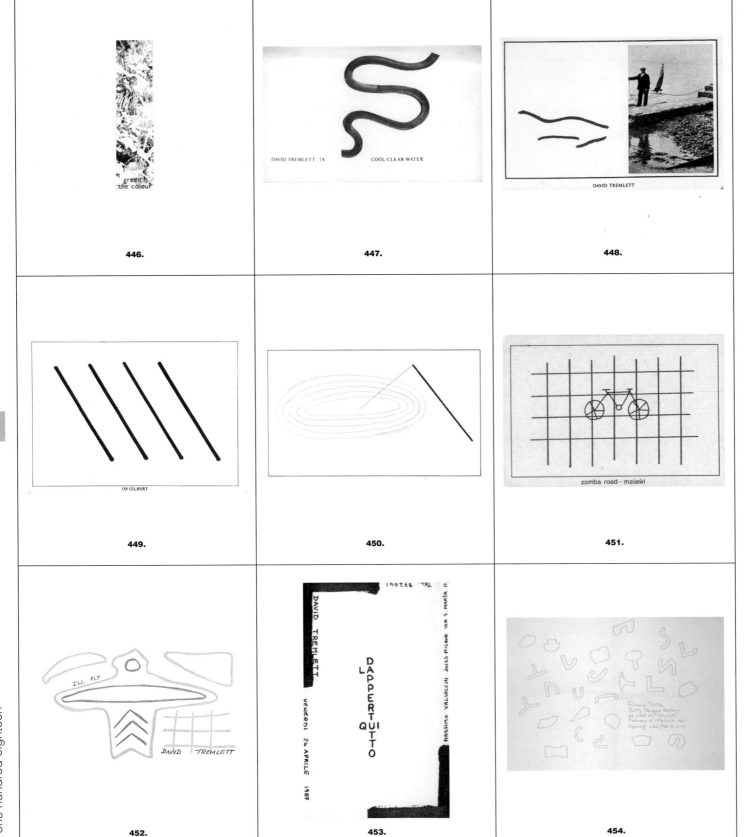

446. **DAVID TREMLETT**
green is the colour. DAVID TREMLETT.
Harold Rivkin, Washington, D.C. [1973].
Announcement card.
Offset lithograph. Printed on both sides.
3.5 x 5.5 inches.

447. **DAVID TREMLETT**
DAVID TREMLETT 74. COOL CLEAR WATER.
DAVID TREMLETT. New Works.
Nigel Greenwood Inc., Ltd., London, England.
September 17–October 12, 1974.
Announcement card.
Offset lithograph. Printed on both sides.
5 x 8 inches.
Reference: Tremlett.

448. **DAVID TREMLETT**
DAVID TREMLETT.
Rolf Preisig, Basel, Switzerland.
January 8–31, 1976.
Announcement card.
Offset lithograph. Printed on both sides.
4.25 x 5.75 inches.
Reference: Tremlett.

449. **DAVID TREMLETT**
ON GILBERT. DAVID TREMLETT.
Massimo Valsecchi, Milan, Italy. Opening April 12, 1978.
Announcement card.
Offset lithograph. Printed on both sides.
4.5 x 6.25 inches.
Reference: Tremlett.

450. **DAVID TREMLETT**
BOTSWANA FISH. ZIMPOPO. DAVID TREMLETT.
Massimo Valsecchi, Milan, Italy. Opening
November 21, 1979.
Announcement card.
Offset lithograph. Printed on both sides.
4 x 6.75 inches.
Reference: Tremlett.

451. **DAVID TREMLETT**
zomba road - malawi. david tremlett.
Marilena Bonomo, Bari, Italy. [1979].
Postcard.
Offset lithograph. Printed on both sides.
4 x 6 inches.
Reference: Tremlett.

452. **DAVID TREMLETT**
I'LL FLY. DAVID TREMLETT.
Liliane & Michel Durand-Dessert, Paris, France.
September 18–November 13, 1982.
Announcement card.
Offset lithograph. Printed on both sides.
4 x 7.25 inches.

453. **DAVID TREMLETT**
LA DAPPERTUTTO QUI. DAVID TREMLETT.
Massimo Valsecchi, Milan, Italy. Opening
April 24, 1987.
Announcement card.
Offset lithograph.
3.5 x 5.75 inches.
Reference: Tremlett.

454. **RICHARD TUTTLE**
Richard Tuttle.
Betty Parsons Gallery, New York, N.Y.
February 15–March 4, 1967.
Poster.
Folded. Offset lithograph.
Unfolded: 14 x 20 inches.
Reference: Tuttle, p. 87.

455. RICHARD TUTTLE
NEW WORK. RICHARD TUTTLE.
Betty Parsons Gallery, New York, N.Y.
March 12–30, 1974.
Announcement card.
Offset lithograph.
3.25 x 5.5 inches.

456. RICHARD TUTTLE
RICHARD TUTTLE. NEW WORK.
Betty Parsons Gallery, New York, N.Y.
January 24–February 11, 1978.
Announcement card.
Offset lithograph.
3.75 x 5.5 inches.

457. RICHARD TUTTLE
Richard Tuttle will be present at a reception from 5
to 7 on Thursday, April 27 at the Bell Gallery, List
Art Building.
Bell Gallery, [Brown University, Providence, R.I.].
[1978.]
Announcement card.
Folded. Offset lithograph. Printed on both sides.
Folded: 4.25 x 8 inches.

458. RICHARD TUTTLE
RICHARD TUTTLE: PAIRS, 1973.
Centre d'Art Contemporain, Geneva, Switzerland.
January 24–February 23, 1980.
Poster.
Folded. Offset lithograph.
Unfolded: 11 x 14 inches.

459. RICHARD TUTTLE
NEW WORK. RICHARD TUTTLE.
Betty Parsons Gallery, [New York, N.Y.].
October 9–27, 1982.
Announcement card.
Offset lithograph.
4 x 8 inches.
Reference: Tuttle, p. 130.

460. RICHARD TUTTLE
RICHARD TUTTLE. Early & recent works.
Anders Tornberg Gallery, Lund, Sweden.
October 3–28, 1987.
Announcement card.
Folded. Offset lithograph. Tipped-in plate.
Folded: 8.75 x 6 inches.
Unfolded: 8.75 x 12.25 inches.
Reference: Tuttle, p. 157.

461. RICHARD TUTTLE
Richard Tuttle. Mai '88.
Galerie Meert Rihoux, Brussels, Belgium.
May 11–June 4, 1988.
Announcement card.
Offset lithograph. Printed on both sides.
7 x 8.5 inches.
Reference: Tuttle, p. 160.

462. CY TWOMBLY
CY TWOMBLY.
Galleria La Tartaruga, Rome, Italy. Opening
April 26, 1960.
Poster.
Offset lithograph.
12 x 13.5 inches.

455.

456.

457.

458.

459.

460.

461.

462.

CALENDAR
1996

Uri Tzaig

MATRIX
University Art Museum and Pacific Film Archive
University of California, Berkeley

463.

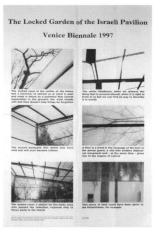

AUGUST

此疑問，首
本人願不願
一手創建的
在新公司的
交椅，因
多年來
而且

some questions, first ● himself whether or not
willing ● built with one hand ● in new company ●
chair, because ● he in many years ● down, and also

The Locked Garden of the Israeli Pavilion
Venice Biennale 1997

464.

Renais
sense

465.

ARTIST STATEMENT

THE RENAIS SENSE PUBLICATIONS
WERE LOOSE, SINGLE-SHEET
EDITIONS PUBLISHED BY THE
GALLERY SERIAAL. THE EDITION
WAS PUBLISHED IRREGULARLY,
ABOUT ONCE EVERY THREE TO SIX
MONTHS; THERE WERE A TOTAL OF SIX
EDITIONS. THE ORIGINAL IMAGES WERE
POLAROIDS THAT WE REPRODUCED IN
ACTUAL SIZE AS SEQUENCES AND/OR
NARRATIVES. EACH EDITION WAS
LIMITED TO 250 COPIES AND WAS
DISTRIBUTED FREE OF CHARGE.
THE POLAROID CORPORATION,
THEN BASED IN AMSTERDAM, PAID
THE PRODUCTION COSTS. —ULAY

ordnung ordnung
ordnung ordnung
ordnung ordnung
ordnung ordnung
ordnung ordnung
ordnung unordn g
ordnung ordnung
ordnung ordnung
ordnung ordnung
ordnung ordnung
ordnung ordnung

visuelle poesie

466.

FLUXPOSTCARD BY BEN. 1965

POSTCARD

(1) RECEIVE, (2) RETURN. BEN-FLUXUS, 1965 TO RETURN CARD, FOLD THE OTHER WAY

467.

FLUX
POST
CARD

© 1967, BY FLUXUS

THE POSTMAN'S CHOICE
LE CHOIX DU FACTEUR

BY BEN, 1965

468.

FLUX
POST
CARD

© 1967, BY FLUXUS

Your thumb present now on
this side of this card is the
realization of my intention.

Votre pouce qui se trouve sur
cette face de cette carte est la
realisation de mon intention.

BY BEN, 1966

469.

463. URI TZAIG
CALENDAR 1996. Uri Tzaig.
Matrix, University Art Museum and Pacific Film
Archive, University of California, Berkeley, Calif.
[1995].
Calendar.
Staple bound. 9 leaves. Offset lithograph.
Printed on both sides.
5.5 x 3.75 inches.

464. URI TZAIG
The Locked Garden of the Israeli Pavilion.
Venice Biennale 1997.
Jerusalem Center for the Visual Arts. Jacqueline
Klugman, Isart, Paris, France. Refusalon Gallery,
San Francisco, Calif. Michael Gordon. 1997.
Poster.
Folded.
Offset lithograph.
Unfolded: 19.25 x 13 inches.

465. ULAY
Renais sense. Ulay Polaroid Video Picture Show.
Instant Issue, Volume two.
Seriaal nv, Amsterdam, The Netherlands.
September 1974.
Artist's publication.
Folded. 3 leaves and flexidisc. Offset lithograph.
Printed on both sides.
[Edition of 250 copies].
Unfolded: 21 x 14.5 inches.
Disc diameter: 7 inches.
Reference: Ulay, plates 17, 19.

466. TIMM ULRICHS
ordnung. visuelle poesie.
Christian-Albrechts-Universität and Kultursenats
der Stadt Kiel, Kiel, Germany.
April 25–May 15, 1972.
Poster.
Folded. Offset lithograph on newsprint.
Unfolded: 23.5 x 23.5 inches.

466.1. GER VAN ELK
See Jan Dibbets/Ger van Elk/Reiner Lucassen.

467. BEN VAUTIER
(1) RECEIVE (2) RETURN.
Fluxus, New York, N.Y. 1965.
Postcard.
Folded. Offset lithograph. Printed on both sides.
Folded: 3.25 x 5.5 inches.
Unfolded: 6.5 x 5.5 inches.
References: Fluxus Etc., p. 201; Fluxus Codex,
p. 515.

468. BEN VAUTIER
THE POSTMAN'S CHOICE.
Fluxus, [New York, N.Y.]. 1967.
Postcard.
Offset lithograph.
3.25 x 5.5 inches.
References: Fluxus Etc., p. 206; Fluxus Codex,
p. 515; Correspondence Art, p. 27; Poinsot.

469. BEN VAUTIER
Your thumb present now on this side of this card
is the realization of my intention.
Fluxus, [New York, N.Y.]. 1967.
Postcard.
Offset lithograph.
3.25 x 5.5 inches.
References: Fluxus Etc., p. 205; Fluxus Codex,
p. 518.

470. BEN VAUTIER
BY THE PRESENT ATTESTATION I BEN VAUTIER
DECLARE ARTISTIC REALITY AND MY PERSONAL
WORK OF ART: THE LAPSE OF TIME BETWEEN
[. . .].
[Self-published, Nice, France?]. N.d.
Certificate.
Offset lithograph.
5 x 7 inches.
Reference: Fluxus Codex, p. 517.

471. BEN VAUTIER
JE N'AIME PAS LA MUSIQUE. BEN.
Self-published, Nice, France. N.d.
Paper bag.
Letterpress.
17.75 x 13.5 inches.

472. BEN VAUTIER
I BEN DECLARE THAT THE FOLLOWING
SIGNATURE APPLIED TO ABSOLUTELY
ANYTHING GIVES IT THE STATUS OF A WORK OF
TOTAL ART.
Gallery "BEN DOUTE DE TOUT," Nice, France.
N.d.
Postcard.
Offset lithograph. Printed on both sides.
3 x 5 inches.
Reference: Poinsot.

472.1. JESSICA VOORSANGER
See Imprint 93/Jessica Voorsanger.

473. WOLF VOSTELL
DUCHAMP HAS QUALIFIED THE OBJECT INTO
ART. I HAVE QUALIFIED LIFE INTO ART. 20TH
CENTURY NYC.
[Self-published]. 1972.
Card.
Offset lithograph. Printed on both sides.
Edition of 500 copies. Signed and numbered.
1 rubber stamp on the verso.
5.25 x 7 inches.
Reference: Correspondence Art, p. 12.

474. ANDY WARHOL
ANDY WARHOL.
Leo Castelli, New York, N.Y.
November 21–December 17, [1964].
Poster.
Folded. Offset lithograph. Printed on both sides.
Unfolded: 21.75 x 21.75 inches.

475. ANDY WARHOL
ANDY WARHOL.
Institute of Contemporary Art, University of
Pennsylvania, Philadelphia, Penn.
October 8–November 21, [1965].
Poster.
Folded. Offset lithograph. Printed on both sides.
[Edition of 6,000 copies].
Unfolded: 22.75 x 22.5 inches.
Reference: Warhol, p. 57.

476. ANDY WARHOL
BOMB HANOI. some/thing HANOI.
Jerome Rothenberg and David Antin,
New York, N.Y. Winter 1966.
Artists' periodical cover for *Some/thing No. 3*
(vol. 2, no. 1 [winter 1966]).
Offset lithograph on perforated, gummed paper.
8.5 x 5.5 inches.

470.

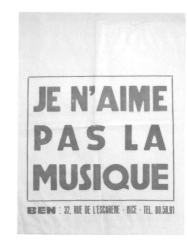

471.

472.

473.

474.

475.

476.

477.

478.

Lawrence Weiner
12 February 1972

1. LOUDLY MADE NOISE (forte) AND/OR
 MODERATELY LOUDLY (mezzoforte)

2. SOFTLY MADE NOISE (piano) AND/OR
 MODERATELY SOFTLY (mezzopiano)

3. NOISE MADE VERY LOUDLY (fortissimo) AND/OR
 MODERATELY LOUDLY (mezzoforte)

4. NOISE MADE VERY SOFTLY (pianissimo) AND/OR
 MODERATELY SOFTLY (mezzopiano)

480.

479.

481.

482.

483.

477. ROBERT WATTS
ONE DOLLAR.
[Fluxus, New York, N.Y.]. [1962].
Play money.
Offset lithograph. Printed on both sides.
3 x 6.5 inches.
Reference: Fluxus Codex, pp. 534–35.

478. ROBERT WATTS
PING KORNBLEE.
Kornblee, N.Y. [1964–65].
Metal button.
Offset lithograph.
Diameter: 1.25 inches.

479. ROBERT WATTS
PONG KORNBLEE.
Kornblee, N.Y. [1964–65].
Metal button.
Offset lithograph.
Diameter: 1.25 inches.

479.1. ROBERT WATTS
See also George Brecht/Robert Watts.

480. LAWRENCE WEINER
Lawrence Weiner. 1. LOUDLY MADE NOISE (forte)
AND/OR MODERATELY LOUDLY (mezzoforte).
2. SOFTLY MADE NOISE (piano) AND/OR
MODERATELY SOFTLY (mezzopiano). 3. NOISE
MADE VERY LOUDLY (fortissimo) AND/OR
MODERATELY LOUDLY (mezzoforte). 4. NOISE
MADE VERY SOFTLY (pianissimo) AND/OR
MODERATELY SOFTLY (mezzopiano).
Leo Castelli, New York, N.Y. Opening
February 12, 1972.
Announcement card.
Offset lithograph. Printed on both sides.
4 x 5.5 inches.

481. LAWRENCE WEINER
50 Arbeiten von Lawrence Weiner.
Westfälischer Kunstverein, Münster, Germany.
[1972].
Poster.
Folded. Offset lithograph.
Unfolded: 32 x 21.5 inches.
Reference: Weiner (Buchloh), p. 4.

482. LAWRENCE WEINER
HAVING A RELATION TO PROGRESS (OF A
SORT): LEFT HERE PUT HERE FOR A LIMITED
TIME.
Whitney Museum Extension, New York, N.Y. 1977.
Poster.
Offset lithograph.
8.5 x 11 inches.
Reference: Weiner (Buchloh), p. 54.

483. LAWRENCE WEINER
A BOX MADE OF WOOD BUILT UPON THE
ASHES OF A BOX MADE OF WOOD.
Centre National d'Art Contemporain de Grenoble,
Grenoble, France. January 1–December 31, 1987.
Announcement/2 cardboard stencils in envelope.
Envelope: Offset lithograph.
Edition of 7,000 copies.
Stencils: 8.5 x 11.5 inches each.
Envelope: 12.75 x 9 inches.
Reference: Weiner.

484. LAWRENCE WEINER
BOOKS DO FURNISH A ROOM. PRINTED
MATTER BOOKS BY ARTISTS. LEARN TO READ
ART. LAWRENCE WEINER 1990.
Printed Matter, New York, N.Y. 1990.
Bookmark.
Offset lithograph. Printed on both sides.
1 die-cut oval.
7 x 2 inches.
Reference: Weiner.

484.1. LAWRENCE WEINER
See also Art & Project/Lawrence Weiner; Cafe
Schiller/Lawrence Weiner; Point d'Ironie/Lawrence
Weiner; Institute for Art and Urban
Resources/Lawrence Weiner.

485. JOYCE WIELAND
WORLD HEALTH DAY. Canada 8.
Canada Post Office, Canada. 1972.
Artist's stamp on envelope.
Offset lithograph.
Stamp: 1 x 1.5 inches. Envelope: 3.75 x 6.5 inches.

486. HANNAH WILKE
Marxism AND Art. BEWARE OF Fascist Feminism.
[Self-published]. 1977.
Flyer.
Offset lithograph.
11.75 x 9 inches.

487. IAN WILSON
On the 20th of September 1974 Ian Wilson will be
present for discussion from 7 p.m. to 10 p.m.
Rolf Preisig, Basel, Switzerland. September 20, 1974.
Announcement card.
Offset lithograph. Printed on both sides.
4 x 5.75 inches.

488. IAN WILSON
June 1, 2 and 3, 1976 Ian Wilson will be at the
John Weber Gallery for discussion.
John Weber Gallery, New York, N.Y. June 1–3, 1976.
Announcement card.
Offset lithograph.
3.5 x 5.5 inches.

489. IAN WILSON
banco 40. on monday may 16, 1977 at 7:00 p.m.
ian wilson will be at the banco for a discussion.
Banco, Brescia, Italy. May 16, 1977.
Flyer.
Offset lithograph.
11.5 x 8 inches.

490. IAN WILSON
On April 28, 1977 at 8:30 P.M., The Van
Abbemuseum, Eindhoven, Ian Wilson will present
Plato's Epistemology of The Parmenides for
discussion.
Van Abbemuseum, Eindhoven, The Netherlands.
1977.
Announcement card.
Offset lithograph. Printed on both sides.
4 x 6 inches.

491. IAN WILSON
That which is both known and unknown: a
discussion with IAN WILSON on Sunday, June 15,
1986 at 3 p.m. (on the occasion of the printing of
sections 35 and 36).
Stedelijk Van Abbemuseum, Eindhoven,
The Netherlands. 1986.
Announcement card.
Offset lithograph. Printed on both sides.
4 x 6 inches.

485.

486.

484.

487.

488.

489.

490.

491.

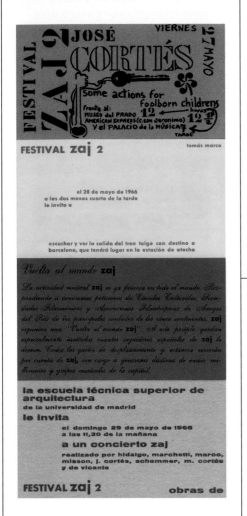

492.

493.

495.

496.

491.1. CHRISTOPHER WOOL
See Felix Gonzalez-Torres/Christopher Wool.

492. ZAJ
FESTIVAL zaj 2. madrid, mayo 1966.
[Self-published?]. May 1966.
8 cards in envelope.
Offset lithograph. 6 cards are printed on both
sides.
Participants included W. Vostell, J. Hidalgo,
W. Marchetti, M. Cortes, E. de Vincente, J. Cortes,
T. Marco, A. el Arias Misson, G. Brecht, G. Chiari,
D. Higgins, T. Kosugi, Ligeti, G. Maciunas,
B. Patterson, Schommer, C. Shiomi, R. Watts, and
E. Williams.
Cards: 2.75 x 5 inches or 5 x 2.75 inches each.
Envelope: 3.75 x 5.5 inches.

493. ZAJ/WALTER MARCHETTI
zaj es como un bar. la gente entra, sale, está; se
toma una copa y deja una propina. walter
marchetti. madrid, 1966.
[Self-published?]. N.d.
Card.
Offset lithograph.
2.25 x 4 inches.

494. ZAJ/JOSÉ LUIS CASTILLEJO
69. ! cinco años de zaj! josé luis castillejo. invierno
68-69.
[Self-published?]. 1969.
Card.
Silkscreen? Printed on both sides.
9.25 x 7.25 inches.
Reference: Sackner, p. 886.

495. ZAJ/WALTER MARCHETTI
NOCHE zaj. WALTER MARCHETTI. MADRID, 1969.
[Self-published?]. 1969.
Card.
Silkscreen?
7 x 8.75 inches.
Reference: Sackner, p. 886.

496. ZAJ/LUIS MATAIX
cencío. luis mataix. zaj. madrid, febrero 69.
[Self-published?]. February 1969.
Card.
Offset lithograph. Printed on both sides.
1.5 x 7 inches.

496.1 JORGE ZONTAL
See General Idea.

EXTRA EXTRA

497. MARTINE ABALLÉA
THE ELASTIC HOTEL is located by the sea [. . .].
[Self-published]. 1978.
Postcard.
Offset lithograph. Printed on both sides.
4 x 6 inches.
Reference: Aballéa, p. 60.

498. MARTINE ABALLÉA
Martine Aballea. PROGRAM OF THE
TURQUOISE ZONE SEDUCTION.
P.S. 1, [Long Island City, N.Y.].
December 3, 1978–January 21, 1979.
Announcement card.
Offset lithograph. Printed on both sides.
9 x 6.25 inches.
Reference: Aballéa, p. 60.

499. MARTINE ABALLÉA
Epaves du Désir. MARTINE ABALLÉA.
Galerie Thaddaeus Ropac, Paris, France.
March 21–April 20, 1995.
Announcement card.
Offset lithograph. Printed on both sides.
6 x 8.25 inches.

500. MARTINE ABALLÉA
Blocnotes présente: Guest Barmaid Martine
Aballéa. THREE HAPPY DRINKS. à La Fléche d'or.
Blocnotes, Paris, France. October 5, 1996.
Artist's publication/drink ticket booklet.
Wrappers. Staple bound. Unpaginated.
2 x 5.75 inches.

501. MARTINE ABALLÉA
Goûter Dangereux.
Jocaste en Arcadie, Château Grignan.
October 26, 1996–January 3, 1997.
Menu.
Folded. Offset lithograph. Printed on both sides.
Folded: 6 x 4 inches. Unfolded: 6 x 8.25 inches.

502. MARTINE ABALLÉA
COUPON. Summer Beast Delight. spicy
morsels in ice foam.
[Self-published]. [1998].
Coupon.
Photocopy.
4.25 x 7.25 inches.

503. MARTINE ABALLÉA
BRIGHT FLAKES. the unexpected treat.
[Self-published]. [1998].
Matchbook.
Offset lithograph. [Edition of 10,000 copies].
2 x 1.5 inches.

504. MARTINE ABALLÉA
Hôtel Passager. services et conforts
introuvables ailleurs.
[ARC Musée d'Art Moderne de la Ville
de Paris, Paris, France]. [1999].
Card.
Offset lithograph. Printed on both sides.
3 x 4 inches.

505. MARTINE ABALLÉA
Un Sommeil Minéral. PERFORMANCE
PAR MARTINE ABALLEA.
[Self-published]. N.d.
Flyer.
Folded. Offset lithograph.
Unfolded: 8.25 x 11 inches.

506. KIM ABELES
Souvenir.
[Self-published]. 1987.
Card.
Offset lithograph and silkscreen. Printed on both
sides. Hair is mounted on the front of the card.
Edition of 900 copies. Signed and numbered.
4.75 x 3 inches.
Reference: Abeles, p. 57.

507. KIM ABELES
HIV/AIDS TAROT.
[Self-published]. 1992.
Brochure/7 perforated tarot cards.
Accordion folded. Offset lithograph.
Printed on both sides.
Folded: 5.75 x 3.25 inches.
Unfolded: 5.75 x 23 inches.
Reference: Abeles, pp. 41–43.

508. KIM ABELES
Kim Abeles. Something old. Something new.
Something borrowed. Something blue.
Turner/Krull Gallery, Los Angeles, Calif.
October 16–November 24, 1993.
Bookmark/announcement card.
Offset lithograph. Printed on both sides.
7 x 2.5 inches.

508.1. MARINA ABRAMOVIC
See Ulay/Marina Abramovic.

509. BAS JAN ADER
Bas Jan Ader. BROKEN FALL (ORGANIC).
Kabinett für Aktuelle Kunst, Bremerhaven,
Germany. June 17–July 2, 1972.
Announcement card.
Offset lithograph. Printed on both sides.
4 x 5.75 inches.
Reference: Ader (Andriesse), p. 42.

509.1. BAS JAN ADER
See also Art & Project/Bas Jan Ader.

510. TERRY ALLEN
TERRY ALLEN.
Michael Walls Gallery, San Francisco, Calif.
May 14–June 8, 1968.
Poster.
Folded. Offset lithograph.
Unfolded: 21 x 17 inches.

511. TERRY ALLEN
The Terry Allen Cowboy Show.
Michael Walls Gallery, San Francisco, Calif.
February 4–28, 1970.
Flyer.
Offset lithograph.
11 x 8.5 inches.

512. TERRY ALLEN
TERRY ALLEN. "The evening Gorgeous
George died".
The Claire Copley Gallery, Inc., Los Angeles,
Calif. May 11–June 5, 1976.
Announcement card.
Offset lithograph. Printed on both sides.
5 x 6 inches.

497.

502.

503.

505.

506.

512.

Durante la V Bienal de la Habana, Francis Alÿs calza sus
zapatos magnéticos y a través de sus paseos por las
calles, recoge cualquier residuo metálico encontrado sobre
su camino. Por esta recolección diaria va ampliándose su
nuevo territorio, y asimila los barrios que va
descubriendo.

During the Fifth Havana Biennal, Francis Alÿs puts on his
magnetic shoes & takes daily walks through the streets,
collecting scraps of metal lying in his path. With each
trip he incorporates the newly-discovered neighbourhood.

514.

519.

522.

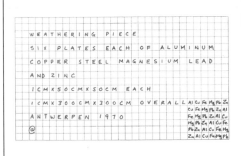

526.

523.

530.

513. TERRY ALLEN
Terry Allen. MESSAGES FROM WRESTLERS IN
HELL and pieces from FIGHTERS OF THE
DARKNESS.
HansenFuller Gallery, San Francisco, Calif.
April 6–29, 1978.
Announcement card.
Offset lithograph. Printed on both sides.
5.75 x 4 inches.

514. FRANCIS ALŸS
Francis Alÿs. Malecón, Habana vieja, Cuba.
6 de mayo de 1994.
N.p. 1994.
Postcard.
Offset lithograph. Printed on both sides.
Photograph by Kurt Hollander.
5.75 x 4.25 inches.

515. FRANCIS ALŸS
FRANCIS ALŸS. "The leak", august 1995.
Sao Paulo, Brazil.
N.p. 1995.
Postcard.
Offset lithograph. Printed on both sides.
Photograph by Kurt Hollander.
4.25 x 5.75 inches.

516. FRANCIS ALŸS
Francis Alÿs, "Duett", 1999. in col. with Honore
D'O, 48. Biennale di Venezia.
Ed. ESPACE, Liège, Belgium. 1999.
Postcard.
Offset lithograph. Printed on both sides.
5.75 x 4.25 inches.

517. WILLIAM ANASTASI
Plants and Waiters - A Play by William Anastasi.
School of Visual Arts, New York, N.Y.
March 6, 13, 20, 1980.
Poster.
Folded. Offset lithograph. Printed on both sides.
Designed by Ayelet Bender. Photo concept by
William Anastasi. Realization by David Behl.
Unfolded: 15 x 19 inches.

518. WILLIAM ANASTASI
William Anastasi. Works 1963-1992.
Anders Tornberg Gallery, Lund, Sweden.
February 8–March 4, 1992.
Announcement card in envelope.
Offset lithograph. Printed on both sides.
A label is mounted on the verso.
Card: 6 x 8.75 inches. Envelope: 6.5 x 9 inches.

519. LAURIE ANDERSON
LAURIE ANDERSON. Laurie Anderson.
Holly Solomon Gallery, New York, N.Y.
September 11–October 3, 1981.
Announcement card.
Offset lithograph.
4 x 6 inches.

520. LAURIE ANDERSON
LAURIE ANDERSON 1969-1983.
Institute of Contemporary Art, University of
Pennsylvania, Philadelphia, Penn.
October 15–December 4, 1983.
Poster.
Folded. Offset lithograph. Printed on both sides.
Unfolded: 11.75 x 17 inches.

521. CARL ANDRE
CARL ANDRE.
Dwan Gallery, Los Angeles, Calif.
March 8–April 1, 1967.
Poster.
Folded. Offset lithograph. Printed on both sides.
Unfolded: 16 x 22.5 inches.

522. CARL ANDRE
CARL ANDRE.
Dwan Gallery, New York, N.Y.
December 2, [1967]–January 3, 1968.
Poster.
Folded. Offset lithograph. Printed on both sides.
Unfolded: 18 x 18 inches.
References: Andre (Whitechapel); Szeemann.

523. CARL ANDRE
CARL ANDRE.
Dwan, New York, N.Y. April 26–May 21, 1969.
Announcement card.
Offset lithograph.
5 x 7.25 inches.
Reference: Szeemann.

524. CARL ANDRE
Al Cu. CARL ANDRE.
Wide White Space, Antwerp, Belgium.
September 20–October 16, 1969.
Announcement card.
Offset lithograph. Printed on both sides.
4 x 6 inches.
Reference: Wide White Space, p. 263.

525. CARL ANDRE
CARL ANDRE.
Konrad Fischer, Düsseldorf, Germany.
October 12–November 11, 1969.
Announcement card.
Offset lithograph. Printed on both sides.
3.75 x 6.25 inches.

526. CARL ANDRE
CARL ANDRE. WEATHERING PIECE.
Wide White Space Gallery, Antwerp, Belgium.
April 1971.
Announcement card.
Offset lithograph. Printed on both sides.
5.25 x 8.5 inches.
Reference: Wide White Space, p. 280.

527. CARL ANDRE
39 PART RETROGRADE INVENTION
(+ THREE ETUDES).
Galerie Heiner Friedrich, Munich, Germany. June 1971.
Flyer.
Folded. Offset lithograph.
Unfolded: 11.75 x 8.25 inches.

528. CARL ANDRE
FOUR MEDITATIONS ON THE YEAR 1960.
Konrad Fischer, Düsseldorf, Germany.
July 12–August 12, 1971.
Announcement card.
Offset lithograph. Printed on both sides.
4 x 5.75 inches.
Reference: Fischer, p. 65.

529. CARL ANDRE
CARL ANDRE. SMALL FLOOR PIECES.
Konrad Fischer, Düsseldorf, Germany. May 1972.
Announcement card.
Offset lithograph.
4 x 5.75 inches.
Reference: Fischer, p. 78.

530. CARL ANDRE
CARL ANDRE. DIPOLES Al-Cu-Fe-.
Konrad Fischer, Düsseldorf, Germany.
June 1–28, 1973.
Announcement card.
Offset lithograph. Printed on both sides.
4 x 4 inches.

531. CARL ANDRE
CARL ANDRE.
Wide White Space, Brussels, Belgium, and
Antwerp, Belgium. January 8–February 4, 1974.
Announcement card.
Offset lithograph. Printed on both sides.
4 x 6 inches.
Reference: Wide White Space, p. 318.

532. CARL ANDRE
CARL ANDRE.
Konrad Fischer, Düsseldorf, Germany.
June 21–July 20, [1974].
Announcement card.
Offset lithograph.
5.75 x 4 inches.
Reference: Fischer, p. 107.

533. CARL ANDRE
CARL ANDRE. WORDS IN THE FORMS
OF POEMS .
John Weber Gallery, New York, N.Y.
January 11–February 5, 1975.
Flyer.
Offset lithograph?
8 x 11.5 inches.

534. CARL ANDRE
CARL ANDRE.
Lisson Gallery, London, England. June 1975.
Announcement card.
Offset lithograph.
6 x 4 inches.

535. CARL ANDRE
CARL ANDRE.
Ace Canada, Vancouver, B.C., Canada.
November 1975.
Announcement card.
Offset lithograph. Printed on both sides.
4 x 6 inches.

536. CARL ANDRE
CARL ANDRE - TWO WORKS.
N.p. May 1–July 1, 1976.
Announcement card.
Offset lithograph.
6 x 4 inches.

537. CARL ANDRE
PASSPORT. CARL ANDRE.
Cusack Gallery, Houston, Tex. May 11, 1976.
Announcement card.
Offset lithograph. Printed on both sides.
5.5 x 3.5 inches.

538. CARL ANDRE
CARL ANDRE.
Konrad Fischer, Düsseldorf, Germany.
June 26–July 31, 1976.
Announcement card.
Offset lithograph. Printed on both sides.
4 x 5.75 inches.
Reference: Fischer, p. 130.

539. CARL ANDRE
CARL ANDRE. SKULPTUREN.
Kabinett für Aktuelle Kunst, Bremerhaven,
Germany. September 11–October 10, 1976.
Announcement card.
Offset lithograph. Printed on both sides.
4 x 5.75 inches.

540. CARL ANDRE
CARL ANDRE.
Otis Art Institute Gallery, Los Angeles, Calif.
January 20–February 27, 1977.
Set of 5 announcement cards.
Offset lithograph. Printed on both sides.
4 x 6 inches each.
Postcards listed individually:

MacArthur Park Lake. 1 of 5.
Otis Art Institute Gallery. 2 of 5.
Santa Fe Metals, Forty-first & Alameda. 3 of 5.
Prime Rectiles. 4 of 5.
Blue Equivalents. 5 of 5.

541. CARL ANDRE
CARL ANDRE.
Konrad Fischer, Düsseldorf, Germany. Opening
September 8, 1984.
Announcement card.
Offset lithograph. Printed on both sides.
4 x 5.75 inches.

542. CARL ANDRE
MANET ISOBARS [. . .]. CARL ANDRE.
Paula Cooper, New York, N.Y.
April 16–May 14, 1992.
Announcement card.
Offset lithograph. Printed on both sides.
4.25 x 7 inches.

543. CARL ANDRE
CARL ANDRE.
Konrad Fischer, Düsseldorf, Germany.
September 26–October 24, 1992.
Announcement card.
Offset lithograph. Printed on both sides.
4 x 5.75 inches.

543.1. PAT ANDREA
See Cafe Schiller/Pat Andrea.

544. ANONYMOUS
LANDSLIDE NO. 3.
[*Landslide*, Los Angeles, Calif.]. 1969.
Artists' periodical.
Envelope containing 1 rubber-stamped card
and pieces of styrofoam.
Card: 5 x 7 inches. Envelope: 5.25 x 7.25 inches.

**545. ANT FARM (CHIP LORD/
DOUG MICHELS/CURTIS SCHREIER)**
TRUCKSTOP Network.
Self-published, Sausalito, Calif. 1971.
Poster.
Folded. Offset lithograph. Printed on both sides.
Unfolded: 11 x 17 inches.
References: Ant Farm; Performance Anthology,
p. 384.

**546. ANT FARM (CHIP LORD/
DOUG MICHELS/CURTIS SCHREIER)**
living room of the FUTURE. 20 20 ANTFARM
VISION.
Contemporary Arts Museum, Houston, Tex.
December 15, 1973–February 1, 1974.
Poster.
Folded. Offset lithograph.
Unfolded: 17 x 11 inches.

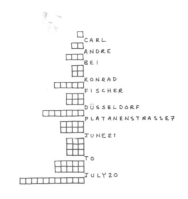

532.

537.

538.

540.

541.

UNCLE BUDDIE'S
USED CARS
4•2MAR•0

ANT FARM

OPEN HOUSE APRIL 1 7pm-9pm

PIER 40

548.

PRESS

MEDIA BURN

ANT FARM

JULY 4 1975 COW PALACE

550.

Z
695.1 Antin, Eleanor
A27 Library Science. Brand Library Art
 Center, November 2-26, 1971

MOUNTAIN AT GRANDVIEW, GLENDALE
TUESDAY AND THURSDAY 12-9, WEDNESDAY,
FRIDAY AND SATURDAY 12-6, SUNDAY 1-5
RECEPTION NOVEMBER 1, 8:00 P.M.

552.

Z Antin, Eleanor
695.1 Library Science. California Institute
A27 of the Arts Library, April 3-28, 1972.

Valencia, California 91355

555.

STEPHEN ANTONAKOS/NEONS—NEW YORK—1977/APRIL 20-MAY 7, 1977
JOHN WEBER GALLERY 420 WEST BROADWAY N.Y.
OPENING WEDNESDAY APRIL 20 — 6-9 PM

557.

561.

547. ANT FARM (CHIP LORD/ DOUG MICHELS/CURTIS SCHREIER)
ANT FARM. 20:20 VISION, A SCAN ON TOMORROW IS GENERATED BY THE ANT FARM AND SPONSORED BY THE CONTEMPORARY ARTS MUSEUM, HOUSTON, TEXAS.
Contemporary Arts Museum, Houston, Tex.
Opening December 21, 1973.
Flyer.
Folded. Photocopy? Printed on both sides.
Unfolded: 11 x 8.5 inches.
References: Ant Farm; Performance Anthology, p. 71.

548. ANT FARM (CHIP LORD/ DOUG MICHELS/CURTIS SCHREIER)
UNCLE BUDDIE'S USED CARS. 4•2MAR•0. ANT FARM. OPEN HOUSE. PIER 40.
[Self-published]. April 1, [1974].
Flyer.
Folded. Photocopy.
Rubber stamps on the front and verso.
Unfolded: 11 x 8.5 inches.

549. ANT FARM (CHIP LORD/ DOUG MICHELS/CURTIS SCHREIER)
MEDIA BURN. JULY 4 1975.
[Self-published]. July 4, 1975.
Sticker.
Offset lithograph. Triangle shape.
2.75 x 3.5 inches overall.

550. ANT FARM (CHIP LORD/ DOUG MICHELS/CURTIS SCHREIER)
PRESS. MEDIA BURN. ANT FARM. COW PALACE.
[Self-published]. July 4, 1975.
Press pass.
Letterpress.
6.5 x 3.5 inches.

551. ANT FARM (CHIP LORD/ DOUG MICHELS/CURTIS SCHREIER)
MEDIA BURN. AN EVENT: ON JULY 4th 1975, ANT FARM WILL DRIVE A PHANTOM DREAM CAR THROUGH A WALL OF BURNING TV SETS.
Self-published. July 4, 1975.
Announcement card.
Offset lithograph. Printed on both sides.
4 x 6 inches.
Reference: Performance Anthology, pp. 140–42.

552. ELEANOR ANTIN
Antin, Eleanor. Library Science.
Brand Library Art Center, Glendale, Calif.
November 2–26, 1971.
Announcement card.
Offset lithograph. 1 die-cut circle.
3 x 5 inches.
Reference: Antin, pp. 34–38, 229.

553. ELEANOR ANTIN
Antin, Eleanor. Library Science.
Nova Scotia College of Art and Design, Halifax, Nova Scotia, Canada. February 1–9, 1972.
Announcement card.
Offset lithograph. 1 die-cut circle.
3 x 5 inches.
Reference: Antin, pp. 34–38, 229.

554. ELEANOR ANTIN
Antin, Eleanor. Library Science.
University of California at San Diego, Cluster Library, San Diego, Calif. February 23–March 31, 1972.
Announcement card.
Offset lithograph. 1 die-cut circle.
3 x 5 inches.
Reference: Antin, pp. 34–38, 229.

555. ELEANOR ANTIN
Antin, Eleanor. Library Science.
California Institute of the Arts Library, Valencia, Calif. April 3–28, 1972.
Announcement card.
Offset lithograph. 1 die-cut circle.
3 x 5 inches.
Reference: Antin, pp. 34–38, 229.

556. ELEANOR ANTIN
Antin, Eleanor. Library Science.
Austin Peay State University, Felix, G. Woodward Library, Clarksville, Tenn. October 1–31, 1972.
Announcement card.
Offset lithograph. 1 die-cut circle.
3 x 5 inches.
Reference: Antin, pp. 34–38, 229.

557. STEPHEN ANTONAKOS
STEPHEN ANTONAKOS / NEONS - NEW YORK - 1977.
John Weber Gallery, New York, N.Y.
April 20–May 7, 1977.
Announcement card.
Offset lithograph.
1 die-cut right angle.
4 x 7 inches.

558. STEPHEN ANTONAKOS
STEPHEN ANTONAKOS.
<<NEONS/ATHENS/1977>>.
Jean & Karen Bernier, [Athens, Greece]. 1977.
Announcement card.
Offset lithograph. Printed on both sides.
1 die-cut arc.
4.25 x 5.75 inches.

559. STEPHEN ANTONAKOS
ANTONAKOS. "Neons for the University of Massachusetts".
University Gallery, Fine Arts Center, University of Massachusetts at Amherst, Amherst, Mass.
April 8–June 4, 1978.
Announcement card.
Offset lithograph. Printed on both sides.
1 die-cut arc and 1 die-cut right angle.
6 x 9 inches.

560. STEPHEN ANTONAKOS
ANTONAKOS. "Neons for the University of Massachusetts".
University Gallery, Fine Arts Center, University of Massachusetts at Amherst, Amherst, Mass.
April 8–June 4, 1978.
Poster.
Folded. Offset lithograph. Printed on both sides.
1 die-cut right angle.
Unfolded: 22 x 19 inches.

560.1. STEPHEN ANTONAKOS
See Art & Project/Stephen Antonakos.

561. ARAKAWA
DIAGRAMS - ARAKAWA.
Dwan Gallery, Los Angeles, Calif.
April 12–May 7, 1966.
Poster.
Folded. Offset lithograph.
Unfolded: 22 x 30 inches.

561.1. KEITH ARNATT
See Art & Project/Keith Arnatt.

562. ART & PROJECT/LAWRENCE WEINER
bulletin 10. lawrence weiner.
Art & Project, Amsterdam, The Netherlands.
September 1, 1969.
Artist's publication.
Folded sheet. Offset lithograph.
Printed on both sides.
Folded: 11.75 x 8.25 inches.
Unfolded: 11.75 x 17 inches.
Reference: Weiner (Schwarz), p. 80.

563. ART & PROJECT/IMI KNOEBEL
bulletin 13. w knoebel IMI.
Art & Project, Amsterdam, The Netherlands.
November 15–December 10, 1969.
Artist's publication.
Folded sheet. Offset lithograph. Printed on both sides.
Folded: 11.75 x 8.25 inches.
Unfolded: 11.75 x 17 inches.

564. ART & PROJECT/GILBERT & GEORGE
bulletin 20.
Art & Project, Tokyo, Japan. [1970].
Artists' publication.
Folded sheet. Offset lithograph. Printed on both sides.
Folded: 11.75 x 8.25 inches.
Unfolded: 11.75 x 17 inches.

565. ART & PROJECT/YUTAKA MATSUZAWA
bulletin 21. yutaka matsuzawa.
Art & Project, Tokyo, Japan. [1970].
Artist's publication.
Folded sheet. Offset lithograph. Printed on both sides.
Folded: 11.75 x 8.25 inches.
Unfolded: 11.75 x 17 inches.

566. ART & PROJECT/DOUGLAS HUEBLER
bulletin 22. douglas huebler.
Art & Project, Amsterdam, The Netherlands.
April 25–May 8, 1970.
Artist's publication.
Folded sheet. Offset lithograph. Printed on both sides.
Folded: 11.75 x 8.25 inches.
Unfolded: 11.75 x 17 inches.

567. ART & PROJECT/KEITH ARNATT
bulletin 23. keith arnatt. 1220400 - 0000000.
Art & Project, Amsterdam, The Netherlands.
May 30–June 13, 1970.
Artist's publication.
Folded sheet. Offset lithograph. Printed on both sides.
Folded: 11.75 x 8.25 inches.
Untolded: 11.75 x 17 inches.

568. ART & PROJECT/MEL BOCHNER
bulletin 27. Excerpts From Speculation
[1967-1970]. 3 CONDITIONS. MEL BOCHNER.
Art & Project, Amsterdam, The Netherlands.
September 15, 1970.
Artist's publication.
Folded sheet. Offset lithograph. Printed on both sides.
Folded: 11.75 x 8.25 inches.
Unfolded: 11.75 x 17 inches.

569. ART & PROJECT/HANNE DARBOVEN
bulletin 28. hanne darboven. 00/366 - 1. 99/365 -
100. on exhibition: 100 books 00 - 99.
Art & Project, Amsterdam, The Netherlands.
October 24–November 13, 1970.
Artist's publication.
Folded sheet. Offset lithograph. Printed on both sides.
Folded: 11.75 x 8.25 inches.
Unfolded: 11.75 x 17 inches.

570. ART & PROJECT/IAN WILSON
bulletin 30. ian wilson.
Art & Project, Amsterdam, The Netherlands.
November 30, 1970.
Artist's publication.
Folded sheet. Offset lithograph.
Folded: 11.75 x 8.25 inches.
Unfolded: 11.75 x 17 inches.

571. ART & PROJECT/RICHARD LONG
bulletin 35. Reflections in the Little Pigeon River,
Great Smoky Mountains, Tennessee.
Richard Long 1970.
Art & Project, Amsterdam, The Netherlands.
[1971].
Artist's publication.
Folded sheet. Offset lithograph. Printed on both sides.
Folded: 11.75 x 8.25 inches.
Unfolded: 11.75 x 17 inches.

572. ART & PROJECT/DANIEL BUREN
bulletin 40. '... one of the characteristics of the
proposition is to reveal the 'container' in which it
is sheltered'.") daniel buren (august 1969).") in:
BEWARE! (g): 'the viewpoint - the location'.
(studio international, march 1970).
Art & Project, Amsterdam, The Netherlands.
[1971].
Artist's publication.
Folded sheet. Offset lithograph. Printed on both sides.
Folded: 11.75 x 8.25 inches.
Unfolded: 11.75 x 17 inches.

573. ART & PROJECT/YUTAKA MATSUZAWA
bulletin 42. yutaka matsuzawa.
Art & Project, Amsterdam, The Netherlands.
August 7–August 21, 1971.
Artist's publication.
Folded sheet. Offset lithograph. Printed on both sides.
Folded: 11.75 x 8.25 inches.
Unfolded: 11.75 x 17 inches.

574. ART & PROJECT/BAS JAN ADER
bulletin 44. bas jan ader. broken fall, westkapelle
(holland), 1971.
Art & Project, Amsterdam, The Netherlands.
October 8, 1971.
Artist's publication.
Folded sheet. Offset lithograph. Printed on both sides.
Folded: 11.75 x 8.25 inches.
Unfolded: 11.75 x 17 inches.
References: Ader (Andriesse), p. 38; Ader
(Braunschweig), p. 30.

575. ART & PROJECT/GILBERT & GEORGE
bulletin 47.
Art & Project, Amsterdam, The Netherlands.
[1971].
Artists' publication.
Folded sheet. Offset lithograph. Printed on both sides.
Signed.
Folded: 11.75 x 8.25 inches.
Unfolded: 11.75 x 17 inches.

576. ART & PROJECT/HAMISH FULTON
bulletin 52. hamish fulton.
Art & Project, Amsterdam, The Netherlands.
March 25–April 14, 1972.
Artist's publication.
Folded sheet. Offset lithograph. Printed on both sides.
Folded: 11.75 x 8.25 inches.
Unfolded: 11.75 x 17 inches.

563.

566.

567.

573.

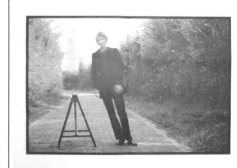

574.

575.

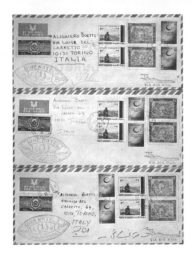

580.

581.

583.

585.

587.

577. ART & PROJECT/LAWRENCE WEINER
bulletin 53. lawrence weiner.
Art & Project, Amsterdam, The Netherlands.
April 22–May 12, 1972.
Artist's publication.
Folded sheet. Offset lithograph. Printed on both sides.
Folded: 11.75 x 8.25 inches.
Unfolded: 11.75 x 17 inches.
Reference: Weiner (Schwarz), p. 82.

578. ART & PROJECT/LAWRENCE WEINER
bulletin 54. lawrence weiner.
Art & Project, Amsterdam, The Netherlands.
April 22–May 12, 1972.
Artist's publication.
Folded sheet. Offset lithograph. Printed on both sides.
Folded: 11.75 x 8.25 inches.
Unfolded: 11.75 x 17 inches.
Reference: Weiner (Schwarz), p. 83.

579. ART & PROJECT/IAN WILSON
bulletin 59. ian wilson.
Art & Project, Amsterdam, The Netherlands.
September 11, 1972.
Artist's publication.
Folded sheet. Offset lithograph. Printed on both sides.
Folded: 11.75 x 8.25 inches.
Unfolded: 11.75 x 17 inches.

580. ART & PROJECT/ALIGHIERO BOETTI
bulletin 62. alighiero boetti.
Art & Project, Amsterdam, The Netherlands.
November 6, 1972.
Artist's publication.
Folded sheet. Offset lithograph. Printed on both sides.
Folded: 11.75 x 8.25 inches.
Unfolded: 11.75 x 17 inches.

581. ART & PROJECT/HANNE DARBOVEN
bulletin 64. hanne darboven.
Art & Project, Amsterdam, The Netherlands.
December 16, 1972–January 12, 1973.
Artist's publication.
Folded sheet. Offset lithograph. Printed on both sides.
Folded: 11.75 x 8.25 inches.
Unfolded: 11.75 x 17 inches.

582. ART & PROJECT/ALLEN RUPPERSBERG
bulletin 67. allen ruppersberg. thank you,
mr. duchamp.
Art & Project, Amsterdam, The Netherlands.
July 5, 1973.
Artist's publication.
Folded sheet and 1 leaf. Offset lithograph.
Printed on both sides.
Folded: 11.75 x 8.25 inches.
Unfolded: 11.75 x 17 inches.
Leaf: 11.75 x 8.25 inches.
Reference: Ruppersberg, p. 107.

583. ART & PROJECT/RICHARD LONG
bulletin 71. CIRCLE IN THE ANDES.
RICHARD LONG 1973.
Art & Project, Amsterdam, The Netherlands. 1973.
Artist's publication.
Folded sheet. Offset lithograph. Printed on both sides.
Folded: 11.75 x 8.25 inches.
Unfolded: 11.75 x 17 inches.

584. ART & PROJECT/LAWRENCE WEINER
bulletin 72. lawrence weiner.
Art & Project, Amsterdam, The Netherlands.
December 11–21, 1973; January 2–11, 1974.
Artist's publication.
Folded sheet. Offset lithograph. Printed on both sides.
Folded: 11.75 x 8.25 inches.
Unfolded: 11.75 x 17 inches.
Reference: Weiner (Schwarz), p. 88.

585. ART & PROJECT/GILBERT & GEORGE
bulletin 73.
Art & Project, Amsterdam, The Netherlands.
[January 1974].
Artists' publication.
Folded sheet. Offset lithograph. Printed on both
sides. Embossed GEORGE & GILBERT THE
SCULPTORS ART FOR ALL LONDON.
Folded: 11.75 x 8.25 inches.
Unfolded: 11.75 x 17 inches.

586. ART & PROJECT/DANIEL BUREN
bulletin 75. daniel buren. transparency.
Art & Project, Amsterdam, The Netherlands.
March 26–April 20, 1974.
Artist's publication.
Folded sheet. Offset lithograph on vellum.
Printed on both sides.
Folded: 11.75 x 8.25 inches.
Unfolded: 11.75 x 17 inches.

587. ART & PROJECT/DANIEL BUREN
bulletin 76. daniel buren. transparency. two
photo-souvenirs, march 26, 1974.
Art & Project, Amsterdam, The Netherlands.
April 18, 1976.
Artist's publication.
Folded sheet. Offset lithograph. Printed on both sides.
Folded: 11.75 x 8.25 inches.
Unfolded: 11.75 x 17 inches.

588. ART & PROJECT/WILLIAM LEAVITT
bulletin 80. william leavitt.
Art & Project, Amsterdam, The Netherlands.
October 1–19, 1974.
Artist's publication.
Folded sheet. Offset lithograph. Printed on both sides.
Folded: 11.75 x 8.25 inches.
Unfolded: 11.75 x 17 inches.

589. ART & PROJECT/ALAN CHARLTON
bulletin 81. alan charlton.
Art & Project, Amsterdam, The Netherlands.
October 29–November 16, 1974.
Artist's publication.
Folded sheet. Offset lithograph. Printed on both sides.
Folded: 11.75 x 8.25 inches.
Unfolded: 11.75 x 24.75 inches.

590. ART & PROJECT/YUTAKA MATSUZAWA
bulletin 84. yutaka matsuzawa.
Art & Project, Amsterdam, The Netherlands.
January 1, 1975.
Artist's publication.
Folded sheet. Offset lithograph. Printed on both sides.
Folded: 11.75 x 8.25 inches.
Unfolded: 11.75 x 17 inches.

591. ART & PROJECT/HAMISH FULTON
bulletin 86. hamish fulton.
Art & Project, Amsterdam, The Netherlands.
January 21–February 8, 1975.
Artist's publication.
Folded sheet. Offset lithograph. Printed on both sides.
Folded: 11.75 x 8.25 inches.
Unfolded: 11.75 x 17 inches.

592. ART & PROJECT/SOL LEWITT
bulletin 88. Sol Lewitt. Incomplete Open Cubes.
Art & Project, Amsterdam, The Netherlands.
March 4–15, 1975.
Artist's publication.
Folded sheet and 1 leaf. Offset lithograph.
Printed on both sides.
Folded: 11.75 x 8.25 inches.
Unfolded: 11.75 x 17 inches.

593. ART & PROJECT/RICHARD LONG
bulletin 90. West Coast of Ireland. Richard Long 1975.
Art & Project, Amsterdam, The Netherlands. 1975.
Artist's publication.
Folded sheet. Offset lithograph. Printed on both sides.
Folded: 11.75 x 8.25 inches.
Unfolded: 11.75 x 17 inches.

**594. ART & PROJECT/HANNE DARBOVEN/
ROY COLMER**
bulletin 95. hanne darboven. roy colmer.
Art & Project, Amsterdam, The Netherlands.
January 6–24, 1976.
Artist's publication.
Folded sheet. Offset lithograph. Printed on both sides.
Folded: 11.75 x 8.25 inches.
Unfolded: 11.75 x 17 inches.

595. ART & PROJECT/DAVID TREMLETT
bulletin 96. david tremlett.
Art & Project, Amsterdam, The Netherlands.
January 27–February 14, 1976.
Artist's publication.
Folded sheet. Offset lithograph. Printed on both sides.
Folded: 11.75 x 8.25 inches.
Unfolded: 11.75 x 17 inches.
Reference: Tremlett.

596. ART & PROJECT/ROBERT BARRY
bulletin 97. robert barry.
Art & Project, Amsterdam, The Netherlands.
February 17–March 6, 1976.
Artist's publication.
Folded sheet. Offset lithograph. Printed on both sides.
Folded: 11.75 x 8.25 inches.
Unfolded: 11.75 x 17 inches.

597. ART & PROJECT/STEPHEN ANTONAKOS
bulletin 98. stephen antonakos. incomplete circle
neons and drawings.
Art & Project, Amsterdam, The Netherlands.
March 9–27, 1976.
Artist's publication.
Folded sheet. Offset lithograph. Printed on both sides.
Folded: 11.75 x 8.25 inches.
Unfolded: 11.75 x 17 inches.

598. ART & PROJECT/RICHARD LONG
bulletin 99. A LINE IN THE HIMALAYAS.
RICHARD LONG.
Art & Project, Amsterdam, The Netherlands.
[1976].
Artist's publication.
Folded sheet. Offset lithograph. Printed on both sides.
Folded: 11.75 x 8.25 inches.
Unfolded: 11.75 x 17 inches.

599. ART & PROJECT/ALAN CHARLTON
bulletin 101. alan charlton.
Art & Project, Amsterdam, The Netherlands.
April 5–30, 1977.
Artist's publication.
Folded sheet. Offset lithograph. Printed on both sides.
Folded: 11.75 x 8.25 inches.
Unfolded: 11.75 x 17 inches.

600. ART & PROJECT/ALLEN RUPPERSBERG
bulletin 105. allen ruppersberg.
Art & Project, Amsterdam, The Netherlands.
March 7–April 1, 1978.
Artist's publication.
Folded sheet. Offset lithograph.
Folded: 11.75 x 8.25 inches.
Unfolded: 11.75 x 17 inches.
Reference: Ruppersberg, p. 112.

601. ART & PROJECT/DAVID TREMLETT
bulletin 108. david tremlett.
Art & Project, Amsterdam, The Netherlands.
September 15, 1978.
Artist's publication.
Folded sheet. Offset lithograph. Printed on both sides.
Folded: 11.75 x 8.25 inches.
Unfolded: 11.75 x 17 inches.
Reference: Tremlett.

602. ART & PROJECT/HAMISH FULTON
bulletin 109. hamish fulton.
Art & Project, Amsterdam, The Netherlands.
June 26–July 21, 1979.
Artist's publication.
Folded sheet. Offset lithograph. Printed on both sides.
Folded: 11.75 x 8.25 inches.
Unfolded: 11.75 x 17 inches.

603. ART & PROJECT/RICHARD LONG
bulletin 116. WATERMARKS. POURING WATER
ON A RIVERBED. THE SIERRA MADRE MEXICO
1979. RICHARD LONG. STONES AND STICKS.
Art & Project, Amsterdam, The Netherlands.
March 22–April 19, 1980.
Artist's publication.
Folded sheet. Offset lithograph. Printed on both sides.
Folded: 11.75 x 8.25 inches.
Unfolded: 11.75 x 17 inches.

604. ART & PROJECT/ALAN CHARLTON
bulletin 117. alan charlton.
Art & Project, Amsterdam, The Netherlands.
April 23–May 17, 1980.
Artist's publication.
Folded sheet. Offset lithograph. Printed on both sides.
Folded: 11.75 x 8.25 inches.
Unfolded: 11.75 x 17 inches.

605. ART & PROJECT/DAVID TREMLETT
bulletin 125. david tremlett.
Art & Project, Amsterdam, The Netherlands.
April 29–May 23, 1981.
Artist's publication.
Folded sheet. Offset lithograph. Printed on both sides.
Folded: 11.75 x 8.25 inches.
Unfolded: 11.75 x 17 inches.
Reference: Tremlett.

606. ART & PROJECT/RICHARD LONG
bulletin 128. A LINE IN SCOTLAND 1981.
RICHARD LONG.
Art & Project, Amsterdam, The Netherlands.
January 23–February 20, 1982.
Artist's publication.
Folded sheet. Offset lithograph. Printed on both sides.
Folded: 11.75 x 8.25 inches.
Unfolded: 11.75 x 17 inches.

607. ART & PROJECT/RICHARD LONG
bulletin 135. BRUSHED PATH A LINE IN NEPAL.
RICHARD LONG 1983.
Art & Project, Amsterdam, The Netherlands. 1983.
Artist's publication.
Folded sheet. Offset lithograph. Printed on both sides.
Folded: 11.75 x 8.25 inches.
Unfolded: 11.75 x 17 inches.

595.

598.

599.

605.

3 sculptures

17.2 - 16.3.1985

610.

613.

The plane was leaving from A. Several nights previous, a dream ended as X_b. my foot moved from the bottom step of a house I was leaving. X_c. My foot struck the pavement as I continued the dream someplace between A and E· which took me down the street and into another house. X_d. Both feet struck the floor when the plane lurched as we landed at E.

X_b X_c X_d

E PARALLEL X. FEBRUARY, 1973. A

615.

619.

624.

608. ART & PROJECT/ROBERT BARRY
bulletin 136. robert barry.
Art & Project, Amsterdam, The Netherlands.
May 3–28, 1983.
Artist's publication.
Folded sheet. Offset lithograph. Printed on both sides.
Folded: 11.75 x 8.25 inches.
Unfolded: 11.75 x 17 inches.

609. ART & PROJECT/DAVID TREMLETT
bulletin 138. david tremlett.
Art & Project, Amsterdam, The Netherlands.
September 8–October 6, 1984.
Artist's publication.
Folded sheet. Offset lithograph. Printed on both sides.
Folded: 11.75 x 8.25 inches.
Unfolded: 11.75 x 17 inches.
Reference: Tremlett.

610. ART & PROJECT/LAWRENCE WEINER
bulletin 140. lawrence weiner. 3 sculptures.
Art & Project/Depot, Amsterdam,
The Netherlands. February 17–March 16, 1985.
Announcement card.
Offset lithograph. Printed on both sides.
4.25 x 6 inches.
Reference: Weiner (Schwarz), p. 100.

611. ART & PROJECT/DAVID TREMLETT
bulletin 152. david tremlett.
Art & Project, Amsterdam, The Netherlands.
Summer 1988.
Artist's publication.
Folded sheet. Offset lithograph. Printed on both sides.
Folded: 11.75 x 8.25 inches.
Unfolded: 11.75 x 17 inches.

612. ART & PROJECT/MTL/SOL LEWITT
SOL LEWITT. VIER MUURTEKENINGEN.
Art & Project/MTL, Brussels, Belgium.
November 13–December 8, 1973.
Artist's publication.
Folded sheet. Offset lithograph. Printed on both sides.
Folded: 11.75 x 8.25 inches.
Unfolded: 11.75 x 17 inches.

613. ART & PROJECT/MTL/HANNE DARBOVEN
HANNE DARBOVEN.
Art & Project/MTL, Brussels, Belgium.
March 12–April 6, 1974.
Artist's publication.
Folded sheet. Offset lithograph. Printed on both sides.
Folded: 11.75 x 8.25 inches.
Unfolded: 11.75 x 17 inches.

614. DAVID ASKEVOLD
reading paragraph - 1968.
Self-published. 1968.
Artist's publication.
1 leaf. Photocopy.
11 x 8.5 inches.

615. DAVID ASKEVOLD
PARALLEL X. FEBRUARY, 1973.
Self-published. 1973.
Artist's publication.
1 leaf. Offset lithograph.
11 x 8.5 inches.

616. DAVID ASKEVOLD
muse extracts.
Anna Leonowens Gallery, Nova Scotia College of
Art and Design, Halifax, Nova Scotia, Canada.
July–September 1974.
Artist's publication.
Folded. 1 leaf. Offset lithograph.
Unfolded: 8.5 x 11 inches.

617. AY-O
AYO'S TACTILE RAINBOW NO. 6.
Gallery 669, Los Angeles, Calif. [1967].
Announcement in muslin bag with address
label attached.
Offset lithograph on crumpled paper.
Announcement: 8.25 x 13 inches.
Bag: 3 x 3.5 inches. Label: 3.25 x 2.25 inches.

618. LUTZ BACHER
LUTZ BACHER.
Simon Watson, New York, N.Y. [1990?].
Announcement card.
Offset lithograph on found postcard.
4.25 x 6 inches.

619. LUTZ BACHER
[Sleep].
[Self-published]. May 3–6, 1996.
Announcement card.
Offset lithograph. Printed on both sides.
4.75 x 7.5 inches.

620. CLAYTON BAILEY
HAVING A GOOD TIME, WISH YOU WERE
HERE. EXHIBITION. CERAMICS. Clayton Bailey.
Sacramento State College, Sacramento, Calif.
December 1969.
Poster.
Folded. Offset lithograph.
Unfolded: 35 x 23 inches.

621. CLAYTON BAILEY
CLAYTON BAILEY. CERAMIC SCULPTURE.
Wenger Gallery Underground, San Francisco,
Calif. November 26–December 21, 1974.
Announcement card.
Offset lithograph. Printed on both sides.
5.5 x 5.75 inches.

622. CLAYTON BAILEY
Souvenir ON/OFF the WONDER ROBOT.
Wonders of the World, Porta Costa, Calif.
[1983?].
Postcard.
Offset lithograph. Printed on both sides.
5.5 x 3.5 inches.

623. CLAYTON BAILEY
DR. GLADSTONE DISCOVERS BIGFOOT.
WONDERS OF THE WORLD EXPEDITION
discovers the first real proof of Bigfoot near Port
Costa, California in March, 1971.
N.p. N.d.
Postcard.
Offset lithograph. Printed on both sides.
Photograph by Marc D'Estout.
3.75 x 5.5 inches.

624. JOHN BALDESSARI
STOOGE.
Stooge, Oconomowoc Lake, Wisc. [1974].
Periodical cover for *Stooge*, no. 11.
Folded. Offset lithograph.
Unfolded: 9.5 x 13.5 inches.
Reference: Baldessari, p. 248.

625. JOHN BALDESSARI
BALDESSARI. RECENT WORK.
James Corcoran Gallery, Los Angeles, Calif.
Opening September 23, 1976.
Announcement card.
Offset lithograph.
10 x 8 inches.

626. JOHN BALDESSARI
THE LOS ANGELES INSTITUTE OF
CONTEMPORARY ART.
The Los Angeles Institute of Contemporary Art,
Los Angeles, Calif. [1980?].
Poster.
Offset lithograph.
34.5 x 22 inches.

627. ROBERT BARRY
IN OTHER WORDS: ARTISTS' USE OF
LANGUAGE, PART 2.
Franklin Furnace, New York, N.Y.
February 9–April 2, 1983.
Poster.
Folded. Offset lithograph.
Unfolded: 22 x 17 inches.

627.1. ROBERT BARRY
See also Art & Project/Robert Barry.

628. LOTHAR BAUMGARTEN
,,Ich flog durch die Luft. Die Urwaldbäume
unter mir sahen aus wie Blumenkohl,..
Konrad Fischer, Düsseldorf, Germany.
March 20–April 8, 1972.
Announcement card.
Offset lithograph. Printed on both sides.
4 x 5.75 inches.

629. LOTHAR BAUMGARTEN
LOTHAR BAUMGARTEN. ANTWERPEN. LOTHAR
BAUMGARTEN. BRUXELLES.
Wide White Space, Antwerp, Belgium. Opening
February 4, 1974. Wide White Space, Brussels,
Belgium. Opening February 5, 1974.
Announcement card.
Offset lithograph? Printed on both sides.
4 x 5.75 inches.
Reference: Wide White Space, pp. 320–21.

630. LOTHAR BAUMGARTEN
In den Wäldern am Orinoco wachsen die Kleider
fertig auf den Bäumen. LOTHAR BAUMGARTEN.
Rolf Preisig, Basel, Switzerland.
September 18–October 14, 1975.
Announcement card.
Offset lithograph. Printed on both sides.
4 x 5.75 inches.

631. LOTHAR BAUMGARTEN
>>DA GEFÄLLT'S MIR BESSER ALS IN
WESTFALEN<<. ELDORADO 1974-1976.
LOTHAR BAUMGARTEN.
Konrad Fischer, Düsseldorf, Germany.
December 1 and 2, [1976].
Announcement card.
Offset lithograph. Printed on both sides.
4 x 5.75 inches.

632. LOTHAR BAUMGARTEN
LOTHAR BAUMGARTEN.
Konrad Fischer, Düsseldorf, Germany.
August 30–September 24, [1985].
Announcement card.
Offset lithograph. Printed on both sides.
Photograph by Bruni Encke.
4 x 5.75 inches.
Reference: Fischer, p. 237.

632.1. IAIN & INGRID BAXTER
See N. E. Thing Co. Ltd.

633. LARRY BELL
ARNOLD GLIMCHER AND FREDRIC MUELLER
PRESENT LARRY BELL.
Pace Gallery, New York, N.Y. April 22–May 20, 1967.
Poster.
Folded. Offset lithograph. Printed on both sides.
Unfolded: 28 x 24 inches.
Reference: Art in Los Angeles, p. 149.

634. LARRY BELL
LARRY BELL.
Mizuno Gallery, Los Angeles, Calif.
January 28–February 22, [1969c].
Announcement card.
Offset lithograph. Printed on both sides.
Photograph by Jan Webb.
9 x 6 inches.

635. LARRY BELL
LARRY BELL.
Pace, New York, N.Y. February 14–March 11, [1970].
Poster.
Folded. Offset lithograph. Printed on both sides.
Unfolded: 17.5 x 34.25 inches.

636. LARRY BELL
LARRY BELL.
Ace, Los Angeles, Calif. November [1970].
Announcement card.
Offset lithograph.
3.5 x 9.25 inches.

637. LARRY BELL
LARRY BELL IN TAOS. One Fracture From the
ICEBERG*.
Tally Richards Gallery of Contemporary Art,
Taos, N.M. August 17–September 14, 1975.
Announcement card.
Offset lithograph. Printed on both sides.
Photograph by Jan Webb.
5 x 7 inches.

638. LARRY BELL
PARIS '67 WINTER 28°. HOUSTON '78 SUMMER
88°. LARRY BELL. "NEW WORKS ON PAPER".
Texas Gallery, Houston, Tex. July 13–August 12, 1978.
Announcement card.
Offset lithograph. Printed on both sides.
4.5 x 6.5 inches.

639. LARRY BELL
LARRY BELL. New Work.
Tally Richards Gallery of Contemporary Art,
Taos, N.M. October 18–November 8, 1980.
Announcement card.
Offset lithograph. Printed on both sides.
Photograph by Gordon Adams.
7 x 5.5 inches.

640. LARRY BELL
New Work. LARRY BELL.
Marian Goodman Gallery, New York, N.Y.
January 27–February 17, 1981.
Announcement card.
Offset lithograph. Printed on both sides.
Photograph by Tony Vinella.
6 x 4.25 inches.

641. LARRY BELL
Dr. Lux and the Artist, Taos NM, 1982. Larry Bell.
CHAIRS IN SPACE / The Game de Lux.
The Museum of Contemporary Art, Los Angeles,
Calif. November 17, 1984–January 6, 1985.
Announcement card.
Offset lithograph. Printed on both sides.
Photograph by Gordon Adams.
4.25 x 6 inches.

626.

627.

631.

632.

634.

638.

642.

644.

647.

650.

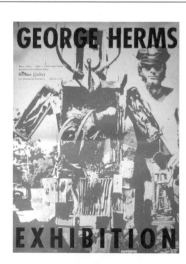

659.

642. BARTON LIDICÉ BENES
BARTON LIDICÉ BENES. SOUVENIRS.
Hoshour Gallery, Albuquerque, N.M.
September 9–October 8, 1983.
Announcement card.
Offset lithograph. Printed on both sides.
10 googly eyes are mounted on the front.
5.25 x 3.25 inches.

643. BARTON LIDICÉ BENES
SEMI-PRECIOUS. Barton Lidicé Benes.
Craig Cornelius Gallery, New York, N.Y.
February 10–March 16, 1985.
Announcement card.
Offset lithograph and glitter. Printed on both sides.
5 x 7 inches.

644. BARTON LIDICÉ BENES
BARTON LIDICE BENES. "Requiems".
Anders Tornberg Gallery, Lund, Sweden.
November 30–December 22, 1985.
Announcement card.
Folded. Offset lithograph. Printed on both sides.
Card-stock cutouts are mounted on the inside right.
Folded: 8.25 x 5.75 inches.
Unfolded: 8.25 x 11.75 inches.

645. BARTON LIDICÉ BENES
BARTON LIDICÉ BENES. MI$C.
Feingarten Galleries, Los Angeles, Calif.
October 29–December 3, 1986.
Announcement.
Offset lithograph on mylar sleeve containing
cut-up pieces of various foreign paper currency.
5 x 8 inches.

646. BARTON LIDICÉ BENES
BARTON LIDICE BENES. "LETHAL WEAPONS" .
Anders Tornberg Gallery, Lund, Sweden.
April 4–May 4, 1994. Announcement in envelope.
Offset lithograph on latex glove.
Glove: 4 x 9 inches overall.
Envelope: 6.5 x 9 inches.

647. BILLY AL BENGSTON
Billy Al Bengston.
Ferus Gallery, [Los Angeles, Calif.].
Opening November 12, 1962.
Poster.
Folded. Offset lithograph.
Unfolded: 14 x 10 inches.
Reference: Art in Los Angeles, p. 131.

648. BILLY AL BENGSTON
EXPOSITION ESPECIAL. BILLY AL BENGSTON.
SERAGRAPHIQUE, LITHOGRAPHIQUE,
TAPESTRY, PEINTURE EN SUITE, UNO-TYPES.
Gallery Margo Leavin, Los Angeles, Calif.
April 1971.
Poster.
Folded. Silkscreen.
Unfolded: 28 x 21 inches.

649. BILLY AL BENGSTON
BILLY AL BENGSTON.
Contact Graphics, Houston, Tex.
Opening October 12, 1971.
Announcement card.
Offset lithograph. Printed on both sides.
6 x 3.75 inches.

650. BILLY AL BENGSTON
I'M STUCK. $10.00 FOR YOUR IDEA.
Texas Gallery, Houston, Tex.
Opening October 9, [1972].
Announcement card.
Offset lithograph. Printed on both sides.
5.75 x 7.75 inches.

651. BILLY AL BENGSTON
Billy Al Bengston. Recent Paintings and Dentos.
Corcoran and Corcoran Gallery, Coral Gables,
Fla. January 4–28, 1973.
Poster.
Folded. Offset lithograph. Printed on both sides.
Unfolded: 16 x 18 inches.

652. BILLY AL BENGSTON
NEW! PAINTINGS THAT ARE FREE HANGING,
PAINTINGS THAT ARE SCREENS, PAINTINGS
THAT ARE PANELS, PAINTINGS THAT ARE
PAINTINGS, - AND MAYBE PAINTINGS THAT ARE
WATERCOLORS OR PORCELAIN PLATES. BY ME
B.A.B. Portland Center for the Visual Arts,
Portland, Ore. November 5–December 11, 1976.
Poster.
Folded. Offset lithograph.
Unfolded: 14.25 x 14 inches.

653. BILLY AL BENGSTON
HONOLULUS. Billy Al Bengston. Current
Watercolors.
James Corcoran Gallery, Los Angeles, Calif.
Opening March 18, 1980.
Poster.
Folded. Offset lithograph.
Unfolded: 11.5 x 17.5 inches.

654. BILLY AL BENGSTON
B.A.B.
James Corcoran Gallery, Los Angeles, Calif.
May 1982.
Announcement card, image cutout, and pin.
Offset lithograph.
Card: 9 x 7 inches. Cutout: 6.25 x 2.5 inches overall.

655. BILLY AL BENGSTON
BILLY AL BENGSTON. 1985 WATERCOLOR.
James Corcoran Gallery, West Hollywood, Calif.
May 1985.
Sheet of 40 artist's stamps.
Offset lithograph on perforated paper.
9 x 10.25 inches.

656. BILLY AL BENGSTON
BILLY AL BENGSTON. NEW PAINTINGS.
Thomas Babeor Gallery, La Jolla, Calif.
September 5–October 11, 1986.
Poster.
Folded. Offset lithograph.
Unfolded: 36.5 x 4.5 inches.

657. BILLY AL BENGSTON
BILLY AL BENGSTON. 7th Annual Exhibition.
Thomas Babeor Gallery, La Jolla, Calif.
September 11–October 10, 1987.
Announcement.
Offset lithograph on vinyl. Rubber stamped IT
GLOWS IN THE DARK on the verso. 2 labels are
mounted on the verso.
4.5 x 5.5 inches.

658. BILLY AL BENGSTON
30 YEARS OF WORK I SHOULDN'T SELL.
James Corcoran Gallery, Santa Monica, Calif. [1988].
Announcement in envelope.
Offset lithograph on crumpled and folded paper.
Unfolded: 5.75 x 8.75 inches.
Envelope: 5.25 x 7.25 inches.

659. WALLACE BERMAN
GEORGE HERMS EXHIBITION.
Batman Gallery, San Francisco, Calif.
May 3–June 3, [1961].
Poster.
Folded. Offset lithograph on newsprint.
Unfolded: 19 x 13.75 inches.
References: Berman, p. 176; Secret Exhibition, p. 74.

660. BARBARA BLOOM
Aanwezig (Present). Afwezig (Absent).
De Appel, Amsterdam, The Netherlands. 1993.
Aluminum tag.
Engraved? Printed on both sides.
Includes a folded card.
Tag: 1.75 x 2.5 inches.
Card folded: 4 x 5.75 inches.

660.1. MEL BOCHNER
See Art & Project/Mel Bochner.

660.2. ALIGHIERO BOETTI
See Art & Project/Alighiero Boetti.

661. CHRISTIAN BOLTANSKI
CHRISTIAN BOLTANSKI a l'honneur de vous
faire ses offres de service.
[Self-published?]. [May 1974].
Flyer.
Offset lithograph.
5.75 x 8.25 inches.
Reference: Boltanski, p. 100.

662. CHRISTIAN BOLTANSKI
CHRISTIAN BOLTANSKI. LES CONCESSIONS.
Galerie Yvon Lambert, Paris, France.
February 24–April 13, 1996.
Artist's publication.
Tabloid format. Folded. Wraparound label.
Unpaginated.
Unfolded: 15.75 x 11.5 inches.

663. CHRISTIAN BOLTANSKI
Christian Boltanski. Passie/Passion.
De Pont, Tilburg, The Netherlands.
December 14, 1996–April 13, 1997.
Artist's publication.
Tabloid format. Folded. Wraparound label.
Unpaginated.
Unfolded: 15.25 x 11.75 inches.

664. JONATHAN BOROFSKY
There's a little bit of Hitler in each of us.
[Self-published]. 1992.
Flyer.
Photocopy.
8.5 x 11 inches.

665. GEORGE BRECHT
8 ROOMS. THE BLACK ROOM. fig.
Self-published. [1964?].
Event card in envelope.
Offset lithograph.
Card: 5 x 5.75 inches. Envelope: 5 x 6 inches.

**666. GEORGE BRECHT/ALISON KNOWLES/
ROBERT WATTS**
SISSOR BROS. WAREHOUSE.
Rolf Nelson Gallery, Los Angeles, Calif. [1963].
Poster.
Folded. Offset lithograph on newsprint. Printed
on both sides. 1 rubber stamp on the verso.
Unfolded: 18.25 x 7 inches.
Reference: Fluxus Etc., p. 233.

666.1. A. A. BRONSON
See General Idea.

667. MARCEL BROODTHAERS
Sophisticated Happening. By Marcel
Broodthaers. Peinture Sculpture Musique Nature
Critique Poésie Instinct Clarté Dada Pop Trap op.
Participation aux frais 50 fr. b.
Galerie Smith, Brussels, Belgium. July 23, [1964].
Announcement.
Silkscreen on page from a telephone book.
Printed on both sides.
11 x 8 inches.
Reference: Broodthaers (Jeu de Paume), p. 66.

668. MARCEL BROODTHAERS
Palais des Beaux-Arts le 7/6/68. A mes amis, [. . .].
Self-published. June 7, 1968.
Open letter.
Folded. Mimeograph?
Unfolded: 10.75 x 8.5 inches.

669. MARCEL BROODTHAERS
KASSEL, le 27 juin '68. Un cube, une sphére, [. . .].
Self-published. June 27, 1968.
Open letter.
Folded. Mimeograph?
Unfolded: 10.75 x 8.5 inches.
Reference: Broodthaers (October), p. 86.

670. MARCEL BROODTHAERS
Bruxelles, le 14 juillet 1968. Mon cher Beuys, [. . .].
Self-published. July 14, 1968.
Open letter.
Folded. Mimeograph?
Unfolded: 10.75 x 8.5 inches.
Reference: Broodthaers (Jeu de Paume), p. 22.

671. MARCEL BROODTHAERS
LIGNANO, le 27 août 1968. J'ai d'abord mis en
scène les objets de la réalité quotidienne, [. . .].
Self-published. August 27, 1968.
Open letter.
Folded. Mimeograph?
Unfolded: 10.75 x 8.5 inches.

672. MARCEL BROODTHAERS
Mutipl'e inimitable illimité. M.B.
Librairie Saint-Germain des Prés, Paris, France.
October 28, 1968.
Announcement.
Folded. Mimeograph? Printed on both sides.
Unfolded: 8 x 5.5 inches.
Reference: Broodthaers (Jeu de Paume), p. 303.

673. MARCEL BROODTHAERS
Antwerpen, le 10 mai 1969. Chers amis, [. . .].
Self-published. May 10, 1969.
Open letter.
Folded. Mimeograph?
Unfolded: 10.75 x 8.5 inches.
Reference: Broodthaers (Jeu de Paume), p. 199.

674. MARCEL BROODTHAERS
AVIS. BRUXELLES, LE 25 nov. 69.
November 25, 1969.
Certificate.
Mimeograph?
Signed and dated.
8.5x 10.75 inches.
Reference: Broodthaers (Jeu de Paume), p. 47.

661.

664.

THE BLACK ROOM

fig

665.

666.

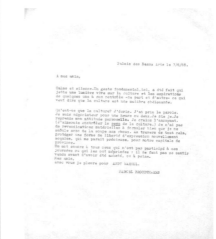

668.

674.

678.

679.

680.

ART & TECHNOLOGY

689.

YANKEE INGENUITY

690.

675. MARCEL BROODTHAERS
PARIS DÜSSELDORF AMSTERDAM. at the
occasion of the opening of an exhibition at the
Guggenheim Museum on Oct. 5 1972, in which I
am taking part among the Dusseldorf artists. -
[Marcel Broodthaers]. Düsseldorf, 28th. Sept 72.
Dear Beuys, [. . .].
Self-published. 1972.
Open letter.
Corner stapled. Mimeograph?
11.75 x 8.25 inches.
Unpaginated. 6 pages.
Reference: Broodthaers (October), pp. 174–76.

676. MARCEL BROODTHAERS
PROGRAMME. MARCEL BROODTHAERS.
Wide White Space, Antwerp, Belgium.
January 13–28, 1973.
Poster.
Folded. Offset lithograph.
Unfolded: 25.5 x 19.75 inches.
Reference: Wide White Space, p. 300.

677. MARCEL BROODTHAERS
FINE RTS. Feuilleton.
Studio International Publications Ltd., London,
England. October 1974.
Periodical cover for *Studio International Journal of
Modern Art* (vol. 188, no. 970 [October 1974]).
Offset lithograph.
12 x 9.5 inches.

678. MARCEL BROODTHAERS
FAUSSES CLÉS POUR LES ARTS. M.B. 74. A NE
PAS JETER SUR LA VOIE PUBLIQUE.
Self-published. 1974.
Flyer.
Folded. Offset lithograph. Printed on both sides.
Edition of 3,000 copies.
Unfolded: 11.75 x 8.25 inches.

679. GUNTER BRUS
Brus. Sonata Domestica.
Galerie Bleich-Rossi, Graz, Austria.
March 27–April 21, 1984.
Poster.
Folded. Offset lithograph.
Unfolded: 24.5 x 17.5 inches.

680. GUNTER BRUS
G. Brus. Augensternstunden.
Van Abbemuseum, Eindhoven, The Netherlands.
April 20–June 3, 1984.
Flyer.
Folded. Offset lithograph.
Unfolded: 11.5 x 8.25 inches.

681. GUNTER BRUS
G. Brus. Der Überblick.
Museum des 20. Jahrhunderts, Vienna, Austria.
February 11–March 9, 1986.
Flyer.
Folded. Offset lithograph. Printed on both sides.
Unfolded: 11.75 x 8.25 inches.

682. GUNTER BRUS
Vor Dem AKZENTFREIEN SCHWEIGEN.
Galerie Heike Curtze, Düsseldorf, Germany.
June 8–September 10, 1988.
Flyer.
Folded. Offset lithograph.
Unfolded: 11.75 x 8.25 inches.

683. GUNTER BRUS
Galerie Heike Curtze zeigt die Bild-Dichtungen
,,NACHTGEWITTER" und ,,FRIEDRICH von
SCHLEGEL: ZEHN SONETTE". von Günter Brus
*1938.
Galerie Heike Curtze, Vienna, Austria.
October 11–November 5, 1988.
Flyer.
Folded. Offset lithograph.
Unfolded: 11.75 x 8.5 inches.

684. GUNTER BRUS
GUNTER BRUS. MAPPE MIT FARBIGEN
RADIERUNGEN ZEICHNUNGEN.
Maximilian Verlag, Sabine Knust, Munich,
Germany. July 6–August 31, 1989.
Flyer.
Folded. Offset lithograph. Printed on both sides.
Unfolded: 11.75 x 8.25 inches.

685. GUNTER BRUS
Bild-Dichtungen. von G. Brus.
Galerie Hubert Klocker, Vienna, Austria.
October–November 1990.
Poster.
Folded. Offset lithograph.
Unfolded: 37.5 x 26.75 inches.

686. GUNTER BRUS
G. Brus. ATMOSPHÄRISCHE UNDICHT WIE
SPRACHE.
Maximilian Verlag, Sabine Knust, Munich,
Germany. September 9–October 29, 1994.
Flyer.
Folded. Offset lithograph. Printed on both sides.
Unfolded: 11.75 x 8.25 inches.

687. GUNTER BRUS
G. Brus. DIE WELTBILDTURBINE.
Galerie Heike Curtze, Vienna, Austria.
May 9–July 6, 1996.
Flyer.
Folded. Offset lithograph. Printed on both sides.
Unfolded: 11.75 x 8.25 inches.

687.1. MARK BRUSSE
See Cafe Schiller/Mark Brusse.

688. ANGELA BULLOCH
Angela Bulloch.
1301, Santa Monica, Calif.
March 13–April 17, 1993.
Poster.
Folded. Offset lithograph.
Unfolded: 18 x 16.5 inches.

689. CHRIS BURDEN
ART & TECHNOLOGY. CHRIS BURDEN.
Stichting "De Appel," Amsterdam, The
Netherlands. October 18–November 13, 1975.
Announcement card.
Offset lithograph. Printed on both sides.
5.5 x 8.25 inches.
Reference: Burden 74–77.

690. CHRIS BURDEN
YANKEE INGENUITY. CHRIS BURDEN.
Galerie Stadler, Paris, France.
October 23–November 8, 1975.
Announcement card.
Offset lithograph. Printed on both sides.
5.5 x 8.25 inches.
Reference: Burden 74–77.

690.1. ANTHONY BURDIN
See Dave Muller/Anthony Burdin

691. DANIEL BUREN
There are visible, alternate vertical stripes, white and blue, from June 15th to July 31th day and night on 50 bus benches.
[Elyse and Stanley Grinstein?].
June 15–July 31, [1970].
Announcement card.
Offset lithograph.
3.25 x 5.5 inches.
Reference: Reconsidering the Object of Art, p. 90.

692. DANIEL BUREN
DANIEL BUREN.
Françoise Lambert, Milan, Italy. Opening June 26, 1970.
Announcement card.
Offset lithograph. Printed on both sides.
5.75 x 7.5 inches.

693. DANIEL BUREN
YOU ARE INVITED TO READ THIS AS A GUIDE TO WHAT CAN BE SEEN.
[John Weber Gallery, New York, N.Y.?].
October 21–31, 1970.
Announcement card.
Offset lithograph with felt pen additions.
6.5 x 5.25 inches.

694. DANIEL BUREN
PART 2*. ANNOUNCEMENT TO BE READ AS A GUIDE TO WHAT IS TO BE SEEN.
John Weber Gallery, New York, N.Y.
October 21–31, 1970.
Announcement card.
Offset lithograph. Printed on both sides.
5 x 6 inches.

695. DANIEL BUREN
1ère Lettre. DEMONSTRATION EMPIRIQUE. EMPERICAL DEMONSTRATION. EMPIRISCHER BEWEIS.
[Self-published?]. 1970.
Flyer/statement.
Folded. Photocopy?
Unfolded: 11.5 x 8.25 inches.

696. DANIEL BUREN
INVITATION A LIRE COMME INDICATION DE CE QUI EST A VOIR.
Yvon Lambert, Paris, France.
December 2, 1970–January 5, 1971.
Announcement card.
Offset lithograph.
5.75 x 4.75 inches.

697. DANIEL BUREN
GRANDS NOMS D'AUJOURD'HUI ET DE DEMAIN ou SPECULATEURS D'HIER ET D'AUJOURD'HUI. Daniel BUREN.
Paris le 4 Novembre 1971.
[Self-published?]. 1971.
Flyer/statement.
Folded. Photocopy?
Unfolded: 10.75 x 8.25 inches.

698. DANIEL BUREN
TRANSPARENCE (Blanc et Jaune). un travail de DANIEL BUREN.
Galerie des Locataires, Paris, France.
March 31–April 3, 1973.
Announcement card.
Offset lithograph.
4 x 5.75 inches.

699. DANIEL BUREN
FRAGMENT 1 / FRAGMENT 2 / FRAGMENT 3. A work by Daniel Buren of white and brown striped paper glued onto various supports along a continuous line 150 feet long.
Nova Scotia College of Art and Design, Halifax,

699. (CONTINUED)
Nova Scotia, Canada. April 12–23, 1973/ April 12–21, 1973/April 12– , 1973.
3 announcement cards.
Offset lithograph.
4 x 4.75 inches each.

700. DANIEL BUREN
PERMUTATIONS. 7 Days - 6 Placements - 7 Colors. Location: Corner of Granville St. and Buckingham St., Halifax, Nova Scotia, Canada. Works by Daniel Buren.
[Nova Scotia College of Art and Design, Halifax, Nova Scotia, Canada?]. [1973].
Announcement card.
Offset lithograph.
4.25 x 7.25 inches.

701. DANIEL BUREN
COMMUNIQUE. Paris le 20.4.74. Daniel Buren.
[Self-published?]. 1974.
Flyer/statement.
Folded. Mimeograph?
Unfolded: 11.75 x 8.25 inches.

702. DANIEL BUREN
SUITE N. 1 NELLO SPAZIO DATO. DANIEL BUREN. SUITE N. 2 NELLO SPAZIO DATO. DANIEL BUREN.
Gian Enzo Sperone, Turin, Italy.
November 20, 1974. Sperone Fischer, Rome, Italy. December 14, 1974.
Announcement card torn in 2 pieces.
Offset lithograph. Printed on both sides.
Card untorn: 5 x 7.5 inches.

703. DANIEL BUREN
DANIEL BUREN. FUNZIONE DEL MUSEO.
Banco, Brescia, Italy. December 1974.
Exhibition brochure.
Offset lithograph. Printed on both sides.
Folded: 9 x 6.5 inches. Unfolded: 9 x 13 inches.

704. DANIEL BUREN
CHEZ GEORGES Restaurateur, 273, boulevard Péreire, "à la Porte Maillot", 75017, PARIS.
Chez Georges, Paris, France? [1974?].
Postcard.
Offset lithograph. Printed on both sides.
Photograph by Roger Mazarguil.
4.25 x 6 inches.
Reference: Correspondence Art, p. 112.

705. DANIEL BUREN
SEVEN BALLETS IN MANHATTAN. CHOREOGRAPHY BY DANIEL BUREN.
John Weber Gallery, New York, N.Y. May 27–June 1975.
Announcement/program.
Folded. Offset lithograph.
Folded: 8.5 x 5.5 inches.
Unfolded: 17 x 22 inches.

706. DANIEL BUREN
PASSAGES FROM DOOR TO DOOR: 5 pieces fragmented by 10 different locations. a work in situ by DANIEL BUREN.
San Francisco Museum of Modern Art, San Francisco, Calif. June 23–August 6, 1978.
Artist's statement.
Offset lithograph. Printed on both sides.
8.5 x 10.25 inches.

707. DANIEL BUREN
EXIT. A Work in Situ by DANIEL BUREN.
John Weber Gallery, New York, N.Y. Opening December 2, 1980.
Announcement card.
Offset lithograph. Printed on both sides.
4 x 6 inches.

There are visible, alternate vertical stripes, white and blue, from June 15th to July 31th day and night on 50 bus benches.

Hollywood at:	La Cienga at:	Fairfax	Plymouth
Curson	Santa Monica	Genesee	Wilton
Fuller	Melrose	Gardner	St. Andrews
Vine	Whitworth	Orange Dr.	Harvard
Bronson	Santa Monica at:	Western	Bonnie Brea
Western	Poinsettia	Normandie	Union
Harvard	La Brea	Wilshire at:	Valencia
Normandie	McCadden	McClellan	Bixel
Alexandria	Las Palmas	San Vincente WLA	Beaudry
Edgemont	Cahuenga	Sawtelle	Figueroa
Rodney	Sunset at:	Westholme	
Sunset	Hammond	McCarthy Vista	
La Brea at:	Horn	Cloverdale	DANIEL BUREN
Santa Monica	Sweetzer	Mansfield	

691.

YOU ARE INVITED TO READ THIS AS A GUIDE
TO WHAT CAN BE SEEN

INDICATIONS

MATERIAL............. 8,7 cm wide, color and white vertically striped paper.
PLACES.............. stuck on walls, store-fronts, billboards, outdoors and indoors in New York City.
DIMENSIONS.......... variable according to the day.
COLOR............... arbitrary according to the day.
LOCATION............ different every day.
DATES............... from October 21 to October 31, 1970.
PERSON RESPONSIBLE. Daniel Buren.

IN ORDER TO SEE

call the following number which will give you all information
at any hour of the day or night:

751 2747

Illustration . . .

693.

FRENCH WINDOW RECTO
GALERIE DES LOCATAIRES VERSO

TRANSPARENCE
(Blanc et Jaune)

un travail de

DANIEL BUREN

31 Mars - 3 Avril 1973

14, Rue de l'Avre, rez-de-chaussée gauche, Paris 15e

698.

701.

704.

707.

711.

712.

713.

717.

718.

719.

708. DANIEL BUREN
Wo? Was? Wie? Arbeiten vor Ort. DANIEL BUREN.
Kunstverein, Hannover, Germany.
September 28–December 29, 1991.
Poster.
Folded. Offset lithograph.
Unfolded: 33 x 23.25 inches.

709. DANIEL BUREN
DANIEL BUREN. TRAVAUX SITUÉS.
Galerie Roger Pailhas, Marseille, France.
October 22–December 28, 1991.
Announcement card.
Offset lithograph. Printed on both sides.
4 x 6 inches.

710. DANIEL BUREN
DANIEL BUREN. TO ALTER. SITUATED WORKS.
John Weber Gallery, New York, N.Y.
April 24–May 22, 1993.
Announcement card.
Offset lithograph. Printed on both sides.
5 x 7 inches.

710.1. DANIEL BUREN
See also Art & Project/Daniel Buren.

**711. DANIEL BUREN/OLIVIER MOSSET/
MICHEL PARMENTIER/NIELE TORONI**
NOUS NE SOMMES PAS PEINTRES.
Constatez-le, le 3 janvier 1967, 11, avenue
du Président-Wilson.
[Self-published]. January 1, 1967.
Announcement/manifesto.
Offset lithograph?
8.25 x 5.25 inches.

712. RICHMOND BURTON
Richmond Burton. New Paintings.
Matthew Marks, New York, N.Y.
October 8–November 30, 1991.
Announcement card.
Folded. Photoengraving and letterpress.
Printed on both sides.
Folded: 10.5 x 6.5 inches.
Unfolded: 10.5 x 13 inches.
Note: Six versions.

713. JAMES LEE BYARS
JAMES LEE BYARS AND A DOZEN FACTS.
[Museum of Contemporary Crafts, New York,
N.Y.?]. [1967?]
Flyer/statement.
Offset lithograph on "dissolvo" paper.
11 x 8.5 inches.
Reference: Byars (Valencia), pp. 202–204.

714. JAMES LEE BYARS
Please limit all talking to the sound of O, as
preview given by W.W.S. Antwerp to This is the
Ghost of James Lee Byars Calling.
Wide White Space, Antwerp, Belgium. [1969].
Announcement (triangle shaped).
Folded. Offset lithograph.
Height: 12.5 inches. Width: 24 inches.
Reference: Byars (Valencia), p. 199.

715. JAMES LEE BYARS
BYARS AT THE MET.......INVISIBLY.
[Metropolitan Museum, New York, N.Y.]. [1971].
Card.
Offset lithograph.
1 x 1 inches.
References: Byars (Weserburg), No. 57; Byars
(Valencia), p. 207.

716. JAMES LEE BYARS
THE PERFECT LOVE LETTER.
The Société des Expositions, Brussels, Belgium.
October 1974.
Announcement card.
Embossed.
6.25 x 4.5 inches.
Reference: Byars (Valencia), p. 214.

717. JAMES LEE BYARS
JAMES LEE BYARS THE PLAY OF DEATH 12 12
12 DOM HOTEL.
Dom Hotel, [Cologne, Germany]. [1976].
Announcement.
Folded. Offset lithograph.
Unfolded: 4 x 34 inches.
Reference: Byars (Weserburg), No. 141.

718. JAMES LEE BYARS
THE PERFECT PERFORMANCE IS TO STAND STILL.
[ICC, Antwerp, Belgium]. [1976].
Card.
Offset lithograph.
3.75 x 3.75 inches.
Reference: Byars (Weserburg), No. 81.

719. JAMES LEE BYARS
Late news of Perfect from MIT is that the word
weighs nothing.
[ICC, Antwerp, Belgium]. [1976].
Flyer.
Folded. Photocopy.
8.25 x 11.75 inches.
Reference: Byars (Weserburg), No. 72.

720. JAMES LEE BYARS
Perfect?
[ICC, Antwerp, Belgium]. [1976].
Flyer.
Folded. Photocopy.
8.25 x 11.75 inches.
Reference: Byars (Weserburg), No. 71.

721. JAMES LEE BYARS
PUT THE PERFECT TEAR IN THE MIDDLE.
[Self-published?]. [1976].
Card.
Offset lithograph.
1 x 1 inches.
Note: Black card-stock version.
Reference: Byars (Weserburg), No. 77.

722. JAMES LEE BYARS
THE EXHIBITION OF PERFECT.
[Self-published?]. [1980].
Card.
Offset lithograph.
1 x 1 inches.
Note: White card-stock version.
Reference: Byars (Weserburg), No. 87.

723. JAMES LEE BYARS
BE QUIET.
[Venice Biennale, Venice, Italy]. [1980].
Card.
Offset lithograph on tissue paper.
0.5 x 1 inches.
Reference: Byars (Weserburg), No. 86.

724. JAMES LEE BYARS
BYARSISDEAD.
[Self-published?]. [1993].
Card.
Offset lithograph.
Diameter: .75 inch.
References: Byars (Weserburg), No. 115;
Byars (Valencia), p. 225.

725. JAMES LEE BYARS
666.
[Self-published?]. [1997c].
Card.
Offset lithograph.
0.25 x 0.25 inches.

726. JAMES LEE BYARS
MR. JOSEPH BEUYS MAKES THE WORLD
DOCUMENTA 8.
[Self-published]. N.d.
Announcement.
Offset lithograph (?) on crumpled tissue paper.
Diameter: 9 inches approximately.

727. JAMES LEE BYARS
PLEASE COME TO A PREVIEW OF AN
EXHIBITION BY JAMES LEE BYARS AT THE
HOUSE OF MARTA AND HANS CHRISTOPH
VON TAVEL.
[Self-published]. N.d.
Announcement.
Offset lithograph (?) on crumpled tissue paper.
Diameter: 22 inches approximately.

728. JAMES LEE BYARS
MR BYARS AND MR BARKER, THE NATIONAL
GALLERY, LONDON, ENGLAND.
The National Gallery, London, England. N.d.
Announcement.
Offset lithograph (?) on black tissue paper
envelope.
5.5 x 5.25 inches.

729. JAMES LEE BYARS
MR. BYARS AT THE ARCHITECTURAL LEAGUE.
Architectural League of New York, New York, N.Y.
N.d.
Poster.
Folded. Offset lithograph. Printed on both sides.
Unfolded: 18.75 x 18.75 inches.

730. JAMES LEE BYARS
NADAT IK HET NIETS GEVONDEN HAD,
VOND IK DE SCHOONHEID. MALLARME.
[Self-published?]. N.d.
Card.
Offset lithograph on tissue paper.
4.25 x 6 inches.

731. JAMES LEE BYARS
Q.
[Self-published?]. N.d.
Card.
Offset lithograph.
1 x 1 inches.
Note: Square red paper version.
Reference: Byars (Weserburg), No. 132.

732. JAMES LEE BYARS
THE CHAIR OF THE ARTIST AT HARVARD?
[Stedelijk van Abbemuseum, Eindhoven,
The Netherlands]. N.d.
Card.
Offset lithograph.
Diameter: 1 inch
Note: Circular black paper version.
Reference: Byars (Weserburg), No. 135.

733. JAMES LEE BYARS
The absence is only present in hiding itself...
(M.Duras).
[Self-published?]. N.d.
Card.
Photocopy?
0.5 x 3.75 inches.

734. JAMES LEE BYARS
Vanish implies a sudden, complete, often
mysterious passing from sight or existence.
[Self-published?]. N.d.
Card.
Photocopy?
0.5 x 4 inches.

735. JAMES LEE BYARS
Vision is the art of seeing things invisible
(J. Swift).
[Self-published?]. N.d.
Card.
Photocopy?
0.25 x 3.5 inches.

736. JAMES LEE BYARS
Absent: v.t. To take (or hold) oneself away.
[Self-published?]. N.d.
Card.
Photocopy?
0.25 x 3 inches.

737. JAMES LEE BYARS
O.
[Self-published?]. N.d.
Card.
Offset lithograph.
Diameter: 0.25 inch.
Reference: Byars (Weserburg), No. 131.

738. ANDRE CADERE
ANDRE CADERE: PRESENTING HIS WORK AT
THE FOLLOWING LOCATIONS: [. . .].
David Ebony Gallery, New York, N.Y. April 8, 1978.
Announcement card.
Offset lithograph.
4 x 6 inches.
Reference: Cadere, p. 65.

739. CAFE SCHILLER/PAT ANDREA
PAT ANDREA.
Café Schiller, [Amsterdam, The Netherlands].
1998.
Beverage coaster.
Offset lithograph. Printed on both sides.
Diameter: 4.25 inches.

740. CAFE SCHILLER/MARK BRUSSE
MARK BRUSSE.
Café Schiller, [Amsterdam, The Netherlands].
1998.
Beverage coaster.
Offset lithograph. Printed on both sides.
Diameter: 4.25 inches.

741. CAFE SCHILLER/KLAAS GUBBELS
KLAUS GUBBELS.
Café Schiller, [Amsterdam, The Netherlands].
1998.
Beverage coaster.
Offset lithograph. Printed on both sides.
Diameter: 4.25 inches.

742. CAFE SCHILLER/JAN ROELAND
JAN ROELAND.
Café Schiller, [Amsterdam, The Netherlands].
1998.
Beverage coaster.
Offset lithograph. Printed on both sides.
Diameter: 4.25 inches.

730.

733.

734.

738.

739.

740.

743.

carte d'invitation

749.

751.

755.

758.

759.

743. ERNST CARAMELLE
ERNST CARAMELLE. works on paper and
video works on.
Galerie Marika Malacorda, Geneva, Switzerland.
September 26–October 17, 1978.
Announcement card.
Folded. Offset lithograph. Printed on both sides.
Folded: 4 x 5.75 inches.
Unfolded: 4 x 11.25 inches.

744. ERNST CARAMELLE
ERNST CARAMELLE.
Galerie Marika Malacorda, Geneva, Switzerland.
Opening October 21, 1982.
Announcement card.
Folded. Offset lithograph. Printed on both sides.
Folded: 4 x 5.75 inches.
Unfolded: 4 x 11.75 inches.

745. ERNST CARAMELLE
ERNST CARAMELLE. zusammenhängende
installationszeichnungen.
Galerie Marika Malacorda, Geneva, Switzerland.
Opening February 7, [1985?].
Announcement card.
Offset lithograph. Printed on both sides.
4 x 6 inches.

746. ERNST CARAMELLE
Here and There: Travels. a lecture by Ernst Caramelle.
The Clocktower, New York, N.Y. September 22, 1988.
Announcement card.
Offset lithograph with graphite additions.
Printed on both sides.
5.5 x 3.5 inches.

747. ERNST CARAMELLE
ERNST CARAMELLE.
Galerie Marika Malacorda, Geneva, Switzerland.
Opening March 8, 1989.
Announcement card.
Offset lithograph. Printed on both sides.
3.5 x 5.5 inches.

748. ERNST CARAMELLE
ERNST CARAMELLE.
Galerie Erika + Otto Friedrich, Bern, Switzerland.
March 10–April 15, 1989.
Announcement card.
Offset lithograph. Printed on both sides.
4 x 5.75 inches.

749. ERNST CARAMELLE
ERNST CARAMELLE.
Musée Départemental de Rochechouart,
Rochechouart, France.
October 12–December 17, 1989.
Announcement card.
Offset lithograph. Printed on both sides.
6 x 4 inches.

750. ERNST CARAMELLE
Ernst Caramelle.
Musée Départemental de Rochechouart,
Rochechouart, France.
October 12–December 17, 1989.
Poster.
Offset lithograph.
23.5 x 18 inches.

751. ERNST CARAMELLE
ERNST CARAMELLE.
Galerie Crousel-Robelin Bama, Paris, France.
March 3–March 28, 1990.
Announcement card.
Offset lithograph. Printed on both sides.
6 x 8.25 inches.

752. ERNST CARAMELLE
Ernst Caramelle.
Museum Haus Lange, Krefeld, Germany.
May 6–June 17, 1990.
Announcement card.
Offset lithograph. Printed on both sides.
5.75 x 4 inches.

753. ERNST CARAMELLE
Ernst Caramelle.
Nationalgalerie Berlin, Berlin, Germany.
May 18–July 1, 1990.
Announcement card.
Offset lithograph. Printed on both sides.
8.25 x 5.75 inches.

754. ERNST CARAMELLE
Ernst Caramelle.
Lawrence Markey, New York, N.Y.
April 3–May 14, 1993.
Announcement card.
Offset lithograph.
5.5 x 4 inches.

755. ERNST CARAMELLE
Ernst Caramelle.
Lawrence Markey, New York, N.Y. 1993.
Poster.
Offset lithograph.
25.5 x 12 inches.

756. ERNST CARAMELLE
Ernst Caramelle.
Galerie & Edition Artelier, Frankfurt am Main,
Germany. April 25–June 9, 1993.
Poster.
Offset lithograph.
27.5 x 20 inches.

757. ERNST CARAMELLE
Ernst Caramelle.
Portikus, Frankfurt, Germany.
November 20, 1993–January 9, 1994.
Announcement card.
Offset lithograph. Printed on both sides.
4 x 5.75 inches.

758. ERNST CARAMELLE
ERNST CARAMELLE.
Galerie Erika + Otto Friedrich, Bern, Switzerland.
April 15–May 20, 1994.
Announcement card.
Offset lithograph. Printed on both sides.
Photograph by Schwitte.
5.75 x 4.25 inches.

759. ERNST CARAMELLE
ERNST CARAMELLE.
Galerie Karlheinz Meyer, Karlsruhe, Germany.
January 26–March 23, 1996.
Announcement card.
Offset lithograph. Printed on both sides.
4 x 8.25 inches.

760. ERNST CARAMELLE
Ernst Caramelle.
Lawrence Markey, New York, N.Y.
April 3–May 17, 1997.
Announcement card.
Offset lithograph.
5.5 x 4.25 inches.

761. ERNST CARAMELLE
ERNST CARAMELLE.
Stichting De Appel, Amsterdam,
The Netherlands. N.d.
Announcement card.
Offset lithograph. Printed on both sides.
4 x 5.75 inches.

762. GUGLIELMO ACHILLE CAVELLINI
cavellini yesterday. cavellini today.
cavellini tomorrow.
[Self-published, Brescia, Italy]. 1981.
Sticker.
Offset lithograph.
4 x 5 inches.

763. GUGLIELMO ACHILLE CAVELLINI
VENEZIA - PALAZZO DUCALE. CAVELLINI
1914-2014. 7 SETTEMBRE - 27 OTTOBRE.
Self-published, Brescia, Italy. N.d.
Postcard.
Offset lithograph. Printed on both sides.
Photograph by Ken Damy.
5.75 x 5.25 inches.

764. GUGLIELMO ACHILLE CAVELLINI
Elenco dei movimenti e dei protagonisti che
hanno contribuito al rinnovamento dell'arte
moderna, rilevati dal libro LA STORIA DELL'ARTE
(Ed. Schiller) in uso nelle scuole tedesche. post
card destined to the cavellinian museum.
Self-published, Brescia, Italy. N.d.
Postcard.
Offset lithograph. Printed on both sides.
6.25 x 4.25 inches.

765. GUGLIELMO ACHILLE CAVELLINI
Graffiti of Altamira Egypt Greece Rome Giotto
Piero della Francesca Caravaggio - El Greco
Rembrandt - Goya van gogh - Cézanne Mondrian
- Duchamp - Picasso Pollock Cavellini.
[Self-published, Brescia, Italy]. N.d.
Sticker.
Offset lithograph.
4.75 x 4.5 inches.

766. GUGLIELMO ACHILLE CAVELLINI
INFORMAZIONE.
[Self-published, Brescia, Italy]. N.d.
Sticker.
Offset lithograph.
3 x 5 inches.

767. GUGLIELMO ACHILLE CAVELLINI
LETTERE.
[Self-published, Brescia, Italy]. N.d.
Sticker.
Offset lithograph.
5 x 4 inches.

768. GUGLIELMO ACHILLE CAVELLINI
Serie "Autostoricizzazione".
Self-published, Brescia, Italy. N.d.
Postcard.
Offset lithograph. Printed on both sides.
Photograph by Ken Damy.
5.75 x 5.75 inches.

769. GUGLIELMO ACHILLE CAVELLINI
CAVELLINI'S TEN COMMANDMENTS.
Self-published, Brescia, Italy. N.d.
Postcard.
Offset lithograph. Printed on both sides.
6.25 x 4.25 inches.

770. GUGLIELMO ACHILLE CAVELLINI
Appello urgente di estrema importanza. Serie
"Autostoricizzazione".
Self-published, Brescia, Italy. N.d.
Postcard.
Offset lithograph. Printed on both sides.
6.25 x 4.5 inches.

771. ALAN CHARLTON
ALAN CHARLTON. PAINTINGS.
Konrad Fischer, Düsseldorf, Germany.
October 20 November 17, 1972.
Announcement card.
Offset lithograph. 4 die-cut rectangles.
4 x 5.75 inches.

772. ALAN CHARLTON
OUTER PIECE 84" SQUARE. INNER PIECE 68 4/10"
SQUARE. 'CHANNEL' 1 8/10" EDGE 1 8/10". SIX
PAINTINGS THE SAME IN SIZE AND SHAPE. EACH
BEING PAINTED WITH A DIFFERENT MIXTURE OF
GREY. AI AN CHARLTON.
Konrad Fischer, Düsseldorf, Germany.
December 11, 1973–January 15, 1974.
Announcement card.
Offset lithograph. Printed on both sides.
4 x 5.75 inches.

773. ALAN CHARLTON
ALAN CHARLTON.
Konrad Fischer, Düsseldorf, Germany.
February 27–March 24, 1975.
Announcement card.
Folded. Offset lithograph. Printed on both sides.
Folded: 5.75 x 4.25 inches.
Unfolded: 5.75 x 12.5 inches.
Reference: Fischer, p. 116.

774. ALAN CHARLTON
alan charlton.
Delfryd Celf, Caernarfon Gwynedd, Wales.
October 7–December 5, 1987.
Poster.
Folded. Offset lithograph. Printed on both sides.
Folded: 15 x 10 inches.

775. ALAN CHARLTON
ALAN CHARLTON.
Galleria Victoria Miro, Florence, Italy.
June 19–July 20, 1990.
Announcement card.
Offset lithograph.
Printed on both sides.
6 x 8.75 inches.

776. ALAN CHARLTON
ALAN CHARLTON.
Museum Haus Esters, Krefeld, Germany.
November 1, 1992–January 31, 1993.
Announcement card.
Offset lithograph. Printed on both sides.
4 x 8 inches.

776.1. ALAN CHARLTON
See also Art & Project/Alan Charlton.

776.2. GARY CHITTY
See Nice Style.

777. CLAUDE CLOSKY
Closky.
L'Hôpital Ephemere, Paris, France.
May 25–June 23, 1991.
Announcement card.
Offset lithograph. Printed on both sides.
Photographs by Jean-Blaise Hall.
11.75 x 8.25 inches.

761.

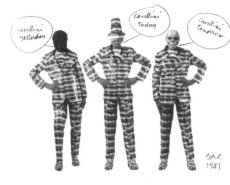

762.

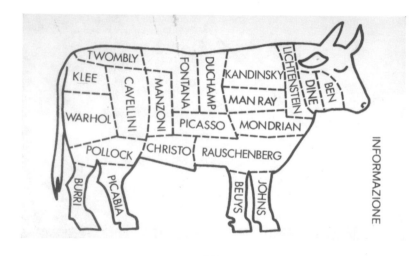

766.

771.

775.

779.

780.

782.

783.

787.

795.

778. **CLAUDE CLOSKY**
8F DE RÉDUCTION SUR VOTRE PROCHAIN
ACHAT SUR PRÉSENTATION DE CE BON.
CLAUDE CLOSKY.
Galerie Jennifer Flay, Paris, France.
April 17–May 22, 1993.
Announcement card.
Offset lithograph.
6 x 2 inches.

779. **CLAUDE CLOSKY**
CLAUDE CLOSKY.
Espace Jules Verne, Brétigny-sur-Orge, France.
December 11, 1993–February 19, 1994.
Announcement card.
Offset lithograph. Perforated.
6 x 4 inches.

780. **CLAUDE CLOSKY**
Claude Closky.
Galerie Jennifer Flay, Paris, France.
Opening December 10, 1994.
Announcement card.
Offset lithograph.
4 x 8.25 inches.

781. **CLAUDE CLOSKY**
CLAUDE CLOSKY. 100 photos qui ne sont pas
des photos de salles de bain et 100 photos qui
ne sont pas des photos de cuisines.
Galeries du Cloître, École Régionale des Beaux-Arts,
Rennes, France. January 23–February 13, 1996.
Announcement card.
Offset lithograph. Printed on both sides.
4 x 6 inches.

782. **CLAUDE CLOSKY**
"Guili guili".
Caisse des Dépôts et Consignations, Paris,
France. May 1–4, 1997.
Flyer.
Folded. Offset lithograph. Printed on both sides.
Unfolded: 11.75 x 8 inches.

783. **CLAUDE CLOSKY**
LIVRES D'ARTISTES. L'INVENTION D'UN
GENRE 1960-1980.
Bibliothèque Nationale de France, Paris, France.
Galerie Mansart, Paris, France.
May 29–October 12, 1997.
Poster.
Offset lithograph.
23.75 x 15.75 inches.

784. **CLAUDE CLOSKY**
Meilleurs voeux pour l'année 1998.
Galerie Jennifer Flay, Paris, France. [1997].
New Year's card.
Offset lithograph. Printed on both sides.
4 x 6 inches.

785. **CLAUDE CLOSKY**
"Les Aoûtiens".
Galerie Jennifer Flay, Paris, France.
September 10–October 17, 1998.
Announcement card.
Offset lithograph. Printed on both sides.
4 x 6 inches.

786. **CLAUDE CLOSKY**
le cercle, le ring.
Maison Levanneur, Chatou, France. 1998.
Announcement card.
Offset lithograph with pen additions.
Edition of 2,000 copies.
7.5 x 7.5 inches.

787. **CLAUDE CLOSKY**
claude closky. tatouages.
Maison Levanneur, Chatou, France.
July 1–September 26, 1999.
Announcement card.
Offset lithograph. Printed on both sides.
7.5 x 7.5 inches.

788. **CLAUDE CLOSKY**
claude closky. tatouages.
Maison Levanneur, Chatou, France.
July 1–September 26, 1999.
Announcement card.
Offset lithograph. Printed on both sides.
2 x 7.5 inches.

789. **CLAUDE CLOSKY**
Claude Closky : 12 h = 10 h. un projet internet /
an internet project.
http://www.fraclr.org/closky/index.htm.
Frac Languedoc-Roussillon, [Montpellier, France].
1999.
Announcement card.
Offset lithograph. Printed on both sides.
4 x 6 inches.

790. **CLAUDE CLOSKY**
Pour trouer le fond du sac, déchirer suivant les
pointillés.
[Gabrielle Maubrie, Paris, France]. [1996].
Plastic bag.
Offset lithograph on clear plastic.
17.5 x 13.5 inches.

791. **COLETTE**
Colette In "Ripping Myself Off".
Victoria Falls, New York, N.Y. December 1–31, 1978.
Announcement card.
Offset lithograph. Printed on both sides.
5 x 7 inches.

792. **COLETTE**
"BEAUTIFUL DREAMER". FUND-RAISING FOR
THE PRESERVATION OF A WORK OF ART.
Colette is Dead Company, New York, N.Y. [1978c].
Announcement card.
Folded. Offset lithograph. Printed on both sides.
1 rubber stamp on the front and verso.
Photograph by Oberto Gili.
Folded: 9 x 4 inches. Unfolded: 9 x 8 inches.

793. **COLETTE**
Justine of Colette is Dead Co. for Fiorucci.
"Deadly Feminine" clothes for FIORUCCI.
Fiorucci. July 24, [1979].
Announcement card.
Offset lithograph. Printed on both sides.
4.75 x 6.25 inches.

794. **COLETTE**
Scott Currie & R Couri Hay, Count & Countess
Reichenbach invite you to celebrate Colette's
exhibition "The Bavarian Adventure".
Dorsky Gallery, New York, N.Y. Opening
May 4, [1989].
Poster.
Folded. Offset lithograph.
Unfolded: 15.5 x 11.5 inches.

795. **JAMES COLLINS**
DELEGATION PROPOSAL 1. JAMES COLLINS.
POSTAL 3.
Self-published. August 1970.
Artist's publication.
Folded sheet. Offset lithograph.
Printed on both sides.
Unfolded: 11.75 x 16.5 inches.

796. JAMES COLLINS
INTERIM TRAVEL PROPOSAL. JAMES COLLINS.
POSTAL 4.
Self-published. September 1970.
Artist's publication.
Folded sheet. Offset lithograph.
Printed on both sides.
Unfolded: 11.75 x 16.5 inches.

796.1. ROY COLMER
See Art & Project/Hanne Darboven/Roy Colmer.

797. BRUCE CONNER
BRUCEXOCONNER EATSXOXOXPUSSY.
[Self-published]. [1960?].
Matchbox.
Offset lithograph on card stock mounted on top
of the box.
1.5 x 2 x 0.5 inches.

798. BRUCE CONNER
BOXCAR SHOW BY BRUCE CONNER. 2:30 P.M.,
APR. 28. CAR NO. 91640. CENTRAL & WICHITA.
WICHITA, KANSAS.
[Self-published]. [1963].
Announcement card/photographic postcard.
Printed label is mounted on the postcard.
3.5 x 5.5 inches.

799. BRUCE CONNER
BRUCE CONNER. DRAWINGS AND
ASSEMBLAGES.
The Alan Gallery, New York, N.Y.
April 20–May 9, [1964?].
Announcement card.
Folded. Offset lithograph. Printed on both sides.
Folded: 3.75 x 8.5 inches.
Unfolded: 7.5 x 8.5 inches.

800. BRUCE CONNER
LOBE KEY STILLED LIONMAN LACED
WINGED APRIL RAPHAEL DANCE WIRY.
Self-published. 1966.
25 cards in envelope.
Offset lithograph. Printed on both sides.
Cards: 2 x 2 inches each.
Envelope: 5.5 x 4.25 inches.

801. BRUCE CONNER
The McPherson County Hospital, McPHERSON,
KANSAS. HOSPITAL BIRTH CERTIFICATE. One-
Man Show: Bruce Conner. Assemblage, Collage
and Sculpture from 1954 to 1964.
The Quay Gallery, San Francisco, Calif.
April 25–May 27, [1967].
Flyer.
Folded. Offset lithograph. Printed on both sides.
8 x 11 inches.

802. BRUCE CONNER
BRUCE CONNER. 34 CARL STREET,
SAN FRANCISCO. 661-4244.
Self-published. [1967].
Business card.
Offset lithograph. Printed on both sides.
2 x 3.25 inches.

803. BRUCE CONNER
SUPER CONNER.
[Self-published]. [1967].
Bumper sticker.
Offset lithograph.
4 x 15 inches.

804. BRUCE CONNER
SUPER CONNER.
[Self-published]. 1967.
Metal button.
Offset lithograph.
Diameter: 1.25 inches.

805. BRUCE CONNER
[Money].
[Self-published]. [1968].
Play money.
Offset lithograph. Printed on both sides.
2.75 x 6.25 inches.

806. BRUCE CONNER
BRUCE CONNER. LITHOGRAPHS.
Martha Jackson Gallery, New York, N.Y.
October 7–November 2, [1972].
Announcement card.
2 parts. Offset lithograph on white card stock and
offset lithograph on clear plastic.
5 x 7 inches each.

807. BRUCE CONNER
BRUCE CONNER AT NICHOLAS WILDER
GALLERY. 1972 B.C.
Nicholas Wilder Gallery, Los Angeles, Calif.
October 24–November 14, 1972.
Bumper sticker in envelope.
Sticker: Silkscreen.
Envelope: Offset lithograph.
Sticker: 3.75 x 11.25 inches.
Envelope: 4 x 11.5 inches.

808. BRUCE CONNER
THE COMPLETE DENNIS HOPPER ONE-MAN
SHOW BY BRUCE CONNER. APPLAUSE.
The Texas Gallery, Houston, Tex.
September 4–October 2, 1973.
Poster.
Folded. Offset lithograph.
Unfolded: 5.5 x 19 inches.

809. BRUCE CONNER
1976. CROSSROADS. a new film by
BRUCE CONNER.
Serious Business Company, Berkeley, Calif.
[1975].
Calendar.
Offset lithograph.
6 x 5.5 inches.

810. BRUCE CONNER
I want to assure film programmers funded by the
National Endowment for the Arts that my movies
will never contain obscene or indecent material
[. . .]. BRUCE CONNER.
Self-published. [1989].
Flyer.
Offset lithograph.
11 x 8.5 inches.

811. BRUCE CONNER
Bruce Conner. 15 Beautiful Mysteries.
Kohn Turner Gallery, Los Angeles, Calif. Opening
June 23, 1995.
Announcement card.
Offset lithograph.
5.5 x 8.5 inches.

797.

798.

802.

805.

807.

810.

812.

JOYCE CUTLER SHAW. 7245 RUE DE ROARK. LA JOLLA, CA 92037

ALPHABET OF BONES

820.

821.

AT SUNRISE on a first of April, there appeared, suddenly as Manco Capac at the lake Titicaca, a man in cream-colors, at the water-side in the city of St. Louis.

His cheek was fair, his chin downy, his hair flaxen, his hat a white fur one, with a long fleecy nap. He had neither trunk, valise, carpet-bag, nor parcel. No porter followed him. He was unaccompanied by friends. From the shrugged shoulders, titters, whispers, wonderings of the crowd, it was plain that he was, in the extremest sense of the word, a stranger.

826.

812. MEG CRANSTON
DULL RHYMES CHAIN'D TO TOTAL GLOOM.
MEG CRANSTON.
1301, Santa Monica, Calif.
September 18–October 31, [1992].
Poster.
Folded. Offset lithograph.
Unfolded: 24 x 18 inches.

813. MEG CRANSTON
MEG CRANSTON.
1301, Santa Monica, Calif.
February 5–March 26, [1994].
Poster.
Folded. Offset lithograph.
Unfolded: 23 x 17.5 inches.

814. MEG CRANSTON
MEG CRANSTON.
Rosamund Felsen Gallery, Santa Monica, Calif.
September 7–October 5, 1996.
Announcement card.
Offset lithograph. Printed on both sides.
4.25 x 6 inches.

815. JOYCE CUTLER-SHAW
The Congressional Poll: Significant Dates of American History.
[Self-published]. February 1976.
Flyer/poll.
Offset lithograph. Printed on both sides.
11 x 8.5 inches.

816. JOYCE CUTLER-SHAW
JoyPEACE [. . .].
Self-published. 1982.
Christmas card.
Folded. Offset lithograph. Printed on both sides.
Signed.
Folded: 5 x 7 inches. Unfolded: 10 x 7 inches.

817. JOYCE CUTLER-SHAW
Joy and Peace. Joyce and Jerry Shaw.
[Self-published]. 1983.
Christmas card.
Folded. Offset lithograph. Printed on both sides.
Signed.
Folded: 5 x 7 inches. Unfolded: 5 x 10 inches.

818. JOYCE CUTLER-SHAW
1985 1955 [. . .].
[Self-published]. 1985.
Christmas card.
Folded. Offset lithograph. Printed on both sides.
Signed.
Folded: 5 x 7 inches. Unfolded: 5 x 10 inches.

819. JOYCE CUTLER-SHAW
PEACE AND JOY. Joyce and Jerry Shaw.
Alphabet of Bones.
[Self-published]. 1986.
Christmas card.
Folded. Offset lithograph. Printed on both sides.
Signed.
Folded: 5 x 7 inches. Unfolded: 5 x 10 inches.

820. JOYCE CUTLER-SHAW
JOYCE CUTLER SHAW, 7245 RUE DE ROARK, LA JOLLA, CA 92037. ALPHABET OF BONES.
[Self-published, La Jolla, Calif.]. N.d.
Calling card.
Offset lithograph.
3.5 x 3.5 inches.

821. HANNE DARBOVEN
Einladung zur Ausstellung: "365 Tage das Jahr 1975" und schreibe ab/auf: "VORWORT" "Aufbruch ins 3. Jahrtausend". hanne darboven.
Lilian & Michel Durand-Dessert, Paris, France.
October 27–November 28, 1979.
Flyer.
Folded. Offset lithograph.
Unfolded: 11.75 x 8.25 inches.

821.1. HANNE DARBOVEN
See also Art & Project/Hanne Darboven; Art & Project/MTL/Hanne Darboven.

822. LOWELL DARLING
"D.I.V.O.R.C.E." Kathleen Darling and Lowell Darling invite you to witness the Dissolution of their marriage with their Legal Counsels and Father Guido Sarducci.
[Self-published]. February 1, 1974.
Announcement card.
Folded. Offset lithograph.
Folded: 5.75 x 4.5 inches.
Unfolded: 5.75 x 8.75 inches.

822.1. AUGUSTO DE CAMPOS
See Openings Press/Augusto de Campos/ Jeffrey Steele.

823. ROY DE FOREST
Roy De foRest.
Dilexi Gallery, San Francisco, Calif.
March 16–April 3, [1965?].
Poster.
Folded. Offset lithograph.
Unfolded: 12.75 x 16 inches.

824. ROY DE FOREST
ROY DE FOREST. paintings & drawings.
San Francisco Art Institute, San Francisco, Calif. [1969].
Poster.
Folded. Offset lithograph. Printed on both sides.
Unfolded: 22.75 x 18.5 inches.

825. ROY DE FOREST
ROY DE FOREST. PAINTINGS.
Dilexi Gallery, San Francisco, Calif. N.d.
Poster.
Folded. Offset lithograph.
Unfolded: 17.75 x 24.25 inches.

826. WALTER DE MARIA
WALTER DE MARIA.
Nicholas Wilder Gallery, Los Angeles, Calif.
April 9–27, [1968?].
Poster and card.
Poster is folded. Offset lithograph.
Photograph by Bob Benson.
Poster unfolded: 14 x 17.75 inches.
Card: 8 x 6 inches.

827. WALTER DE MARIA
WALTER DE MARIA. 50 M3 (1600 CUBIC FEET) LEVEL DIRT.
Galerie Heiner Friedrich, Munich, Germany.
September 28–October 10, 1968.
Poster.
Folded. Offset lithograph.
Unfolded: 23.75 x 22.75 inches.

828. WALTER DE MARIA
UNCONDITIONAL RELEASE.
Dwan Gallery Inc. 1969.
Release form and gelatin silver print (Spike Sculpture).
Offset lithograph.
Form: 10 x 8.25 inches. Print: 10 x 8.25 inches.

829. NIKI DE SAINT PHALLE
"Flash Niki de Saint Phalle".
Galerie Iolas, Paris, France.
October 24–November 6, 1968.
Announcement card.
Offset lithograph. Printed on both sides.
5.25 x 6.75 inches.

830. NIKI DE SAINT PHALLE
Nous sommes des sculptures de joie et de
Bonheur. Niki de Saint Phalle.
Gimpel Hanover Galerie, Zurich, Switzerland.
1968.
Poster.
Folded. Offset lithograph.
Folded: 9.75 x 6.75 inches.
Unfolded: 9.75 x 40 inches.

831. NIKI DE SAINT PHALLE
exposition Niki de Saint Phalle.
Galerie Bonnier, Geneva, Switzerland.
Opening September 23, 1976.
Announcement card.
Folded. Offset lithograph.
Folded: 8.25 x 6 inches.
Unfolded: 8.25 x 11.75 inches.

832. NIKI DE SAINT PHALLE
Niki de Saint Phalle. Monumental Projects.
Gimpel and Weitzenhoffer Gallery, New York, N.Y.
Opening April 3, 1979.
Poster.
Folded. Offset lithograph on newsprint.
Printed on both sides.
Unfolded: 18 x 24 inches.

833. NIKI DE SAINT PHALLE
Chers Amis et Collectionneurs [. . .].
Jan Runnquist, Geneva, Switzerland. N.d.
Card.
Offset lithograph.
8.25 x 5.75 inches.

834. TONY DELAP
TONY DELAP.
Nicholas Wilder, Los Angeles, Calif.
March 21–April 8, 1972.
Announcement card.
Offset lithograph.
4.75 x 6.5 inches.

835. TONY DELAP
Tony DeLap/The Floating Lady.
Robert Elkon Gallery, New York, N.Y.
Opening February 3, 1973.
Announcement card.
Offset lithograph and rubber stamp.
4.25 x 7.5 inches.

836. TONY DELAP
TONY DELAP. New Deceptions. Paintings
and Drawings.
Nicholas Wilder Gallery, Los Angeles, Calif.
February 17–March 6, 1976.
Announcement card.
Offset lithograph.
6.25 x 4.75 inches.

837. ERIK DIETMAN
ERIK DIETMAN. "EXILIRIUM". UN MOMENT MENTAL
D'UN MONUMENT MONOMENTAL (sculptures).
Galerie Bama, Paris, France.
September 15–October 31, 1984.
Announcement card.
Offset lithograph. Printed on both sides.
Photograph by M. Haberland.
5.25 x 7.25 inches.

838. ERIK DIETMAN
ERIK DIETMAN.
Anthony Reynolds Gallery, London, England.
November 22–December 22, 1985.
Announcement card.
Offset lithograph. Printed on both sides.
5.75 x 4 inches.

839. ERIK DIETMAN
ERIK DIETMAN. ŒUVRES DE 1974 À 1977.
Galerie Georges-Philippe Vallois, Paris, France.
June 19–July 20, 1992.
Announcement card.
Offset lithograph. Printed on both sides.
5.25 x 3.75 inches.

840. ERIK DIETMAN
ERIK DIETMAN.
Fonds Régional d'Art Contemporain Champagne-
Ardenne, Reims, France. June 22–August 28, 1994.
Poster.
Folded. Printed on both sides.
Unfolded: 12.5 x 8.25 inches.

841. PETER DOWNSBROUGH
PETER DOWNSBROUGH. AN INSTALLATION.
Pool Fine Art Center, Greenvale (L.I.), N.Y.
October 18–November 1, 1978.
Announcement card.
Offset lithograph.
4 x 7 inches.

842. PETER DOWNSBROUGH
here there and again here. qui la e ancora o qui.
P. DOWNSBROUGH.
Fernando Pellegrino, Bologna, Italy.
Opening April 12, 1980.
Flyer.
Offset lithograph.
11.5 x 8.25 inches.

843. PETER DOWNSBROUGH
PETER DOWNSBROUGH.
Galerie L'A, Liege, Belgium. February 1–20, 1985.
Announcement card.
Offset lithograph. Printed on both sides.
4 x 6.25 inches.

844. PETER DOWNSBROUGH
PETER DOWNSBROUGH.
Galerie Rupert Walser, Munich, Germany.
July 14–September 18, 1987.
Poster.
Folded. Offset lithograph.
Unfolded: 16.5 x 11.25 inches.

845. PETER DOWNSBROUGH
peter downsbrough. installationen, objekte, zeichnungen.
Edition & Galerie A. Hoffmann, Friedberg,
Germany. October 7–December 1, 1989.
Poster.
Folded. Offset lithograph.
Unfolded: 16.75 x 15.75 inches.

846. PETER DOWNSBROUGH
PETER DOWNSBROUGH.
Galerie Sylvana Lorenz, Paris, France.
March 31–April 28, 1990.
Announcement card.
Offset lithograph. Printed on both sides.
4.25 x 6 inches.

847. PETER DOWNSBROUGH
PETER DOWNSBROUGH.
Tilman, Fesler & Coufo Art Gallery, Brussels,
Belgium. February 8–March 16, 1991.
Announcement card.
Offset lithograph. Printed on both sides.
4 x 8.25 inches.

833.

834.

837.

839.

841.

847.

851.

855.

857.

859.

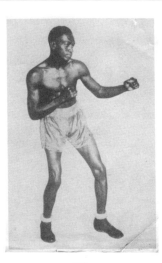

863.

865.

848. PETER DOWNSBROUGH
PETER DOWNSBROUGH. multiples
and wallobject.
Zeger Reijers' Multiples, Rotterdam,
The Netherlands. May 17–June 9, [1991].
Announcement card.
Offset lithograph. Printed on both sides.
6 x 4 inches.

849. PETER DOWNSBROUGH
PETER DOWNSBROUGH.
Galerie Rupert Walser, Munich, Germany.
June 11–July 19, 1991.
Poster.
Folded. Offset lithograph.
Unfolded: 16.5 x 11.75 inches.

850. PETER DOWNSBROUGH
PETER DOWNSBROUGH.
Galerie Anne de Villepoix, Paris, France.
February 1–March 14, 1992.
Announcement card.
Folded. Offset lithograph. Printed on both sides.
Folded: 8.25 x 3 inches.
Unfolded: 8.25 x 6 inches.

851. PETER DOWNSBROUGH
MAQUETTES. PETER DOWNSBROUGH.
The Archives/Art Information Centre, Rotterdam,
The Netherlands. October 24–November 27, 1992.
Poster.
Folded. Offset lithograph. Printed on both sides.
Unfolded: 23.5 x 15.75 inches.

852. PETER DOWNSBROUGH
AND/TO. P. DOWNSBROUGH.
Neues Museum Weserburg, Bremen, Germany.
March 21–May 23, 1993.
Poster.
Folded. Offset lithograph.
Unfolded: 23.25 x 16 inches.

853. PETER DOWNSBROUGH
PETER DOWNSBROUGH.
Pavillon de Bercy–Parc de Bercy, Paris, France.
October 9–November 15, 1996.
Announcement card.
Folded. Offset lithograph. Printed on both sides.
Folded: 6 x 8.25 inches.
Unfolded: 6 x 16.5 inches.

854. PETER DOWNSBROUGH
peter downsbrough.
Maison Levanneur, Chatou, France.
March 28–May 31, 1998.
Announcement card.
Offset lithograph. Printed on both sides.
7.5 x 7.5 inches.

855. SAM DURANT
California Displacement Project: You Project
is What You Get. Sam Durant 1997.
[Self-published]. 1997.
Poster.
Offset lithograph.
22 x 17 inches.

856. JIMMIE DURHAM
(OGiNALi'i). PLEASE HELP! ...
Anders Tornberg Gallery, Lund, Sweden.
August 31–October 2, 1996.
Poster in envelope.
Folded. Offset lithograph.
Unfolded: 21 x 15 inches.
Envelope: 6.25 x 9 inches.

857. ENDART
Endat.
Oranienstr. 36, Berlin, Germany. January 22, 1984.
Announcement card.
Silkscreen.
5.5 x 4 inches.

858. ENDART
Eröffnung bei Ändat. Claudine Katz.
Endart, Berlin, Germany. February 18, 1984.
Announcement card.
Offset lithograph. 1 rubber stamp on the verso.
4 x 5.75 inches.

859. ENDART
„TAUSEND LECKEREIEN".
Galerie Penis, Oranienstr. 36, [Berlin, Germany].
March 9, 1984.
Announcement card.
Silkscreen. Printed on both sides.
5.75 x 8.25 inches.

860. ENDART
FALLE NR. I. TRAP N. 1. EINLADUNG ZU EINER
PERSONELLEN INSTALLATION VON HERBERT
VOLKMANN.
Galerie Endart, Berlin, Germany.
September 15, [1984].
Announcement card.
Offset lithograph. Printed on both sides.
5.5 x 8 inches.

861. ENDART
KASPERL im BUNDESKOHL oder: (Was ist
Bloss mit Seppel los).
Galerie Bundeskohl, Oranienstr. 36, Berlin,
Germany. December 21, 1984.
Announcement card.
Offset lithograph.
5.5 x 8.25 inches.

862. PIETER ENGELS
ENGELS PRODUCTS / EPO / ART / LAST LUXURY.
Wide White Space, Antwerp, Belgium.
February 17–March 15, 1967.
Poster.
Folded. Offset lithograph. Printed on both sides.
Unfolded: 37 x 21.75 inches.
Reference: Wide White Space, p. 236.

863. PIETER ENGELS
THE TWO (F)ACES OF ENGELS PRODUCTS.
Galerie U. Kückels, Bochum/Ehrenfeld, Germany.
Opening March 23, 1968.
Announcement card.
Folded. Offset lithograph. Printed on both sides.
Folded: 11.75 x 5 inches.
Unfolded: 11.75 x 16.5 inches.
Note: Folds to form an open-ended cube.

864. HANS-PETER FELDMANN
HANS-PETER FELDMANN ZEIGT SEINE
SPIELZEUG-SAMMLUNG.
Paul Maenz, Cologne, Germany.
March 11–26, 1975.
Announcement card.
Offset lithograph. Printed on both sides.
4 x 5.75 inches.
Reference: Feldmann, p. 50.

865. HANS-PETER FELDMANN
(Boxer).
[Self-published]. [1993].
Card.
Offset lithograph.
6.25 x 4 inches.

866. HANS-PETER FELDMANN
IM NORDWESTEN, DA WO DAS LAND FLACH
WIRD [. . .].
[Walther König, Cologne, Germany?]. [1999?].
Wrapping paper.
Offset lithograph on brown paper.
13.75 x 19.75 inches.

867. ROBERT FILLIOU
Robert Filliou. EXPOSITION INTUITIVE (avec
matériaux et sans matériau, presque).
Jacqueline Ranson, Paris, France.
Opening October 6, 1966.
Announcement card.
Folded. Offset lithograph. Printed on both sides.
Folded: 10.5 x 4 inches.
Unfolded: 10.5 x 8.25 inches.
Reference: Filliou, p. 51.

868. ROBERT FILLIOU
die >>CRÉATION PERMANENT<< von
Robert Filliou.
Galerie Schmela, Düsseldorf, Germany.
February 25–March 20, 1969.
Announcement card.
Offset lithograph. Printed on both sides.
8.25 x 6 inches.
Reference: Filliou, p. 59.

869. ROBERT FILLIOU
15 WORKS OF ROBERT FILLIOU TO BE LOOKED
UPON AS. EXHIBITION FOR THE 3d EYE.
Wide White Space, Antwerp, Belgium.
November 4–December 2, 1971.
Announcement card.
Offset lithograph.
Photograph by M. Gilissen.
4.5 x 6.25 inches.
Reference: Wide White Space, p. 286.

870. ROBERT FILLIOU
"do as you likE" R.F. ROBERT FILLIOU.
V.E.C. Gallery, Jan van Eyck Academy,
Maastricht, The Netherlands.
March 26–April 16, 1976.
Announcement card.
Rubber stamp and offset lithograph.
Printed on both sides.
3.75 x 5.75 inches.

871. ROBERT FILLIOU
the Eternal Network presents: R. Filliou.
Galerie Bama, Paris, France. April 1–May 15, 1976.
Announcement card.
Offset lithograph. Printed on both sides.
6 x 8.25 inches.
Reference: Filliou, p. 106.

872. ROBERT FILLIOU
ROBERT FiLLiOU. TELEPATHiC MUSiC N° 5, 4, 3, 2, 1.
John Gibson Gallery, New York, N.Y.
May 1–29, [1976].
Announcement card.
Offset lithograph.
4 x 6 inches.
References: Filliou, p. 107; Postkarten, p. 66.

873. ROBERT FILLIOU
ROBERT WiTH MARiANNE FiLLiOU. long livre
court concu a l'occasion d'une exposition.
THE ETERNAL NETWORK.
Galerie Catherine Issert, St. Paul de Vence,
France. April 21–May 15, 1981.
Announcement card.
Folded. Offset lithograph. Printed on both sides.
Folded: 4.25 x 3 inches.
Unfolded: 4.25 x 6 inches.

874. ROBERT FILLIOU
BRIQUOLAGES de filliou.
Galerie M. Malacorda, Geneva, Switzerland.
September 23–October 17, 1982.
Announcement card.
Offset lithograph. Printed on both sides.
4 x 5.75 inches.
Reference: Filliou, p. 125.

875. ROBERT FILLIOU
FiLLiou.
Galerie Schmela, Düsseldorf, Germany. N.d.
Announcement card/2 postcards.
Perforated. Offset lithograph. Printed on
both sides.
8.25 x 5.75 inches.

876. ROBERT FILLIOU
joint works of ROBERT FILLIOU and [. . .].
Galerie Schmela, Düsseldorf, Germany. N.d.
Announcement card.
Folded. Offset lithograph. Printed on both sides.
Folded: 8.25 x 5.75 inches.
Unfolded: 8.25 x 11.5 inches.

877. SABATO FIORELLO
SABATO FIORELLO. CONFESSIONS OF AN
ARTIST. A SERIES FOR 1982.
[Self-published], North Hollywood, Calif. 1982.
Series of 12 postcards.
Offset lithograph. Printed on both sides.
Photographs by Joe Messinger.
[Edition of 500 copies].
6 x 4 inches each.
Postcards listed individually (in order sent):

#1 "THE VELVET PASHA".
#2 "THE ENGLISH BUCCANEER".
#3 "THE EGYPTIAN SORCERER".
#4 "THE ATLANTIC COMMODORE".
#5 "THE FRENCH COURTIER".
#6 "THE RAIN SAMARI".
#7 "THE AMERICAN ADVENTURER".
#8 "THE CHINESE EMISSARY".
#9 "THE VENETIAN SINGER".
#10 "THE DAKOTA HUNTER".
#11 "THE GALACTIC VISITOR".
#12 "THE LEVENTINE MERCHANT".
Reference: High Performance, pp. 40–41.

878. SABATO FIORELLO
SABATO FIORELLO. CONFESSIONS OF AN
ARTIST. A SERIES FOR 1984.
[Self-published], North Hollywood, Calif. 1984.
Series of 12 postcards.
Offset lithograph. Printed on both sides.
Photographs by Joe Messinger.
[Edition of 500 copies].
6 x 4 inches each.
Postcards listed individually (in order sent):

a. #1 "THE POET CAVALIER".
#2 "THE ICON MAKER".
#3 "THE BLIND PROPHET".
#4 "THE MONK HERMIT".
#5 "THE TATTOOED ARTIST".
#6 "THE MIME PUPPETEER".
#7 "THE ITALIAN TENOR".
#8 "THE PARTISAN SCOUT".
#9 "THE LAUGHING BOOKIE".
#10 "THE HINDU PILGRIM".
#11 "THE DANCING GENIE".
#12 "THE SILVER MAGICIAN".

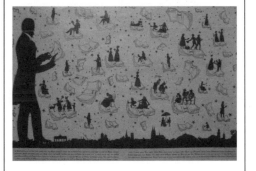

866.

"do as you likE" R.F.

870.

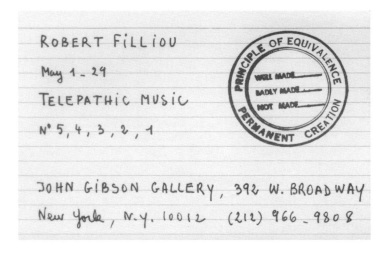

872.

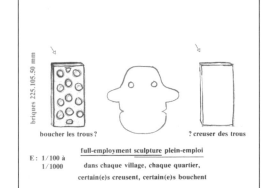

874.

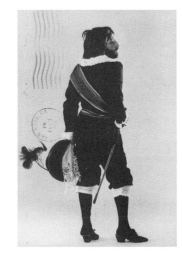

878.a

882.

886.

888.

890.

893.

879. JOEL FISHER
MARILENA BONOMO. FOTO DI JOEL FISHER.
JOEL FISHER. FOTO DI MARILENA BONOMO.
Galleria Marilena Bonomo, Bari, Italy. [1976].
2 announcement cards.
Offset lithograph. Printed on both sides.
4 x 6 inches each.

880. JOEL FISHER
FOTO: SALVATORE ALA BY JOEL FISHER.
FOTO: JOEL FISHER BY SALVATORE ALA.
Salvatore Ala, Milan, Italy. Opening March 17, 1976.
2 announcement cards in envelope.
Offset lithograph. Printed on both sides.
Announcement cards: 4 x 5.25 inches each.
Envelope: 4.75 x 6.75 inches.

881. JOEL FISHER
TILLY HADEREK. FOTO VON JOEL FISHER.
JOEL FISHER. FOTO VON TILLY HADEREK.
Tilly Haderek, Galerie 2, Stuttgart, Germany. [1976].
2 announcement cards.
Perforated. Offset lithograph.
Printed on both sides.
4 x 6 inches each. 8.25 x 6 inches overall.

882. JOEL FISHER
OLIVER DOWLING. Photograph by Joel Fisher.
JOEL FISHER. Photograph by Oliver Dowling.
Oliver Dowling Gallery, Dublin, Ireland. August 1977.
2 announcement cards.
Offset lithograph. Printed on both sides.
4 x 6.25 inches each.

883. JOEL FISHER
JAROSLAW KOZLOWSKI. FOTOGRAFIA:
JOEL FISHER. JOEL FISHER. FOTOGRAFIA:
JAROSLAW KOZLOWSKI.
Galeria Akumulatory 2 (SZSP), Poznan, Poland.
1977.
2 announcement cards.
Offset lithograph. Printed on both sides.
3.75 x 8.75 inches each.

884. JOEL FISHER
LIA RUMMA. Photograph by JOEL FISHER. JOEL
FISHER. Photograph by LIA RUMMA.
Lia Rumma, Naples, Italy. [1977].
2 announcement cards.
Perforated. Offset lithograph.
Printed on both sides.
3.75 x 6 inches each. 7.5 x 6 inches overall.

885. JOEL FISHER
K.J. GEIRLANDT. Foto door Joel Fisher. JOEL
FISHER. Photo par K.J. Geirlandt.
Société des Expositions du Palais des Beaux-
Arts, Brussels, Belgium. [1977].
2 announcement cards.
Offset lithograph. Printed on both sides.
4 x 5.75 inches each.

886. JOEL FISHER
MATT E. MULSION. PHOTOGRAPH BY JOEL
FISHER. JOEL FISHER. PHOTOGRAPH BY ROBIN
KLASSNIK. INSTALLATION BY JOEL FISHER.
Matt's Gallery, London, England.
November 19–25, 1979.
2 announcement cards.
Offset lithograph. Printed on both sides.
4 x 5.75 inches each.

886.1. ROBIN FLETCHER
See Nice Style.

887. SYLVIE FLEURY
SYLVIE FLEURY.
Postmasters Gallery, New York, N.Y.
February 21–March 21, [1992].
Announcement card.
Offset lithograph. Printed on both sides.
4 x 6 inches.

888. SYLVIE FLEURY
Hervé Mikaeloff présente: SYLVIE FLEURY
"VITAL PERFECTION".
Hervé Mikaeloff, Paris, France.
Opening January 21, 1993.
Announcement.
Offset lithograph.
5.75 x 8.25 inches.
Reference: Fleury, p. 44.

889. SYLVIE FLEURY
SYLVIE FLEURY. is your makeup crashproof?
Postmasters Gallery, New York, N.Y.
November 22–December 20, [1997].
Announcement card.
Offset lithograph. Printed on both sides.
4 x 6 inches.

890. SYLVIE FLEURY
Hot HeeLs. sylvie fleury.
Migros Museum, Museum für Gegenwartskunst,
Zurich, Switzerland.
November 7, 1998–January 10, 1999.
Announcement card.
Offset lithograph. Printed on both sides.
8.25 x 5.75 inches.

891. SYLVIE FLEURY
Sylvie Fleury.
Ace Contemporary Exhibitions, Los Angeles,
Calif. Opening March 11, 1999.
Announcement card.
Offset lithograph?
4.75 x 3.5 inches.

892. SYLVIE FLEURY
SYLVIE FLEURY.
Art & Public, Geneva, Switzerland.
September 23–October 30, 1999.
Announcement card.
Offset lithograph. Printed on both sides.
5.75 x 4 inches.

893. FLUXUS
fluxus Vaudeville TouRnamEnt No. 6 (Fluxus
Newspaper No. 6).
Fluxus, [New York, N.Y.]. July 1965.
Artists' periodical.
Newspaper format. Offset lithograph.
[Editor: G. Maciunas].
Unpaginated. 4 pages.
22 x 17 inches.
References: Fluxus Etc., pp. 256–58; Fluxus
Codex, p. 97.

894. FLUXUS
FLUXORCHESTRA CIRCULAR LETTER NO. 2.
[Fluxus, New York, N.Y.]. [1965].
Newsletter.
Offset lithograph.
11 x 8.5 inches.
Reference: Fluxus Etc. Addenda I, p. 160.

895. FLUXUS
CONDITIONS FOR PERFORMING FLUXUS
PUBLISHED COMPOSITIONS, FILMS & TAPES.
[Fluxus, New York, N.Y.]. [1965c].
Newsletter.
Offset lithograph.
14 x 8.5 inches.
Reference: Fluxus Etc. Addenda I, p. 158.

896. FLUXUS
HI RED CENTER.
[Fluxus, New York, N.Y.]. 1965.
Poster.
Offset lithograph. Printed on both sides.
Designed by George Maciunas.
Edited by Shigeko Kubota.
22 x 17 inches.
References: Fluxus Codex, p. 266; Fluxus Etc.,
p. 119; Fluxus Etc. Addenda I, p. 49.

897. FLUXUS
FLUXSHOPNEWS.
[Fluxus, New York, N.Y.]. [Late 1960s].
Price list.
Offset lithograph.
Designed by George Maciunas.
8.5 x 8.5 inches.
Reference: Fluxus Etc., p. 279.

898. FLUXUS
FLUX-MASS, FLUX-SPORTS AND FLUX-SHOW.
[Fluxus, New York, N.Y.]. February 16–20, 1970.
Poster/program.
Offset lithograph.
Designed by George Maciunas.
23 x 17.5 inches.
Reference: Fluxus Etc., p. 349.

899. FLUXUS
FLUX FEST KIT 2.
[Fluxus, New York, N.Y.]. [1970c].
Poster.
Offset lithograph. Printed on both sides.
Designed by George Maciunas.
22 x 17 inches.
References: Fluxus Etc., p. 285; Fluxus Codex,
pp. 57–58.

900. FLUXUS
FLUX GAME FEST. MAY 19, 20, 26, 27.
[Fluxus, New York, N.Y.]. [1973].
Flyer.
Offset lithograph.
Designed by George Maciunas.
8.5 x 11 inches.
Reference: Fluxus Etc., p. 355.

901. FLUXUS
FLUXFEST AT HIPPODROME. NAM JUNE PAIK.
FLUXSONATA 4. AT 80 WOOSTER ST.
[Fluxus, New York, N.Y.]. [1975].
Flyer.
Offset lithograph.
Designed by George Maciunas.
11 x 8.5 inches.
Reference: Fluxus Etc. Addenda I, pp. 130, 133.

902. FLUXUS
FREE FLUX-TOURS.
[Fluxus, New York, N.Y.]. May 1–6, [1976].
Flyer.
Offset lithograph.
Designed by George Maciunas.
12.25 x 9 inches.
Reference: Fluxus Etc., p. 356.

903. FLUXUS
20 FLUXFILMS AT ANTHOLOGY FILM ARCHIVES.
[Fluxus, New York, N.Y.]. April 5, [1977].
Flyer.
Offset lithograph.
Designed by George Maciunas.
11 x 8.5 inches.
Reference: Fluxus Etc. Addenda I, pp. 134, 136.

904. LLYN FOULKES
LLYN FOULKES.
Rolf Nelson Gallery, Los Angeles, Calif.
October 20–November 14, 1964.
Announcement card and reproduction.
Folded. Offset lithograph.
Card folded: 4.5 x 6 inches. Card unfolded: 9 x 6
inches. Reproduction folded: 5.75 x 4.5 inches.
Reproduction unfolded: 5.75 x 8.75 inches.

905. LLYN FOULKES
LLYN FOULKES.
David Stuart Galleries, Los Angeles, Calif.
Opening November 4, 1969.
Poster.
Folded. Offset lithograph.
Unfolded: 12.75 x 9 inches.

906. LLYN FOULKES
IT'S A GREAT SHOW.
Santa Barbara Contemporary Arts Forum, Santa
Barbara, Calif. Opening January 25, [1985].
Announcement card.
Offset lithograph. Printed on both sides.
8 x 8 inches.

907. HOWARD FRIED
ALLMYDIRTYBLUECLOTHES. HOWARD FRIED.
Reese Palley, San Francisco, Calif.
June 16–July 11, 1970.
Poster.
Folded. Offset lithograph.
Unfolded: 29.5 x 35 inches.
References: Performance Anthology, pp. 17–19;
Space/Time/Sound, pp. 68–69, 134–35; Out of
Actions, pp. 112, 114.

908. HOWARD FRIED
HOWARDFRIEDSYNCHROMATICBASEBALL,
16ROSEST.SANFRANCISCO,
PHOTOSLARRYFOX, VIDIOGEORGEBOLLING.
De Saisset Art Gallery, Santa Clara, Calif.
February 3–27, 1972.
Announcement card.
Folded. Offset lithograph. Printed on both sides.
Folded: 9 x 11.75 inches.
Unfolded: 9 x 23.5 inches.
References: Performance Anthology, pp. 52, 54;
Space/Time/Sound, pp. 69, 70; Out of Actions, p. 113.

909. HOWARD FRIED
FKUPURDUE. FK U WARD. HOWARD FRIED.
Reese Palley, San Francisco, Calif.
March 11–April 8, 1972.
Announcement card.
Folded. Offset lithograph. Printed on both sides.
Photographs by Larry Fox.
Unfolded: 10 x 12 inches.
References: Performance Anthology, pp. 37, 40,
65; Space/Time/Sound, p. 143.

910. HOWARD FRIED
HOWARDFRIED.
Nova Scotia College of Art and Design, Halifax,
Nova Scotia, Canada. October 23–31, 1972.
Announcement card.
Offset lithograph. Printed on both sides.
11 x 8.5 inches.

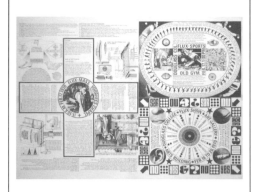

898.

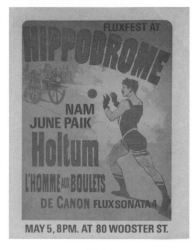

901.

905.

906.

908.

909.

O-ONA-GAZHEE (Oglala Sioux). Sheltering place, an elevated plateau in the Badlands of South Dakota, with precipitous sides, and inaccessible save by one narrow neck of land easily defended.

912.

917.

922.

SALMON LEAPING UPSTREAM

923.

STARS

ROCKS

TWO COASTAL WALKS FROM LANDS END TO NEWLYN
ONE BY NIGHT AND ONE BY DAY
CORNWALL JANUARY 1981

924.

911. HAMISH FULTON
MAGPIE! HAMISH FULTON.
Konrad Fischer, Düsseldorf, Germany.
April 23–May 12, 1971. Announcement card.
Offset lithograph. Printed on both sides.
4 x 8.25 inches.
Reference: Fischer, p. 63.

912. HAMISH FULTON
O-ONA-GAZHEE (Oglala Sioux). Sheltering place,
an elevated plateau in the Badlands of South
Dakota, with precipitous sides, and inaccessible
save by one narrow neck of land easily defended.
Situation, London, England. June 3–30, 1971.
Announcement card.
Offset lithograph. 3 rubber stamps on the verso.
4 x 7.5 inches.

913. HAMISH FULTON
PORRIDGE, BACON AND EGGS, TOAST AND A
POT OF HOT TEA. HAMISH FULTON.
Konrad Fischer, Düsseldorf, Germany. June 1972.
Announcement card.
Offset lithograph. Printed on both sides.
3.5 x 5.5 inches.

914. HAMISH FULTON
HAMISH FULTON.
Yvon Lambert, Paris, France.
Opening September 13, 1972.
Announcement card.
Offset lithograph. Printed on both sides.
4.25 x 6 inches.

915. HAMISH FULTON
MANKINHOLES - ON THE PENNINE WAY.
HAMISH FULTON.
Galleria Toselli, Milan, Italy.
Opening November 27, 1973.
Announcement card.
Folded. Offset lithograph. Printed on both sides.
Folded: 5.5 x 6.5 inches.

916. HAMISH FULTON
HAMISH FULTON.
Yvon Lambert, Paris, France.
Opening December 5, 1973.
Announcement card.
Offset lithograph. Printed on both sides.
7.5 x 5.75 inches.

917. HAMISH FULTON
HAMISH FULTON.
Robert Self Ltd., London, England. [1975?].
Announcement card/photographic postcard.
Offset lithograph.
4 x 6 inches.

918. HAMISH FULTON
HAMISH FULTON.
The Claire Copley Gallery, Inc., Los Angeles,
Calif. Opening September 11, 1976.
Announcement card.
Offset lithograph. Printed on both sides.
3 x 5.75 inches.

919. HAMISH FULTON
HAMISH FULTON. ALBERTA 1976.
Rolf Preisig, Basel, Switzerland.
January 11–February 6, 1977.
Announcement card.
Offset lithograph. Printed on both sides.
5.75 x 4.25 inches.

920. HAMISH FULTON
THE DOVER ROAD. A TWO AND A HALF DAY
WALK FROM LONDON BRIDGE TO DOVER.
EARLY 1977.
City of Canterbury Museum, Kent, England.
May 2–28, 1977.
Announcement card.
Offset lithograph. Printed on both sides.
7.25 x 4.75 inches.

921. HAMISH FULTON
ALASKA AUTUMN 1977. HAMISH FULTON.
Konrad Fischer, Düsseldorf, Germany.
February 4–28, 1978.
Announcement card.
Offset lithograph. Printed on both sides.
3.75 x 5.75 inches.

922. HAMISH FULTON
HAMISH FULTON.
Rolf Preisig, Basel, Switzerland. May 8–June 2, 1979.
Announcement card.
Offset lithograph. Printed on both sides.
7.75 x 3.75 inches.

923. HAMISH FULTON
SALMON LEAPING UPSTREAM. HAMISH FULTON.
Graeme Murray Gallery, Edinburgh, Scotland.
August 22–September 20, 1980.
Announcement card.
Offset lithograph. Printed on both sides.
4 x 5.75 inches.

924. HAMISH FULTON
STARS ROCKS. TWO COASTAL WALKS FROM
LANDS END TO NEWLYN. ONE BY NIGHT AND
ONE BY DAY. CORNWALL JANUARY 1981.
HAMISH FULTON.
Waddington Galleries Ltd, London, England.
April 28–May 22, 1982.
Announcement card.
Offset lithograph. Printed on both sides.
4 x 6 inches.

925. HAMISH FULTON
DONEGAL HORIZON. A WALK FROM THE
TOWN OF GALWAY TO THE TOWN OF DERRY.
IRELAND JULY 8-16 1981. HAMISH FULTON.
Orchard Gallery, Londonderry, Ireland.
Opening May 21, [1982].
Announcement card.
Offset lithograph. Printed on both sides.
4 x 6 inches.

926. HAMISH FULTON
HAMISH FULTON. A SEVENTEEN DAY WALK IN
THE ROCKY MOUNTAINS OF ALBERTA.
AUTUMN 1984.
John Weber Gallery, New York, N.Y.
November 2–23, 1985.
Announcement card.
Accordion folded. Offset lithograph.
Printed on both sides.
Folded: 6.25 x 5 inches.
Unfolded: 6.25 x 20 inches.

927. HAMISH FULTON
HAMISH FULTON.
Gillespie Laage Salomon, Paris, France.
September 13–October 15, 1986.
Announcement card.
Folded. Offset lithograph. Printed on both sides.
Folded: 6 x 4 inches. Unfolded: 6 x 8.25 inches.

928. HAMISH FULTON
ONE CROW TWO CROWS. A FIFTEEN DAY
WALKING JOURNEY IN LAPPLAND.
OCTOBER 1985. Hamish Fulton.
John Weber Gallery, New York, N.Y.
November 7–28, 1987.
Announcement card.
Offset lithograph. Printed on both sides.
4 x 6 inches.

**929. HAMISH FULTON. TWENTY ONE WALKS
TWENTY ONE YEARS 1969 - 1989.**
Victoria Miro Gallery, London, England.
October 25–November 30, 1989.
Announcement card.
Folded. Offset lithograph. Printed on both sides.
Folded: 8.25 x 5.75 inches.

930. HAMISH FULTON
HAMISH FULTON. TWENTY ONE WALKS
WALKING FROM ONE TO TWENTY ONE DAYS.
Tyler Gallery, Tyler School of Art, Temple
University, Elkins Park, Penn.
November 18–December 18, 1989.
Poster.
Folded. Offset lithograph.
Unfolded: 23.5 x 34.5 inches

931. HAMISH FULTON
HAMISH FULTON. A WALK TO THE SUMMIT OF
PICO DE ORIZABA MEXICO NOVEMBER 1979.
ONE NIGHT BIVOUAC ON THE CRATER RIM. A
WALK TO THE SUMMIT OF POPOCATEPETL
MEXICO JANUARY 1990. ONE NIGHT BIVOUAC
ON THE CRATER RIM.
John Weber Gallery, New York, N.Y.
April 28–May 19, 1990.
Poster.
Folded. Offset lithograph.
Unfolded: 18 x 24 inches.

932. HAMISH FULTON
HAMISH FULTON. ONLY ART RESULTING FROM
THE EXPERIENCE OF INDIVIDUAL WALKS.
Annely Juda Fine Art, London, England.
January 28–March 6, 1993.
Announcement card.
Accordion folded. Offset lithograph.
Printed on both sides.
Folded: 5.75 x 8 inches.
Unfolded: 5.75 x 31.75 inches.

933. HAMISH FULTON
A 21 DAY WANDERING WALK 20 NIGHTS CAMPING
IN THE BEARTOOTH MOUNTAINS OF MONTANA
U.S.A. ENDING WITH THE SEPTEMBER FULL
MOON 1997. HAMISH FULTON.
Gallery Koyanagi, Tokyo, Japan.
June 8–27, 1998.
Announcement card.
Offset lithograph. Printed on both sides.
5.75 x 8.25 inches.

934. HAMISH FULTON
DOOR ROAD. Hamish Fulton. Walking Artist.
Annely Juda Fine Art, London, England.
October 30–December 18, 1998.
Announcement card.
Offset lithograph. Printed on both sides.
5.75 x 8.25 inches.

934.1. HAMISH FULTON
See also Art & Project/Hamish Fulton.

**935. GENERAL IDEA (A. A. BRONSON/
FELIX PARTZ/JORGE ZONTAL)**
General Idea's Going Thru the Motions.
Self-published. 1975.
Poster.
Folded. Silkscreen. 1 rubber stamp on the verso.
Unfolded: 49 x 32.5 inches.
Reference: General Idea, No. 36.

936. JOCHEN GERZ
IS THERE LIFE ON EARTH?
Éditions Agentzia, Paris, France. 1969.
Mylar sleeve.
Offset lithograph.
11 x 8.75 inches.

937. JOCHEN GERZ
L'ART EST UN AVENTURE FICHUE.
JOCHEN GERZ. 14.4.1970.
[Self-published]. 1970.
Card.
Offset lithograph.
7.75 x 7.75 inches.

938. JOCHEN GERZ
Phone-Book of Paris.
Self-published, Paris, France. [1970c].
Flyer.
Offset lithograph.
11.75 x 8.25 inches.
Reference: Poinsot.

939. JOCHEN GERZ
vorher. nachher. vom 9. bis zum 23.
November in der Kunsthalle Basel.
[Self-published?]. N.d.
Card.
Offset lithograph?
4 x 5.25 inches.

940. JOCHEN GERZ
DEN MEDIEN DEN RUECKEN KEHREN.
Jochen Gerz. between november 9th and 23rd
at the Kunsthalle of Basle.
[Self-published?]. N.d.
Card.
Offset lithograph and rubber stamp.
4 x 5.25 inches.

941. JOCHEN GERZ
326.
[Self-published]. N.d.
Card.
Offset lithograph.
4 x 5.75 inches.
Reference: Gerz, pp. 32–33.

942. JOCHEN GERZ
In the bourgeois society authenticity probably
consists for an artist in being unauthentic and to
say so. Du 4 avril 1940 au. Jochen Gerz.
[Self-published]. N.d.
Card.
Offset lithograph.
4 x 5.5 inches.

943. JOCHEN GERZ
Mr. Li Hô is dead. Mr. Cavalcanti is dead. Mr. da
Vinci is dead. Mr. Tatlin is dead. Thank you. Du 4
avril 1940 au. Jochen Gerz.
[Self-published]. N.d.
Card.
Offset lithograph.
4 x 5.5 inches.

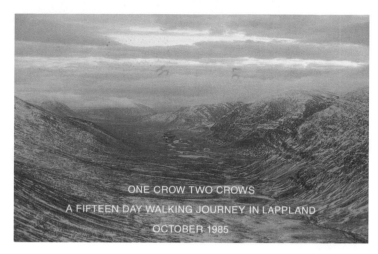

928.

931.

935.

938.

940.

CE SOIR A 23 HEURES 45 ENTRE LA PORTE DE CLIGNANCOURT ET LA RUE D'ALÉSIA 1 MILLION DE PARISIENS FONT L'AMOUR CHEZ EUX. VOUS ÊTES INVITÉS A PARTICIPER AU SPECTACLE.

AGENTZIA

1979 - Elsa-Maria på Ribersborgstranden.

947. **950.**

953.

954. **956.**

944. JOCHEN GERZ
J'ai vu quelqu'un faire un geste pour son propre plaisir. (Il n'y aura pas d'exposition). Du 4 avril 1940 au. Jochen Gerz.
[Self-published]. N.d.
Card.
Offset lithograph.
4 x 5.5 inches.

945. JOCHEN GERZ
Please think on. Du 4 avril 1940 au. Jochen Gerz.
[Self-published]. N.d.
Card.
Offset lithograph.
4 x 5.5 inches.

946. JOCHEN GERZ
Art is a convention. Du 4 avril 1940 au. Jochen Gerz.
[Self-published]. N.d.
Card.
Offset lithograph.
4 x 5.5 inches.

947. JOCHEN GERZ
CE SOIR A 23 HEURES 45 ENTRE LA PORTE DE CLIGNANCOURT ET LA RUE D'ALÉSIA 1 MILLION DE PARISIENS FONT L'AMOUR CHEZ EUX. VOUS ÊTES INVITÉS A PARTICIPER AU SPECTACLE.
Agentzia. N.d.
Card.
Offset lithograph.
5.25 x 8.25 inches.

948. JOCHEN GERZ
SINCE THE NOTION OF THE SPECTACULAR TENDS TO SUBSTITUTE ITSELF FOR INFORMATION, I TRY TO LINK THE PERCEPTION OF A PROPOSED PROCESS AS CLOSELY TO THE PROCESS ITSELF [. . .].
[Self-published?]. N.d.
Flyer.
Offset lithograph?
8.25 x 10.5 inches.

949. JOCHEN GERZ
A certain number of papers will be exposed to the free air and thus be subjected to the process of ATMOSPHERICAL PRINTS [. . .].
[Self-published]. N.d.
Flyer.
Offset lithograph?
11.75 x 9.25 inches.

950. PAUL-ARMAND GETTE
1979 - Elsa-Maria på Ribersborgstranden. PAUL-ARMAND GETTE.
Malmö Konsthall, Malmö, Sweden.
February 16–March 9, 1980.
Announcement card.
Offset lithograph. Printed on both sides.
5.75 x 4.25 inches.

951. PAUL-ARMAND GETTE
PAUL-ARMAND GETTE. METAPHORES ET PAYSAGE OU DE L'EFFUSION À LA BAIE DES ANGES.
Galerie Pierre Bernard, Nice, France.
June 20–July 28, 1990.
Announcement.
Offset lithograph. Printed on both sides.
8 x 10.25 inches.

952. PAUL-ARMAND GETTE
E.A. 9. Paul-Armand Gette.
Epreuve d'Artiste, Lille, France.
January 18–February 28, 1991.
Announcement card.
Offset lithograph. Printed on both sides.
3.75 x 7.75 inches.

953. PAUL-ARMAND GETTE
SPECIMEN. No O.
Eter, [Malmö, Sweden?]. 1992.
Artist's periodical.
Photocopy. Unpaginated. 8 pages.
5.75 x 4.25 inches.
Reference: Gette, No. 0.34.

954. PAUL-ARMAND GETTE
SPECIMEN [No. 2]. manuel et confidentiel.
Eter, [Malmö, Sweden?]. 1992.
Artist's periodical.
Photocopy. Unpaginated. 8 pages.
5.75 x 4.25 inches.
Reference: Gette, No. 0.35.

955. PAUL-ARMAND GETTE
SPECIMEN. NO 3.
Eter, [Malmö, Sweden?]. 1992.
Artist's periodical.
Photocopy. Unpaginated. 8 pages.
5.75 x 4.25 inches.
Reference: Gette, No. 0.36.

956. PAUL-ARMAND GETTE
Buddlea variabilis Hems. - Erigeron canadensis L. 47 avenue Pasteur, Montreuil-sous-Bois 1992.
[Self-published]. 1992?
Flyer.
Photocopy. 1 rubber stamp.
11.75 x 8.25 inches.

957. PAUL-ARMAND GETTE
Paul-Armand Gette. La vue et le toucher et De l'écume à la dentelle.
Musée des Beaux-Arts et de la Dentelle, Calais, France. January 16–March 28, 1993.
Announcement card.
Offset lithograph. Printed on both sides.
6 x 8.25 inches.

958. PAUL-ARMAND GETTE
PROMENADE POUR UNE NAÏADE. PAUL ARMAND GETTE.
Champclause D 422, Champclause, France.
April 2–12, [1993].
Announcement card.
Offset lithograph. Printed on both sides.
8.25 x 11.75 inches.

959. PAUL-ARMAND GETTE
Paul-Armand Gette.
Portikus, Frankfurt am Main, Germany.
July 3–August 8, 1993.
Announcement card.
Offset lithograph. Printed on both sides.
4 x 5.75 inches.

960. PAUL-ARMAND GETTE
Mont Mézenc - 1753 m.
Champclause D 422, Champclause, France.
August 12, 1993.
Announcement card.
Offset lithograph. Printed on both sides.
4.25 x 6 inches.

961. PAUL-ARMAND GETTE
PAUL-ARMAND GETTE. Stickerein und Spitzen.
Textil Museum, St. Gallen, Switzerland.
September 27, 1993–January 7, 1994.
Announcement card.
Offset lithograph. Printed on both sides.
1 rubber stamp.
4.25 x 5.75 inches.

962. PAUL-ARMAND GETTE
PROPOSITIONS PAYSAGÈRES. OU LES
DIVERTISSEMENTS DE PAUL-ARMAND GETTE
EN PROVENCE.
Crestet Centre d'Art, Vaison la Romaine, France.
July 3–September 3, 1994
Announcement card
Offset lithograph. Printed on both sides.
6 x 8.25 inches.

963. PAUL-ARMAND GETTE
Paul-Armand Gette. Exotisch - Erotisch -
Erratisch.
Podewil Kunst im Foyer, Berlin, Germany.
March 11–April 5, 1995.
Announcement card.
Offset lithograph. Printed on both sides.
4 x 5.75 inches.

964. PAUL-ARMAND GETTE
A l'occasion de l'ouverture de la heart galerie et
de l'exposition Paul-Armand Gette TECHNIKART
vous invite à venir fêter le printemps, les filles, les
garçons, les fleurs, les coeurs [. . .].
Shéhérazade, Paris, France. Heart Galerie, Paris,
France. May 5, 1995.
Announcement card.
Offset lithograph.
7.75 x 4.25 inches.

965. PAUL-ARMAND GETTE
PAUL-ARMAND GETTE. 7 pièces 1980-1995.
Heart Galerie, Paris, France. May 9–June 10,
1995.
Announcement card.
Offset lithograph.
8.25 x 5.75 inches.

966. PAUL-ARMAND GETTE
Paul-Armand Gette. "Suite printanière: l'intime".
Appartement d'Artésia, Paris, France. [Heart
Galerie, Paris, France.] May 23, 1995.
Announcement card.
Offset lithograph.
5.25 x 7.75 inches.

967. PAUL-ARMAND GETTE
PAUL-ARMAND GETTE. <<Sambucus,
Rubus und die Modelle>>.
Paszti-Bott Galerie, Cologne, Germany.
September 9–October 28, 1995.
Announcement card.
Offset lithograph. Printed on both sides.
4 x 5.75 inches.

968. PAUL-ARMAND GETTE
Paul-Armand Gette. SUCS ET FLAQUES.
Éditions Alain Buyse Lille, Lille, France. Heart
Galerie, Paris, France.
October 29–November 9, 1996.
Announcement card.
Offset lithograph. Printed on both sides.
4.25 x 6 inches.

969. PAUL-ARMAND GETTE
PAUL-ARMAND GETTE. "L'INTIMITÉ
VOLCANIQUE DE LA DÉESSE COUCHÉE."
Musée des Beaux-Arts de Fukuoka, Fukuoka,

969. (CONTINUED)
Japan. July 8–July 21, 1997.
Announcement card.
Folded. Offset lithograph. Printed on both sides.
Folded: 6 x 8.25 inches.

970. PAUL-ARMAND GETTE
Paul-Armand Gette / Sheela-Na-Gig.
Web Bar, Paris, France. October 20, 1997.
Announcement card.
Offset lithograph. Printed on both sides.
4.25 x 5.75 inches.

971. PAUL-ARMAND GETTE
PAUL-ARMAND GETTE. VARIATIONS SUR LES
NYMPHES ET UNE DEESSE COUCHEE JAPONAISE.
Galerie Aline Vidal, Paris, France.
November 6–December 20, 1997.
Announcement card.
Folded. Offset lithograph. Printed on both sides.
Includes an insert.
Card folded and insert: 6 x 4.25 inches each.

972. PAUL-ARMAND GETTE
Paul-Armand Gette. VULKANISMUS.
Büchsenhausen Ausstellungsraum, Innsbruck,
Austria. January 23–March 6, 1998.
Announcement card/brochure.
Folded. Offset lithograph. Printed on both sides.
Includes an insert.
Card folded and insert: 11.75 x 8.25 inches each.
Unfolded: 11.75 x 24.5 inches.

973. PAUL-ARMAND GETTE
LE VOYAGE IMMOBILE.
[Self-published]. 1999.
Flyer.
Photocopy. 1 rubber stamp.
11.75 x 8.25 inches.

974. GILBERT & GEORGE
Gilbert and George and David dined at 8 o'clock
on Wednesday 14th of May 1969.
Self-published. May 14, 1969.
Menu/program.
Folded. Offset lithograph and food stains.
Signed.
Unfolded: 9.75 x 7.75 inches.
Note: Menu/program for the performance "The Meal."

975. GILBERT & GEORGE
THE MEAL. Isabella Beeton and Doreen Marriott will
cook a meal for the two sculptors Gilbert and George
and their guest Mr. David Hockney, the painter [. . .].
Antony Mathews? May 14, 1969.
Invitation.
Folded. Offset lithograph. Burned and distressed.
Unfolded: 8 x 8 inches.

976. GILBERT & GEORGE
Anniversary. 'UNDERNEATH THE ARCHES'
(The most fascinating, realistic, beautiful, dusty
and serious art piece you have ever seen).
"Art for All," London, England. October 26, [1969].
Flyer/invitation.
Folded. Offset lithograph. 1 rubber stamp
with red ink additions.
Unfolded: 7.75 x 9.75 inches.

977. GILBERT & GEORGE
[ALL MY LIFE].
"Art for All," London, England. 1969.
Card/"postal sculpture."
Offset lithograph and embossed.
4.25 x 6 inches.
References: Gilbert & George (Violette), p. 13;
Gilbert & George (Jahn), pp. 18, 490.

962.

966.

967.

972.

975.

977.

978.

979.

980.

986.

995.

978. GILBERT & GEORGE
[NEW DECADENT ART].
"Art for All," London, England. [1969/70].
Print/"postal sculpture" in distressed/smoked
envelope.
Folded. Offset lithograph.
Signed.
Unfolded: 8 x 6.75 inches. Envelope: 4.5 x 7 inches.
References: Gilbert & George (Violette), p. 13;
Gilbert & George (Jahn), pp. 86, 490.

979. GILBERT & GEORGE
[THE LIMERICKS].
Art for All, London, England. March–May 1971.
Series of 8 greeting cards/"postal sculpture" in
envelope.
Offset lithograph. Printed on both sides.
Each card is signed.
Cards: 8 x 5 inches each. Envelope: 6 x 9 inches.
Greeting cards listed individually (in order sent):

Lost Day. 11th March 1971.
Shyness. 29th March 1971.
Experience. 2nd April 1971.
Worldliness. 13th April 1971.
Idiot Ambition. 24th April 1971.
Normal Boredom. 1st May 1971.
Manliness. 15th May 1971.
Artist's Culture. 19th May 1971.
Reference: Gilbert & George (Violette), pp. 32–34.

980. GILBERT & GEORGE
1st POST CARD.
Art for All, London, England. Spring 1972.
Postcard/"postal sculpture."
Offset lithograph. Printed on both sides.
Signed.
5.5 x 3.5 inches.
Reference: Gilbert & George (Jahn), pp. 115, 490.

981. GILBERT & GEORGE
2nd POST CARD.
Art for All, London, England. Spring 1972.
Postcard/ "postal sculpture."
Offset lithograph. Printed on both sides.
Signed.
3.5 x 5.5 inches.
Reference: Gilbert & George (Jahn), pp. 115, 490.

982. GILBERT & GEORGE
GILBERT and GEORGE in 'UNDERNEATH THE
ARCHES'. The most beautiful sculpture in the
whole world 1968-1970.
"Art for All," London, England. N.d.
Card.
Folded. Offset lithograph.
Signed.
Folded: 4 x 5 inches.

982.1. GILBERT & GEORGE
See also Art & Project/Gilbert & George.

983. DAVID GILHOOLY
HERE COMES TROUBLE! new imports from
Canada, DAVID GILHOOLY, new egyptian museum
(nonsectarian), all new knick-knack section.
Candy Store Gallery of Adeliza McHugh, Folsom,
Calif. Opening May 16, [1971].
Announcement card.
Offset lithograph. Printed on both sides.
3.5 x 5.5 inches.

984. DAVID GILHOOLY
Candy Store Candygram. The Photographically
Elusive Adeliza McHugh.
Candy Store Art Gallery, Folsom, Calif.
November 12–December 11, [1977].
Flyer.
Folded. Photocopy.
Unfolded: 11 x 8.5 inches.

985. DAVID GILHOOLY
David Gilhooly.
Ruth S. Schaffner Gallery, Los Angeles, Calif.
December 15, [1977]–January [1978].
Announcement card.
Offset lithograph. Printed on both sides.
4.25 x 6 inches.

986. DAVID GILHOOLY
Big Garage Sale to benifit [*sic*] the IRS.
Self-published. 1981.
Flyer.
Folded. Photocopy.
Unfolded: 11 x 8.5 inches.

987. DAVID GILHOOLY
The Last of the Frogs. DAVID GILHOOLY.
This is not Art, Mendocino, Calif.
October 22–November 6, 1983.
Flyer.
Folded. Offset lithograph.
Unfolded: 8.5 x 5.75 inches.

988. FELIX GONZALEZ-TORRES*
DETAIL from: "Untitled" (Veterans Day Sale), 1989.
Offset print on paper.
Endless copies.
22 inches at ideal height x 29 x 23 inches.
Reference: Gonzalez-Torres, pp. 20–21, 224.

989. FELIX GONZALEZ-TORRES*
Detail from: "Untitled," 1989-90.
Offset print on paper.
Endless copies.
2 Parts: 26 inches at ideal height x 29 x 56 inches
overall. 26 x 29 x 23 inches each.
Reference: Gonzalez-Torres, pp. 82–83, 218.

990. FELIX GONZALEZ-TORRES*
Detail from: "Untitled", 1990.
Offset print on paper.
Endless copies.
28 inches at ideal height x 28.75 x 22.5 inches.
Reference: Gonzalez-Torres, pp. 97, 218.

991. FELIX GONZALEZ-TORRES*
Every week there is something different.
A four part project by Felix Gonzalez-Torres.
Andrea Rosen Gallery, New York, N.Y.
May 2–June 1, 1991.
Invitation.
Folded. Offset print on paper.
Unfolded: 11 x 8.5 inches.

992. FELIX GONZALEZ-TORRES*
Detail from: "Untitled" (Double Portrait), 1991.
Offset print on paper.
Endless copies.
10.25 inches at ideal height x 39.375 x
27.5 inches.
Reference: Gonzalez-Torres, pp. 70, 220.

*The catalogue descriptions for entries 988–993
are provided by Andrea Rosen Gallery, New York.

993. FELIX GONZALEZ-TORRES*
Felix Gonzalez-Torres.
Andrea Rosen Gallery, New York, N.Y.
April 24–May 29, 1993.
Invitation.
12 leaves. Offset print on paper.
11 x 8.5 inches each.

994. JOE GOODE
an exhibition of paintings by Joe Goode.
Rolf Nelson Gallery, Los Angeles, Calif.
March 8–30, [1963].
Poster.
Folded. Offset lithograph.
Unfolded: 14 x 12 inches.
Reference: Art in Los Angeles, p. 132.

995. RODNEY ALAN GREENBLAT
RODNEY DESIGN.
Gracie Mansion Gallery, New York, N.Y. 1985?
Announcement card.
Rubber stamp. Printed on both sides.
3.5 x 5.5 inches.

996. RODNEY ALAN GREENBLAT
RODNEY ALAN GREENBLAT. "House of Progress".
Gracie Mansion Gallery, New York, N.Y
October 30–November 23, 1986.
Announcement card.
Folded. Offset lithograph. Printed on both sides.
Folded: 4.5 x 6 inches. Unfolded: 9 x 6 inches.

997. RODNEY ALAN GREENBLAT
Cosmic Adhesive. Rodney A. Greenblat.
Gracie Mansion Gallery, New York, N.Y.
April 28–May 25, 1990.
Announcement card.
Folded. Offset lithograph. Printed on both sides.
Folded: 9 x 6 inches. Unfolded: 9 x 18 inches.

998. RODNEY ALAN GREENBLAT
SPRINGTIME IS THE RIGHT TIME To Visit THE
NEW GRACIE MANSION MUSEUM STORE.
Gracie Mansion Museum Store, New York, N.Y. N.d.
Announcement card.
Offset lithograph. Printed on both sides.
4.25 x 6.25 inches.

999. RED GROOMS
HAPPENINGS AT THE REUBEN GALLERY: ART
IN A NEW MEDIUM PRODUCED BEFORE A
SEATED AUDIENCE. FIREMAN'S DREAM - RED
GROOMS. THE BIG LAUGH - ALLAN KAPROW.
SMALL CANNON - ROBERT WHITMAN.
Reuben Gallery, New York, N.Y. [1960].
Poster.
Folded. Offset lithograph. Printed on both sides.
Unfolded: 17 x 12 inches.
References: Happening & Fluxus; Fröliche
Wissenschaft, p. 38.

1000. RED GROOMS
RED GROOMS. PROPS & ANIMATION FROM
FAT FEET.
Tibor de Nagy, [New York, N.Y.]. January 7–26,
[1967].
Poster.
Folded. Offset lithograph.
Unfolded: 24.5 x 18.5 inches.

1001. RED GROOMS
TIBOR DE NAGY PRESENTS RED GROOMS.
FEATURING EXTENSION PAINTINGS.
Tibor de Nagy Gallery, New York, N.Y. N.d.
Announcement card.
Folded. Offset lithograph with glitter additions.
Unfolded: 12.25 x 9.25 inches.

1002. RED GROOMS
RED GROOMS' DISCOUNT STORE. BENEFIT
FOR THE SPANISH REFUGEE AID.
John Bernard Myers Gallery, New York, N.Y. N.d.
Poster.
Folded. Offset lithograph.
Unfolded: 11.75 x 29 inches.

1002.1. KLAAS GUBBELS
See Café Schiller/Klaas Gubbels.

1003. GUERRILLA GIRLS
WOMEN IN AMERICA EARN ONLY 2/3 OF WHAT
MEN DO. WOMEN ARTISTS EARN ONLY 1/3 OF
WHAT MEN ARTISTS DO.
Self-published. [1985].
Poster.
Folded. Offset lithograph.
Unfolded: 17 x 22 inches.

1004. GUERRILLA GIRLS
THESE GALLERIES SHOW NO MORE THAN 10%
WOMEN ARTISTS OR NONE AT ALL.
Self-published. [1985].
Poster.
Folded. Offset lithograph.
Unfolded: 17 x 22 inches.

1005. GUERRILLA GIRLS
IT'S EVEN WORSE IN EUROPE.
Self-published, New York, N.Y. [1986].
Poster.
Folded. Offset lithograph.
Unfolded: 17 x 22 inches.

1006. GUERRILLA GIRLS
WHICH ART MAG WAS WORST FOR WOMEN
LAST YEAR?
Self-published, New York, N.Y. [1986].
Poster.
Folded. Offset lithograph.
Unfolded: 17 x 22 inches.

1007. GUERRILLA GIRLS
GUERRILLA GIRLS' 1986 REPORT CARD.
GUERRILLA GIRLS.
Self-published, New York, N.Y. 1986.
Poster.
Folded. Offset lithograph.
Unfolded: 22 x 17 inches.

1008. GUERRILLA GIRLS
WE SELL WHITE BREAD.
Self-published, New York, N.Y. [1988].
Poster.
Folded. Offset lithograph.
Unfolded: 13 x 22 inches.

1009. GUERRILLA GIRLS
THE ADVANTAGES OF BEING A WOMEN
ARTIST: [. . .].
Self-published, New York, N.Y. [1988].
Poster.
Folded. Offset lithograph.
Unfolded: 17 x 22 inches.

1010. GUERRILLA GIRLS
Q. HOW MANY WORKS BY WOMEN ARTISTS
WERE IN THE ANDY WARHOL* AND TREMAINE
AUCTIONS AT SOTHEBY'S?
Self-published, New York, N.Y. [1989].
Poster.
Folded. Offset lithograph.
Unfolded: 17 x 22 inches.

998.

999.

1001.

1002.

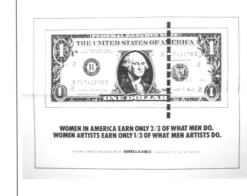

1003.

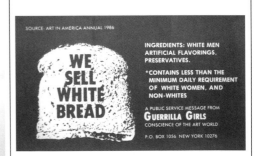

1008.

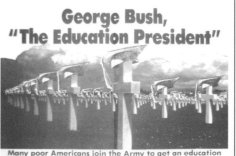

1012.

1015.

1019.

1020.

1021.

1024.

1011. GUERRILLA GIRLS
GUERRILLA GIRLS' IDENTITIES EXPOSED!
"We've signed up to fight discrimination in the art world. Call us Guerrilla Girls."
Self-published. [1990].
Poster.
Folded. Offset lithograph.
Unfolded: 17 x 22 inches.

1012. GUERRILLA GIRLS
George Bush, "The Education President". Many poor Americans join the Army to get an education and a better life. If Bush had a real policy for public education, who would fight his wars?
Self-published, New York, N.Y. [1991].
Poster.
Folded. Offset lithograph.
Unfolded: 17 x 22 inches.

1013. GUERRILLA GIRLS
Q. What's the difference between a prisoner of war and a homeless person? A. Under the Geneva Convention, a prisoner of war is entitled to food, shelter and medical care.
Self-published, New York, N.Y. [1991].
Poster.
Folded. Offset lithograph.
Unfolded: 22 x 17 inches.

1014. GUERRILLA GIRLS
GUERRILLA GIRLS EXPLAIN THE CONCEPT OF NATURAL LAW.
Self-published. [1993].
Poster.
Folded. Offset lithograph.
Unfolded: 11 x 16.75 inches.

1015. GUERRILLA GIRLS
HORMONE IMBALANCE. MELANIN DEFICIENCY.
Self-published, New York, N.Y. [1993].
Poster.
Folded. Offset lithograph.
Unfolded: 17 x 11 inches.

1016. GUERRILLA GIRLS
GUERRILLA GIRLS URGE DRASTIC N.E.A. CUTS!
Self-published, New York, N.Y. N.d.
Poster.
Folded. Offset lithograph.
Unfolded: 17 x 22 inches.

1016.1. STEVEN GWON
See Institute for Art and Urban Resources/ Steven Gwon.

1017. HANS HAACKE
HANS HAACKE.
Francoise Lambert, Milan, Italy.
Opening June 7, 1972.
Announcement card.
Offset lithograph. Printed on both sides.
4.75 x 7 inches.

1018. HANS HAACKE
Business could hold art exhibitions to tell its own story. William B. Renner, President, Alcoa.
Hans Haacke.
John Weber Gallery, New York, N.Y.
May 5–29, [1979].
Announcement card.
Offset lithograph.
3.75 x 8.5 inches.
Reference: Haacke (Unfinished Business), pp. 196–97.

1019. HANS HAACKE
Mobil Upstairs at. HANS HAACKE.
John Weber Gallery, New York, N.Y.
February 7–March 4, [1981].
Announcement card.
Offset lithograph.
6 x 4 inches.
Reference: Haacke (Unfinished Business), p. 241.

1020. HANS HAACKE
Hans Haacke.
John Weber Gallery, New York, N.Y.
April 30–May 21, 1983.
Announcement card.
Offset lithograph. Printed on both sides.
4 x 6 inches.

1021. HANS HAACKE
Many public relations opportunites are available through the sponsorship of programs, special exhibitions and services [. . .] Hans Haacke.
John Weber Gallery, New York, N.Y.
May 4–25, 1985.
Announcement card.
Offset lithograph. Printed on both sides.
5.75 x 8.5 inches.

1022. HANS HAACKE
HANS HAACKE: UNFINISHED BUSINESS.
Knight Gallery, Spirit Square Center for the Arts, Charlotte, N.C. January 15–February 27, 1988.
Announcement card.
Offset lithograph. Printed on both sides.
6.25 x 10.75 inches.

1023. HANS HAACKE
BUSINESS: AS USUAL. Hans Haacke.
John Weber Gallery, New York, N.Y.
April 9–30, 1988.
Announcement card.
Offset lithograph. Printed on both sides.
6.5 x 5.25 inches.

1024. HANS HAACKE
Helmsboro Country. HANS HAACKE.
John Weber Gallery, New York, N.Y.
March 31–April 22, 1990.
Announcement card.
Offset lithograph. Printed on both sides.
7 x 5 inches.

1025. HANS HAACKE
Hans Haacke. "The Vision Thing".
John Weber Gallery, New York, N.Y.
April 25–May 16, 1992.
Announcement card.
Offset lithograph. Printed on both sides.
7 x 5 inches.

1026. HANS HAACKE
les must de Rembrandt. Stellenbosch, Afrique du Sud. hans haacke.
Le Consortium, Centre d'Art Contemporain, Dijon, France. June 12–July 18, 1996.
Announcement card.
Folded. Offset lithograph and embossed.
Printed on both sides.
Folded: 8.25 x 6 inches.
Unfolded: 8.25 x 11.75 inches.

1027. KEITH HARING
KEITH HARING.
Fun Gallery, New York, N.Y.
February 3–27, 1983.
Poster.
Folded. Offset lithograph.
Unfolded: 29 x 23 inches.

1028. KEITH HARING
KEITH HARING. DRAWINGS.
121 Gallery, Antwerp, Belgium.
September 29–November 5, 1983.
Poster.
Folded. Offset lithograph.
Unfolded: 19.75 x 16.25 inches.

1029. KEITH HARING
KEITH HARING. DRAWINGS.
"121" Art Gallery, Antwerp, Belgium.
September 29–November 5, 1983.
Announcement card.
Offset lithograph. Printed on both sides.
4 x 5.75 inches

1030. KEITH HARING
GALERIE PAUL MAENZ INVITES YOU TO A
PARTY FOR: KEITH HARING NEW YORK. AT
THE COCONUT CLUB, COLOGNE.
Galerie Paul Maenz, Cologne, Germany.
Opening May 3, 1984.
Announcement.
Offset lithograph.
4 x 2.75 inches.

1031. KEITH HARING
KEITH HARING.
Paul Maenz, Cologne, Germany.
May 3–30, 1984.
Announcement card.
Folded. Offset lithograph. Printed on both sides.
Folded: 8.25 x 5.75 inches.
Unfolded: 8.25 x 11.5 inches.

1032. KEITH HARING
KEITH HARING.
Salvatore Ala, Milan, Italy.
Opening June 11, 1984.
Announcement card.
Offset lithograph. Printed on both sides.
4.25 x 6 inches.

1033. KEITH HARING
KEITH HARING.
Hammarskjold Plaza Sculpture Garden,
New York, N.Y. January 20–May 4, 1986.
Announcement card.
Offset lithograph. Printed on both sides.
4 x 9.25 inches.

1034. KEITH HARING
FROHE WEIHNACHTEN. HAPPY NEW YEAR!
1988. FROM HANS MAYER.
Hans Mayer. 1987.
Christmas card.
Folded. Offset lithograph.
Folded: 10.25 x 8 inches.
Unfolded: 10.25 x 16.25 inches.

1035. KEITH HARING
ISO RESTAURANT.
Iso Restaurant, New York, N.Y. N.d.
Chopstick sleeve.
Offset lithograph. Printed on both sides.
1.5 x 7.5 inches.

1036. GEORGE HERMS
GEORGE HERMS. Spring Visions.
Stryke Gallery, New York, N.Y.
March 26–April 15, 1965.
Poster.
Folded. Offset lithograph
Unfolded: 16 x 9 inches.

1037. GEORGE HERMS
THE TEMPLE OF MAN MAGIC
THEATRE BENEFIT.
Topanga Corral, Topanga, Calif.
May 28, 1967.
Flyer.
Offset lithograph?
11 x 8.5 inches.

1038. GEORGE HERMS
GEORGE HERMS HOLIDAY EXHIBITION
and SALE.
Molly Barnes Gallery, Los Angeles, Calif.
December 18, 1970–January 15, 1971.
Announcement card.
Offset lithograph. Printed on both sides.
11 x 8.5 inches.

1039. GEORGE HERMS
GEORGE HERMS EXHIBITION.
Nicholas Wilder Gallery, Los Angeles, Calif.
February 13–March 3, 1973.
Poster.
Folded. Offset lithograph.
Unfolded: 23.5 x 17.5 inches.

1040. GEORGE HERMS
STREAMING. a theatre piece by George Herms.
Pasadena Museum of Art, Pasadena, Calif.
September 23, 1973.
Announcement card.
Letterpress and woodblock.
5.5 x 8.5 inches.

1041. GEORGE HERMS
THE WORLD PREMIERE OF EXPLODING
THE CUBE and FRAGMENTIA PRAECOX by
GEORGE HERMS.
San Jose State University, Gallery 1, Art Building,
San Jose, Calif. February 1–28, 1975.
Announcement card.
Offset lithograph. Printed on both sides.
10 x 8 inches.

1042. GEORGE HERMS
For Members. The Museum of Contemporary Art,
Los Angeles, Calif. Fall 1984.
Museum newsletter.
Folded. Offset lithograph. Printed on both sides.
Folded: 11 x 8.5 inches.
Unfolded: 11 x 34 inches.

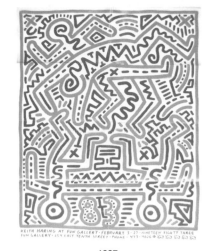

1027.

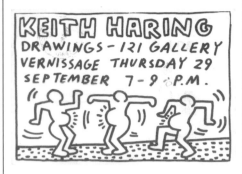

1029.

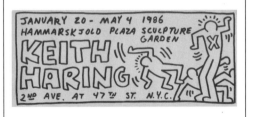

1033.

1038.

1040.

1041.

1043.

1045.

Camille's Reports #1

I'm back from Afghanistan in my new hat—sort of a Puritan gentleman's affair with one of the silver buckles on it that used to be on my shoes. Off and on I'll be doing the cards again—except now it's a newsletter. Usually.

I must be getting old, because I can remember way back to the early 1960's when, at the Judson Poets' Theatre, Florence Tarlow bounded and grinned, Mae West-like, to Al Carmine's music in Ruth Krauss's "This Breast." It was glorious, and looks it too in Ruth's *There's a little ambiguity over there among the bluebells.* Count the colors in the book, by the way. They're all made from blue and yellow, but because of tints and secondary reflectances they make ochres, blacks, even a brown at one point. Cloth, $3.95.

Technically, historically, it is said, Eugen Gomringer (a Bolivian Swiss living in Germany) is the papa of Concrete Poetry, and that his "Constellations" series is the beginning of the medium. Actually his *Book of the Hours and Constellations* is so gentle, so unpretentious that it's hard to realize one is reading a historic work. Seems too perfect for that. And hats off to Jerome Rothenberg for his selection and translation. Cloth, $4.50. Paper, $1.95.

What do Columbus, Melville, and Carl Mills (the kidnapper) have in common? Well, for one thing they're all in the sentence you just read. And they're all obsessional personalities—documented and reacted to—in Paul Metcalf's *GENOA*, published by Jargon and available through the SMALL PUBLISHERS COMPANY, 175 Park Avenue South, New York, N. Y. 10010. It's the most exciting big prose work I've come across, since, well, since Afghanistan.
CAMILLE GORDON

1046.

the something else
NEWSLETTER

Volume 1, Number 11 December, 1969 40¢

TOWARDS THE 1970's

by DICK HIGGINS

1055.

1043. GEORGE HERMS
GAYLYN & GEORGE ARE PROUD TO ANNOUNCE THE ARRIVAL OF GRAESON WILDER HERMS, FEBRUARY 4, 1985, 8 LBS., 15 OZ. AND ALREADY WILDER SMILES [. . .].
Self-published. 1985.
Flyer.
Photocopy.
11.75 x 8.5 inches.

1044. GEORGE HERMS
LIGHT SHOW. ELIAS ROMERO AND COMPANY.
The Topanga Corral. N.d.
Flyer.
Offset lithograph and woodblock.
11 x 8.5 inches.

1045. LYNN HERSHMAN
CHAIN REACTION. AN ENVIRONMENTAL "LIGHT" OPERA FOR FOG, FILM AND RECOMBINANT NEWS. ALICE TULLY HALL, LINCOLN CENTER.
[Self-published]. 1983.
Artist's publication/program.
Folded. Newspaper format.
Unpaginated. 4 pages.
15 x 11.75 inches.
Reference: Hershman, p. 126.

1046. DICK HIGGINS
Camille's Reports #1.
Something Else Press, Inc., New York, N.Y. [1965].
Postcard.
Offset lithograph. Printed on both sides.
3.25 x 5.5 inches.
Reference: Something Else Press, p. 80.

1047. DICK HIGGINS
the something else NEWSLETTER. Volume 1, Number 2.
Something Else Press, Inc., New York, N.Y. March 1966.
Newsletter.
Folded sheet. Offset lithograph. Printed on both sides.
Folded: 11 x 8.5 inches. Unfolded: 11 x 17 inches.
Reference: Something Else Press, p. 80.

1048. DICK HIGGINS
the something else NEWSLETTER. Volume 1, Number 3.
Something Else Press, Inc., New York, N.Y. April 1966.
Newsletter.
Folded sheet. Offset lithograph. Printed on both sides.
Folded: 11 x 8.5 inches. Unfolded: 11 x 17 inches.
Reference: Something Else Press, p. 80.

1049. DICK HIGGINS
the something else NEWSLETTER. Volume 1, Number 5.
Something Else Press, Inc., New York, N.Y. February 1967.
Newsletter.
Folded sheet. Offset lithograph. Printed on both sides.
Folded: 11 x 8.5 inches. Unfolded: 11 x 17 inches.
Reference: Something Else Press, p. 80.

1050. DICK HIGGINS
the something else NEWSLETTER. Volume 1, Number 6.
Something Else Press, Inc., New York, N.Y. May 1967.
Newsletter.
Folded sheet. Offset lithograph. Printed on both sides.
Folded: 11 x 8.5 inches. Unfolded: 11 x 17 inches.
Reference: Something Else Press, p. 80.

1051. DICK HIGGINS
the something else NEWSLETTER. Volume 1, Number 7.
Something Else Press, Inc., New York, N.Y. January 1968.
Newsletter.
Folded sheet. Offset lithograph. Printed on both sides.
Folded: 11 x 8.5 inches. Unfolded: 11 x 17 inches.
Reference: Something Else Press, p. 80.

1052. DICK HIGGINS
the something else NEWSLETTER. Volume 1, Number 8.
Something Else Press, Inc., New York, N.Y. April 1968.
Newsletter.
Folded sheet. Offset lithograph. Printed on both sides.
Folded: 11 x 8.5 inches. Unfolded: 11 x 25.25 inches.
Reference: Something Else Press, p. 80.

1053. DICK HIGGINS
the something else NEWSLETTER. Volume 1, Number 9.
Something Else Press, Inc., New York, N.Y. December 1968.
Newsletter.
Folded sheet. Offset lithograph. Printed on both sides.
Folded: 11 x 8.5 inches. Unfolded: 11 x 25.25 inches.
Reference: Something Else Press, p. 81.

1054. DICK HIGGINS
the something else NEWSLETTER. Volume 1, Number 10.
Something Else Press, Inc., New York, N.Y. November 1969.
Newsletter.
Folded sheet. Offset lithograph. Printed on both sides.
Folded: 11 x 8.5 inches. Unfolded: 11 x 17 inches.
Reference: Something Else Press, p. 81.

1055. DICK HIGGINS
the something else NEWSLETTER. Volume 1, Number 11.
Something Else Press, Inc., New York, N.Y. December 1969.
Newsletter.
Folded sheet. Offset lithograph. Printed on both sides.
Folded: 11 x 8.5 inches. Unfolded: 11 x 17 inches.
Reference: Something Else Press, p. 81.

1056. DICK HIGGINS
the something else NEWSLETTER. Volume 1, Number 12.
Something Else Press, Inc., New York, N.Y. February 1970.
Newsletter.
Folded sheet. Offset lithograph. Printed on both sides.
Folded: 11 x 8.5 inches. Unfolded: 11 x 17 inches.
Reference: Something Else Press, p. 81.

1057. DICK HIGGINS
SOME POETRY INTERMEDIA. BY DICK HIGGINS.
Unpublished Editions, New York, N.Y. 1976.
Poster.
Folded. Offset lithograph. Printed on both sides.
Unfolded: 22 x 17 inches.

1058. DICK HIGGINS
CONCRETE POETRY. THE EARLY YEARS.
Thomas J. Watson Library, The Metropolitan Museum of Art, New York, N.Y. July 1–31 and September 2–26, 1986.
Poster.
Folded. Offset lithograph. Printed on both sides.
Unfolded: 22.5 x 16.5 inches.

1059. DICK HIGGINS?
Friend: A group of us agreed that the artist/designer Dieter Roth was insufficiently appreciated. I said he deserved at least two pounds of gold compliments - and the enclosed cards are my way of manifesting this [. . .].
[Self-published?]. N.d.
3 cards.
Offset lithograph. Printed on both sides.
3.5 x 5.5 inches each.

1060. JENNY HOLZER
SYMBOLS ARE MORE MEANINGFUL THAN THINGS THEMSELVES [. . .].
N.p. [1977–79].
Poster. Offset lithograph on newsprint.
Printed on both sides.
Unfolded: 34 x 21.5 inches.

1061. JENNY HOLZER
THINGS ARE SO URGENT NOW THAT SUICIDE IS ALMOST OBSOLETE.
N.p. [1903–85].
Sticker.
Offset lithograph.
2.5 x 3 inches.

1062. JENNY HOLZER
ABUSE OF POWER COMES AS NO SURPRISE [. . .] JENNY HOLZER.
University Gallery, Fine Arts Center, University of Massachusetts at Amherst, Amherst, Mass.
September 15–October 26, 1984.
Poster.
Folded. Offset lithograph.
Unfolded: 22 x 14.75 inches.

1063. DAVI DET HOMPSON
Davi Det Hompson declares the following series of unauthorized occurrences at Apple, 161 West 23rd Street, New York, N.Y. 10011.
N.p. [1974?]
Flyer.
Offset lithograph.
11 x 8.5 inches.

1064. DAVI DET HOMPSON
She said, "I'm limping because a wrinkle in my sock gave me a nasty blister." POST SOCK NOTICE.
Self-published, Richmond, VA. 1981.
Flyer.
Offset lithograph.
14 x 8.25 inches.

1065. DAVI DET HOMPSON
For a moment, each post's shadow touched the base of the post beside it. POST SOCK NOTICE.
Self-published, Richmond, Va. 1981.
Flyer.
Offset lithograph.
14 x 8.25 inches.

1066. DAVI DET HOMPSON
Do you believe that I am different from you?... POST SOCK NOTICE.
Self-published, Richmond, Va. 1981.
Poster.
Folded. Offset lithograph.
Unfolded: 22 x 17 inches.

1067. TEHCHING HSIEH
STATEMENT.
[Self-published, New York, N.Y.]. April 1980.
Artist's statement.
Photocopy.
11 x 8.5 inches.

1068. TEHCHING HSIEH
STATEMENT.
[Self-published, New York, N.Y.]. September 1981.
Artist's statement.
Photocopy.
11 x 8.5 inches.

1069. TEHCHING HSIEH
STATEMENT.
[Self-published, New York, N.Y.]. July 1, 1985.
Artist's statement.
Folded. Photocopy.
Unfolded: 11 x 8.5 inches.

1070. TEHCHING HSIEH
ONE YEAR PERFORMANCE 1985-1986.
ORGANIZED by TEHCHING HSIEH.
PERFORMED by OTHER PEOPLE.
[Self-published, New York, N.Y.]. 1985.
Artist's statement and form letter.
Folded. Photocopy.
Unfolded: 11 x 8.5 inches each.

1071. TEHCHING HSIEH
STATEMENT.
[Self-published, New York, N.Y.]
December 31, 1986.
Artist's statement.
Folded. Offset lithograph?
Unfolded: 11 x 8.5 inches.

1072. TEHCHING HSIEH
Explanation of Procedure for Sam Hsieh's One Year Performance.
[Self-published, New York, N.Y.]. N.d.
Artist's statement.
Folded. Photocopy.
Unfolded: 11 x 8.5 inches.

1073. DOUGLAS HUEBLER
DOUGLAS HUEBLER.
Gian Enzo Sperone & Konrad Fischer, Rome, Italy. Opening March 21, 1973.
Announcement card.
Offset lithograph. Printed on both sides.
4.25 x 6 inches.

1073.1. DOUGLAS HUEBLER
See also Art & Project/Douglas Huebler.

1074. ROBERT HUOT
NO NUKES IS GOOD NUKES.
[Self-published]. [1979].
Metal button.
Offset lithograph.
Diameter: 3 inches.

1075. ROBERT HUOT
DOCTOR FAUSTUS' FOOT FETISH.
[Self-published]. [1981].
Matchbook.
Offset lithograph.
2 x 2 inches.

1076. ROBERT HUOT/CAROL KINNE
YOU ARE WHAT YOU EAT.
[Self-published]. [1978].
Matchbook.
Offset lithograph.
2 x 2 inches.

1059.

dieter roth is magnificent
diter rot is magnificent
dieter rot is magnificent
diter roth is magnificent

(signed and attested)

THINGS ARE SO URGENT NOW THAT SUICIDE IS ALMOST OBSOLETE

1061.

She said, "I'm limping because a wrinkle in my sock gave me a nasty blister."

1064.

April, 1980

STATEMENT

I, SAM HSIEH, plan to do a one year performance piece.
I shall punch a Time Clock in my studio every hour on the hour for one year.
I shall immediately leave my Time Clock room, each time after I punch the Time Clock.
The performance shall begin on April 11, 1980 at 7 P.M. and continue until April 11, 1981 at 6 P.M.

111 HUDSON ST 2FL N.Y.C. 10013

1067.

ONE YEAR PERFORMANCE
1985 - 1986
ORGANIZED by TEHCHING HSIEH
PERFORMED by OTHER PEOPLE

STATEMENT

NEW YORK CITY

1070.

NO NUKES IS GOOD NUKES

1074.

1077.

1078.

1081.

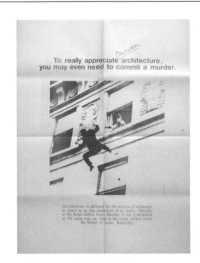

1084.

1087.

1077. ROBERT INDIANA
ROBERT INDIANA.
Rolf Nelson Gallery, Los Angeles, Calif.
May 10–June 5, 1965.
Announcement card and print.
Card: Folded. Offset lithograph.
Print: Silkscreen.
Card folded: 4.75 x 6 inches.
Card unfolded: 9 x 6 inches.
Print: 5 x 4.25 inches.

1078. INSTITUTE FOR ART AND URBAN RESOURCES/ALLEN RUPPERSBERG
NEW URBAN LANDSCAPES-AL RUPPERSBERG-a focus on urban centers through a series of documented projects, proposals, and events.
Institute for Art and Urban Resources,
New York, N.Y. [1977].
Artist's publication.
Folded sheet. Offset lithograph on newsprint.
Printed on both sides.
Folded: 17 x 11.5 inches.
Unfolded: 17 x 22.75 inches.
Reference: Ruppersberg, p. 111.

1079. INSTITUTE FOR ART AND URBAN RESOURCES/LES LEVINE
NEW URBAN LANDSCAPES-LES LEVINE-a focus on urban centers through a series of documented projects, proposals, and events.
Institute for Art and Urban Resources, Inc.,
New York, N.Y. 1978?
Artist's publication.
Folded sheet. Offset lithograph on newsprint.
Printed on both sides.
Folded: 17 x 11.5 inches.
Unfolded: 17 x 22.75 inches.

1080. INSTITUTE FOR ART AND URBAN RESOURCES/ANTONIO MUNTADAS
NEW URBAN LANDSCAPES-MUNTADAS-a focus on urban centers through a series of documented projects, proposals, and events.
Institute for Art and Urban Resources, Inc.,
New York, N.Y. [1978].
Artist's publication.
Folded sheet. Offset lithograph on newsprint.
Printed on both sides.
Folded: 17 x 11.5 inches.
Unfolded: 17 x 22.75 inches.

1081. INSTITUTE FOR ART AND URBAN RESOURCES/FRED SANDBACK
NEW URBAN LANDSCAPES-FRED SANDBACK-a focus on urban centers through a series of documented projects, proposals, and events.
Institute for Art and Urban Resources, Inc.,
New York, N.Y. 1978?
Artist's publication.
Folded sheet. Offset lithograph on newsprint.
Printed on both sides.
Folded: 17 x 11.5 inches.
Unfolded: 17 x 22.75 inches.

1082. INSTITUTE FOR ART AND URBAN RESOURCES/STEVE GWON
NEW URBAN LANDSCAPES-STEVE GWON-a focus on urban centers through a series of documented projects, proposals, and events.
Institute for Art and Urban Resources, Inc.,
New York, N.Y. 1979?
Artist's publication.
Folded sheet. Offset lithograph on newsprint.
Printed on both sides.
Folded: 17 x 11.5 inches.
Unfolded: 17 x 22.75 inches.

1083. INSTITUTE FOR ART AND URBAN RESOURCES/KAREN SHAW
NEW URBAN LANDSCAPES-KAREN SHAW-a focus on urban centers through a series of documented projects, proposals, and events.
Institute for Art and Urban Resources, Inc.,
New York, N.Y. N.d.
Artist's publication.
Folded sheet. Offset lithograph on newsprint.
Printed on both sides.
Folded: 17 x 11.5 inches.
Unfolded: 17 x 22.75 inches.

1084. INSTITUTE FOR ART AND URBAN RESOURCES/BERNARD TSCHUMI
NEW URBAN LANDSCAPES-BERNARD TSCHUMI-a focus on urban centers through a series of documented projects, proposals, and events.
Institute for Art and Urban Resources, Inc.,
New York, N.Y. N.d.
Artist's publication.
Folded sheet. Offset lithograph on newsprint.
Printed on both sides.
Folded: 17 x 11.5 inches.
Unfolded: 17 x 22.75 inches.

1085. JIM ISERMANN
MOTEL MODERN. an installation by JIM ISERMANN. at the INN OF TOMORROW.
Richard Kuhlenschmidt Gallery, Los Angeles, Calif. October 23 and 24, 1982.
Announcement card.
Offset lithograph on found postcard
3.5 x 5.5 inches.
Reference: Isermann, p. 24.

1086. JIM ISERMANN
JIM ISERMANN. HIGHLIGHTS. JIM ISERMANN. HANDIWORK.
Sue Spaid Fine Arts, Los Angeles, Calif.
March 5–March 30, 1994. Richard Telles Fine Art, Los Angeles, Calif. March 19–April 16, 1994.
Announcement card.
Folded. Offset lithograph. Embroidered fabric label mounted on inside right.
Printed on both sides.
Folded: 4 x 6 inches. Unfolded: 4 x 11.75 inches.

1087. RAY JOHNSON
6 LB. 3 OZ. KATE ARA ANN 6 LB. 6 1/2 OZ. WILSON. JUNE 6TH.
[Self-published]. [1962].
Birth announcement.
Offset lithograph?
11 x 8.5 inches.
Reference: Johnson/Willenbecher.

1088. RAY JOHNSON
Ray Johnson.
Richard Feigen Gallery, Chicago, Ill.
October 19–November 19, [1966].
Poster.
Folded. Offset lithograph. Printed on both sides.
Unfolded: 22 x 17 inches.

1089. RAY JOHNSON
RAY JOHNSON NEW YORK CORRESPONDANCE SCHOOL MEETING.
Sacramento State Art Gallery, Sacramento, Calif.
March 26, [1969].
Announcement card.
Offset lithograph.
7.25 x 5.25 inches.

1090. RAY JOHNSON.
RAY JOHNSON.
Jacobs Ladder Gallery, Washington, D.C.
March 4–April 5, 1972.
Poster.
Folded. Offset lithograph. Printed on both sides.
Unfolded: 24 x 18 inches.

1091. RAY JOHNSON
Ray Johnson. ASPARAGUS CLUB. A CONSEPT
EVENT.
René Block Gallery, New York, N.Y. [1974].
Announcement card.
Offset llthograph.
6.25 x 4.25 inches.
Reference: Johnson, p. 207.

1092. RAY JOHNSON
TENDER BUTTONS.
Tender Buttons, New York, N.Y. N.d.
Receipt form.
Offset lithograph on newsprint.
6 x 3.75 inches.

1093. RAY JOHNSON
Charles Fahlen, grappler. Ray Johnson
fingernails.
Marian Locks Gallery, Philadelphia, Penn. N.d.
Announcement card.
Offset lithograph with red felt-pen additions.
5.75 x 4.75 inches.

1094. RAY JOHNSON
a bird can do easy flying games high in j
sky [. . .].
[Self-published]. N.d.
Flyer.
Folded. Offset lithograph.
Unfolded: 13.75 x 8.5 inches.

1095. RAY JOHNSON
AMERICAN FLAG HAND LAUNDRY [. . .].
[Self-published]. N.d.
Flyer.
Folded. Photocopy?
Unfolded: 14 x 8.5 inches.

1096. RAY JOHNSON
A BOOBOOK IS A SMALL AUSTRALIAN OWL.
[Self-published]. N.d.
Flyer.
Folded. Offset lithograph?
Unfolded: 13 x 8.5 inches.

1097. RAY JOHNSON
IF TEARS ARE DROPPED ON A DRY PIECE OF
PAPER, STAINED WITH THE JUICE OF THE
PETALS OF MALLOWS OR VIOLETS, THEY WILL
CHANGE THE PAPER TO A PERMANENTLY
GREEN COLOUR.
[Self-published]. N.d.
Flyer.
Folded. Offset lithograph.
Unfolded: 11 x 8.5 inches.

1098. TADEUSZ KANTOR
EMBALLAGE. Manifeste. T. Kantor. 1964.
[Self-published?]. 1964.
Artist's publication/manifesto.
Accordion folded. Offset lithograph.
Printed on both sides.
Folded: 12 x 5 inches.
Unfolded: 12 x 30.5 inches.

1099. TADEUSZ KANTOR
CONTRACT.
The Foksal PSP Gallery, Warsaw, Poland. 1970.
Contract/brochure.
Offset lithograph. Unpaginated. 4 pages.
8.25 x 6 inches.

1100. ALLAN KAPROW
TRANSFER. A HAPPENING (FOR CHRISTO)
BY ALLAN KAPROW.
Wesleyan University, Middletown, Conn.
February 18, 1968.
Poster.
Folded. Offset lithograph.
Unfolded: 11 x 21.75 inches.

1101. ALLAN KAPROW
OVERTIME. A HAPPENING (for Walter De Maria)
BY ALLAN KAPROW.
The State University of New York at New Paltz,
New Paltz, N.Y. April 16, 1968.
Poster.
Folded. Offcet lithograph.
Photograph by Peter Moore.
Unfolded: 21 x 16 inches.

1102. ALLAN KAPROW
ARRIVALS. A HAPPENING BY ALLAN KAPROW.
Firehouse Gallery, Nassau Community College,
New York, N.Y. April 22, 1968.
Poster.
Folded. Offset lithograph.
Unfolded: 21 x 15 inches.

1103. ALLAN KAPROW
POPULATION. A HAPPENING BY ALLAN
KAPROW.
Colby Junior College, New London, N.H.
April 30,1968.
Poster.
Folded. Offset lithograph.
Unfolded: 22 x 17 inches.

1104. ALLAN KAPROW
COURSE. A HAPPENING BY ALLAN KAPROW.
The University of Iowa, Iowa City, Iowa.
May 9, [1969].
Poster.
Folded. Offset lithograph.
Unfolded: 21 x 15 inches.

1105. ALLAN KAPROW
SIX ORDINARY HAPPENINGS BY ALLAN
KAPROW.
Other Ways, Berkeley, Calif. [1969].
Poster.
Folded. Offset lithograph.
Photograph by Carol Bowen.
Unfolded: 28.75 x 23 inches.

1106. ALLAN KAPROW
HOMEMOVIES. A marriage Happening for
Catherine and Daniel Schmidt some time after
their marriage. A. Kaprow.
[Self-published?]. 1969.
Poster.
Folded. Offset lithograph.
Unfolded: 17 x 11 inches.

1107. ALLAN KAPROW
GRAFT. (An activity by Allan Kaprow).
Kent State University, Ohio. January 20, [1970].
Poster.
Folded. Offset lithograph.
Unfolded: 21 x 16 inches.

1092.

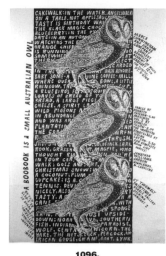

1096.

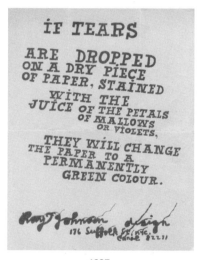

1097.

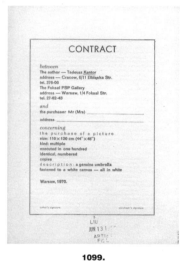

1099.

1100.

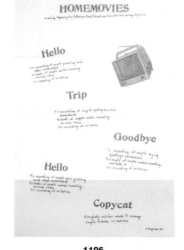

1106.

EYE LEVEL GALLERY
JUNE 23 - JULY 1, 1980
HALIFAX, NOVA SCOTIA

1111.

1110.

ECZEMA
PITYRIASIS
IMPETIGO

PSORIASIS
DERMATITIS
SCABIES

1114.

GARRY NEILL KENNEDY

UH - HUH

S.L.SIMPSON GALLERY
MAY 7-30 1992 TORONTO

1118.

1108. **MIKE KELLEY**
MIKE KELLEY. WORKS FROM PLATO'S CAVE, ROTHKO'S CHAPEL, LINCOLN'S PROFILE.
Rosamund Felsen Gallery, Los Angeles, Calif.
September 7–October 12, 1985.
Announcement card.
Offset lithograph. Printed on both sides.
4.25 x 6 inches.

1109. **MIKE KELLEY**
MIKE KELLEY.
Rosamund Felsen Gallery, Los Angeles, Calif.
October 6–November 10, 1990.
Announcement card.
Folded. Offset lithograph. Printed on both sides.
Folded: 4.5 x 6.25 inches.
Unfolded: 9.25 x 6.25 inches.

1110. **MIKE KELLEY**
THE GREATEST TRAGEDY OF PRESIDENT CLINTON'S ADMINISTRATION [. . .]. MIKE KELLEY.
Patrick Painter Inc., Santa Monica, Calif.
January 23–February 20, 1999.
Poster.
Folded. Offset lithograph. Printed on both sides.
Unfolded: 36 x 24 inches.

1111. **GARRY NEILL KENNEDY**
GARRY NEILL KENNEDY.
Eye Level Gallery, Halifax, Nova Scotia, Canada.
June 23–July 1, 1980.
Flyer.
Folded. Offset lithograph.
Unfolded: 11 x 8.5 inches.

1112. **GARRY NEILL KENNEDY**
HORIZONS. ALLOCATIONS. GARRY NEILL KENNEDY. PLURALITIES 1980.
National Gallery of Canada, Ottawa, Ontario, Canada. July 5–September 7, 1980.
Flyer.
Offset lithograph. Printed on both sides.
12 x 9 inches.

1113. **GARRY NEILL KENNEDY**
GARRY NEILL KENNEDY. RECENT PLANTS. AN EXHIBITION OF POTTED PLANTS ON LOAN FROM THE GALLERIES OF FIFTEEN TORONTO ART DEALERS.
Mercer Union Gallery, Toronto, Ontario, Canada.
September 6–19, 1980.
Announcement card.
Offset lithograph.
5.5 x 4.25 inches.

1114. **GARRY NEILL KENNEDY**
GARRY NEILL KENNEDY. SIX PINK PAINTINGS.
Cold City Gallery, Toronto, Ontario, Canada.
May 26–June 18, 1984.
Announcement.
Folded. Photocopy. Printed on both sides.
Folded: 6 x 5.5 inches. Unfolded: 6 x 11 inches.

1115. **GARRY NEILL KENNEDY**
GARRY NEILL KENNEDY. FRIEZE.
OO Gallery, Halifax, Nova Scotia, Canada.
February 24–30, [1990].
Announcement.
Folded. Photocopy. Printed on both sides.
Folded: 6.5 x 5.5 inches.
Unfolded: 6.5 x 11 inches.

1116. **GARRY NEILL KENNEDY**
GARRY NEILL KENNEDY. COLOR YOUR WORLD.
2098 Gottingen Street, Halifax, Nova Scotia, Canada. July 16–22, 1990.
Announcement.
Folded. Offset lithograph. Printed on both sides.
Folded: 8.5 x 5.5 inches.
Unfolded: 8.5 x 11 inches.

1117. **GARRY NEILL KENNEDY**
GARRY NEILL KENNEDY. MOVING STILLS.
Cold City Gallery, Toronto, Ontario, Canada.
February 2–27, 1991.
Announcement card.
Folded. Offset lithograph. Printed on both sides.
Folded: 8.5 x 4.75 inches.
Unfolded: 8.5 x 9.5 inches.

1118. **GARRY NEILL KENNEDY**
GARRY NEILL KENNEDY. UH - HUH.
S. L. Simpson Gallery, Toronto, Ontario, Canada.
May 7–30, 1992.
Announcement card.
Folded. Offset lithograph. Printed on both sides.
Folded: 5.75 x 5.5 inches.
Unfolded: 5.75 x 11 inches.

1119. **GARRY NEILL KENNEDY**
GARRY NEILL KENNEDY. MIDDLE EAST (A ROOM PAINTING).
Galleri II, Reykjavik, Iceland.
June 27–July 7, 1992.
Announcement card.
Folded. Photocopy. Printed on both sides.
Folded: 8.5 x 4.75 inches.
Unfolded: 8.5 x 9.75 inches.

1120. **GARRY NEILL KENNEDY**
GARRY NEILL KENNEDY. MIDDLE EAST (75 PAINTINGS).
Anna Leonowens Gallery, Nova Scotia College of Art and Design, Halifax, Nova Scotia, Canada. 1992?
Announcement. Folded. Photocopy.
Printed on both sides.
Folded: 8.5 x 4.75 inches.
Unfolded: 8.5 x 9.75 inches.

1121. **GARRY NEILL KENNEDY**
GARRY NEILL KENNEDY. MIDDLE EAST.
Cold City Gallery, Toronto, Ontario, Canada.
January 16–February 4, 1993.
Announcement card.
Folded. Photocopy. Printed on both sides.
Folded: 8.5 x 4.75 inches.
Unfolded: 8.5 x 9.75 inches.

1122. **GARRY NEILL KENNEDY**
GARRY NEILL KENNEDY. DÉCORATIONS FIGURATIVES. ALGÉRIE MAROC TUNISIE.
Cour Vitrée, Palais des Études, École Nationale Supérieure des Beaux-Arts, Paris, France.
April 11–18, 1995.
Announcement card.
Folded. Offset lithograph. Printed on both sides.
Folded: 8.25 x 5.75 inches.
Unfolded: 8.25 x 11.75 inches.

1123. **GARRY NEILL KENNEDY**
GARRY NEILL KENNEDY. A HOUSE DIVIDED.
Cold City Gallery, Toronto, Ontario, Canada.
August 31–September 23, 1995.
Announcement.
Folded. Photocopy. Printed on both sides.
Folded: 8.5 x 4.25 inches.
Unfolded: 8.5 x 8.5 inches.

1124. GARRY NEILL KENNEDY
GARRY NEILL KENNEDY. AUTUMN (A WALL PAINTING).
Saint Mary's University Art Gallery,
[Halifax, Nova Scotia, Canada].
October 30–November 24, 1996.
Announcement card.
Folded. Photocopy. Printed on both sides.
Folded: 6 x 5.5 inches. Unfolded: 6 x 11 inches.

1125. KAREN KILIMNIK
THE UNDEAD APPEAR AT JACK HANLEY GALLERY.
Jack Hanley Gallery, San Francisco, Calif.
May 4–27, [1995].
Poster.
Folded. Offset lithograph.
Unfolded: 17 x 10.75 inches.

1126. BEN KINMONT
WE ARE THE SOCIAL SCULPTURE! THIS IS THE THIRD SCULPTURE! YOU ARE THE THINKING SCULPTURE! Ben Kinmont, 1991.
[Self-published]. 1991.
Flyer/"catalytic text."
1 leaf. Photocopy.
11 x 8.5 inches.

1127. BEN KINMONT
WE ARE THE SOCIAL SCULPTURE! THIS IS THE THIRD SCULPTURE! YOU ARE THE THINKING SCULPTURE! Ben Kinmont. 1992.
Self-published. 1992.
Flyer/"catalytic text."
1 leaf. Photocopy.
11 x 8.5 inches.

1127.1. CAROL KINNE
See Robert Huot/Carol Kinne.

1128. IMI KNOEBEL
Imi Knoebel. Radio Beirut, 1982.
Galerie Six Friedrich, Munich, Germany.
September 9–October 20, 1982.
Announcement card.
Offset lithograph. Printed on both sides.
6 x 4.25 inches.

1128.1. IMI KNOEBEL
See also Art & Project/Imi Knoebel.

1128.2. ALISON KNOWLES
See George Brecht/Alison Knowles/Robert Watts.

1129. KOMAR & MELAMID
Komar & Melamid ANNOUNCING PEOPLE'S CHOICE. A TRAVELING EXHIBITION.
Self-published, New York, N.Y. April 1994.
Press release.
Laser printed?
Signed.
11 x 8.5 inches.

1130. KOMAR & MELAMID
I ♥ BAYONNE. KOMAR & MELAMID.
Solo Gallery/Solo Press. N.d.
Bumper sticker.
Offset lithograph.
3.25 x 12 inches.

1131. JEFF KOONS
Made in Heaven. 1991.
Series of 3 artist's advertisements (listed individually):

JEFF KOONS. Made in Heaven. SONNABEND, NEW YORK. MAX HETZLER, KÖLN.
Brant Art Publications Incorporated, New York, N.Y. November 1991.
Artist's advertisement in the periodical *Art in America* (vol. 79, no. 11 [November 1991], p. 13).
Offset lithograph.
10.75 x 9 inches.

JEFF KOONS.
Made in Heaven. SONNABEND, NEW YORK. MAX HETZLER, KÖLN.
Artforum, New York, N.Y. November 1991.
Artist's advertisement in the periodical *Artforum* (vol. 30, no. 3 [November 1991], p. 7).
Offset lithograph.
10.5 x 10.5 inches.

JEFF KOONS. Made in Heaven. SONNABEND, NEW YORK. MAX HETZLER, KÖLN.
Giancarlo Politi Editore, Milan, Italy.
November/December 1991.
Artist's advertisement in the periodical *Flash Art* (vol. 24, no. 161 [November/December 1991], p. 19).
Offset lithograph.
10.5 x 8 inches.

1132. MARK KOSTABI
KOSTABI.
Bloomingdale's, New York, N.Y. 1986.
Shopping bag.
Folded. Offset lithograph. Printed on both sides.
Unfolded: 16.25 x 12 inches.

1133. JAROSLAW KOZLOWSKI
JAROSLAW KOZLOWSKI. CWICZENIE Z SEMIOTYKI. (Exercise of Semiotics).
Galeria Akumulatory 2, Poznan, Poland. 1977.
Announcement card.
Offset lithograph. Printed on both sides.
4 x 8.25 inches.

1134. JAROSLAW KOZLOWSKI
JAROSLAW KOZLOWSKI. 1 + 5 strokes or 5 + 1 stroke. or 2 strokes. or 10. or 1. or more or less.
Galeria Akumulatory 2, Poznan, Poland. 1979.
Announcement card.
Offset lithograph. Printed on both sides.
4 x 8.25 inches.

1135. JAROSLAW KOZLOWSKI
JAROSLAW KOZLOWSKI. (Time Drawings, Quantity Drawings 8c Weight Drawings).
Galeria Akumulatory 2, Poznan, Poland. 1980.
Announcement card.
Offset lithograph. Printed on both sides.
4 x 8.25 inches.

1136. JAROSLAW KOZLOWSKI
JAROSLAW KOZLOWSKI. (18 Pieces in Watercolour).
Galeria Akumulatory 2, Poznan, Poland. 1981.
Announcement card.
Offset lithograph with watercolor additions.
Printed on both sides.
4 x 8.25 inches.

1125.

1127.

1128.

1130.

1134.

1136.

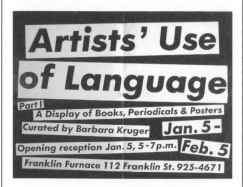

1138.

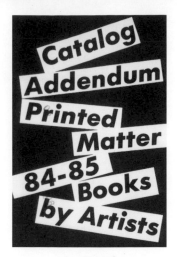

1140.

The Flayed Ox, 1655, Rembrandt.
The Louvre, Paris

Rembrandt's palette is made up of Naples Yellow, Raw Umber,
Burnt Sienna, Yellow Ochre, Prusian Blue.

1145.

MY NAME IS SEAN LANDERS, I'M AN ART-IST WHO WORKS IN A VARIETY OF MEDIA THOUGH MOST PEOPLE RESPOND TO MY WRITING AND VIDEO. I'LL BE EXHIBITING A FEW OF MY ART WORKS AT JAY JOPLING'S GALLERY IN MAY/JUNE. I'M SIX FOOT ONE INCH TALL AND WEIGH 165 LBS. MY HAIR IS ABOUT CHIN LENGTHE AND DARK BROWN AS ARE MY EYES. MY SKIN IS PALE WITH A SLIGHT OLIVE TINT. I'M 31 YEARS OLD AND HAVE A THIN BUT ATH-LETIC PHYSICKE. MY ERECTION IS SEVEN INCHES AND I'VE GOT A REAL PROBLEM WITH PREMATURE EJACULATION. I DON'T KNOW IF IT'S PSYCOLOGICAL OR PHYSICAL, BUT FOR THE LIFE OF ME I CAN'T LAST LONG ENOUGH TO PLEASE MY GIRLFREIND. SHE'S EXTRODINARILY PATIENT WITH ME HOWEVER WE'RE BOTH WONDERING IF I'LL EVER GET MY SHIT TOGETHER I SURE HOPE I DO BECAUSE I REALLY LOVE HER AND WOULD HATE TO LOSE HER OVER THIS. THIS WILL BE MY FIRST SHOW IN ENGLAND, I HOPE YOU LIKE IT. IF YOU DON'T HOWEVER, I'D BE THE FIRST TO AGREE WITH WHAT EVER YOUR CRITISISM MIGHT BE. I MEAN WHO COULD BE MORE SICK OF ME THAN I AM?

SCINCERELY
Sean Landers

1149.

1150.

1152.

1137. BARBARA KRUGER
PICTURES AND PROMISES. A Display of Advertisings, Slogans and Interventions.
The Kitchen, New York, N.Y.
January 8–February 5, [1981].
Poster.
Folded. Offset lithograph.
Unfolded: 21 x 16.75 inches.

1138. BARBARA KRUGER
Artists' Use of Language. Part I. A Display of Books, Periodicals & Posters.
Franklin Furnace, New York, N.Y.
January 5–February 5 , [1982].
Poster.
Folded. Offset lithograph.
Unfolded: 17 x 22 inches.
Reference: Kruger, p. 236.

1139. BARBARA KRUGER
The Revolutionary Power of Women's Laughter.
Jenny Holzer, Mary Kelly, Silvia Kolbowski, Barbara Kruger.
Protetch McNeil, New York, N.Y. Opening January 15, [1983].
Poster.
Folded. Offset lithograph.
Unfolded: 16.25 x 22.25 inches.
Reference: Kruger, p. 236.

1140. BARBARA KRUGER
Catalog Addendum. Printed Matter 84-85.
Books by Artists.
Printed Matter Inc., New York, N.Y. 1984.
Announcement card.
Offset lithograph. Printed on both sides.
6 x 4 inches.

1141. BARBARA KRUGER
Remaking History. Discussions in Contemporary Culture.
Dia Art Foundation, New York, N.Y.
October 1987–May 1988.
Poster.
Folded. Offset lithograph.
Unfolded: 22 x 26.75 inches.
Reference: Kruger, p. 237.

1142. BARBARA KRUGER
Fear and hate make you small, bitter, and mean.
Do to others as you would have them do to you.
By Barbara Kruger, 1992. Produced for Dissent, Difference and the Body Politic.
Portland Art Museum, Portland, Ore. 1992.
Matchbook.
Offset lithograph. Printed on both sides.
2 x 1.5 inches.

1143. SUZANNE LACY
Dear Sisters, On March 14, 1979 women around the world joined hands in the International Dinner Party Event, forming a continuous 24 hour celebration of women's culture [. . .].
[Self-published?]. 1979?
Announcement card.
Offset lithograph. Printed on both sides.
4 x 8.5 inches.

1144. SUZANNE LACY
River Meetings: Lives of Women in the Delta. A performance and potluck dinner by Suzanne Lacy and Jeanne Nathan, 1980.
Self-published, Los Angeles, Calif. 1980?
Announcement card.
Offset lithograph. Printed on both sides.
Photograph by Jeannine Brown.
3.75 x 8.5 inches.

1145. SUZANNE LACY
The Flayed Ox, 1655, Rembrandt. The Louvre, Paris. Rembrandt's palette is made up of Naples Yellow, Raw Umber, Burnt Sienna, Yellow Ochre, Prussian Blue. GREAT MASTERPIECE SERIES NUMBER 2: IN THE LAST THROES OF ARTISTIC VISION. Performance/Installation by Suzanne Lacy.
Self-published? N.d.
Announcement card.
Offset lithograph. Printed on both sides.
6 x 4 inches.

1146. SUZANNE LACY
ART-PAINTING AND HOUSE-PAINTING [. . .].
Art & Economics: pt. 1. Wallworks in Progress.
[Self-published?]. N.d.
Announcement card.
Offset lithograph. Printed on both sides.
5 x 8 inches.

1147. SEAN LANDERS
SEAN LANDERS.
Andrea Rosen Gallery, New York, N.Y.
October 22–November 27, 1993.
Announcement card.
Offset lithograph. Printed on both sides.
4.25 x 6 inches.

1148. SEAN LANDERS
SEAN LANDERS.
Regen Projects, Los Angeles, Calif.
March 5–April 9, 1994.
Poster.
Folded. Offset lithograph.
Unfolded: 17 x 11 inches.

1149. SEAN LANDERS
Sean Landers.
White Cube, London, England.
May 13–June 25, 1994.
Announcement card.
Offset lithograph. Printed on both sides.
6 x 6 inches.

1150. THOMAS LANIGAN-SCHMIDT
VENETIAN GLASS SERIES. THOMAS LANIGAN-SCHMIDT.
Holly Solomon Gallery, New York, N.Y.
September 5–28, 1985.
Announcement card/collage.
Mixed media.
6.25 x 4.25 inches.

1151. THOMAS LANIGAN-SCHMIDT
HALF WAY TO PARADISE. New Art Works By Thomas Lanigan-Schmidt.
Holly Solomon Gallery, New York, N.Y.
September 14–October 8, 1988.
Announcement card, foil ornament, and leaf mounted on foil paper.
Card offset lithograph.
Card: 2 x 3.5 inches. Ornament: 1.5 inches diameter. Leaf: 9.5 x 7 inches.

1152. THOMAS LANIGAN-SCHMIDT
Love Flight of a Pink Candy Heart: A Compliment with an I. A Compliment to Florine Stettheimer. T. LANiGAN-Schmidt.
Holly Solomon Gallery, New York, N.Y. Opening October 11, 1995.
Flyer.
Folded. Photocopy with 1 rubber stamp.
Unfolded: 11 x 8.5 inches.

1153. THOMAS LANIGAN-SCHMIDT
HIDDEN TREASURE. 30 Years of rarely seen
Art by Thomas Lanigan-Schmidt.
Holly Solomon Gallery, New York, N.Y.
October 1–November, 1998.
Announcement card.
Offset lithograph on reflective paper.
4.5 x 6.25 inches.

1154. THOMAS LANIGAN-SCHMIDT
Thomas Lanigan-Schmidt. NEW WORKS. RUSSO-
BYZANTINE AMERI-CONTEMPORARY ICONS.
Holly Solomon Gallery, New York, N.Y. N.d.
Flyer
Folded. Offset lithograph.
Unfolded: 11 x 8.5 inches.

1154.1. DIRK LARSEN
See Reindeer Werk.

1155. LOUISE LAWLER
ARTISTS SPACE.
Artists Space, [New York, N.Y]. 1978?
Poster.
Offset lithograph.
17 x 11 inches.

1156. LOUISE LAWLER
DOCUMENTA 7: A STORY. KASSEL, WEST
GERMANY. 1982. EXCERPTS FROM A LETTER
TO THE PARTICIPATING ARTISTS BY THE
DIRECTOR OF DOCUMENTA 7, R.H. FUCHS.
Self-published. 1982.
2 sheets of stationery and envelope.
Offset lithograph.
Stationery: 11 x 8.5 inches.
Envelope: 4.25 x 9.5 inches.

1157. LOUISE LAWLER
BIRDCALLS BY LOUISE LAWLER. RECORDED
AND MIXED BY TERRY WILSON.
Pierre et Marie, Paris, France. Summer 1983.
Announcement card.
Offset lithograph. Printed on both sides.
5.25 x 3.25 inches.

1158. LOUISE LAWLER
INTERESTING. LOUISE LAWLER.
Nature Morte, New York, N.Y. May 1985.
Announcement card.
Offset lithograph. Printed on both sides.
4 x 6.5 inches.

1159. LOUISE LAWLER
Exhibition confirms, complies, and perseveres. Is
belief in exposure enough of a question? Is
exposure of beliefs enough of a question?
Louise Lawler.
Maison de la Culture et de la Communication,
St.-Etienne, France. Opening November 12, 1987.
Announcement card.
Offset lithograph. Printed on both sides.
4 x 6 inches.

1160. LOUISE LAWLER
It is something like Putting Words In Your Mouth.
[Self-published]. [1988].
Cards.
Offset lithograph. Printed on both sides.
4.25 x 6.5 inches.
Note: Multiple versions in red, yellow, green,
and blue.

1161. LOUISE LAWLER
LOUISE LAWLER. FOR SALE.
Metro Pictures, New York, N.Y.
May 25–June 22, 1991.
Flyer/stationery.
Folded. Offset lithograph. Printed on both sides.
Folded: 3.75 x 8.5 inches. Unfolded: 11 x 8.5 inches.

1162. LOUISE LAWLER
she made no attempt to rescue art from ritual.
A SPOT ON THE WALL. LOUISE LAWLER.
De Appel, Amsterdam, The Netherlands.
October 17, 1995–January 14, 1996.
Matchbook.
Imprinted (hot stamp). Printed on both sides.
2 x 2 inches.

1163. JEAN LE GAC
Le Propriétaire de cet Agenda: MR. LE GAC JEAN.
[Self-published]. [December 1969].
Flyer.
Offset lithograph.
[Edition of 100 copies?],
11.75 x 8.25 inches.
Reference: Poinsot.

1164. JEAN LE GAC
DESCRIPTION D'UN DESSIN FAIT D'APRES NATURE.
[Self-published]. [January 1970].
Flyer.
Offset lithograph.
[Edition of 100 copies?].
11.75 x 8.25 inches.
Reference: Poinsot.

1165. JEAN LE GAC
1 – carnet [. . .].
[Self-published]. [June 1970].
2 flyers.
Offset lithograph. One flyer is printed on both
sides.
12.25 x 8.25 inches each.

1166. JEAN LE GAC
LIEU 1. LIEU 2. LIEU 3. LIEU 4.
[Self-published]. [September 1970].
Flyer.
Offset lithograph.
[Edition of 200 copies?].
11.75 x 8.25 inches.
Reference: Poinsot.

1167. JEAN LE GAC
Nous venions dans la région à la bonne saison [. . .].
[Self-published]. [September 1970].
Flyer.
Offset lithograph. Printed on both sides.
11.5 x 8.25 inches.

1168. JEAN LE GAC
Je fis, dans le même temps [. . .].
[Self-published]. [September 1970].
Flyer.
Offset lithograph.
11.75 x 8.25 inches.

1169. JEAN LE GAC
L'année dernière un peu avant la saison [. . .]
HYPOTHESES INCURIEUSES [. . .].
[Self-published]. [October 1970].
Flyer.
Offset lithograph.
[Edition of 200 copies?].
10.5 x 8.25 inches.
Reference: Poinsot.

1157.

1158.

1161.

1162.

1163.

1167.

VUE 1

BONNE NUITS PETITS

MANET ET PICASSO !

Un jour plus rien ne coïncida avec le souvenir que chacun en avait gardé. On n'eut même pas le temps de s'habituer à ce nouvel état des choses, ils se mirent aussitôt à creuser. Enfin ils déblayèrent tout le périmètre et l'activité cessa, définitivement.

Pour creuser au plus court beaucoup prévoit la manière habituelle de traverser le terrain. Bientôt les lignes des sentiers se superposèrent à l'ancien plan des terrassements, Les terriers creusés par les enfants minèrent chaque jour un peu plus les talus, Des objets mis au rebut, de tous les remblais, témoignaient à leur place initiale : ils semblaient même à certains moments avoir été transportés par camions entiers, sans que l'on ait eu connaissance ni de leur provenance, ni de la matière dont ce genre de déchargements frauduleux provenait d'opérer.

Tout se passait en somme comme si l'on cherchait insidieusement à aliérer chez quelqu'un une représentation usuelle qu'ils se déjalaient de ce lieu pour lui substituer une image douteuse ... au ras du sol.

VUE 2

Copyright by LE GAC Jean.

1172. **1179.**

LES ATHLÈTES DE LA PENSÉE :

plus forts que le penseur de Rodin sur son chiotte, on annonce toutes veines temporales dilatées, les "dix ans" de réflexion d'Alfred et Bernard au Centre G. Pompidou.

* on ne sait pas si leurs unité sont décomptés.

1180. **1181.**

SCHEMAS POUR L'ECOULEMENT DES EAUX

here
i
am
please
don't
be
mean

1185.

1170. **JEAN LE GAC**
24 MESSAGES PERSONNELS.
[Self-published]. [October 1970].
Flyer.
Offset lithograph.
[Edition of 200 copies?].
10.5 x 8.25 inches.
Reference: Poinsot.

1171. **JEAN LE GAC**
SCHEMAS POUR LA SERRE CHAUDE.
[Self-published]. [October 1970].
Flyer.
Offset lithograph.
8.25 x 11.75 inches.

1172. **JEAN LE GAC**
VUE 1. VUE 2.
[Self-published]. [November 1970].
Flyer.
Offset lithograph.
[Edition of 200 copies?].
11.75 x 8.25 inches.
Reference: Poinsot.

1173. **JEAN LE GAC**
LA MACHINE A TIRER LES PLANS A
FONCTIONNE TOUTE L'APRES MIDI.
[Self-published]. [November 1970].
Flyer.
Offset lithograph.
10.5 x 8.25 inches.
Reference: Poinsot.

1174. **JEAN LE GAC**
LECTURE 1.
[Self-published]. [December 1970].
Flyer.
Offset lithograph.
13 x 8.25 inches.

1175. **JEAN LE GAC**
lecture 2.
[Self-published]. [January 1971].
Flyer.
Offset lithograph.
8.25 x 11.75 inches.

1176. **JEAN LE GAC**
LE FORMAT TRES COURANT [. . .].
Galerie Rive Droite, Paris, France.
April 20–May 8, 1971.
Announcement.
Folder containing 2 leaves. Offset lithograph.
The leaves are printed on both sides.
Leaves: 10.75 x 8.25 inches each.
Folder: 11 x 8.75 inches.

1177. **JEAN LE GAC**
Aux bons soins du Comité Directeur du 27ème
Salon de Mai (1971).
[Self-published]. [May 1971].
Flyer.
Offset lithograph.
10.5 x 8.25 inches.

1178. **JEAN LE GAC**
L'annonce de l'exposition "PEINTURE
AMERICAINE: LES ANNEES 80 - une
interprétation critique de Barbara Rose" [. . .].
[Self-published]. April 15, 1980.
Flyer.
Offset lithograph.
11.75 x 8.25 inches.

1179. **JEAN LE GAC**
BONNE NUITS PETITS MANET ET PICASSO!
[Self-published]. [1983].
Card.
Offset lithograph.
3 x 5 inches.

1180. **JEAN LE GAC**
LES ATHLÈTES DE LA PENSÉE: plus forts que
le penseur de Rodin sur son chiotte, on annonce
toutes veines temporales dilatées, les "dix ans*
de réflexion" d'Alfred et Bernard au Centre G.
Pompidou.
[Self-published]. [1987].
Card.
Offset lithograph.
4 x 5.75 inches.

1181. **JEAN LE GAC**
SCHEMAS POUR L'ECOULEMENT DES EAUX.
[Self-published]. [October 1970].
Flyer.
Offset lithograph. Printed on both sides.
8.25 x 11.75 inches.

1181.1.WILLIAM LEAVITT
See Art & Project/William Leavitt.

1182. **CARY LEIBOWITZ**
WORLDS BEST FRIED CHICKEN.
Stux Gallery, New York, N.Y. September 6–30, 1989.
Poster.
Folded. Offset lithograph. Printed on both sides.
Edition of 1,000 copies. Numbered.
Unfolded: 14 x 9 inches.

1183. **CARY LEIBOWITZ**
she was an ordinary girl with ordinary taste until one day
she won the worlds biggest Lottery prize ever [. . .].
Hampden Gallery, [University of Massachusetts,
Amherst, Mass.]. November 2–22, 1989.
Announcement.
Offset lithograph on clear plastic bag.
29.5 x 27.5 inches.

1184. **CARY LEIBOWITZ**
Misery Loves Company.
[Self-published]. [1989].
Card.
Offset lithograph. Initialed and rubber stamped
"Candy ass" on the verso.
2 x 3.5 inches.

1185. **CARY LEIBOWITZ**
here i am please don't be mean.
[Self-published]. [1989].
Card.
Offset lithograph. Initialed and rubber-stamped
"Candy ass" on the verso.
2 x 3.5 inches.

1186. **CARY LEIBOWITZ**
Homo.
[Self-published]. [1989].
Card.
Offset lithograph. Initialed and rubber-stamped
"Candy ass" on the verso.
2 x 3.5 inches.

1187. **CARY LEIBOWITZ**
dearest art observer/buyer. please take kindly to this little
note to let you know and feel welcome to attend [. . .].
Shoshana Wayne Gallery, [Santa Monica, Calif.].
Opening March 28, 1991.
Announcement card.
Offset lithograph.
4 x 6 inches.

1188. **CARY LEIBOWITZ**
eye lov u but i hate u i plan my death every day u
cant b smart all the time.
Galerie Krinzinger, Vienna, Austria. April/May 1991.
Announcement card.
Folded. Offset lithograph.
Folded: 6 x 8.25 inches. Unfolded: 6 x 24.75 inches.

1189. **CARY LEIBOWITZ**
hey! Question: When do Good things happEN 2
Loozers? ANSWER: CANDYASS CArnivaL!
Stux Gallery, New York, N.Y.
October 19–November 16, 1991.
Announcement card.
Offset lithograph.
4 x 9 inches.

1190. **CARY LEIBOWITZ**
Coffee Clatch at Shoshana Wayne gallery!!
Shoshana Wayne Gallery, Santa Monica, Calif.
Opening February 15, 1992.
Announcement card.
Offset lithograph.
6 x 4 inches.

1191. **CARY LEIBOWITZ**
ADDENDUM.
Shoshana Wayne Gallery, Santa Monica, Calif.
March 18–April 29, 1995.
Anouncement card.
Offset lithograph.
4 x 6 inches.

1192. **LES LEVINE**
CENTRAL PARK POETRY EVENTS.
THE BAND SHELL ON THE MALL.
N.p. September 27–29, 1968.
Poster.
Folded. Offset lithograph.
Unfolded: 28 x 22 inches.
Reference: Levine.

1193. **LES LEVINE**
THE FASHION SHOW POETRY EVENT. BY Eduardo
Costa, John Perreault, and Hannah Weiner.
Center for Inter-American Relations, New York,
N.Y. January 14, 1969.
Poster.
Folded. Offset lithograph.
Unfolded: 19.5 x 26.75 inches.
Reference: Levine.

1194. **LES LEVINE**
PROFIT SYSTEMS I BY LES LEVINE.
[Self-published?]. March 27–April 3, 1969.
Announcement.
Offset lithograph.
4.25 x 11 inches.

1195. **LES LEVINE**
Release 2: A BENEFIT FOR THE RON GOLD
DEFENSE FUND. ST. MARK'S CHURCH.
N.p. 1969.
Poster.
Offset lithograph.
22.25 x 17.5 inches.
Reference: Levine.

1196. **LES LEVINE**
"LES LEVINE COPIES EVERYONE." HOLLY
SOLOMON IN CONVERSATION WITH LITA HORNICK.
The Isaacs Gallery, Toronto, Ontario, Canada.
October 20–November 9, 1970.
Poster.
Offset lithograph.
19.75 x 27.75 inches.
Reference: Levine.

1197. **LES LEVINE**
18K SOLID GOLD CHEWING GUM. LES LEVINE.
Fischbach, New York, N.Y. February 19–March 9, 1972.
Announcement card.
Offset lithograph. Printed on both sides.
5.5 x 7 inches.

1198. **LES LEVINE**
18-CARAT SOLID GOLD CHEWING GUM.
LES LEVINE.
Fischbach Gallery, New York, N.Y.
Opening February 19, 1972.
Poster.
Folded. Offset lithograph.
Unfolded: 13 x 9 inches.

1199. **LES LEVINE**
THE LES LEVINE GROUP SHOW.
Stefanotty, New York, N.Y. Opening December 5, [1974].
Announcement card.
Offset lithograph. Printed on both sides.
4.25 x 6 inches.

1200. **LES LEVINE**
WHAT CAN YOUR FEDERAL GOVERNMENT
DO FOR YOU? Les Levine.
M. L. D'Arc Gallery, New York, N.Y.
February 25–March 31, 1976.
Poster.
Folded Offset lithograph.
Unfolded: 28.75 x 23 inches.

1201. **LES LEVINE**
Orgyen Chö Dzong. A BENEFIT PERFORMANCE
FOR THE VISIT TO THE UNITED STATES OF His
Holiness Dudjom Rinpoche.
Giorno Poetry Systems Institute, Inc., New York,
N.Y. November 9, 1976.
Poster.
Folded. Offset lithograph.
Unfolded: 29 x 23 inches.

1202. **LES LEVINE**
LES LEVINE'S GAME ROOM. A TRIBUTE TO
THE GREAT AMERICAN LOSER.
M. L. D'Arc Gallery, New York, N.Y.
February 15–March 12, 1977.
Poster.
Folded. Offset lithograph.
Unfolded: 24 x 17.5 inches.

1203. **LES LEVINE**
GROUP SHOWS CUT-UP THE GROUP.
[Self-published]. 1989.
Color photograph and form letter.
The letter is folded and a photocopy.
The photograph is in an edition of 250 copies
and signed and numbered. The letter is signed.
Photograph: 6.75 x 5 inches.
Letter unfolded: 11 x 8.5 inches.

1204. **LES LEVINE**
LES LEVINE. SEE YOUR MIND.
Brigitte March Galerie, Stuttgart, Germany.
April 26–May 31, 1996.
Announcement card.
Offset lithograph. Printed on both sides.
4.25 x 6 inches.

1205. **LES LEVINE**
LES LEVINE Good Taste is no excuse.
Brigitte March Galerie, Philipp March
Kunstprojekte, Stuttgart, Germany.
June 27–July 31, 1997.
Announcement card.
Offset lithograph. Printed on both sides.
4 x 5.75 inches.

1190.

1192.

1193.

1197.

1201.

1203.

1206.

1207.

1210.

1212.

1214.

1219.

1206. LES LEVINE
See the other side of art at the CULTURE-IN.
The Aspen Center of Contemporary Art,
Aspen, Colo. N.d.
Poster.
Offset lithograph.
29 x 19 inches.
Reference: Levine.

1206.1. LES LEVINE
See also Institute for Art and Urban
Resources/Les Levine.

1207. SOL LEWITT
SOL LEWITT.
Konrad Fischer, Düsseldorf, Germany.
January 6–February 3, 1968.
Announcement card.
Offset lithograph.
4.25 x 4.25 inches.

1208. SOL LEWITT
SOL LEWITT. WALL DRAWINGS.
Cusack Gallery, Houston, Tex.
October 4–25 1973.
Announcement card.
Offset lithograph. Printed on both sides.
4 x 6 inches.

1209. SOL LEWITT
sol lewitt.
Saman Gallery, Genova, Italy.
Opening May 23, 1975.
Announcement card.
Offset lithograph. Printed on both sides.
4 x 5.75 inches.

1210. SOL LEWITT
THE LOCATION OF YELLOW, RED AND BLUE
LINES ON YELLOW, RED AND BLUE WALLS.
SOL LEWITT.
Rolf Preisig Gallery, Basel, Switzerland.
Opening October 18, 1975.
Announcement card.
Offset lithograph. Printed on both sides.
4 x 5.75 inches.

1211. SOL LEWITT
ALL TWO PART COMBINATIONS OF ARCS
FROM FOUR CORNERS, ARCS FROM FOUR
SIDES, STRAIGHT, NOT-STRAIGHT & BROKEN
LINES IN FOUR DIRECTIONS. SOL LEWITT.
Art Gallery of New South Wales, Sydney,
Australia. 1977.
Poster.
Folded. Offset lithograph.
Unfolded: 10 x 15 inches.

1211.1. SOL LEWITT
See also Art & Project/Sol LeWitt.

1212. RICHARD LONG
WALKING WITH THE RIVER'S ROAR.
RICHARD LONG.
Anthony d'Offay and Helen van der Meij, London,
England. Opening March 29, 1983.
Announcement card.
Offset lithograph. Printed on both sides.
5.25 x 7.75 inches.

1213. RICHARD LONG
LINES OF LAKE STONES, TORINO 1983.
RICHARD LONG.
Konrad Fischer, Dusseldorf, Germany.
September 16–October 14, 1983.
Announcement card.
Offset lithograph. Printed on both sides.
4 x 5.75 inches.

1214. RICHARD LONG
RICHARD LONG. NEW WORKS.
Galerie Crousel-Hussenot, Paris, France.
March 10–April 15, 1984.
Announcement card.
Offset lithograph. Printed on both sides.
9 x 5.75 inches.

1215. RICHARD LONG
SHADOWS AND WATERMARKS NEPAL 1983.
RICHARD LONG.
Jean Bernier, Athens, Greece.
March 29–April 28, 1984.
Announcement card.
Offset lithograph. Printed on both sides.
4 x 5.75 inches.

1216. RICHARD LONG
A LAPPLAND WALK. RICHARD LONG.
Sperone Westwater, New York, N.Y.
May 5–June 2, 1984.
Announcement card.
Offset lithograph. Printed on both sides.
4.5 x 6.25 inches.

1217. RICHARD LONG
MUDDY WATER FALLS. RICHARD LONG.
Anthony d'Offay, London, England.
October 16–November 16, 1984.
Announcement card.
Offset lithograph. Printed on both sides.
4 x 5.75 inches.

1218. RICHARD LONG
FROM PASS TO PASS. SNIOGOUTSE LA.
RICHARD LONG.
Anthony d'Offay, London, England.
June 4– 29, 1985.
Announcement card.
Offset lithograph. Printed on both sides.
4 x 6 inches.

1219. RICHARD LONG
WIND LINE ACROSS ENGLAND. RICHARD
LONG. NEW WORKS.
Anthony d'Offay Gallery, London, England.
October 8–November 12, 1986.
Announcement card.
Offset lithograph. Printed on both sides.
5 x 8.25 inches.

1220. RICHARD LONG
RICHARD LONG.
Konrad Fischer, Düsseldorf, Germany.
Opening February 20, 1988.
Announcement.
Folded. Offset lithograph.
Unfolded: 8.25 x 8.25 inches.

1221. RICHARD LONG
RICHARD LONG.
Anthony d'Offay Gallery, London, England.
October 22–November 26, 1988.
Announcement card.
Offset lithograph. Printed on both sides.
4.5 x 6.75 inches.

1222. RICHARD LONG
TURF. LINE.
RICHARD LONG.
Konrad Fischer, Düsseldorf, Germany.
Opening July 14, 1990
Announcement card.
Offset lithograph. Printed on both sides.
3 x 5 inches.

1223. RICHARD LONG
IN THE CLOUD. ALONG AN 8 DAY WALK
ACROSS SCOTLAND 3/4 HOUR IN CLOUD
WHILE GOING OVER BEN MACDUI THE
HIGHEST POINT OF THE WALK. COAST TO
COAST WEST TO EAST 1991. RICHARD LONG.
Sperone Westwater, New York, N.Y.
October 19–November 16, 1991.
Announcement card.
Offset lithograph. Printed on both sides.
5.25 x 7.75 inches.

1224. RICHARD LONG
IN THE CLOUD. RICHARD LONG. STONE
LINE 1980 AND SELECTED NEW WORKS.
Scottish National Gallery of Modern Art,
Edinburgh, Scotland.
December 1991–February 1992.
Announcement card.
Offset lithograph. Printed on both sides.
4.75 x 6.75 inches.

1225. RICHARD LONG
HIGH TIDE TO HIGH TIDE. RICHARD LONG.
Konrad Fischer, Düsseldorf, Germany.
November 7–December 2, 1992.
Announcement card.
Offset lithograph. Printed on both sides.
4.25 x 7.5 inches.

1226. RICHARD LONG
RICHARD LONG.
Inkong Gallery, Seoul, Korea.
April 23–June 19, 1993.
Announcement card.
Offset lithograph. Printed on both sides.
4 x 5.75 inches.

1227. RICHARD LONG
SHENANDOAH. NEANDERTAL. RICHARD LONG.
Konrad Fischer, Düsseldorf, Germany.
March 3–April 5, 1994.
Announcement card.
Offset lithograph. Printed on both sides.
4 x 6 inches.

1228. RICHARD LONG
AN 8 DAY MOUNTAIN WALK IN SOBAEKSAN
KOREA SPRING 1993. RICHARD LONG
BOOKS PRINTS PRINTED MATTER.
The New York Public Library, New York, N.Y.
Opening March 24, 1994.
Announcement card.
Offset lithograph. Printed on both sides.
5 x 6.75 inches.

1229. RICHARD LONG
MEANDERING AND CIRCLING. A THREE DAY
MEANDERING WALK CROSSING AN
IMAGINARY CIRCLE ON DARTMOOR. ENGLAND
1993. RICHARD LONG.
Sperone Westwater, New York, N.Y.
March 26–April 23, 1994.
Announcement card.
Offset lithograph. Printed on both sides.
5.25 x 8 inches.

1230. RICHARD LONG
RICHARD LONG: Books Prints Printed Matter.
The New York Public Library, New York, N.Y.
March 26–June 25, 1994.
Poster/exhibition brochure.
Folded. Offset lithograph. Printed on both sides.
Unfolded: 22 x 16 inches. Folded: 11 x 8 inches.

1231. RICHARD LONG
WALKING. STONES. RICHARD LONG.
Konrad Fischer, Düsseldorf, Germany.
December 16, 1995–February 6, 1996.
Announcement card.
Offset lithograph. Printed on both sides.
4 x 5.75 inches.

1232. RICHARD LONG
RICHARD LONG. CIRCLES CYCLES MUD STONES.
Contemporary Arts Museum, Houston, Tex.
April 27–June 30, 1996.
Poster.
Folded. Offset lithograph. Printed on both sides.
Unfolded: 22 x 17 inches.

1233. RICHARD LONG
SPLASHING AROUND A CIRCLE. A STONE
THROWN INTO EACH RIVER AND STREAM AT ITS
CROSSING PLACE WITH AN IMAGINARY CIRCLE
41 MILES WIDE SURROUNDING SALISBURY PLAIN
AND THE MARLBOROUGH DOWNS. A WALK OF
FOUR DAYS ENGLAND 1997. RICHARD LONG.
Sperone Westwater, New York, N.Y.
September 20–November 8, 1997.
Announcement card.
Offset lithograph. Printed on both sides.
5 x 6.5 inches.
Reference: Sperone, p. 471.

1234. RICHARD LONG
HERD DROPPINGS MONGOLIA 1996.
RICHARD LONG. SIX STONE CIRCLES Sculpture
1981 AND RECENT TEXT WORKS, PHOTO
WORKS, MAP WORKS.
Yorkshire Sculpture Park, West Yorkshire,
England. June 11–September 6, 1998.
Announcement card.
Offset lithograph. Printed on both sides.
5.75 x 8.25 inches.

1234.1. RICHARD LONG
See also Art & Project/Richard Long.

1234.2. CHIP LORD
See Ant Farm.

1235. GEORGE MACIUNAS
U.S. SURPASSES ALL NAZI GENOCIDE RECORDS!
[Self-published, New York, N.Y.]. 1966.
Flyer.
Offset lithograph. Printed on both sides.
7 x 8.5 inches.
Reference: Fluxus Etc., p. 143.

1236. GEORGE MACIUNAS
ARTISTS' BENEFIT FOR JUDSON CHURCH.
Judson Church, New York, N.Y. [1975c].
Flyer.
Offset lithograph.
11 x 8.5 inches.

1237. BRICE MARDEN
BRICE MARDEN.
Bykert Gallery, New York, N.Y.
October 31–November 26, 1970.
Announcement card.
Offset lithograph. Printed on both sides.
5.75 x 8 inches.

1222.

1226.

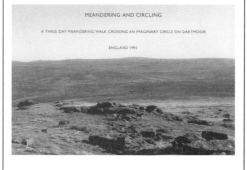

1229.

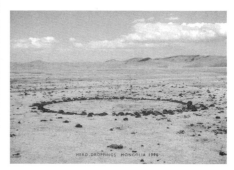

1234.

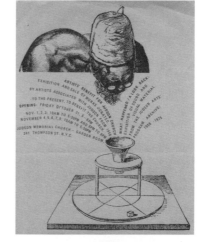

1236.

1237.

1241.

1243.

1247.

1248.

1251.

1238. BRICE MARDEN
BRICE MARDEN.
Bykert Gallery, New York, N.Y.
February 5–March 1, 1972.
Announcement card.
Offset lithograph.
6 x 4.5 inches.

1239. BRICE MARDEN
Shape Book. BRICE MARDEN.
Konrad Fischer, Düsseldorf, Germany.
September 2–23, 1975.
Announcement card.
Offset lithograph. Printed on both sides.
4 x 5.75 inches.
Reference: Fischer, p. 120.

1240. BRICE MARDEN
BRICE MARDEN. Two New Paintings with
Five Tang Dynasty Stone Epitaphs.
Matthew Marks Gallery, New York, N.Y.
May 3–June 27, 1997.
Announcement card.
Letterpress.
8.5 x 6 inches.

1241. TOM MARIONI
ARTISTS' CREDIT CARD. Good any Friday from
4 to 6 in Jerry and Johnny's Bar next door to
MOCA for FREE BEER (imported or domestic)
or wine and water.
Museum of Conceptual Art and Site, Cite, Sight
Inc., San Francisco, Calif. [1981].
Card/"credit card."
Offset lithograph. Printed on both sides.
[Edition of 500 copies].
2.25 x 3.25 inches.

1242. DANIEL JOSEPH MARTINEZ
WOODEN NICKEL.
[Self-published?]. [1985?].
Wood coin.
Offset lithograph on wood. Printed on both sides.
Diameter: 1.5 inches.

1243. DANIEL JOSEPH MARTINEZ
BRIGHTOFFFLAT. WHITEWHITEWHITE.
FEARGUILTSTUPIDITY.
[Self-published]. [1995?].
Matchbook.
Foil stamped.
2 x 3.

1244. DANIEL JOSEPH MARTINEZ
JUSTORDINARYTRADITIONAL
AMERICANFAMILYVALUES.
[Self-published]. [1995?].
Matchbook.
Foil stamped.
2 x 3 inches.

1244.1. YUTAKA MATSUZAWA
See Art & Project/Yutaka Matsuzawa.

1245. JOHN MCCRACKEN
JOHN MCCRACKEN.
Elkon, New York, N.Y. Wilder, Los Angeles, Calif.
December 1968.
Poster.
Folded. Offset lithograph.
Unfolded: 22 x 16 inches.

1246. JOHN MCCRACKEN
Exhibitions (faculty member) John McCracken.
UNLV Art Gallery, University of Nevada, Las
Vegas, Nev. November 25–December 6, [1974?].
Announcement card.
Offset lithograph. Printed on both sides.
9.5 x 7 inches.

1247. JOHN MCCRACKEN
John McCracken Paintings.
UNLV Art Gallery, University of Nevada, Las
Vegas, Nev. October 29–November 18, 1977.
Announcement card.
Offset lithograph. Printed on both sides.
8.5 x 11 inches.

1248. MCDERMOTT & MCGOUGH
Messrs McDermott & McGough. the 15th
instance of March through to the 6th instance of
April 1799-1945. Pat Hearn Gallery, Manhattan.
Artforum, New York, N.Y. March 1986.
Artists' advertisement in the periodical Artforum
(vol. 24, no. 7 [March 1986], p. 18).
Offset lithograph.
Image size: 2.75 x 10.5 inches.
Page size: 10.5 x 10.5 inches.

1249. MCDERMOTT & MCGOUGH
Messrs. McDermott & McGough. March 15th
through April 6th, 1972. Massimo Audiello
Gallery, Manhattan.
Artforum, New York, N.Y. March 1986.
Artists' advertisement in the periodical Artforum
(vol. 24, no. 7 [March 1986], p. 49).
Offset lithograph.
Image size: 2.75 x 10.5 inches.
Page size: 10.5 x 10.5 inches.

1250. MCDERMOTT & MCGOUGH
REWARD $10.000 CASH. FOR ANY
INFORMATION LEADING TO THE RECOVERY
OF THE FOUR HUDSON RIVER PAINTINGS BY
MESSERS. McDERMOTT - McGOUGH STILL
MISSING FROM THE ORIGINAL PRIMEVAL
VISITATION SERIES LAST SHOWN BETWEEN
1845 AND 1848 AT THE AMERICAN INSTITUTE
OF THE CITY OF NEW YORK.
Artforum, New York, N.Y. Summer 1986.
Artists' advertisement in the periodical Artforum
24, no. 10 (summer 1986), p. 29.
Offset lithograph.
10.5 x 10.5 inches.

1251. MCDERMOTT & MCGOUGH
SPERONE WESTWATER Purveyors of High Class
Art WANT THE PUBLIC NOT TO OVERLOOK
Messrs. McDermott & McGough painters of
pictures IN A GREAT EXHIBITION to open on 17
November 1890. "THE BIGGEST, BRIGHTEST,
BEST PICTURES" IN ALL THE WORLD.
Sperone Westwater, New York, N.Y. Opening
November 17, [1990].
Announcement card.
Folded. Perforated. Offset lithograph.
Printed on both sides.
Folded: 5.25 x 7.5 inches.
Unfolded: 10.5 x 7.5 inches.

1251.1. BRUCE MCLEAN
See Nice Style.

1251.2. DOUG MICHELS
See Ant Farm

1252. PIETER LAURENS MOL
PIETER LAURENS MOLS. PORTRETTEN VAN DE
WAAN 1983-1985 (AFB). DICK VERDULT. 3
RUBBERSNEDES 1985. RENÉ DANIELS.
HET VERLOREN HUIS TERUGGEVONDEN
1982-1983. HENK VISCH. OUT OF THE
DEPTHS INTO THE LIGHT 1984.
Galerie Paul Andriesse, Amsterdam,
The Netherlands. Opening June 26, 1985.
Announcement card.
Offset lithograph. Printed on both sides.
4 x 6 inches.

1253. PIETER LAURENS MOL
PIETER LAURENS MOL.
Galerie Paul Andriesse, Amsterdam,
The Netherlands. Opening March 8, 1995.
Announcement card.
Offset lithograph. Printed on both sides.
4 x 6 inches.

1254. PIETER LAURENS MOL
PIETER LAURENS MOL. PATHWAY COLOURS.
Galerie Paul Andriesse, Amsterdam,
The Netherlands.
December 4, 1998–January 16, 1999.
Announcement card.
Offset lithograph. Printed on both sides.
4 x 6 inches.

1255. PIETER LAURENS MOL
PIETER LAURENS MOL. 'IN ONE EAR, OUT
THE OTHER'.
HCAK, Haags Centrum Voor Actuele Kunst,
The Hague, The Netherlands. N.d.
Card.
Offset lithograph. Printed on both sides.
4 x 6 inches.

1256. PIETER LAURENS MOL
Pieter Laurens Mol, ,,Am 15 Februar 1983".
Galerie Hartmut Beck, Erlangen, Germany. N.d.
Announcement card.
Offset lithograph. Printed on both sides.
4 x 5.75 inches.

1256.1. OLIVIER MOSSET
See Daniel Buren/Olivier Mosset/Michel
Parmentier/Niele Toroni.

1257. DAVE MULLER
filmstrips by Lisa Barnet.
Three Day Weekend, Los Angeles, Calif.
November 11, 1994.
Poster.
Photocopy. 2 googly eyes are mounted
on the front.
17 x 11 inches.

1258. DAVE MULLER
Keiji Haino, The Red Crayola, Clancy Pearson.
Three Day Weekend, Los Angeles, Calif.
April 15, 1995.
Announcement.
Photocopy.
8.5 x 3.5 inches.

1259. DAVE MULLER/ANTHONY BURDIN
Anthony Burdin.
Three Day Weekend, Los Angeles, Calif.
November 13–15, 1998.
Flyer.
Folded. Photocopy.
Unfolded: 11 x 8.5 inches.

1259.1. ANTONIO MUNTADAS
See Institute for Art and Urban
Resources/Antonio Muntadas.

**1260. N. E. THING CO. LTD.
(IAIN & INGRID BAXTER)**
N.E. BAXTER THING CO. THINGS AND
SERVICES. "Anything Does It".
N. E. Baxter Thing Co., N. Vancouver, B.C.,
Canada. [1966].
Business card.
Offset lithograph.
[Edition of 250 copies].
2 x 3.5 inches.
Reference: N. E. Thing Co. Ltd., No. 22.

**1261. N. E. THING CO. LTD.
(IAIN & INGRID BAXTER)**
N.E. BAXTER THING CO. THINGS AND
SERVICES. "Anything Does It".
[N. E. Baxter Thing Co., N. Vancouver, B.C.,
Canada]. [1966?].
Sticker.
Offset lithograph.
2.75 x 5 inches.

**1262. N. E. THING CO. LTD.
(IAIN & INGRID BAXTER)**
PRESIDENT'S MESSAGE.
The National Gallery of Canada, Ottawa, Ontario,
Canada. June 4–July 6, 1969.
Poster.
Folded. Offset lithograph.
Unfolded: 24 x 9 inches.

**1263. N. E. THING CO. LTD.
(IAIN & INGRID BAXTER)**
PLEASE COMPLETE AND RETURN. N.E. THING
COMPANY LIMITED.
[Self-published], N. Vancouver, B.C., Canada.
[1969].
Card.
Offset lithograph. Printed on both sides.
[Edition of 500 copies].
Designed by Allan Fleming.
2.5 x 2.25 inches.
Reference: N. E. Thing Co. Ltd., No. 38.

**1264. N. E. THING CO. LTD.
(IAIN & INGRID BAXTER)**
N.E. BAXTER THING COMPANY. IAIN BAXTER.
The McIntosh Memorial Gallery, University of
Western Ontario. N.d.
Announcement card.
Folded. Offset lithograph.
Unfolded: 4.75 x 17 inches.

1265. MAURIZIO NANNUCCI
ALWAYS ENDEAVOR TO FIND SOME
INTERESTING VARIATION. maurizio nannucci /
tekst in geluid.
Stedelijk Museum, Amsterdam, The Netherlands.
April 1977.
Poster.
Folded. Offset lithograph on parchment paper.
Unfolded: 38.5 x 26.5 inches.

1253.

1254.

1259.

1260.

1263.

1264.

1266.

YOU CAN IMAGINE
THE OPPOSITE

1271.

1. Monday Bruce Nauman - 6 day week - 6 sound problem
 - walking in the gallery.
2. Tuesday - Bouncing Two balls in the gallery.
3. Wednesday - Violin sounds in the gallery.
4. Thursday- Walking and bouncing balls.
5. Friday - walking and Violin sounds.
6. Saturday - violin sounds and bouncing balls.

1276.

Imagine Contrived Situations **Contrive Imagined Situations**

1277.

1266. MAURIZIO NANNUCCI
MAURIZIO NANNUCCI. IT MUST BE ABSTRACT
IT MUST CHANGE IT MUST GIVE PLEASURE.
Westfälischer Kunstverein, Münster, Germany.
September 3–October 23, 1988.
Announcement card.
Folded. Offset lithograph. Printed on both sides.
4.75 x 4.75 inches.

1267. MAURIZIO NANNUCCI
MAURIZIO NANNUCCI / AT ANYBODY
ANYWHERE ANYWAY ANYTIME.
Galleria del Cortile, Rome, Italy.
Opening December 14, 1988.
Announcement card.
Offset lithograph. Printed on both sides.
4 x 6 inches.

1268. MAURIZIO NANNUCCI
MAURIZIO NANNUCCI. THERE'S NO REASON
TO BELIEVE THAT ART EXISTS.
Victoria Miro Gallery, London, England.
February 2–March 5, 1989.
Announcement card.
Folded. Offset lithograph. Printed on both sides.
Folded: .25 x 9.25 inches.
Unfolded: .25 x 18.5 inches.

1269. MAURIZIO NANNUCCI
THERE'S NO REASON TO BELIEVE THAT ART
EXISTS. MAURIZIO NANNUCCI/NEON.
Insam Gleicher Gallery, Chicago, Ill.
December 14, 1990–January 26, 1991.
Announcement card/1991 calendar.
Offset lithograph on plastic.
Printed on both sides.
3.5 x 2.25 inches.

1270. MAURIZIO NANNUCCI
MAURIZIO NANNUCCI / NOT NECESSARILY
A MONOLOGUE.
Galleria Victoria Miro, Florence, Italy.
April 11–May 25, 1991.
Announcement card in envelope.
Folded and glued. Offset lithograph.
Printed on both sides.
Card folded: 3.25 x 5 inches.
Envelope: 3.5 x 5.5 inches.

1271. MAURIZIO NANNUCCI
YOU CAN IMAGINE THE OPPOSITE. MAURIZIO
NANNUCCI / LEHNBACHHAUS MÜNCHEN 1991.
Städtische Galerie im Lenbachhaus, Munich,
Germany. September 11–November 3, 1991.
Announcement card.
Offset lithograph? Printed on both sides.
4 die-cut holes.
5.75 x 8.25 inches.
Note: 2 versions in blue and red.

1272. MAURIZIO NANNUCCI
3PIÙ2FA5. MAURIZIO NANNUCCI /
ROSSOPURO BLUPURO GIALLOPURO.
Massimo Minini, Brescia, Italy. Opening
November 5, 1991.
Announcement card.
Offset lithograph. Printed on both sides.
4.25 x 6.5 inches.

1273. MAURIZIO NANNUCCI
COLLECTORS ARE WELCOME. MAURIZIO
NANNUCCI & MASSIMO MININI.
Massimo Minini, Brescia, Italy. Opening
November 5, 1991.
Announcement card.
Offset lithograph. Printed on both sides.
4.25 x 6.5 inches.

1274. MAURIZIO NANNUCCI
BLENDING THE VISIBLE WITH THE INVISIBLE.
WESTERN FRONT 20TH ANNIVERSARY
1973/1993.
Western Front, Vancouver, B.C., Canada. 1993.
Announcement card/1993 calendar.
Offset lithograph on plastic.
Printed on both sides.
2.25 x 3.25 inches.

1275. MAURIZIO NANNUCCI
MAURIZIO NANNUCCI / DOUBLE TRUTH.
Galerie Fahnemann, Berlin, Germany.
September 27–October 25, 1997.
Announcement card.
Offset lithograph. Printed on both sides.
4 x 8.25 inches.

1276. BRUCE NAUMAN
Bruce Nauman - 6 day week - 6 sound problems.
Konrad Fischer, Düsseldorf, Germany.
July 10–August 8, [1968].
Announcement card.
Offset lithograph. Printed on both sides.
4.25 x 8.5 inches.
Reference: Szeemann.

1277. BRUCE NAUMAN
Imagine Contrived Situations. Contrive Imagined
Situations.
[Self-published?]. [1968?].
2 postcards stapled together.
Silkscreen? Printed on both sides.
5 x 7 inches.

1278. BRUCE NAUMAN
SNAF. BRUCE NAUMAN.
Wide White Space, Antwerp, Belgium.
Opening March 8, 1974.
Announcement card.
Offset lithograph. Printed on both sides.
4 x 5.75 inches.
Reference: Wide White Space, p. 322.

1279. PAUL NEAGU
"GOING TORNADO" EVENT. BY PAUL NEAGU
c/o GENERATIVE ART GROUP.
Richard Demarco, Edinburgh, Scotland.
February 22, 1975.
Poster.
Folded. Offset lithograph. 1 rubber stamp.
Unfolded: 22 x 15 inches.
Reference: Out of Actions, p. 327.

1280. PAUL NEAGU
P. HONEYSUCKLE. a fictitious name for P.
NEAGU (from the story of the Generative
Arts Group).
The Richard Demarco Gallery, Edinburgh,
Scotland. February 22–March 12, 1975.
Poster.
Folded. Offset lithograph. Printed on both sides.
1 rubber stamp.
Unfolded: 22 x 15 inches.

1281. PAUL NEAGU
PAUL NEAGU. performing 'GRADUALLY GOING
TORNADO'.
Arnolfini Gallery, Bristol, England.
March 20, 1976?
Poster.
Folded. Offset lithograph. 1 rubber stamp.
Unfolded: 25.25 x 17.75 inches.
Reference: Out of Actions, pp. 327–28.

1282. PAUL NEAGU
PAUL NEAGU. HYPHEN-RAMP.
Serpentine North Gallery, [London, England].
December 5–12, 1976.
Poster.
Folded.
Offset lithograph. 1 rubber stamp.
Unfolded: 25.25 x 17.75 inches.
Reference: Out of Actions, pp. 326–27.

**1283. NICE STYLE (GARY CHITTY/
ROBIN FLETCHER/BRUCE MCLEAN/
PAUL RICHARDS)**
NICE STYLE-the World's first Pose Band.
Pose International Productions, London, England.
1973.
Postcard.
Offset lithograph. Printed on both sides.
Photograph by Peter Mackertich.
5.25 x 7.5 inches.
Reference: Out of Actions, p. 221.

**1284. NICE STYLE (GARY CHITTY/
ROBIN FLETCHER/BRUCE MCLEAN/
PAUL RICHARDS)**
NICE STYLE. "GRAB IT WHILE YOU CAN".
Sonja Heine–Niels Onstad Foundations, Oslo,
Norway. N.d.
Postcard.
Offset lithograph. Printed on both sides.
5.25 x 7.5 inches.

1285. RICHARD NONAS
Richard Nonas. Rochester Surround 3 days/3 ways.
University of Rochester, Rochester, N.Y.
November 15, 16, 17, 1971.
Poster.
Offset lithograph.
12 x 18 inches.

1286. RICHARD NONAS
Richard Nonas.
112 Greene, [New York, N.Y.].
December 2–14, [1972].
Announcement card.
Offset lithograph.
8.75 x 6.25 inches.

1287. RICHARD NONAS
ROOMS P.S.1.
Institute for Art and Urban Resources, P.S. 1,
Long Island City, N.Y. June 10–26, 1976.
Poster.
Folded. Offset lithograph.
Photograph by Peter Davis.
Unfolded: 22.5 x 24.75 inches.

1288. RICHARD NONAS
GOATSITCH. RICHARD NONAS. NARRATIVE
WORK/SCULPTURE/DRAWING/SOUND-TAPE.
Franklin Furnace, New York, N.Y.
September 17–October 16, 1982.
Poster.
Folded. Offset lithograph.
Unfolded: 23.5 x 16.25 inches.

1289. RICHARD NONAS
RICHARD NONAS. SMALL SCULPTURE / SOME
DRAWING.
Jack Tilton Gallery, New York, N.Y.
November 15–December 10, [1983].
Announcement card.
Folded. Offset lithograph
Unfolded: 8.75 x 12 inches.

1290. RICHARD NONAS
CRUDE THINKING/RICHARD NONAS.
Lunds Konsthall, Lund, Sweden.
September 2–October 22, 1995.
Poster.
Offset lithograph.
27.5 x 39.25 inches.

1291. RICHARD NONAS
JACK THIBEAU READS POETRY ON MAY 8 [. . .].
The Dance Gallery, New York, N.Y. N.d.
Announcement card.
Offset lithograph.
6.25 x 8.75 inches.

1292. RICHARD NONAS
THE NATURAL HISTORY OF THE AMERICAN
DANCER. LESSER KNOWN SPECIES. VOL. 4.
CH. 12-24. COMPILED BY BARBARA LLOYD.
Whitney Museum of American Art, New York, N.Y.
N.d.
Poster.
Offset lithograph. Printed on both sides.
11.5 x 11 inches.

1293. RICHARD NONAS
EMERGENCY FIRE PERFORMANCE.
Lower Manhattan Ocean Club, New York, N.Y.
N.d.
Poster.
Offset lithograph.
17.5 x 22.5 inches.

1294. JIM NUTT
Phyllis kind Gallery presents J. Nutt.
Phyllis Kind Gallery, Chicago, Ill.
Opening June 3, [1970].
Poster.
Folded. Offset lithograph.
Unfolded: 21.75 x 17 inches.

1295. JIM NUTT
phyllis kind gallery does it again! an exhibition of
paintings By Jim Nutt.
Phyllis Kind Gallery, Chicago, Ill. Opening
April 1, [1972].
Announcement card.
Offset lithograph. Printed on both sides.
11 x 8.5 inches.

1296. JIM NUTT
JIM NUTT.
Phyllis Kind Gallery, Chicago, Ill. Opening
October 24, 1975.
Announcement card.
Offset lithograph. Printed on both sides.
4.75 x 9.25 inches.

1297. CLAES OLDENBURG
DRAWINGS SCULPTURES. THE STREET. CLAES
OLDENBURG.
Reuben Gallery, New York, N.Y. Opening
May 6, [1960].
Flyer.
Folded. Offset lithograph. Printed on both sides.
Unfolded: 9 x 13 inches.
Reference: Oldenburg, p. 62.

1298. CLAES OLDENBURG
NEW MEDIA-NEW FORMS IN PAINTING AND
SCULPTURE.
Martha Jackson Gallery, New York, N.Y.
June 6–24, 1960.
Poster.
Folded. Offset lithograph.
Unfolded: 22 x 17.25 inches.
Reference: Oldenburg, p. 65.

1283.

1286.

1291.

1293.

1295.

1300.

1303.

1305.

1306.

1307.

1310.

1299. CLAES OLDENBURG
aileen passloff and dance company.
[Aileen Pasloff, New York, N.Y].
February 5, [1961].
Poster.
Folded. Offset lithograph on brown Kraft paper.
Unfolded: 14 x 10 inches.
Reference: Oldenburg, p. 67.

1300. CLAES OLDENBURG
RAY GUN THEATER. PROD. C. OLDENBURG.
SCHEDULE WINTER-SPRING 1962.
[Self-published], New York, N.Y. 1962.
Announcement card.
Offset lithograph. Printed on both sides.
3.75 x 5.75 inches.
Reference: Oldenburg, p. 81.

1301. CLAES OLDENBURG
RAY GUN THEATER. PROD. C. OLDENBURG.
SCHEDULE WINTER-SPRING 1962.
[Self-published], New York, N.Y. 1962.
Announcement card.
Offset lithograph. Printed on both sides.
3.75 x 5.75 inches.
Reference: Oldenburg, p. 82.

1302. YOKO ONO
INSTRUCTIONS FOR POEM No. 81. by Yoko
Ono. first performed by Tony Cox. Summer, 1963.
Instructions for Poem No. 86.
[Self-published]. 1963.
2 scores/birth announcement in envelope.
Folded. 3 leaves. Offset lithograph.
Unfolded: 9 x 2.5 inches and 9 x 2.25 inches.
Envelope: 8 x 3.25 inches.
Reference: Ono, pp. 309–10.

1303. YOKO ONO
DRAW CIRCLE [. . .].
[Self-published]. 1964.
Card.
Offset lithograph.
3.75 x 8.5 inches.
Reference: Ono, pp. 311–12.

**1304. OPENINGS PRESS/AUGUSTO DE
CAMPOS/JEFFREY STEELE**
Opening number 2. event/poet: Augusto de
Campos / artist: Jeffrey Steele.
[Openings Press], Gloucestershire, England.
1965?
Card.
Folded. Offset lithograph.
Edition of 500 copies. Numbered.
Editor: John Furnival.
Folded: 9 x 4.5 inches. Unfolded: 9 x 9 inches.

1305. GENESIS P-ORRIDGE
["TIME TRANSFIXED"]. "jusqu'a la balle crystal".
Self-published. 1975.
Postcard.
Offset lithograph. Printed on both sides.
[Edition of 500 copies].
5.75 x 4 inches.
Reference: Coum, p. 6.11.

1306. NAM JUNE PAIK
EXPERIMENTAL COLOUR T V EXPERIMENT.
Nam June PAIK. Shuya Abe (technic).
Cybernetic Art Studio, New York, N.Y.
August 1964.
Flyer.
Folded. Offset lithograph? "PAIK ROBOT" is
written in felt pen. 1 rubber stamp on the verso.
Unfolded: 11 x 8.5 inches.

1307. NAM JUNE PAIK
g.brecht.d.higgins.a.knowles.c.moorman.n.j.
paik.d.rot
will/just/drink/or/perhaps/do/something/or/not[. . .].
Museum College of Art, Philadelphia, Penn.
October 16, 1965.
Announcement card.
Offset lithograph.
1.25 x 3.25 inches.

1308. NAM JUNE PAIK
World first VIDEO-TAPE MONTHLY MAGAZINE.
by NAM JUNE PAIK.
Self-published? [1966].
Flyer.
Folded. Offset lithograph.
Unfolded: 11 x 8.5 inches.

1309. NAM JUNE PAIK
FLUXSONATA BY NAM JUNE PAIK.
[George Maciunas, New York, N.Y].
March 17, [1973].
2 flyers.
Offset lithograph.
Designed by George Maciunas.
11 x 8.5 inches each.
Reference: Fluxus Etc., p. 354.

1310. NAM JUNE PAIK
Channel 13 WNET TV New York Nov 3
Wednesday 11 PM - 11.30 PM. A TRiBute to
JoHN CAGE. by Nam June Paik.
Artists Video Tapes, Electronic Arts Intermix, Inc.,
New York, N.Y. November 3, 1976.
Poster.
Folded. Offset lithograph. Printed on both sides.
Unfolded: 19.5 x 13 inches.

1311. NAM JUNE PAIK
Dear J. Cage! Do you want to be a cow in
Holland? or a cow in Switzerland? (N.J. PAIK).
[Self-published?]. N.d.
Poster.
Folded. Mimeograph?
Unfolded: 14.25 x 10.25 inches.

1312. NAM JUNE PAIK
"John-Cage - for - PULIZER-PRIZE,,. Committee
N.J. PAIK. "John-Cage - NOT - for PULITZER-
PRIZE,,. Committee N.J. PAIK.
[Self-published?]. N.d.
Card.
Folded. Offset lithograph. Printed on both sides.
Unfolded: 5.5 x 8.5 inches.

1313. PANAMARENKO
OPGEPAST ! BOCHTEN! BLIJF OP HET
VOETPAD! PANAMARENKO MULTIMILLIONAIR.
Wide White Space Gallery, Antwerp, Belgium.
November 24–December 20, [1967].
Poster.
Folded. Offset lithograph.
Unfolded: 22.75 x 30 inches.
Reference: Wide White Space, p. 243.

1313.1. MICHEL PARMENTIER
See Daniel Buren/Olivier Mosset/Michel
Parmentier/Niele Toroni.

1313.2. FELIX PARTZ
See General Idea.

1314. IZHAR PATKIN
IZHAR PATKIN. "The perfect existence in
the rose garden".
Rena Bransten Gallery, San Francisco, Calif.
April 5–30, [1988].
Announcement.
Offset lithograph on Chinese joss paper.
7.5 x 8.25 inches.

1315. IZHAR PATKIN
IZHAR PATKIN. Don Quijote Segunda Parte.
Holly Solomon Gallery, New York, N.Y.
May 3–June 3, [1989].
Announcement.
Silkscreen on envelope. The envelope contains a
metal medallion with a ribbon strung through it.
Envelope: 4.5 x 5.5 inches.
Medallion diameter: 1.5 inches.

1316. IZHAR PATKIN
Izhar Patkin. "Judenporzellan".
Holly Solomon Gallery, New York, N.Y.
May 2–June 13, [1008].
Announcement.
Folded. Offset lithograph and watercolor.
Printed on both sides.
Folded: 5.5 x 4.25 inches.
Unfolded: 10.75 x 8.5 inches.

1317. IZHAR PATKIN
You are invited to an exhibition of new work by Izhar
Patkin. A suite of eight paintings "The Exile," [. . .].
Holly Solomon Gallery, New York, N.Y. N.d.
Announcement.
Folded. Silkscreen and watercolor.
Folded: 5.5 x 4 inches.
Unfolded: 10.75 x 8.25 inches.

1318. A. R. PENCK
ACCROCHAGE.
[Galerie Michael Werner, Cologne, Germany].
1987.
Poster.
Folded. Offset lithograph. Printed on both sides.
Unfolded: 16.25 x 22.25 inches.

1319. RAYMOND PETTIBON
BLACK FLAG. FEAR. STAINS. YOUTH GONE
MAD. CaUsTic caUsE. DEVONSHIRE DOWNS.
[Black Flag. SST Records]. N.d.
Flyer.
Photocopy.
11 x 8.5 inches.

1320. RAYMOND PETTIBON
BLACK FLAG. At the Starwood. w/ Eddie & the
Subtitles and the Minutemen.
[Black Flag. SST Records]. N.d.
Flyer.
Photocopy.
11 x 8.5 inches.

1321. RAYMOND PETTIBON
BLACK FLAG. DOA. SACCHARINE TRUST.
Overkill. at the Elite Club.
[Black Flag. SST Records]. N.d.
Flyer.
Photocopy.
11 x 8.5 inches.
Reference: Fucked Up + Photocopied, p. 36.

1322. RAYMOND PETTIBON
BLACK FLAG. ZZZZZZZZZ.
[Black Flag. SST Records]. N.d.
Flyer.
Photocopy.
11 x 8.5 inches.

1323. RAYMOND PETTIBON
BLACK FLAG. TURN ON TUNE IN DROPOUT.
AT THE MABUHAY.
[Black Flag. SST Records]. N.d.
Flyer.
Photocopy.
11 x 8.5 inches.

1324. RAYMOND PETTIBON
BLACK FLAG. FLIPPER. MINUTEMEN. Stains.
10th street hall.
[Black Flag. SST Records]. N.d.
Flyer.
Photocopy.
11 x 8.5 inches.

1325. RAYMOND PETTIBON
BLACK FLAG. WITH: NO ALTERNATIVE,
IMPATIENT YOUTH, NUBS. RAT'S PALACE.
[Black Flag. SST Records]. N.d.
Flyer.
Photocopy.
11 x 8.5 inches.

1326. RAYMOND PETTIBON
BLACK FLAG. UXA. ADOLESENTS [sic].
SCREWS. AT BACES Hall.
[Black Flag. SST Records]. N.d.
Flyer.
Photocopy.
11 x 8.5 inches.

1327. RAYMOND PETTIBON
THROBBING GRISTLE. FLIPPER. Kezar Pavillion.
[Black Flag. SST Records]. N.d.
Flyer.
Photocopy.
11 x 8.5 inches.
Reference: Fucked Up + Photocopied, p. 42.

1328. MICHELANGELO PISTOLETTO
ONE YEAR PROGRAM. 12 one-man shows of
PISTOLETTO. first three exhibitions.
Galleria Christian Stein, Turin, Italy. 1975.
Exhibition brochure.
Folded. Offset lithograph?
Folded: 9 x 4.5 inches. Unfolded: 9 x 13 inches.

1329. LUCIO POZZI
A MONTH OF SUNDAYS.
Institute for Art and Urban Resources, P.S. 1,
Project Studios One, Long Island City, Queens,
N.Y. September 19, September 26, October 3,
October 10, 1976.
Poster.
Folded. Offset lithograph. Printed on both sides.
Unfolded: 22.5 x 16.5 inches.

1317.

1318.

1320.

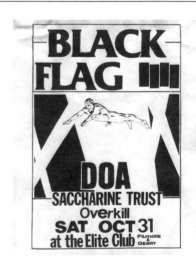

1321.

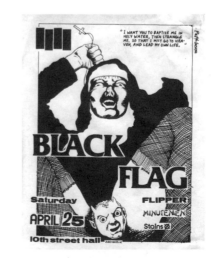

1324.

1329.

1330.

1337.

1340.

1344.

1330. LUCIO POZZI
LUCIO POZZI. 4 WINDOWS. First Stage.
White Paint. P.S. 1.
[Self-published]. January 9–February 1, 1977.
Announcement card.
Offset lithograph. Printed on both sides.
4 x 6 inches.

1331. LUCIO POZZI
LUCIO POZZI. 4 WINDOWS. Second Stage.
Red Paint. P.S. 1.
[Self-published]. February 6–March 1, 1977.
Announcement card.
Offset lithograph. Printed on both sides.
4 x 6 inches.

1332. LUCIO POZZI
LUCIO POZZI. 4 WINDOWS. Third Stage.
Green Paint. P.S. 1.
[Self-published]. March 6–30, 1977.
Announcement card.
Offset lithograph. Printed on both sides.
4 x 6 inches.

1333. LUCIO POZZI
LUCIO POZZI. 4 WINDOWS. Fourth Stage.
Yellow Paint. P.S. 1.
[Self-published]. April 3–26, 1977.
Announcement card.
Offset lithograph. Printed on both sides.
4 x 6 inches.

1334. LUCIO POZZI
LUCIO POZZI. 4 WINDOWS. Fifth Stage.
Blue Paint. P.S. 1.
[Self-published]. May 1–June 1, 1977.
Announcement card.
Offset lithograph. Printed on both sides.
4 x 6 inches.

1335. LUCIO POZZI
LUCIO POZZI. 4 WINDOWS. Sixth Stage.
Black Paint. P.S. 1.
[Self-published]. June 5–30, 1977.
Announcement card.
Offset lithograph. Printed on both sides.
4 x 6 inches.

1336. LUCIO POZZI
Lucio Pozzi. double and triple, Hangovers,
Turnovers, Teas, Side Relocations, Swirls.
Young Hoffman Gallery, Chicago, Ill.
April 13–May 9, 1979.
Announcement card.
Offset lithograph. Printed on both sides:
2 die-cut circles.
5.75 x 8.75 inches.

1336.1. TOM PUCKEY
See Reindeer Werk.

1337. ARNULF RAINER
RAINER.
Galerie Rewolle, Bremen, Germany. April 1969.
Poster.
Folded. Offset lithograph.
Unfolded: 22 x 16.5 inches.

1338. ARNULF RAINER
A. RAINER.
Kunstverein, Hamburg, Germany.
March 26–April 25, 1971.
Poster.
Folded. Offset lithograph.
Unfolded: 33 x 23.25 inches.

1339. ARNULF RAINER
A. RAINER.
Galerie Zwirner, Cologne, Germany.
March 21–May 13, 1979.
Poster.
Folded. Offset lithograph.
Unfolded: 33 x 22.75 inches.

1340. ARNULF RAINER
Arnulf Rainer. Mort et sacrifice.
Centre National d'Art et de Culture Georges
Pompidou, [Paris, France].
February 1–March 26, 1984.
Announcement card.
Folded. Offset lithograph. Printed on both sides.
Folded: 3 x 8.25 inches.
Unfolded: 3 x 16.5 inches.

1341. ARNULF RAINER
ARNULF RAINER. Målningar 1980-90.
Malmö Konsthall, Malmö, Sweden.
February 9–April 1, 1991.
Announcement card.
Offset lithograph. Printed on both sides.
10.75 x 7.5 inches.

1342. ARNULF RAINER
ARNULF RAINER.
Galerie Stadler, Paris, France.
November 23, 1991–January 18, 1992.
Announcement card.
Offset lithograph.
8.25 x 4 inches.

1343. ROBERT RAUSCHENBERG
ROBERT RAUSCHENBERG.
Dwan Gallery, Los Angeles, Calif.
March 1–31, [1962].
Poster.
Folded. Offset lithograph.
Unfolded: 20 x 17 inches.

1344. ROBERT RAUSCHENBERG
RAUSCHENBERG.
The Miami Herald Publishing Company, Miami,
Fla. December 30, 1979.
Periodical cover for *TROPIC* magazine
(December 30, 1979).
Folded sheet. Offset lithograph.
Edition of approximately 650,000 copies.
Folded: 12.5 x 10.75 inches.
Unfolded: 12.5 x 21.5 inches.

1345. ROBERT RAUSCHENBERG
ROBERT RAUSCHENBERG. 3 OF THE
CLOISTER SERIES.
Ace, Los Angeles, Calif. Opening April 24, [1980].
Poster.
Folded. Offset lithograph.
Unfolded: 27 x 32 inches.

1346. ROBERT RAUSCHENBERG
RAUSCHENBERG ON GREENE ST.
Castelli + Sonnabend Gallery, New York, N.Y.
January [1983].
Poster.
Folded. Offset lithograph.
Unfolded: 12.25 x 10 inches.

1347. ROBERT RAUSCHENBERG
TIBETAN LOCKS + KEYS. RAUSCHENBERG.
Castelli Graphics, New York, N.Y.
Opening May 21, [1987].
Poster.
Folded. Offset lithograph.
Unfolded: 20 x 29.75 inches.

1348. ROBERT RAUSCHENBERG
FOR TRISHA BROWN DANCE CO.
Castelli, New York, N.Y. N.d.
Poster.
Folded. Offset lithograph.
Unfolded: 15.25 x 22 inches.

1349. ROBERT RAUSCHENBERG
RAUSCHENBERG. 2ND WEEK.
Castelli, [New York, N.Y.], N.d.
Poster.
Folded. Offset lithograph.
Unfolded: 22.5 x 17.5 inches.

1350. ROBERT RAUSCHENBERG
RAUSCHENBERG.
Linda Farris Gallery, Seattle, Wash. N.d.
Poster.
Folded. Offset lithograph.
Unfolded: 25.5 x 24.5 inches.

1351. MARTIAL RAYSSE
1964 meilleurs vœux. martial raysse.
[Self-published?]. [1963].
New Year's card.
Folded. Offset lithograph. Printed on both sides.
Folded: 2.5 x 4 inches.
Unfolded: 2.5 x 8.25 inches.

1352. MARTIAL RAYSSE
Advertisement.
The Village Voice, New York, N.Y.
February 19, 1970.
Artist's advertisement in *The Village Voice*
(February 19, 1970, p. 61).
Folded. Offset lithograph on newsprint.
Unfolded: 16.75 x 11.25 inches.

1353. REINDEER WERK (DIRK LARSEN/ TOM PUCKEY)
WASCHUNG VAN CONCEPTS. ASSOCIATES MIT DIE GRÜNEN. AT: WERKSTADT ODEM.
[Self-published?]. 1980.
Poster.
Folded. Offset lithograph.
16.5 x 11.5 inches.

1354. REINDEER WERK (DIRK LARSEN/ TOM PUCKEY)
REINDEER WERK. The Regality of Glass & the King of Ireland. Emperors of Migration [. . .].
Academie voor Beeldende Kunst, Onderlangs, Arnhem, The Netherlands.
Opening December 18, 1980.
Announcement/sticker.
Offset lithograph.
3.75 x 2.75 inches.

1355. REINDEER WERK (DIRK LARSEN/ TOM PUCKEY)
KÖNIG HUND. REINDEER WERK.
Galerie Moltkerei, Cologne, Germany.
June 12–18, 1981.
Poster.
Folded. Offset lithograph.
Unfolded: 24 x 14.75 inches.

1356. REINDEER WERK (DIRK LARSEN/ TOM PUCKEY)
Reindeer Werk. DER ZWEITE KONSTRUKTIONS-ZUSTAND DES ARBLIQUELIA: EINE NEUE ART FRAGEN ZU STELLEN.
Beuys/FIU Raum + Eingangshalle, Kunstakademie Düsseldorf, Düsseldorf, Germany. 1981.
Poster.
Folded. Offset lithograph.
Unfolded: 32.75 x 23.25 inches.

1357. REINDEER WERK (DIRK LARSEN/ TOM PUCKEY)
Reindeer Werk. Tom Puckey / Dirk Larsen. Gesellschaft der Prediction. Documenta VII. Zentrum der Freien Internationalen Universität bei der Orangerie, Kassel, Germany.
August 2–5, 1982.
Poster.
Folded. Silkscreen.
Unfolded: 31 x 21.5 inches.

1358. REINDEER WERK (DIRK LARSEN/ TOM PUCKEY)
I LIKE THE CORNERS. REINDEER WERK [. . .].
[Self-published, London, England?]. N.d.
Poster.
Folded. Silkscreen.
Unfolded: 30 x 19.75 inches.

1359. JASON RHOADES
JASON RHOADES. "SWEDISH EROTICA AND FIERO PARTS".
Rosamund Felsen Gallery, Los Angeles, Calif.
March 19–April 16, 1994.
Announcement card.
Offset lithograph. Printed on both sides.
4 x 6 inches.

1359.1. PAUL RICHARDS
See Nice Style.

1360. JAMES RIDDLE
LOOK-WITHIN.
Self-published, West Point, Va. 1973.
Event score.
Offset lithograph.
Edition of 200 copies. Signed and numbered.
7 x 7 inches.

1361. JAMES RIDDLE
HOME. PLEASE GO HOME.
[Self-published]. N.d.
Event score.
Offset lithograph. Printed on both sides.
5 x 6.25 inches.

1362. JAMES RIDDLE
TARGET. I OBJECT. II EVENT.
[Self-published]. N.d.
Event score.
Offset lithograph.
8.5 x 11 inches.

1363. JUDY RIFKA
JUDY RIFKA. PAINTINGS.
Brooke Alexander Inc., New York, N.Y.
February 12–March 12, 1983.
Poster.
Folded. Silkscreen on newsprint.
Unfolded: 18 x 11.75 inches.

1364. LARRY RIVERS
RiverS 1960-1963.
Dwan, [Los Angeles, Calif.]. Opening April 15, [1963].
Announcement card.
Offset lithograph.
9 x 9 inches.

1365. LARRY RIVERS
LARRY RIVERS. WORKS WITH PAPER THEN AND NOW.
Marlborough Gallery, New York, N.Y.
January 8–February 5 (1977?).
Flyer.
Folded. Photocopy.
Unfolded: 8.25 x 14 inches.

1353.

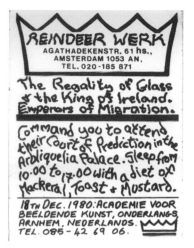

1354.

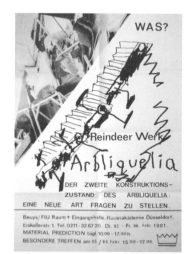

1356.

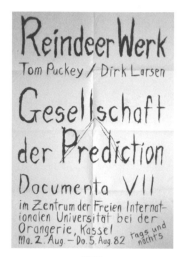

1357.

1360.

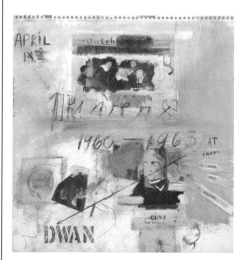

1364.

1368. 1371.

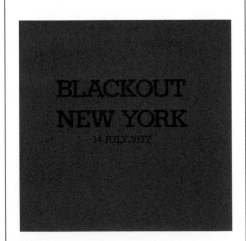

drfrd

1373.

AIDS — assistance, advocate, save,
assist, secours, socorro, ayuda, help,
stand-by, accommodation, ally, lift,
succor, recourse, service, resource,
benefit, friend, helping hand, rally,
care, subsidy, relief, humanitarian,
co-operation, sustenance, support

1374.

BLACKOUT
NEW YORK
14 JULY 1977

1379. 1381.

1366. LARRY RIVERS
Larry Rivers.
Robert Miller Gallery, New York, N.Y.
Opening October 25, 1977.
Poster.
Folded. Offset lithograph.
Unfolded: 23.25 x 21.75 inches.

1367. LARRY RIVERS
RETROSPECTIVE. LARRY RIVERS 1954 - 1979.
Staatliche Kunsthalle, Berlin, Germany.
March 7–April 18, 1982.
Poster.
Folded. Offset lithograph.
Unfolded: 33 x 22.5 inches.

1368. DOROTHEA ROCKBURNE
Dorothea Rockburne.
Bykert Gallery, New York, N.Y.
December 5, 1970–January 6, 1971.
Announcement card.
Offset lithograph. Printed on both sides.
7 x 8.5 inches.

1369. DOROTHEA ROCKBURNE
Dorothea Rockburne.
Bykert Gallery, New York, N.Y.
Opening January 8, 1972.
Announcement card.
Offset lithograph. Printed on both sides.
8.25 x 10 inches.

1370. DOROTHEA ROCKBURNE
Dorothea Rockburne. twelve works on paper.
Series Carta Carbone. Bari, Italy, 1972.
Marilena Bonomo, Bari, Italy.
Opening November 7, 1972.
Announcement card.
Folded. Offset lithograph and carbon printing.
A piece of carbon paper is mounted on the
inside left of the card.
Folded: 5.75 x 5.75 inches.
Unfolded: 5.75 x 11.5 inches.

1370.1. JAN ROELAND
See Cafe Schiller/Jan Roeland.

1371. NIGEL ROLFE
CHALLENGE. I WANT TO CHALLENGE: THE
WAY PUBLIC SPACE IS USED TO PRESENT ART
WORK. NIGEL ROLFE. DUBLIN 1978.
[Self-published?]. 1978.
Card.
Offset lithograph.
8.25 x 5.75 inches.

1372. KAY ROSEN
aacCllooss. Kay Rosen, a colossal C, 1989.
[Self-published]. 1989.
Christmas card.
Offset lithograph. Printed on both sides.
4 x 6 inches.

1373. KAY ROSEN
d r f r d. Kay Rosen, Dr. Freud.
[Self-published]. 1990.
Card.
Offset lithograph. Printed on both sides.
6 x 4 inches.

1374. KAY ROSEN
Kay Rosen, "AIDS".
The Museum of Contemporary Art, Los Angeles,
Calif. Otis Gallery, Otis College of Art and Design,
Los Angeles, Calif. Opening December 1, 1998.
Poster/handout.
Folded. Offset lithograph.
Unfolded: 11 x 17 inches.

1375. MARTHA ROSLER
season's greetings from our house to your
house. 5'4" x 119 lbs. framed & reframed.
[Self-published]. Christmas card/photographic postcard.
Rubber stamped "martha rosler" on the verso.
3.5 x 7 inches.

1376. ALLEN RUPPERSBERG
Al's Grand Hotel.
[Self-published]. [1971].
Stationery and envelope.
Offset lithograph.
Stationery: 10.5 x 7.25 inches.
Envelope: 4 x 7.5 inches.
Reference: Ruppersberg, p. 104.

1377. ALLEN RUPPERSBERG
Al's Cafe (reheated) by Allen Ruppersberg.
A Gala Ten Year Anniversary Celebration.
Rosamund Felsen Gallery, Los Angeles, Calif.
September 28–29, 1979.
Announcement card.
Offset lithograph.
4.25 x 6 inches.
Reference: Ruppersberg, p. 114.

1377.1. ALLEN RUPPERSBERG
See also Art & Project/Allen Ruppersberg;
Institute for Art and Urban Resources/Allen
Ruppersberg.

1378. EDWARD RUSCHA
REJECTED Oct. 2, 1963 by the Library of
Congress Washington 25, D.C.
Artforum, San Francisco, Calif. March 1964.
Artist's advertisement in the periodical Artforum
(vol. 2, no. 9 [March 1964], p. 55).
Offset lithograph.
5 x 2.25 inches.
Reference: Ruscha, No. M6.

1378.1. FRED SANDBACK
See Institute for Art and Urban Resources/Fred
Sandback.

1379. SARKIS
BLACKOUT NEW YORK 14 JULY 1977.
Artforum, New York, N.Y. 1977.
Advertisement order form.
Offset lithograph. Printed on both sides.
6.25 x 6.25 inches.

1380. PETER SAUL
Peter Saul. New Pictures.
Sacramento State College, Sacramento, Calif.
Opening March 10, [1968?].
Poster.
Folded. Offset lithograph.
Unfolded: 24 x 18 inches.

1381. PETER SAUL
"Castro's Mother Invades U.S.A." and related drawings.
Drawing Gallery, Frumkin/Adams Gallery,
New York, N.Y. March 21–April 21, 1995.
Announcement card.
Offset lithograph.
5.5 x 7.5 inches.

1382. CAROLEE SCHNEEMANN
MEAT JOY. BY Carolee Schneemann. Kinetic EYE
BODY Theatre.
Judson Memorial Church, New York, N.Y.
November 16, 17, 19, 1964.
Flyer.
Offset lithograph.
14.25 x 8.75 inches.

1383. CAROLEE SCHNEEMANN
TONE ROADS presents A CONCERT OF 20th
CENTURY AMERICAN MUSIC.
The New School for Social Research, New York,
N.Y. June 4, 1965.
Poster.
Folded. Offset lithograph.
Unfolded: 13.25 x 9.5 inches.

1384. CAROLEE SCHNEEMANN
WATER LIGHT. WATER NEEDLE. by CAROLEE
SCHNEEMANN. kinetic theater.
St. Mark's Church, New York, N.Y.
March 17, 18, 19, 20, 1966.
Flyer.
Offset lithograph.
9.5 x 15 inches.

1385. CAROLEE SCHNEEMANN
HOMERUNMUSE TEXT -SLIDES.
Franklin Furnace, New York, N.Y.
Opening January 9, 1979.
Announcement card.
Offset lithograph. Printed on both sides.
Photograph by Bill Thompson.
5.5 x 8 inches.

1385.1. CURTIS SCHREIER
See Ant Farm.

1386. PETER SCHUYFF
PETER SCHUYFF.
Anders Tornberg Gallery, Lund, Sweden.
February 6–March 3, 1993.
Announcement/sticker.
Offset lithograph.
8.25 x 5.75.

1387. SARAH SEAGER
experimental poster. DELUXE EDITION.
SARAH SEAGER. PROPOSALS.
1301, Santa Monica, Calif.
November 12–December 23, 1994.
Poster.
Folded. Offset lithograph.
Unfolded: 22.75 x 17.25 inches.

1388. JIM SHAW
I dreamed I was performing in an alternative
space in my Maidenform bra. JIM SHAW.
Rosamund Felsen Gallery, Santa Monica, Calif.
January 7–February 4, 1995.
Announcement card.
Offset lithograph. Printed on both sides.
4.25 x 6 inches.

1389. JIM SHAW
THE ARTIST WILL ATTEMPT TO SATISFY THE
DESIRES OF PATRONS [. . .]. JIM SHAW
(in residence).
Rosamund Felsen Gallery, Santa Monica, Calif.
August 13–24, 1996.
Announcement card.
Offset lithograph. Printed on both sides.
4.25 x 6 inches.

1389.1. KAREN SHAW
See Institute for Art and Urban Resources/Karen
Shaw.

1390. BONNIE SHERK
A LIVING LIBRARY IS A PARK OF THE FUTURE
FOR THE PRESENT [. . .].
[Self-published?]. 1983
2 flyers.
Folded. Offset lithograph. Printed on both sides.
1 rubber stamp on each.
Unfolded: 11 x 8.5 inches each.

1391. CINDY SHERMAN
Our spring/summer 94 collections arrive on
Thursday 20 January 1994.
Comme des Garçons, New York, N.Y. 1994.
Postcard.
Offset lithograph. Printed on both sides.
[Edition of 5,000 copies].
9 x 6.25 inches.

1392. CINDY SHERMAN
We have the pleasure in announcing new arrivals
from Comme des Garçons [. . .].
Comme des Garçons, New York, N.Y. 1994.
Postcard.
Offset lithograph. Printed on both sides.
[Edition of 5,000 copies].
9 x 6.25 inches.

1393. CINDY SHERMAN
New selections from our summer '94 collections
have arrived.
Comme des Garçons, New York, N.Y. 1994.
Postcard.
Offset lithograph. Printed on both sides.
[Edition of 5,000 copies].
9 x 6.25 inches.

1394. CINDY SHERMAN
An extensive selection of our fall-winter 94-95
collections awaits your next visit.
Comme des Garçons, New York, N.Y. 1994.
Poster.
Folded. Offset lithograph. Printed on both sides.
[Edition of 5,000 copies].
Unfolded: 20.25 x 14.25 inches.

1395. ALEXIS SMITH
ANTEROOM. ALEXIS SMITH.
Carp, Los Angeles, Calif. August 12–23, [1975].
Announcement card.
Offset lithograph. Printed on both sides.
8 x 6.5 inches.

1396. ALEXIS SMITH
ALEXIS SMITH. Rapido.
The Art Galleries, University of California, Santa
Barbara, Calif. November 4–16, 1975.
Announcement card.
Offset lithograph. Printed on both sides.
4 x 7.5 inches.

1397. ALEXIS SMITH
ALEXIS SMITH. "Tales of Mystery and
Enchantment."
Nicholas Wilder Gallery, Los Angeles, Calif.
January 21–March 5, [1976].
Announcement card.
Offset lithograph. Printed on both sides.
4 x 5.5 inches.

1382.

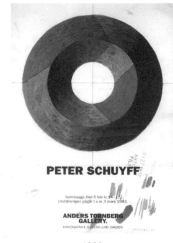

1386.

1387.

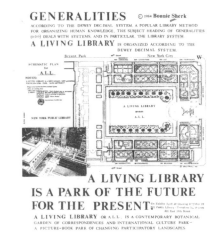

1390.

1392.

1397.

1400.

1401.

1404.

1405.

1410.

1413.

1398. ALEXIS SMITH
My life is an open book. Alexis Smith. Selected Works from 1972-1975.
Gallery 1, San Jose State University, San Jose, Calif. April 19–May 20, 1976.
Announcement card.
Offset lithograph. Printed on both sides.
3.5 x 5.5 inches.

1399. ALEXIS SMITH
ALEXIS SMITH. Star Material.
Mandeville Art Gallery, University of California, San Diego, La Jolla, Calif. October 7–31, 1976.
Announcement card.
Offset lithograph. Printed on both sides.
4 x 6 inches.

1400. ALEXIS SMITH
Alexis Smith.
Holly Solomon Gallery, New York, N.Y.
March 26–April 16, 1977.
Announcement card.
Offset lithograph. Printed on both sides.
5 x 7 inches.

1401. ALEXIS SMITH
card n. colloq. A remarkable person, usu. a prankster; a joker; a wit; a character. ALEXIS SMITH. (APRIL FOOLE).
Holly Solomon Gallery, New York, N.Y. [1978].
Announcement card.
Offset lithograph. Printed on both sides.
3.75 x 5.5 inches.

1402. ALEXIS SMITH
ALEXIS SMITH.
Rosamund Felsen Gallery, Los Angeles, Calif.
April 19–May 17, 1980.
Announcement card.
Offset lithograph and rubber stamp.
Printed on both sides.
4.25 x 6 inche.

1403. ALEXIS SMITH
Alexis Smith presents "U.S.A.".
Holly Solomon Gallery, New York, N.Y.
January 3–24, 1981.
Announcement card.
Folded. Printed on both sides.
Folded: 4.5 x 6.25 inches.
Unfolded: 9.25 x 6.25 inches.

1404. ALEXIS SMITH
The 4th International Contemporary Art Fair.
Los Angeles Convention Center.
Art L.A. 89. December 7–17, 1989.
Poster.
Folded. Offset lithograph.
Unfolded: 18 x 24 inches.

1405. KIKI SMITH
Kiki Smith.
MAK, Österreichisches Museum für Angewandte Kunst, [Vienna, Austria]. 1992.
Poster.
Folded. Silkscreen on handmade paper.
2 rubber stamps.
Unfolded: 18.75 x 29.5 inches.

1405.1. JEFFREY STEELE
See Openings Press/Augusto de Campos/ Jeffrey Steele.

1406. STELARC
EVENT FOR STRETCHED SKIN.
Maki Gallery, Tokyo, Japan. May 16, 1976.
Postcard.
Offset lithograph. Printed on both sides.
4 x 5.75 inches.

1407. STELARC
EVENT FOR INCLINED SUSPENSION.
Tamura Gallery, Tokyo, Japan. January 7, 1979.
Postcard.
Offset lithograph. Printed on both sides.
Photograph by Tamera Davis.
4 x 5.75 inches.
Reference: www.stelarc.va.com.au.

1408. STELARC
EVENT FOR SUPPORT STRUCTURE.
Tamura Gallery, Tokyo, Japan. July 9–15, 1979.
Postcard.
Offset lithograph. Printed on both sides.
Photograph by Yuichi Konno.
4 x 5.75 inches.
Reference: www.stelarc.va.com.au.

1409. STELARC
SITTING/SWAYING EVENT FOR ROCK SUSPENSION.
Tamura Gallery, Tokyo, Japan. May 11, 1980.
Postcard.
Offset lithograph. Printed on both sides.
Photograph by Kenji Nozawa.
4 x 5.75 inches.
Reference: www.stelarc.va.com.au.

1410. STELARC
TILTED/TWISTING EVENT FOR CONE CONFIGURATION.
Tamura Gallery, Tokyo, Japan. December 30, 1980.
Postcard.
Offset lithograph. Printed on both sides.
Photograph by Tadasu Yamamoto.
5.75 x 4 inches.

1411. STELARC
SEASIDE SUSPENSION: EVENT FOR WIND AND WAVES.
Jogashima, Tokyo, Japan. May 30, 1981.
Postcard.
Offset lithograph. Printed on both sides.
Photograph by Hiro Suzuki.
5.75 x 4 inches.

1412. STELARC
SCULPTURE SPACE SUSPENSION.
U.N.A.M., Mexico City, Mexico. August 16, 1981.
Announcement card.
Offset lithograph. Printed on both sides.
Photograph by Pablo Ortiz Monasterio.
4 x 5.75 inches.

1413. STELARC
DECA-DANCE.
Komai Gallery, Tokyo, Japan. November 15, 1981.
Postcard.
Offset lithograph. Printed on both sides.
Photograph by Shigeo Anzai.
4 x 5.75 inches.

1414. MICHELLE STUART
MICHELLE STUART. jordbilder, stenböcker.
Gallerie T, Lund, Sweden.
September 6–October 1, 1980.
Announcement card.
Offset lithograph. A stone is mounted on the card.
4 x 5.75 inches.

1415. MICHELLE STUART
NAVIGATING COINCIDENCE. MICHELLE
STUART. paintings & prints.
Anders Tornberg Gallery, Lund, Sweden.
February 14–March 11, 1987.
Announcement card.
Folded. Offset lithograph. A folded poster is
tipped in on the inside. A cardboard cutout is
mounted on the poster.
Card folded: 6.25 x 6.25 inches.
Card unfolded: 6.25 x 12.25 inches.
Poster untolded: 12.25 x 12.25 inches.

1416. ERNEST T.
31ème Championnat du Monde d'Échecs
Moscou, 10 septembre 1984 - 9 février 1985.
Anatoli Karpov, Garri Kasparov.
13ème Biennale de Paris, Paris, France.
March 21–May 21, 1985.
Announcement card.
Offset lithograph. Printed on both sides.
4 x .75 inches.

1417. ERNEST T.
Première série des peintures nulles d'Ernest T. à
partir du 13 mars 1986 à l'Atelier Schwarz [. . .].
[Self-published]. 1986?
Flyer.
Offset lithograph.
11.75 x 8.25 inches.
Reference: Ernest T., p. 10.

1418. ERNEST T.
Deuxième série des peintures nulles d'Ernest T. à
partir de juin 1986 chez Danae, Pouilly (Oise) [. . .].
[Self-published]. 1986?
Flyer.
Offset lithograph.
11.75 x 8.25 inches.
Reference: Ernest T., p. 10.

1419. ERNEST T.
Terza serie di dipinti nulli di Ernest T. dal 23 al 30
ottobre 1986 da Annamaria Di Cesare [. . .].
[Self-published]. 1986?
Flyer.
Offset lithograph.
11.75 x 8.25 inches.
Reference: Ernest T., p. 11.

1420. ERNEST T.
ERNEST T.'S WORKS DIRECTIONS FOR USE.
[Self-published]. 1986?
Flyer.
Offset lithograph.
11.75 x 8.25 inches.

1421. ERNEST T.
Ce 22 mai 1987 est le centenaire d"Arthur
Cravan. Il eut le grand avantage de disparaître
jeune. Actuellement se célèbrent les dix ans
d'existence du Centre Beaubourg. PERIL GRIS.
[Self-published]. 1987?
Flyer.
Offset lithograph.
11.75 x 8.25 inches.

1422. ERNEST T.
Vous êtes invités à ne pas attacher d'importance
au travail d'Ernest T. qu'Art & Cie a l'audace ou
plutôt l'inconscience de montrer [. . .].
[Self-published]. October 24, 1987.
Flyer.
Offset lithograph.
8.25 x 11.75 inches.

1423. ERNEST T.
Ernest T. versucht mit allen Mitteln sich eine
internationale Künstlerstatur zu geben. 1.
FORUM, Hamburg, Germany. Gabrielle Maubrie,
Paris, France. March 25–28, 1988.
Announcement card.
Offset lithograph. Printed on both sides.
4.25 x 5.25 inches.
Reference: Ernest T., p. 16.

1424. ERNEST T.
Ernest T. prova con tutti i mezzi di darsi
un'immagine di artista internazionale. 2.
Villa Redenta, Spoleto, Italy.
June 29–July 30, 1988.
Announcement card.
Offset lithograph. Printed on both sides.
4.25 x 6.5 inches.
Reference: Ernest T., p. 16.

1425. ERNEST T.
Ernest T. tries by all means, to achieve the status
of an international artist. 3.
ACCA, Australian Center for Contemporary Art,
Melbourne, Victoria, Australia. September
1–October 30, 1988.
Announcement card.
Offset lithograph. Printed on both sides.
4.25 x 6.25 inches.
Reference: Ernest T., p. 16.

1426. ERNEST T.
NAISSANCE DE LA CRITIQUE D'ART POST
APPROPRIATIVE. GUY FUNNY. Hotel des
Palmes, 17 novembre 1989.
Self-published. 1989?
Flyer.
Offset lithograph.
11.75 x 8.25 inches.

1427. ERNEST T.
Ernest T. essaie, par tous les moyens, de
devenir un artiste international. 5.
Galerie Eric Franck, Geneva, Switzerland.
November 10–December 22, 1990.
Announcement card.
Offset lithograph. Printed on both sides.
4 x 5.75 inches.
Reference: Ernest T., p. 16.

1428. ERNEST T.
Galerie Gabrielle Maubrie, Paris, France.
January 4–February 1, 1992.
Announcement card.
Offset lithograph. Printed on both sides.
5.5 x 4.25 inches.

1429. ERNEST T.
Ernest T. et son chevalet rassemblent autour d'eux
de jeunes admirateurs. Club du Capitaine Pip.
Espace Jules Verne, Brétigny-sur-Orge, France.
December 4, 1995.
Flyer.
Folded. Offset lithograph.
Unfolded: 8.25 x 11.75 inches.

1430. ERNEST T.
M. et Mme Dossilat, les sympathiques
collectionneurs de peintures d'Ernest T. Club du
Capitaine Pip.
Espace Jules Verne, Brétigny-sur-Orge, France.
January 15, 1996.
Flyer.
Folded. Offset lithograph.
Unfolded: 8.25 x 11.75 inches.

Première série des *peintures nulles* d'Ernest T.
à partir du 13 mars 1986 à l'Atelier Schwarz.

Notre système de valeurs a réussi la gageure
de transformer le consommateur moyen en
homme-sandwich permanent : il paie, cher,
l'«honneur» de porter des vêtements griffés.
L'artiste ne peut rester insensible à ce petit
mais significatif fait de société. Il sait que
dans le domaine de l'art, aucune intention
valorisante ne motive plus son travail parce
que les problèmes d'évolution et de régres-
sion ont été évacués, que tous les styles se
côtoient harmonieusement et que les notions
de qualité et de talent s'établissent sur des
normes floues et variables.
L'artiste qui veut se faire un nom n'a pas trou-
vé mieux que de peindre son nom.
On ne saurait voir dans ce travail le moindre
narcissisme puisqu'il n'est que la simple mise
en pratique de la proposition énoncée juste
au-dessus.

1417.

ERNEST T.'S WORKS
DIRECTIONS FOR USE

1420.

Vous êtes invités à ne pas attacher
d'importance au travail d'Ernest T.
qu'Art & Cie a l'audace ou plutôt
l'inconscience de montrer à partir
de 15 h. le samedi 24 octobre 1987,
33, quai de Bourbon 75004 Paris.

Mais vous y verrez, heureusement, des œuvres de Muntadas et de Rutault.

1422.

Ernest T. tries by all means,
to achieve the status of an
international artist.

3

1425.

M. et Mme Dossilat, les sympathiques collectionneurs de peintures d'Ernest T.

1430.

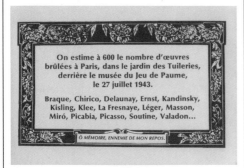

1432.

1433.

1434.

1436.

1442.

1443.

1431. ERNEST T.
Vous êtes prié d'assister au vernissage de l'exposition <<Dessins français>> d'ERNEST T. Galerie Gabrielle Maubrie, Paris, France. January 24–March 8, 1997.
Flyer.
Offset lithograph.
11.75 x 8.25 inches.

1432. ERNEST T.
On estime à 600 le nombre d'œuvres brûlées à Paris, dans le jardin des Tuileries, derrière le musée du Jeu de Paume, le 27 juillet 1943. Braque, Chirico, Delaunay, Ernst, Kandinsky, Kisling, Klee, La Fresnaye, Léger, Masson, Miró, Picasso, Soutine, Valadon... Ô MÉMOIRE, ENNEMIE DE MON REPOS.
[Self-published]. N.d.
Flyer.
Offset lithograph.
8.25 x 11.75 inches.

1433. JEAN TINGUELY
TiNGUELY's TiNGUEly.
Dwan Gallery, Los Angeles, Calif.
Opening May 13, 1963.
Poster.
Folded. Offset lithograph.
Unfolded: 29.75 x 24.5 inches.

1434. JEAN TINGUELY
Jean TiNGUELY.
Galerie Alexander Iolas, Geneva, Switzerland.
May 19–June 8, 1964.
Poster.
Folded. Offset lithograph.
Unfolded: 17 x 12 inches.

1435. JEAN TINGUELY
Le Rotozaza de Tinguely.
Alexander Iolas, Paris, France.
June 9–July 8, 1967.
Announcement card.
Folded. Offset lithograph.
Folded: 5 x 6.5 inches.
Unfolded: 9.75 x 6.5 inches.

1436. JEAN TINGUELY
In Zusammenarbeit mit Jean Tinguely ist eine Ausstellung von 50 Künstlern entstanden, zu der wir Sie und Ihre Freunde herzlich einladen. Galerie Renée Ziegler, Zurich, Switzerland.
June 11–August 7, 1982.
Flyer.
Folded. Photocopy with handcoloring.
Printed on both sides.
Unfolded: 11.75 x 8.25 inches.

1437. JEAN TINGUELY
TINGUELY.
Musée Rath, Geneva, Switzerland.
March 11–May 23, 1983.
Announcement card.
Folded. Offset lithograph. Printed on both sides.
Folded: 8.25 x 5.75 inches.
Unfolded: 8.25 x 11.75 inches.

1438. JEAN TINGUELY
JEAN TINGUELY. SKULPTUREN.
Galerie Schmela, Düsseldorf, Germany.
Opening March 16, 1984.
Announcement card.
Offset lithograph. Printed on both sides.
8.25 x 6 inches.

1439. JEAN TINGUELY
JEAN TINGUELY. INFERNO.
Kornfeld, Bern, Switzerland.
November–December 1984.
Announcement card.
Folded. Offset lithograph. Printed on both sides.
Folded: 10.75 x 7.75 inches.
Unfolded: 10.75 x 15.25 inches.

1440. JEAN TINGUELY
JEAN TINGUELY.
Galerie Beyeler, Basel, Switzerland.
February 27–April 30, 1987.
Announcement card.
Folded. Offset lithograph. Printed on both sides.
Folded: 9.25 x 6.75 inches.
Unfolded: 9.25 x 13.5 inches.

1441. JEAN TINGUELY
Jean Tinguely. „Die Philosophen" und andere Schreckgespenster.
Galerie Schmela, Düsseldorf, Germany.
November 3–December 31, 1989.
Announcement card.
Folded. Offset lithograph. Printed on both sides.
Folded: 8.25 x 5.75 inches.
Unfolded: 8.25 x 11.5 inches.

1441.1. NIELE TORONI
See Daniel Buren/Olivier Mosset/Michel Parmentier/Niele Toroni.

1442. ENDRE TÓT
IF YOU FEEL BORED GO TO THE MOVIE. CLOSE YOUR EYES AND YOU WILL SEE MY FILM. ENDRE TÓT.
[Self-published?]. N.d.
Postcard.
Offset lithograph?
4 x 5.75 inches.

1443. DAVID TREMLETT
DAVID TREMLETT.
Nigel Greenwood Inc. Ltd., London, England.
April 6–May 1, 1976.
Announcement card.
Offset lithograph. Printed on both sides.
5.25 x 6 inches.
Reference: Tremlett.

1444. DAVID TREMLETT
DAVID TREMLETT.
Galeria Marilena Bonomo, Bari, Italy. Opening October 27, 1976.
Announcement card.
Offset lithograph. Printed on both sides.
6.75 x 6.75 inches.
Reference: Tremlett.

1445. DAVID TREMLETT
WHITE LIGHT. David Tremlett.
Waddington Galleries, London, England.
October 7–31, 1981.
Announcement card.
Offset lithograph. Printed on both sides.
8 x 5 inches.
Reference: Tremlett.

1446. DAVID TREMLETT
THE SHAPE OF THINGS. DAVID TREMLETT.
Galleria Marilena Bonomo, Bari, Italy.
November 28, 1981.
Announcement card.
Offset lithograph. Printed on both sides.
4.25 x 6.75 inches.
Reference: Tremlett.

1447. DAVID TREMLETT
OLDER THAN FIRE. DAVID TREMLETT.
Massimo Valsecchi, Milan, Italy.
Opening March 16, 1983.
Announcement card.
Offset lithograph. Printed on both sides.
5.5 x 4.75 inches.
Reference: Tremlett.

1448. DAVID TREMLETT
UNA MOSTRA DI DAVID TREMLETT.
Galleria Marilena Bonomo, Bari, Italy.
Opening October 19, 1985.
Announcement card.
Offset lithograph. Printed on both sides.
6.5 x 3.75 inches.
Reference: Tremlett.

1449. DAVID TREMLETT
WALL DRAWINGS. DAVID TREMLETT.
Liliane & Michel Durand-Dessert, Paris, France.
February 4–March 18, 1989.
Announcement card.
Offset lithograph. Printed on both sides.
5.5 x 8 inches.

1449.1. DAVID TREMLETT
See also Art & Project/David Tremlett.

1449.2. BERNARD TSCHUMI
See Institute for Art and Urban
Resources/Bernard Tschumi.

1450. RICHARD TUTTLE
first one-man show. RICHARD TUTTLE.
constructed paintings.
Betty Parsons Gallery, New York, N.Y.
September 7–25, 1965.
Announcement card/brochure.
Accordion folded. Offset lithograph.
Folded: 4.75 x 5 inches.
Unfolded: 23.5 x 4.75 inches.
Reference: Tuttle, p. 86.

1451. RICHARD TUTTLE
NEW WORK BY RICHARD TUTTLE.
Yvon Lambert, Paris, France.
Opening June 20, [1972?].
Poster.
Offset lithograph.
13 x 10 inches.

1452. RICHARD TUTTLE
Richard Tuttle. New Work.
Young Hoffman Gallery, Chicago, Ill.
February 10–March 11, [1978].
Announcement card.
Offset lithograph. Printed on both sides.
8 x 8 inches.
Reference: Tuttle, p. 110.

1453. RICHARD TUTTLE
an exhibition of the work of Richard Tuttle.
College of Creative Studies, University of
California, [Santa Barbara, Calif.].
February 14–March 11, 1979.
Announcement card.
Offset lithograph. Printed on both sides.
4 x 8 inches.

1454. RICHARD TUTTLE
RICHARD TUTTLE.
Baronian-Lambert, Gent, Belgium.
Opening October 6, 1981.
Announcement card.
Offset lithograph. Printed on both sides.
4.25 x 6 inches.

1455. RICHARD TUTTLE
RICHARD TUTTLE. 70's DRAWINGS.
Brooke Alexander, New York, N.Y.
January 27–February 28, 1990.
Announcement card.
Offset lithograph. Printed on both sides.
3 x 8 inches.

1456. RICHARD TUTTLE
RICHARD TUTTLE.
Yvon Lambert, Paris, France. March 17–April 10, 1990.
Poster.
Folded. Offset lithograph.
Unfolded: 17 x 14 inches.

1457. RICHARD TUTTLE
Richard Tuttle. New Work.
Annemarie Verna Galerie, Zurich, Switzerland.
March 3–April 11, 1992.
Announcement card.
Offset lithograph. Printed on both sides.
5 x 6.5 inches.

1458. RICHARD TUTTLE
RICHARD TUTTLE.
Galerie Meert Rihoux, Brussels, Belgium.
September 16–November 5, 1994.
Announcement card.
Offset lithograph. Printed on both sides.
7.75 x 6 inches.

1459. RICHARD TUTTLE
Richard Tuttle: Books and Prints.
Trinity College, Widener Gallery, Hartford, Conn.
The New York Public Library, New York, N.Y. 1996.
Exhibition brochure and poster with wraparound label.
Brochure: Wrappers. Staple bound. Unpaginated.
Poster: Folded. Offset lithograph. Printed on both sides.
Brochure: 11 x 7.75 inches.
Poster unfolded: 22 x 16 inches.

1460. CY TWOMBLY
CY TWOMBLY.
Leo Castelli, New York, N.Y. March 14–April 10, 1964.
Poster.
Offset lithograph. Printed on both sides.
27.5 x 19.25 inches.

1461. CY TWOMBLY
Cy Twombly.
Leo Castelli Gallery, New York, N.Y.
Opening October 7, 1967.
Poster.
Folded. Offset lithograph. Printed on both sides.
Unfolded: 25.75 x 22 inches.

1462. CY TWOMBLY
CY TWOMBLY.
Galeria La Tartaruga, Rome, Italy.
Opening February 26, 1968.
Poster.
Offset lithograph.
19.75 x 23.75 inches.

1463. CY TWOMBLY
Cy Twombly.
Leo Castelli, New York, N.Y.
Opening November 30, 1968.
Poster.
Folded. Offset lithograph. Printed on both sides.
Unfolded: 24 x 17.7 inches.

1464. CY TWOMBLY
Actualité d'un bilan.
Yvon Lambert, Paris, France. October 1972.
Poster.
Offset lithograph.
35 x 23 inches.

1447.

1448.

1450.

1455.

1456.

1464.

1466.

Pour mon cher chien Russe

1471.

1474.

1476.

1477.

1481.

1465. URI TZAIG
(Blue Landscape).
[University Art Museum, Berkeley, Calif.]. [1996].
Poster.
Folded. Offset lithograph on newsprint.
Unfolded: 16.75 x 22 inches.

1466. URI TZAIG
(Sorcerer).
[University Art Museum, Berkeley, Calif.]. [1996].
Card.
Offset lithograph.
4.5 x 2.25 inches.

1467. URI TZAIG
(Cowboy).
[University Art Museum, Berkeley, Calif.]. [1996].
Card.
Offset lithograph.
4.75 x 1.75 inches.

1468. URI TZAIG
We're Gonna Fold Your Face.
[University Art Museum, Berkeley, Calif.]. [1996].
Brochure/short story.
Folded. Offset lithograph on newsprint.
Unfolded: 16.75 x 22 inches.

1469. ULAY
Renais sense. Ulay Polaroid Video Picture Show.
Instant Issue, Volune [*sic*] three.
[Serial nv, Amsterdam, The Netherlands].
December 1974.
Artist's publication.
2 leaves. Offset lithograph. 1 leaf is printed on
both sides.
[Edition of 250 copies].
21 x 14.5 inches.

1470. ULAY
BERLIN-MITTE. ULAY.
Anders Tornberg Gallery, Lund, Sweden.
March 4–29, 1995.
Announcement card.
Folded. Offset lithograph. Tied shut with wire
strung through a hole. Die-cut rectangle in which
a photo negative is mounted.
Folded: 5.75 x 6.5 inches.

1471. ULAY/MARINA ABRAMOVIC
Pour mon cher chien Russe. MARINA
ABRAMOVIC ULAY 55. PRAG 17-1-1976.
[Self-published]. 1976.
Card.
Offset lithograph. Printed on both sides.
3.25 x 7.25 inches.
Reference: Ulay/Abramovic, p. 6.

1472. ULAY/MARINA ABRAMOVIC
Für meinen lieben kleinen Teufel. MARINA
ABRAMOVIC ULAY. AMSTERDAM 17-3-1976.
[Self-published]. 1976.
Card.
Offset lithograph. Printed on both sides.
3.25 x 7.25 inches.
Reference: Ulay/Abramovic, p. 6.

1473. TIMM ULRICHS
Timm Ulrichs: Ich mache (diese) Schlagzeilen!
Gamm(a), Utrecht, The Netherlands.
October 29–November 26, 1977.
Poster.
Folded. Offset lithograph.
Unfolded: 23.25 x 16.5 inches.

1474. TIMM ULRICHS
VORSICHT Kunstblätter! Nicht Knicken. timm ulrichs.
Galerie Howeg, Hinwil-Zurich, Switzerland. N.d.
Poster.
Folded. Offset lithograph.
Unfolded: 23.5 x 16.5 inches.

1475. LILY VAN DER STOKKER
LiLY VAN DER STOKKER. MURAL DRAWiNGS
PAiNTiNGS.
Feature, New York, N.Y.
November 6–December 1, [1990].
Poster.
Folded. Offset lithograph. Printed on both sides.
Unfolded: 11 x 17 inches.

1476. LILY VAN DER STOKKER
Lily van der Stokker. wall paintings.
Feature, New York, N.Y. March 26–April 23, 1994.
Flyer.
Folded. Offset lithograph. Printed on both sides.
Unfolded: 8.5 x 11 inches.

1477. ATELIER VAN LIESHOUT
ATELIER VAN LIESHOUT. 29 OKTOBER 1999.
[Museum Boymans-van Beuningen, Rotterdam,
The Netherlands]. 1999.
Placemat.
Offset lithograph.
10.5 x 16.5 inches.

1478. BEN VAUTIER
Your thumb present now on this side of this card
is the realisation of my intention. BEN 1966.
FLUXUS POSTCARD (TOUT) BEN.
Self-published? 1966.
Postcard.
Offset lithograph.
4.25 x 6.5 inches.

1479. BEN VAUTIER
FLUXUS NICE. Why not try to pass A GODD DAY […].
[Self-published]. 1967?
Card.
Folded. Offset lithograph. Printed on both sides.
Folded: 5 x 6.25 inches. Unfolded: 4 x 12.75 inches.

1480. BEN VAUTIER
Ben à la Fiac.
Baudoin Lebon Fiac, Paris, France.
October 20–28, 1984.
Sticker/announcement.
Offset lithograph. Printed on both sides.
3.5 x 5.5 inches.

1481. BEN VAUTIER
France-Soir.
[Self-published]. N.d.
Poster.
Offset lithograph.
22 x 14.5 inches.

1482. BEN VAUTIER
ABSOLUMENT N'IMPORTE QUOI EST ART.
[Self-published]. N.d.
Poster?
Folded. Offset lithograph?
Unfolded: 9.25 x 12.75 inches.

1483. WOLF VOSTELL
bloomsday 64. ACTIONS / AGIT POP /
DE-COLL/AGE HAPPENING / TEXTE.
Galerie Loehr, Frankfurt-Niederursel, Germany. 1964.
Poster.
Offset lithograph.
48.5 x 34.5 inches.
Reference: Happening & Fluxus.

1484. WOLF VOSTELL
lesen sie dieses manifest und décollagieren sie
es indem sie sich darin waschen und abtrocknen.
Self-published? December 22, 1965.
Manifesto.
Offset lithograph on folded paper napkin.
Folded: 6.5 x 6.75 inches.

1485. WOLF VOSTELL
"AUTO"/HOMMAGE AN HENRY FORD! EINE
HAPPENINGUMGEBUNG VON VOSTELL,
TSAKIRIDIS, DIETRICH.
Auto Pavillon Maletz, Cologne, Germany.
January 16–February 3, 1967.
Poster.
Folded. Silkscreen.
Unfolded: 29.5 x 22.25 inches.

1486. VULTO
VULTO. Composition in Display (In Preserved State).
Sandra Gering Gallery, New York, N.Y.
October 26–November 23, [1991].
Announcement card.
Folded. Offset lithograph on smoked paper with
grommet on upper right corner.
Folded: 4.5 x 6 inches. Unfolded: 4.5 x 7.75 inches.

1487. VULTO
smoking buildings. vulto.
Storefront for Art and Architecture, New York, N.Y.
July 15–August 7, 1999.
Poster in Ziploc bag.
Folded. Offset lithograph on smoked newsprint.
Printed on both sides.
Poster unfolded: 22.5 x 16 inches.
Bag: 9.75 x 6.25 inches.

1488. ANDY WARHOL
ONES. Andy Warhol. THIS PHOTOGRAPH
MAY NOT BE ETC. (from Artcash).
[E.A.T/Experiments in Art & Technology,
New York, N.Y.]. [1971].
Play money.
Offset lithograph. Printed on both sides.
2.75 x 6.25 inches.

1489. ROBERT WATTS
NEWSPAYER 1984. ONE HUNDRED SPECIAL
CONTRIBUTORS.
[Self-published]. October 1985.
Artist's publication.
Poster format. Folded. Offset lithograph.
Printed on both sides.
Unfolded: 24 x 18 inches.

1489.1. ROBERT WATTS
See also George Brecht/Alison Knowles/Robert Watts.

1490. SUSAN WEIL
EAR'S EYE FOR JAMES JOYCE. SUSAN WEIL.
paintings, drawings & objects.
Anders Tornberg Gallery, Lund, Sweden.
March 10–April 4, 1990.
Announcement card.
Folded. Offset lithograph. A reproduction is
stapled onto the inside right of the card.
Folded: 11.75 x 8.75 inches.
Unfolded: 11.75 x 17.25 inches.

1491. SUSAN WEIL
SUSAN WEIL. "Cuppa Coffe". poem works & a
book of poetry.
Anders Tornberg Gallery, Lund, Sweden.
January 18–February 16, 1997.
Announcement card.
Folded. Offset lithograph. Printed on both sides.
The card folds into a box.
Unfolded: 13.75 x 7.75 inches. Folded: 4 x 4 x 4 inches.

1492. LAWRENCE WEINER
LAWRENCE WEINER. AND THEN UNTENDED
AS [. . .] COLLECTION PUBLIC FREEHOLD.
Gallery A-402, California Institute of the Arts,
[Valencia], Calif. October–November 1972.
Announcement card.
Offset lithograph.
3.5 x 5.5 inches.

1493. LAWRENCE WEINER
LAWRENCE WEINER. WITH A RELATION TO A
MANNER OF PLACEMENT AND/OR LOCATION
[. . .]. COLLECTION PUBLIC FREEHOLD.
Art Gallery of New South Wales, Sydney,
Australia. April 1974.
Announcement card.
Offset lithograph.
3.5 x 6.5 inches.

1494. LAWRENCE WEINER
DROPPED STONES. LAWRENCE WEINER.
Leo Castelli, New York, N.Y.
January 19–February 9, 1991.
Poster.
Folded. Offset lithograph. 4 die-cut squares.
Unfolded: 19.5 x 14.5 inches.

1495. LAWRENCE WEINER
LAWRENCE WEINER.
Marian Goodman Gallery. January 8–February 13, 1993.
Poster.
Folded. Offset lithograph.
Unfolded: 19 x 18.5 inches.

1496. LAWRENCE WEINER
LAWRENCE WEINER. GERALD FERGUSON:
3 STRUCTURES.
Galerie Lallouz + Watterson, Montreal, Quebec,
Canada. June 4–July 17, 1993.
Poster.
Offset lithograph.
18 x 15 inches.

1497. LAWRENCE WEINER
LAWRENCE WEINER. TO BUILD A SQUARE IN
THE RHINELAND.
Jablonka Galerie, Cologne, Germany.
October 7–November 5, 1994.
Poster.
Folded. Offset lithograph. Printed on both sides.
Unfolded: 16.5 x 11.75 inches.

1498. LAWRENCE WEINER
MUSEUM STUDIES 3: LAWRENCE WEINER.
Philadelphia Museum of Art, Philadelphia, Penn.
December 7, 1994–February 5, 1995.
Poster.
Folded. Offset lithograph.
Unfolded: 24 x 18 inches.

1499. LAWRENCE WEINER
LEARN TO READ ART. THE BOOKS:
LAWRENCE WEINER.
The New York Public Library, New York, N.Y.
February 4–April 8, 1995.
Poster.
Folded. Offset lithograph. Printed on both sides.
Includes a sheet of text.
Unfolded: 22 x 16 inches.
Sheet: 10.75 x 7.75 inches.

1500. LAWRENCE WEINER
MATTER CAUSED TO CEASE TO FUNCTION AS
IT HAD. LAWRENCE WEINER.
Regen Projects, Los Angeles, Calif. 1995.
Poster.
Folded. Offset lithograph. Printed on both sides.
Unfolded: 10.75 x 16.75 inches.

1484.

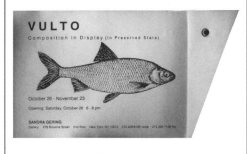

1486.

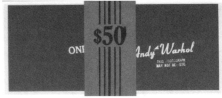

1488.

1492.

1499.

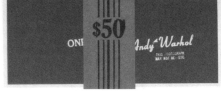

1500.

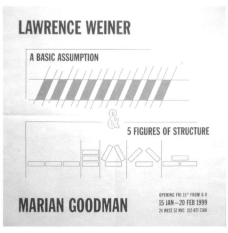

1506.

1507.

1508.

May 2nd through 4th 1976 Ian Wilson will be
in Basel for discussion.

1511.

1515.

1501. LAWRENCE WEINER
HEART OF DARKNESS. LAWRENCE WEINER.
Holstebro Kunstmuseum, Hostebro, Denmark.
October 14–December 30, 1995.
Poster.
Folded. Offset lithograph. Printed on both sides.
Unfolded: 22 x 15.75 inches.

1502. LAWRENCE WEINER
VIEWS FROM ABROAD.
Museum für Moderne Kunst, Frankfurt, Germany.
January 31–May 4, 1997.
Poster.
Folded. Offset lithograph.
Unfolded: 47 x 33 inches.

1503. LAWRENCE WEINER
THEN NOW & THEN. LAWRENCE WEINER.
Leo Castelli, New York, N.Y.
February 15–March 15, 1997.
Poster.
Folded. Offset lithograph.
Unfolded: 14 x 12.5 inches.

1504. LAWRENCE WEINER
LAWRENCE WEINER. WRITTEN ON THE WIND.
Kunsthalle Nürnberg, Nürnberg, Germany.
October 15–December 6, 1998.
Poster.
Folded. Offset lithograph.
Unfolded: 33 x 23.25 inches.

1505. LAWRENCE WEINER
SOME PRINTED POSTERS OF LAWRENCE WEINER.
Bound & Unbound, New York, N.Y.
January 9–February 27, 1999.
Poster.
Folded. Offset lithograph.
Unfolded: 14.25 x 10.5 inches.

1506. LAWRENCE WEINER
LAWRENCE WEINER. A BASIC ASSUMPTION &
5 FIGURES OF STRUCTURE.
Marian Goodman, New York, N.Y.
January 15–February 20, 1999.
Poster.
Folded. Offset lithograph.
Unfolded: 18 x 18 inches.

1506.1. LAWRENCE WEINER
See also Art & Project/Lawrence Weiner.

1507. PAE WHITE
Sarah Gavlak presents: The Third Annual
Flaming June. Alexander Calder, Michael Couglin,
Kathleen Johnson, Yayoi Kusama, Charline Von
Heyl, Pae White, TJ Wilcox.
Works on Paper, Inc., Los Angeles, Calif.
June 13–July 25, 1998.
Announcement card/fan mounted on wood stick.
Offset lithograph. Printed on both sides.
6 x 8.75 inches overall.

1508. PAE WHITE
Global Fun - Kunst und Design von Mondrian,
Gehry, Versace and Friends.
Stadt Leverkusen, Leverkusen, Germany. 1998.
6 cards and 1 sticker.
Offset lithograph. The cards are printed on both sides.
Card diameter: 3.75 inches each. Sticker: 4 x 4 inches.

1509. ROBERT WHITMAN
HOLE. A THEATRICAL WORK BY ROBERT WHITMAN.
N.p. May 27–June 1, [1963].
Poster.
Folded. Offset lithograph. Unfolded: 22 x 16.75 inches.
Reference: Happening & Fluxus.

1510. IAN WILSON
Ian Wilson. Can Something be "Made" Clear? A
discussion to be held at the John Weber Gallery.
John Weber Gallery, New York, N.Y. May 25, 1972.
Announcement card.
Offset lithograph.
3.75 x 5.75 inches.

1511. IAN WILSON
May 2nd through 4th 1976 Ian Wilson will be in
Basel for discussion.
Rolf Preisig, Basel, Switzerland. May 2–4, 1976.
Announcement card.
Offset lithograph. Printed on both sides.
4 x 5.75 inches.

1512. IAN WILSON
At 16.00 P.M., June 28th 1980, Ian Wilson will be
at the Van Abbemuseum for a discussion.
Van Abbemuseum, Eindhoven, The Netherlands.
June 28, 1980.
Flyer.
Folded. Offset lithograph.
Unfolded: 11.75 x 8.25 inches.

1513. IAN WILSON
Ian Wilson. Discussions of the Absolute. On
Sunday the 9th of May, 1999, at 18.00 p.m., there
will be a discussion at the Palais des Beaux-Arts,
Brussels.
Galerie Mot & Van den Boogaard, Brussels,
Belgium. May 9, 1999.
Announcement card.
Offset lithograph. Printed on both sides.
4 x 5.75 inches.

1514. IAN WILSON
At 8:00 P.M. Ian Wilson will be present for
discussion. March 18, John Weber Gallery, 240
West Broadway. March 20, Gian Enzo Sperone,
142 Greene Street.
John Weber Gallery, New York, N.Y. Gian Enzo
Sperone, New York, N.Y. N.d.
Announcement card.
Offset lithograph.
4.25 x 5.25 inches

1515. IAN WILSON
Les 3, 4 et 5 mai de 14 h à 19 h 30 IAN WILSON
sera présent à la galerie pour des discussions.
Liliane & Michel Durand-Dessert, Paris, France.
N.d.
Announcement card.
Offset lithograph.
4 x 6 inches.

1515.1. IAN WILSON
See also Art & Project/Ian Wilson.

1516. CHRISTOPHER WOOL
SPOKESMAN. CHRISTOPHER WOOL.
Galerie Max Hetzler, Cologne, Germany.
September 8–October 10, 1989.
Poster.
Folded. Offset lithograph. Printed on both sides.
Unfolded: 39.5 x 26 inches.

1517. CHRISTOPHER WOOL
CHRISTOPHER WOOL.
. Luhring Augustine, New York, N.Y.
May 4–June 8, 1991.
Poster.
Folded. Offset lithograph.
Unfolded: 22.75 x 33.5 inches.

1518. CHRISTOPHER WOOL
CHRISTOPHER WOOL.
Galerie Gisela Capitain. June 6–July 4, 1992.
Poster.
Folded. Offset lithograph.
Unfolded: 38 x 27 inches.

1519. CHRISTOPHER WOOL
CHRISTOPHER WOOL.
Luhring Augustine, New York, N.Y.
April 29–June 3, 1995.
Poster.
Folded. Offset lithograph
Unfolded: 19.25 x 14.25 inches.

1520. CHRISTOPHER WOOL
CHRISTOPHER WOOL.
Galerie Gisela Capitain, Cologne, Germany.
March 22–April 20, 1996.
Poster.
Folded. Offset lithograph.
Unfolded: 21.5 x 16.25 inches.

1521. CHRISTOPHER WOOL
CHRISTOPHER WOOL.
Luhring Augustine Gallery, New York, N.Y.
November 8–December 20, 1997.
Poster.
Folded. Offset lithograph. Printed on both sides.
Unfolded: 24 x 18 inches.

1522. ZAJ
Ludwig van Beethoven desea a todos sus
amigos un año especial de meditación 1970 con
la visita zaj de juan hidalgo y walter marchetti.
[Self-published?]. May 28, 1968.
Announcement card.
Offset lithograph. Printed on both sides.
9.5 x7 inches.

1523. ZAJ
C. zaj. josé luis castillejo. invierno 68-69.
[Self-published?]. 1968.
Card.
Silkscreen? Printed on both sides.
9.25 x 7.25 inches.

1524. ZAJ/JOSÉ LUIS CASTILLEJO
Modern writing. José Luis Castillejo, Bonn 1970.
[Self-published?]. 1970.
Card.
Offset lithograph. Printed on both sides.
5 x 8 inches.

1525. ZAJ/JUAN HIDALGO
zaj. desea a todos sus amigos un año especial
de meditación 1969 con la "acción zaj" de
juan hidalgo.
[Self-published?]. 1969.
Announcement card.
Offset lithograph. Printed on both sides.
Photograph by H. Wolters.
8.5 x 7 inches.

1526. ZAJ/WALTER MARCHETTI
walter marchetti. un hora zaj. madrid, enero 1970.
[Self-published?]. 1970.
Poster.
Folded. Offset lithograph.
Unfolded: 13.75 x 14.5 inches.

1527. MARIAN ZAZEELA
Marian Zazeela. Lights, Drawings. Dream Festival.
Dia Art Foundation, New York, N.Y. May 6–31, 1975.
Poster.
Folded. Offset lithograph.
Unfolded: 17 x 11 inches.

1528. MARIAN ZAZEELA
Memorial Concerts. The Electronic Music of
Richard Maxfield. Dream Festival.
Dia Art Foundation, New York, N.Y. May 13, 1975.
Poster.
Folded. Offset lithograph.
Unfolded: 17 x 11 inches.

1529. MARIAN ZAZEELA
Morning, Late Night, Afternoon Ragas. Pandit
PranNath. Dream Festival.
Dia Art Foundation, New York, N.Y.
May 18, 23, 25, 1975
Poster.
Folded. Offset lithograph.
Unfolded: 17 x 11 inches.

1530. MARIAN ZAZEELA
The Descending Moonshine Dervishes. Terry
Riley. Dream Festival.
Dia Art Foundation, New York, N.Y.
May 21, 22, 24, 1975.
Poster.
Folded. Offset lithograph.
Unfolded: 17 x 11 inches.

1531. MARIAN ZAZEELA
Solid State. Jon I lassell. Dream Festival.
Dia Art Foundation, New York, N.Y.
May 29, 30, 31, 1975.
Poster.
Folded. Offset lithograph.
Unfolded: 17 x 11 inches.

1532. MARIAN ZAZEELA
Marian Zazeela. Light.
Dia Art Foundation, Heiner Friedrich Inc.,
New York, N.Y. September 10–24, 1978?
Poster.
Folded. Offset lithograph.
Unfolded: 13.75 x 11 inches.

1533. MARIAN ZAZEELA
La Monte Young. The Well-Tuned Piano. Marian
Zazeela. The Magenta Lights.
Dia Art Foundation, New York, N.Y.
January–February 1981.
Poster.
Folded. Offset lithograph.
Unfolded: 15 x 20 inches.

1534. MARIAN ZAZEELA
Pandit Pran Nath. Raga Cycle.
MELA Foundation, New York, N.Y.
October 2 and 8, 1988.
Flyer.
Folded. Photocopy.
Unfolded: 14 x 8.5 inches.

1535. MARIAN ZAZEELA
La Monte Young. Marian Zazeela. The Theatre of
Eternal Music Big Band.
MELA Foundation, New York, N.Y. March 1990.
Poster.
Folded. Offset lithograph.
Unfolded: 13.75 x 11 inches.

1535.1. JORGE ZONTAL
See General Idea.

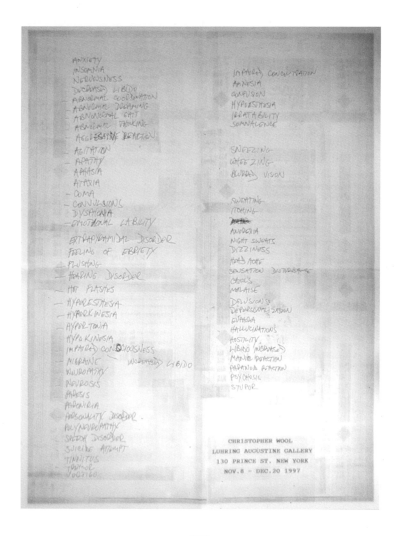

1521.

1519.

1533.

Anonymous
(Landslide Print (Bonus Issue)).
Landslide, Los Angeles, Calif.
1969.
Print.
REF NO. 19

EXTRA ART: COPYRIGHT

SMART READER

You are now in possession of Smart Art Press's smartest book, the extensive exploration of a heretofore unrecognized genre—artists' ephemera. The exhibition and catalogue were conceived and compiled by the incomparable and uncompromising Steven J. Leiber of San Francisco, California, whom we thank profusely. Thanks also to Larry Rinder, former director of the California College of Arts and Crafts, for initiating this project, and Ralph Rugoff, the CCAC's new director, for keeping it alive. Kudos, too, to Pilar Perez for shepherding the project through a minefield of complications, to Michele Perez for her exceptional design, and to Dave Muller for the cover art. Try not to lose it. You'll be sorry if you do. —Tom Patchett

1.

2.

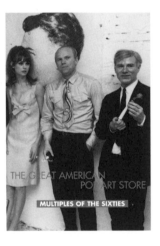

3.

MAN RAY: PARIS>>L.A.

Man Ray: Paris>>L.A. is the first-ever in-depth look at the life and art of Man Ray during the decade he spent in Southern California (1941–50), including major paintings and other important works created during this period, never-before-seen photographs documenting the local scene, and letters and other documents relating to Man Ray's life in California. Includes an essay by Dickran Tashjian and a reminiscence by James and Barbara Byrnes.

Softcover, 12 x 9 inches • 128 pp • Illustrated throughout
ISBN 0-9646426-8-9 • $30

THE GREAT AMERICAN POP ART STORE: MULTIPLES OF THE SIXTIES

The Great American Pop Art Store is a comprehensive look at the wildly eclectic multiples created when Pop art was in its infancy. Featuring work by Dine, Johns, Lichtenstein, Oldenburg, Rauschenberg, Rosenquist, Warhol, and Wesselmann, to name just a few, this book is a primary source for the reexamination and rediscovery of an art form that was profoundly influencial. Essays by Constance W. Glenn and Dorothy Lichtenstein.

Softcover, 9½ x 6½ inches • 116 pp
63 color and 31 black-and-white reproductions
ISBN 0-936270-36-5 • $25
Smart Art Press/University Art Gallery,
California State University, Long Beach

BECK AND AL HANSEN: PLAYING WITH MATCHES

Featuring collages, assemblages, drawings, facsimile texts, and never-before-seen photographs, *Beck and Al Hansen: Playing with Matches* examines the artistic relationship between Grammy-winning musician Beck and his grand-father, Happenings/Fluxus artist Al Hansen. Essay by Wayne Baerwaldt, interview with Beck by Carlo McCormick.

Softcover, 10½ x 9 inches • 124 pp
109 color and 42 black-and-white reproductions
ISBN 0-921381-13-1 • $24.95
Smart Art Press/Plug In Editions